Art as Spiritual Activity

VISTA SERIES

VOLUME 3

Art as Spiritual Activity

Rudolf Steiner's Contribution
to the Visual Arts

Selected Lectures on the Visual Arts
by Rudolf Steiner

with an Introduction by Michael Howard

Anthroposophic Press

To Susan and Kiri Anna

Introduction copyright © 1998 Michael Howard
Lectures copyright © 1998 Anthroposophic Press

Published by Anthroposophic Press
3390 Route 9, Hudson, NY 12534

The lectures in this book are found in the *Rudolf Steiner Gesamtausgabe* [the collected works of Rudolf Steiner], published by Rudolf Steiner Verlag, Dornach, Switzerland, as follows: 1. in vol. 30, *Methodische Grundlagen der Anthroposophie 1884–1901*; 2. in vol. 271, *Kunst und Kunsterkenntnis*; 3. in vol. 286, *Wege zu einem neuen Baustil*; 4. in vol. 170, *Das Rätsel des Menschen*; 5. in vol. 272, *Kunst und Kunsterkenntnis*; 6. in vol. 181 *Erdensterben und Weltenleben*; 7. in vol. 271, *Kunst und Kunsterkenntnis*; 8. in vol. 82, *Damit der Mensch ganz Mensch werde*; 9. in vol. 220, *Lebendiges Naturerkennen Intellektueller Sündenfall und spirituelle Sündenerhebung*; 10. in vol. 349, *Vom Leben des Menschen und der Erde*. The lectures for this edition were either newly translated or thoroughly revised from an earlier translation by Catherine E. Creeger.

Library of Congress Cataloging-in-Publication Data 12/98

Steiner, Rudolf, 1861–1925.
 [Rudolf Steiner Gesamtausgabe. English. Selections]
 Art as spiritual activity : Rudolf Steiner's contribution to the visual arts / lectures
by Rudolf Steiner : with an introduction by Michael Howard.
 p cm. — (Vista series ; v. 3)
 Includes bibliographical references and index.
 ISBN 0-88010-396-5 (pbk.)
 1. Art—Philosophy. 2. Anthroposophy. I. Howard, Michael, 1946– .
II. Title. III. Series.
N7445.4.S74213 1997
701—dc21 97-37381
 CIP

10 9 8 7 6 5 4 3 2 1

Printed in the United States of America

CONTENTS

The Vista Series Foreword by Robert McDermott *vii*

INTRODUCTION

by Michael Howard

I. Is Art Dead? *3*

II. To Muse or Amuse *8*

III. Artistic Activity as Spiritual Activity *12*

IV. The Representative of Humanity *36*

V. Beauty, Creativity, and Metamorphosis *57*

VI. New Directions in Art *93*

LECTURES

by Rudolf Steiner

1. The Aesthetics of Goethe's Worldview (L 1) *113*
 Vienna, November 9, 1888

2. The Spiritual Being of Art (L 2) *135*
 Berlin, October 28, 1909

3. Buildings Will Speak (L 3) *154*
 Dornach, June 17, 1914

4. The Sense Organs and Aesthetic Experience (L 4) *176*
 Dornach, August 15, 1916

5. The Two Sources of Art:
 Impressionism and Expressionism (L 5) *195*
 Munich, February 15, 1918

6. The Building at Dornach (L 6) *214*
 Berlin, July 3, 1918

7. The Supersensible Origin of the Arts (L 7) *237*
 Dornach, September 12, 1920

8. Anthroposophy and the Visual Arts (L 8) *250*
 The Hague, April 9, 1922

9. Truth, Beauty, and Goodness (L 9) *272*
 Dornach, January 19, 1923

10. Christ, Ahriman, and Lucifer (L 10) *281*
 Dornach, May 7, 1923

BIBLIOGRAPHY

 Rudolf Steiner on Art and Related Matters in English *297*
 Works of Visual Art Created by Rudolf Steiner *306*

INDEX *315*

In the first quarter of the twentieth century, Rudolf Steiner offered an account of the spiritual origin and meaning of art. He articulated and demonstrated the transformative capacity of arts practiced as a spiritual experience. When he lectured on the arts and gave recommendations to artists working in central Europe, mostly in German-speaking cultures, Steiner emphasized the role that the arts could play in restoring a capacity for spiritual activity. He felt that this capacity was weakening under the reigning cultural assumptions of the time.

In recent decades, the center of artistic innovation has moved from Europe to the United States, and new technologies, materials, and subject matters have made the art scene look very different from the way it did in Steiner's time. The spiritual aspects of artistic processes, however, remain as important and relatively unexamined as they were when Steiner addressed them decades ago. These topics include artistic and spiritual experience, and the role of imagination in aesthetic, spiritual, and conceptual domains. As a spiritual teacher, Steiner was able to identify these and similar questions and introduce ways of exploring them that are still valid many decades after he first brought them to attention.

Steiner did not set out to become an artist. He neither studied nor practiced a particular artistic discipline. Although he created several significant works of art—particularly a double cupola building he called the Goetheanum—and exercised a profound and direct influence on many arts and artists, it is slightly misleading to characterize

him as an artist. He was surely artistic in all of his activities, including thinking, writing, lecturing, and rendering intelligible the reality of the spiritual world, but he was not exclusively or even primarily an artist, as were, for example, Picasso or Brancusi. Rudolf Steiner was an artist in the same way that he was a philosopher and scriptural exegete, physicist and astronomer, economist and educator, namely, within the framework of his spiritual-esoteric research and teaching.

As is evidenced by his three hundred and fifty volumes of writings and lectures, Steiner spared no effort in his attempt to disclose and render useful the fruits of his esoteric research in more than a dozen entirely distinct fields. Steiner's artistic work was a by-product of his larger effort to bring the spirit into view. Steiner's access to the spiritual world enabled him to work with color, shape, sounds, and words in ways that rendered their spiritual qualities both visible and tangible. As Michaelangelo was able to free the form of the mother of Jesus and her crucified Son from a formless mass of marble, Steiner was able to see, and to help the artist liberate, spiritual realities in matter. Steiner was a spiritual scientist whose research generated profound and transformative insights concerning visual and performing arts.

This volume focuses on Rudolf Steiner's contributions to the visual arts themselves, as well as to our understanding of these arts, and his directions for practicing them as a path of spiritual activity. Steiner was able to access the inner realities of space, time, sound, word, shape, and color because of his clairvoyance, both innate and developed. By providing advice to artists (always in response to requests from the artists themselves), Steiner bequeathed an enormous body of spiritual aesthetics and practical indications for many visual arts, including painting, sculpture, architecture, form drawing, and stained glass. In response to requests for direction from performing artists, including poets, dramatists, dancers, singers, and instrumental musicians, Steiner gave similar indications of ways to draw out of material realities their latent spiritual capacities. Such drawing forth of spiritual meanings is a spiritual practice, one that requires and in turn develops spiritual capacities.

In contrast to anyone whose consciousness is characterized by modern Western materialism and an inability to know spiritual realities, Steiner knew the spiritual world throughout his life and struggled both to understand the limited capacities of others and the ways those capacities could be developed. According to Steiner's practical advice for anyone on a path of spiritual development, scarcely any approach is more promising of positive results than the spiritual practice of artistic discipline.

The primary purpose and result of Steiner's lectures on the arts is to show various ways by which to transform art from a profane to a spiritual activity. In Steiner's spiritual teaching, called *anthroposophy* (the wisdom of the truly human), the individual and the universe are essentially spiritual and interwoven, and art can be, and should be, an effective way of relating these two spiritual realities ordinarily separated.

As is evident in his introductory essay, Michael Howard has been striving throughout his adult life to extend Steiner's insights concerning the visual arts. By virtue of his own experience as sculptor and teacher of sculpture classes for adults, Howard is able to place Steiner's lectures on the spiritual mission of the arts within the context of contemporary aesthetics and spiritual experience. He is particularly adept at showing the ways in which Steiner's lectures on the arts—ten of the best of which are printed in this book—are relevant for our attempt to understand the origin of art, the esoteric character of the building Steiner designed, the relationship of the arts to supersensible experience, and the need for balance between materiality and spirituality.

Through the introduction by Michael Howard and Steiner's ten lectures, this volume offers an account of the sources and purposes of art as well as a particularly helpful approach to art as a spiritual practice. So, far from being dated, Steiner's account of art and its relation to spiritual experience is at least contemporary and probably ahead of its time. As this book ably shows, Steiner's insights concerning art, particularly when approached and practiced as a spiritual activity, might be exactly what art, artists, and contemporary culture urgently need.

· · · · · · · ·

The Vista Series, of which this is the third volume, has been generously supported by a grant from Mr. Laurance S. Rockefeller, a legendary philanthropist and visionary, who practices business as an art.

INTRODUCTION

Working with Rudolf Steiner's Contribution

to the Visual Arts

MICHAEL HOWARD

I. Is Art Dead?

Could it be possible? This old saint in the forest
has not heard anything of this, that God is dead! — Nietzsche[1]

The search in modern life is for utility, the endeavor is to improve
existence materially ... it is no longer a question of spirit, of thought,
of dreams. Art is dead. — Rodin[2]

The fine arts are dead.[3]

I was twenty years old, reading Nietzsche's *Thus Spoke Zarathustra*, when the question arose, "If God is dead, is Art dead?" Although I had been artistically inclined throughout my boyhood, I see the dawning of this question as the beginning of my artistic life.

What did this question mean to me? I recall feeling unsettled, yet stimulated to integrate Nietzsche's negation of divinity with the many ways of relating to the Divine that I was meeting at the time. For me, the significance of Nietzsche's claim that "God is dead" was not primarily theological; it was a catalyst awakening me to questions about art that had, until then, only slumbered within me. This questioning of my assumptions about art proved essential to setting my course as an artist.

My reading of Nietzsche came after two years at the Ontario College of Art in Toronto, Canada. Majoring in sculpture, I felt totally in my element; I had found a way of life true to myself. Nevertheless, I began to feel uneasy about devoting my life to art. Practicing my art was personally fulfilling, but I was haunted by the feeling that there was more to being an artist than satisfying my personal need to be creative.

1. Nietzsche, *Thus Spoke Zarathustra* (OA 21). The symbols in parentheses refer to the bibliography at the end of this book as follows: (RSE 1–74)—Rudolf Steiner in English; (AA 1–70)—Anthroposophical Authors; (OA 1-33)—Other Authors; (L 1–10)—Steiner Lectures in this volume.
2. Paul Gsell, *Rodin on Art and Artists*, p. 1 (OA 13).
3. Unnamed artist, *Newsweek*, July 26, 1993.

At sixteen, I had read Irving Stone's biographical novel on the life of Michelangelo, *The Agony and the Ecstasy*. This portrayal of Michelangelo as a lone genius, living only for his creative work and driven to achieve greatness, shaped my own ideals and creative efforts. I suspect there are few artists today who are completely free from the influence of this image of the heroic artist, especially in a culture that is so permeated by the cult of success and fame.

Even while this ideal held me in its spell, my questions about art began to surface, questions that led me to discontinue my art training and to wander in search of an unknown something. At the time, I could not have articulated exactly what it was I sought. I recognize in retrospect that, impelled from unknown depths, I was looking for a new vision, a new model of the artist. Although the ideal that Michelangelo represented continued to hold its attraction, I sensed that there were new tasks and new ways of working. Intuitively, I knew that art was not dead, but it was not clear to me how I might discover new life and meaning as an artist.

For three years after leaving art college, my subconscious search for new meaning and direction in art produced few tangible results. Then I met the work of Rudolf Steiner. At first I was drawn to Steiner's thinking because he addressed the half-conscious questions I had about human life in general. I subsequently discovered that the arts played a central role in his vision of human evolution. A picture began to form within me in which my potential development as artist and human being appeared to be complementary. I learned from Steiner that the development of artistic faculties and capacities could directly affect my development as a human being. I began to envision how I could work at my art in a way that allowed color and form to bridge the everyday world of sensory experience to the realms of soul and spirit. I saw that working with these dimensions of reality gave meaning and purpose to all aspects of my life and work. Life brought answers to my questions, only to initiate a continual awakening to ever deeper layers of mystery and new questions.

This book is an introduction to Rudolf Steiner's monumental contribution to the visual arts of the twentieth century and beyond. How I came to Steiner's work has relevance only as a means of conveying

to the reader that Steiner's approach to the arts is not abstract or theoretical, but speaks to the deepest questions we may hold as human beings—artists and nonartists alike. Steiner's perspectives reveal the arts to be the stage of a great spiritual drama in which the destiny of humankind is intimately interwoven with the deeds of spiritual beings. Any introduction to Steiner's contribution to the visual arts must, as a primary goal, attempt to give the reader a feeling for this living drama that underlies the history of art, and for the spiritual forces at work shaping artistic activity to this day. The central issues at the heart of this drama must be raised with all their life-filled complexity and ambiguity.

This sense of being part of a spiritual drama when speaking, viewing, or creating works of art is the fundamental note sounding through the introduction that follows, shaping its form and content. It seems, from this perspective, neither possible nor desirable to introduce all the main points of Steiner's contribution to the visual arts, nor to address all the concerns and challenges that might be raised in response to them. I have limited myself to the more modest task of discussing only those aspects of Steiner's work that have come to life within my experience as a practicing artist. There are areas of Steiner's work that I do not address, and those I do take up I discuss in the way that has become meaningful to me, even when they are thoughts and experiences of the most modest and elementary kind. Someone else would approach the same material in quite a different way. The particulars of my descriptions—or those of anyone else— are less important in themselves; they will have served their purpose if they awaken the reader to the realization that artistic experience can be cultivated as a way to know the spiritual in the world and in ourselves. It is up to each individual to tread his or her particular path. The descriptions of one person's travels in a foreign land may inspire others to visit there as well. But how each one gets there and what each experiences will, in the details, be unique for every individual.

Since Steiner's insights originate from realms that transcend everyday experience, it is tempting to jump to the conclusion that our unfamiliarity with what he discusses must mean they have no practical

relevance to our life and artistic concerns. The thoughts and experiences offered in the following introduction attempt to demonstrate the valuable process of translating his ideals into artistic practice.

Twenty-five years have passed since I first met Steiner's thinking through lectures such as the ones found in this volume. I can remember well my own feelings of bewilderment. What could I possibly do with such ideas? How could I incorporate them into my own creative efforts? Slowly, mysteriously, over the years I have encountered both artistic and life experiences that would not have been mine without the illumination gained from Steiner's insights.

In studying these lectures, the reader may encounter difficulties familiar to many who concern themselves with Steiner's writings. The insight Steiner gives to all subjects, including the visual arts, can be grasped only in the context of his whole worldview—one that often challenges our sense of reality with descriptions that might initially seem outside the scope of our own experience. In reading Steiner's perspectives about art, non-artists may ascribe their difficulties to their lack of practical experience in the arts. Accomplished artists, however, can be just as bewildered, frustrated, and sometimes threatened by his ideas. Some degree of struggling is necessary to assimilate Steiner's views. Whether we feel this struggle is worth the effort usually depends on the questions we have about human life in general and the arts in particular. Are we equally attracted and repulsed by the developments in human culture and the art world of this century? Do we feel doubts and even anguish about where humankind is headed?

A helpful approach to Steiner is to neither accept nor reject him, but simply hold in abeyance what one cannot at first assimilate. One of the most enriching aspects of working with Steiner's thinking is the way it can mature within us, over time, to greater clarity. Because it introduces dimensions of reality with which most of us are unacquainted, we should expect that it will take considerable time and effort to make Steiner's indications our own. To work with Steiner's ideas is daunting, but ultimately liberating; we are challenged to grow into realms of experience that, initially, are outside of our present horizons. Steiner's views challenge us not merely to

assimilate a body of new ideas but rather to develop new organs of perception that eventually lead us to new vistas beyond the limits of reality already familiar to us.

Steiner's indications for the arts are too deeply rooted in the mystery of human diversity to be interpreted dogmatically, although the temptation to do so often arises. Steiner offers an evolving vision of what the arts could be for human life and development. Superficial impressions too often lead to the erroneous view that he advocated only a narrow stylistic formula. In these matters each of us—artist and non-artist—must find our own way, in our own time. To read about the efforts of someone else cannot replace our own efforts, but to see the way one person has worked to bring such ideals into practice may stimulate others to do the same.

I hope the reader will bear in mind that what I have to say has evolved over years of practical effort to integrate Steiner's thinking and his example into my own creative work in a way that is true to me. Steiner challenges us to develop capacities that, at present, we may barely imagine, but that are critical both to individual and world evolution. He would be the first to support the inner necessity for that development to be individualized and, for the most part, self-directed. Knowing that my own insights and experiences are still very much in a process of growth, I invite the reader to join me in "the agony and the ecstasy" of clarifying the ever near, but ever elusive, way our humanity evolves through the path of art.

II. To Muse or Amuse?

The problem is not that television presents us with entertaining subject matter, but that all subject matter is presented as entertaining.[1]

It always signifies a distinct decadence in art when its mission is sought in mere amusement.[2]

We live in the "Age of Entertainment." Sports, movies, and television are the most popular forms of entertainment. The performing arts of music, drama, and dance are generally regarded as part of the entertainment business. Perhaps the term *entertainment* is not so often applied to the visual arts of architecture, sculpture, and painting, but the personal reaction of pleasure or displeasure is commonly presumed to be the appropriate response to paintings, sculptures, and architecture as it is with the other forms of entertainment. Personal feelings of sympathy and antipathy, cloaked in all manner of rationales, drive not only entertainment but most spheres of human life, including the arts. In contemporary culture the situation is compounded by the development of art forms such as dadaism, pop art, and performance art, which, by their very nature and intent, blur the lines between art and entertainment. To have our feelings of like and dislike is commonly considered a sacred right; for many, this is the only way imaginable of relating to works of art. The conscious intent of many artists is specifically to shock and trigger reactions of dislike and disgust.

In his book *Amusing Ourselves To Death* (OA 24), Neil Postman has vividly portrayed the extent to which we have come to measure all experiences according to their entertainment value. To "amuse ourselves" was once reserved for moments of leisure, when we rejuvenated ourselves in body, soul, and spirit in order to better meet the needs and challenges of life. The related concept *recreation* is clear in

1. Neil Postman, *Amusing Ourselves To Death* (OA 24).
2. Rudolf Steiner, *The Aesthetics of Goethe's Worldview* (L1).

its original meaning: "to recreate," or renew, oneself. Today *recreation* can apply, along with *entertainment*, to anything that occupies or captivates our attention, whether it is rejuvenating or not. Postman puts before us a mirror of modern life in which we see how, in leisure, as well as in work, we seek all manner of means to distract us from the full reality and significance of human life. Are we "amusing ourselves to death," as Postman asks? Are we conscious of the profoundly deadening effect our entertainment mind-set has on the quality of human life today?

Whether or not we share Postman's assessment of our culture, we might ponder the source of this need to amuse ourselves and our inclination to judge all matters by their entertainment value. At the very least, the desire to be entertained is a force in our lives with which we must reckon. That fact alone gives us good reason to examine the source of our need to be amused and its place in human life.

The word *amusement* has become synonymous with *entertainment*, something that, in its lightheartedness, distracts us from the more weighty concerns of life. Actually, the word has quite a different meaning. *To amuse* is derived from the Middle French word *amuser*, which means "to cause to muse." *To muse* means to meditate, ponder, reflect, or dream. The verb *muse* is no longer used as frequently as the other terms used to define it, perhaps because it implies an experience that is not so familiar to us. In most dictionaries, the verb *muse* precedes the proper noun *Muse*, by which the Greeks referred to the nine goddesses who presided over the arts and sciences. *Muse*, of course, is also used to describe "the genius of a poet."

Today, if one uses the term *muse* at all, one means it metaphorically. We might do well to remember the thinking of the Greeks, and the consciousness of most cultures until about five hundred years ago when a relationship with actual spiritual beings was a given part of reality. Steiner's views challenge us because he spoke out of a reality that included the direct experience of spiritual beings, who were as real to him as human beings are to us.

> This has been said only in order to show you the way to the thought that modern consciousness has evolved from an

age-old state of consciousness, when the human being was not in direct touch with outer objects in the modern sense, but instead was in connection with facts and beings of the spiritual world.... Such a consciousness perceived spiritual facts and the spiritual world. Today human beings are among beings of flesh; at that time ... they lived among spiritual beings, which were present for them—they were spirits among spirits.... They lived at that time among spiritual beings; and just as you need no proof to be convinced of the presence of stones, plants, and animals, so humankind in those primeval times needed no testimony to be convinced of the existence of spiritual beings.... A dreary, arid learning with no inkling of real spiritual processes asserts that all the figures of Nordic or Germanic mythology, of Greek mythology, and all the records of gods and their deeds are merely inventions of popular fantasy.[3]

The capacities by which we can gain insights into higher worlds lie dormant within each of us. Mystics, gnostics, and theosophists have always spoken of a world of soul and spirit that is as real to them as the world we can see with our eyes and touch with our hands. Listening to them, we can say to ourselves at every moment: "I know that I, too, can experience what they talk about, if only I unfold certain forces within me that today still lie dormant there." All we need to know is how to begin to develop these faculties for ourselves.[4]

Steiner would have us neither accept nor reject the reality of spiritual beings. Instead, he invites us to remain open to the possibility that the capacity to perceive spiritual beings and their influence upon human affairs is one that all human beings can potentially develop. Fundamental to Steiner's view concerning the arts is the reality that creative activity does not originate solely out of ourselves, but out of an actual world of spirit and in relationship with specific spiritual beings.

3. Rudolf Steiner, June 17, 1908, Nuremberg (RSE 68).
4. Rudolf Steiner, *How to Know Higher Worlds: A Modern Path of Initiation*, p. 13 (RSE 7).

How can we, as modern individuals, find a meaningful connection to this extraordinary statement? To refer to the arts as a "domain of spiritual activity" is not uncommon. Steiner claims that now, however, we can and must learn to be exact in what we mean by the "spiritual in art." Vague generalities about the spiritual—no less than absolute denial of it—prevent the arts from fully serving human culture.

This will be our first and most critical task: to clarify our understanding and experience of the spiritual in the visual arts. Can we find a starting point that is grounded in the physical world, where we find our present sense of reality but that, at the same time, contains dimensions unaccounted for by physical forces? Is the spirit totally absent from the physical world we perceive through our senses, or is it a question of our learning? How can we learn to distinguish the spirit in the physical world with the same exactness and concreteness by which we strive to know the facts of the everyday physical world?

These questions touch all spheres of human concern and can be taken up within each domain of human culture. Our focus on the visual arts requires that we narrow these general issues to the following more specific questions: What is the spiritual dimension of each art? How do we cultivate the capacity to perceive and work with this spiritual dimension?

This essay focuses on specialized questions about the nature of form—as it pertains to sculpture and architecture—and the nature of color in painting, so that we may recognize the spiritual dimension that constitutes the foundation of each art. Toward this end we will distinguish between the spiritual and the physical in each medium.

Having established some basic insights about the nature and significance of form, we shall turn to a particular sculpture created by Rudolf Steiner called *The Representative of Humanity*. This sculpture serves to demonstrate Steiner's capacity to realize his ideals for the arts, not only in theory, but in practice. We will dwell on this sculpture in considerable detail because, along with Steiner's written views, it will lead us to new insights on subjects such as beauty, creativity, and metamorphosis.

III. Artistic Activity as Spiritual Activity

What Is Form?

We see, in figure 1, a quantity of material substance, in this case, a patch of ink. As a drawing, it fills an area that is more readily measured than its physical weight. However, if this and any of the subsequent drawings we shall be looking at are seen as the silhouette of a quantity of clay, then its weight is also measurable.

Figure 1

In either case, as a two-dimensional drawing or as a three-dimensional sculpture, the quantitative attributes of volume and weight that an object possesses are self-evident to our experience. With every sense impression, we encounter matter but in a diversity of forms. Although form is a commonplace phenomenon, we must be clear about its meaning. For example, does the above patch of ink (figure 1) have *form*?

When I put this question to my students, very few doubt that it has form. When asked to justify their claim, they point to the fact that it occupies space, has volume and, in particular, that it has a boundary. If these are the defining attributes of form, then we must agree that such a drawing or sculpture has form.

The Distinction between Form and Matter

However understandable, this commonly held view of *form* poses a difficulty. It makes no distinction between *form* and *matter*; they become one and the same thing. Matter always has volume, occupies

space, and at some point ends, thus creating a boundary. Does matter by definition have form, or are there conditions in which matter is without form?

Until recently we could say matter is formless when it exhibits no apparent order or is, in other words, in a state of *chaos*. Today, chaos is a major subject of scientific research, the fruits of which indicate that order may be found where it had previously eluded our awareness and that our recognizing it may simply depend upon our developing more refined capacities of perception and thinking. The unveiling of such hidden order within apparent chaos, rather than blurring the distinction between form and matter, actually helps clarify it. When we perceive form in a material substance, whether microscopic or macroscopic, an ordering principle may be recognized behind it; conversely, wherever an ordering agent is active, form is created. Form always points back to an ordering principle; an ordering principle always results in form.

With the aid of ever more refined instruments, modern science has been able to recognize ever more subtle manifestations of order within matter itself. We can say that material substances, because of their lawful properties, possess order and, in that sense, inherent form. This is a matter of practical experience for a sculptor when modeling clay in contrast to carving various woods or stones: each material must be worked according to its inherent properties. But no matter how much a sculptor cultivates a sensitivity for the lawful nature of the material, he or she would not equate "the natural form of the material" with "giving form to the material." The driving force for an artist who has a full appreciation for his or her material is to give form where there is none or at least to transform the material from one form into another. In this sense, figure 1 (especially as a mass of clay) represents the raw, unformed material that awaits our forming activity. In forming matter, however, we enter a world of great mystery. How does matter acquire form? What are the sources of order that give birth to form?

The full scope of our inquiry into the nature of form leads us beyond the specialized concerns of sculpture or philosophy, for it touches upon the heart of our common humanity. For example: What is the relationship between sculptural forms and social forms?

Does the capacity to experience and create harmonious sculptural forms have any bearing on our ability to create healthy social forms?

Social Form

The formation of matter is not limited to the visual arts. All commercial fabrication of cars, furniture, and so on takes raw matter and gives it form. But formative activity is not limited to creating tangible objects. Every human being participates—unconsciously, for the most part—in creating the intangible, but real, social forms of culture, politics, and the economy. In this respect we are all artists. In every human encounter, large or small, we each shape the fabric of social life. How conscious are we of the forms we create? The laws of nation, state, and community form the quality of our lives. The form of our education shapes our character and worldview. The form of the economy in which we participate shapes the resources at our disposal. Every relationship between husband and wife, parent and child, friend and colleague is unique in character or form. Do we perceive the form of these relationships? Do we experience these relational forms as something we creatively shape and transform?

At the heart of Steiner's work is the view that self-directed transformation is necessary for the realization of human potential. Steiner taught that the arts influence individual development, which, in turn, leads to social transformation. We will develop this theme more fully as we proceed, but for now we can glimpse the breadth of Steiner's view of the social significance of the arts from the following excerpt of a lecture included in this volume.

My dear friends, regardless of how much people contemplate getting rid of criminality in the world by means of outer institutions and arrangements, for human souls in the future, true redemption—the true transformation of evil into good—will happen when art permeates human souls and hearts with a spiritual substance. If they allow themselves to be influenced by the quality of architectural and sculptural forms and the like, then they will stop lying if they are predisposed to lying; they will stop disturbing the peace of their fellow human beings if that was

their tendency. Buildings will begin to *speak*. They will speak a language that people today do not even dream of.

Today people assemble in congresses to negotiate world peace. They believe that what is spoken from person to person can really create peace and harmony. But congresses do not create peace and harmony. Peace and harmony worthy of the human being will result only when the gods speak to us. When will the gods speak to us? (L 3)

How can we make practical sense of this provocative question, "When will the gods speak to us?" Steiner seems to be suggesting that our creative efforts in the visual arts and social life depend upon our ability to perceive the activity of spiritual beings. To modern consciousness, this sounds fantastic. Yet, Steiner intends this to be taken as a practical matter: the capacity to know the activity of spiritual beings lies within the potential of normal human development. Not only was this capacity ours in the past, but in the not so distant future it will become once again as normal as ordinary sense perception is today. The existence of a future capacity can never be proven; only a practical method of development can be outlined and then pursued. The demonstration lies in developing the capacity oneself.

Most of us require time to accept such a point of view. In the meantime, two activities can help us find our own way to what Steiner proposes as possibilities. The first is to refrain from rejecting the ideas outright. By analogy, we may at present lack the strength or skill to climb a mountain; if we assert that the development of such capacities is impossible, we exclude the possibility that one day we might develop them. The second helpful activity is to develop a clearer, more vivid understanding of spiritual matters. For example, reading about others who climb mountains can make the possibility become so vivid that we begin to imagine doing it ourselves. With this in mind, we can turn to another lecture included in this volume where Steiner addresses the relationship of spiritual beings to the various arts.

In *The Spiritual Being of Art* (L 2), Steiner describes seven spiritual beings who "lacked anything that might still recall the physical, sense-perceptible world." Each appears before the Being of Art, who

asks each in turn, "Who are you?" Each responds differently, but there is a common character to their responses. For example, the Spirit of Dance answers, "Yonder in the physical world, people describe me as one of their senses, a very minor sense they call the sense of balance, which has become very small and consists of three not quite complete circles that are attached to each other in the ear."

To the question, "What can I do to help you?" the spirit replies, "You can help me only by *uniting your soul with mine*, by transmitting to me here everything that people in life on the other side experience through the sense of balance. Then you will grow into me and become as large as I am myself. You will liberate your sense of balance; as a spiritually free being, you will raise yourself above attachment to the Earth."

In uniting herself with this spiritual being, the Being of Art puts one foot in front of the other, changing repose into movement, and changing movement into dance, completing it as a form.

Physical Senses, Spiritual Beings

Each of the seven spiritual beings identifies the domain of their activity in relation to a particular sense organ in the physical world. Dance is grounded in the sense of equilibrium; drama, the sense of movement; sculpture, the sense of life; architecture, the sense of touch; painting, the sense of sight or light; music, the sense of hearing tone; and poetry, the sense of hearing speech. We must note that Steiner speaks of twelve senses instead of the usual five.[1] For our discussion of art, it is enough for us to recognize each of the above-mentioned senses as realms of normal experience.

How Do the Gods Speak?

If we are open to the possibility that Steiner is not being allegorical, but quite exact, in describing spiritual beings, and if, at the same time,

1. See the lecture contained in this volume, *The Sense-Organs and Aesthetic Experience* (L 4), August 15, 1916, Dornach. Also see: *Man's Twelve Senses in Their Relationship to Imagination, Inspiration and Intuition* (RSE 39), August 8, 1920, Dornach. For lectures on this theme see, *Man as a Being of Sense and Perception* (RSE 48) and *The Foundations of Human Experience* (RSE 73), lecture 8. Also see (AA 34) and (AA 64).

we do not wish to take this on faith but make it our own, then we must find a practical starting point. In the above conversation with the Being of Art, we can find some guidance. There, we can see two tasks for us, if we wish to enter into this reality. The first task is to look more carefully at the various modes of sense perception. Although the senses seem bound to material reality, we shall see that they can bridge the material to the spiritual—if we can achieve the second, more difficult requirement, *to unite our soul with the soul of each sense.*

In order to understand what this means, we must return to our investigation of the nature of form. If we take the view that figure 1, in spite of its having volume and boundary, is unformed matter, then we can ask, what must happen for it to acquire form?

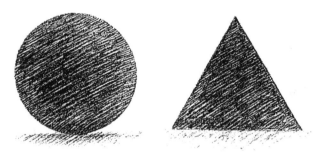

Figures 2a, 2b

In figure 1, we may have tried to find something recognizable to which we could have given a name—perhaps a face or animal. Even if we did give it a name, we could not claim for certain that the maker of those marks intended such a face or animal. We would have to admit that we might be imposing the idea upon it. When in a playful mood we see something in a cloud, we know we are only projecting our own mental pictures onto the random configuration of the cloud. Similarly, with all natural and manufactured forms we can learn to discern when a concept inherently belongs to it or not.

Formed Matter

With figure 2, however, we find a significant difference. From the first instant our vision falls on these figures, we can hardly avoid

thinking "circle" and "triangle" or, as silhouettes, "ball" and "pyramid." There is no question that they have form; they are quantities of ink or clay organized by an idea. In fact, the material substance is all but forgotten, relative to the power the idea holds over our attention. How do we read an idea from formed matter?

The Elements of Form

Figure 2a is a surface with a particular convex curve that remains constant and thereby returns on itself. In contrast, 2b is a surface with three straight lines, or planes, intersecting as three sharp angles. In addition, Form 2a is widest in the middle, tapering to a single point both at the top and bottom. Form 2b is widest at the very bottom and tapers to a point at the top. Both forms are symmetrical. Particular configurations constitute the various forms:

> curved / angular
> wide / narrow
> symmetry / asymmetry

We make such distinctions so automatically that we are usually unconscious of the process. With familiar forms such as these, we effortlessly and subconsciously search through our field of mental pictures to find the appropriate concept, such as "ball" and "pyramid."

Even the simplest of forms are composed of these more fundamental elements of form. As viewers, we look, however subconsciously, for such elements in order to make sense of what is otherwise a blur of sense impressions. What elements of form are before us? How do they combine to make a form? Is it a familiar form?

No existing natural or manufactured form, nor any possible form yet to be created in the future, can exist outside these form elements. No painting can employ a color outside the spectrum created by the infinite shades and combinations of red, yellow, and blue. We have tremendous, seemingly limitless freedom in the forms and colors we can make, but these are all within a given reality that we did not create.

Form as Idea

The above examples demonstrate that matter is organized into form through the presence of a particular constellation of ideal form elements.

Curvature-angularity, wideness-narrowness, symmetry-asymmetry are some of the ideal elements from which all conceivable forms are composed. They are the alphabet by which the ideal world of ideas expresses itself in natural or human-made forms. The world of ideas, from the simple to the complex, is therefore one source by which matter is organized into a form. But idea, as we normally understand it, is not the only force that orders and gives form to matter.

Like and Dislike

In the presence of every sense phenomenon and, in particular, works of art, we not only think, but also feel. We feel some degree of like or dislike, pleasure or displeasure. If the ball and pyramid illustrated in figure 2 were presented to us as objects made of the same material, and we were invited to keep only one, how would we choose? Very likely our choice would be based on the relative degree of like or dislike we feel for their respective forms. Such feelings of sympathy (attraction) and antipathy (repulsion) are active not only toward finished forms but also with respect to something we are forming. In this case, we can observe within ourselves the play of like and dislike influencing what we change or keep of our form. This is the most elementary way in which feelings act as an organizing principle to form matter.

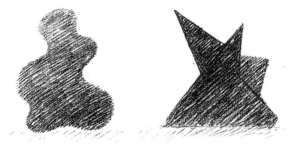

Figures 3a, 3b

With forms such as 3a and 3b, it may not be so easy for us to give them a name as we could with a ball or pyramid, but it is very likely that we feel some sympathy and/or antipathy for them. Some people may be drawn to the curved form; others, the angular. Most of us tend to accept as a given the apparent subjectivity of our feelings.

It is not uncommon for us to identify with our feelings to such a degree that we can feel personally threatened by someone who feels differently. We are inclined to treat our own sympathies and antipathies as objective facts while we often regard the feelings of others as subjective. Sometimes we can be so enamored by the vitality of our feelings that we empower them with primordial significance. At other times, we can feel overwhelmed and wary of feelings just because of their power and intensity. Clearly, feelings are a central aspect of being human.

Likewise, it is generally understood that feelings are a central force in generating works of art; some artists seem to work predominantly out of feelings, while others are more active with ideas. Thoughts and feelings are the ordering principles of forming activity, as intentions, values, sympathies, and antipathies. This has been the case throughout the history of art, but in this century, the quality of thoughts and feelings has assumed particular significance, as shall become clearer when we turn to the question of creativity in chapter 5.

Feeling and Naming Color

The experience of color will help us see a further dimension of feeling. If we look at a patch of yellow, most of us have no difficulty in determining that it is indeed the color yellow and not red or blue. If we have no training or experience with color, most of us will be quick to express our like or dislike for the yellow; fewer will be able to say with confidence whether it is a warm or a cool yellow. Some may be able to determine whether it is more orange-like or more green-like and, thereby, deduce whether it is warm or cool. But actually to *feel* the warmth or coolness of a color is another capacity that for many people must be developed.

To name the color as yellow is possible only when we compare it, physically or imaginatively, with all other colors. This occurs instantly and subconsciously, when we imaginatively see this one color in relation to the full spectrum of colors. It is this searching within a whole and the reference of a part to that whole that enables us to say it is yellow and not red or blue. The identical activity, on a more subtle level, enables someone to say it is a warm yellow or a cool

yellow. All naming activity occurs within the realm of our thinking, in which we seek the one concept that corresponds accurately with the given phenomenon.

Knowing Our Feeling

When our response to color or anything else is characterized by like or dislike, we are describing the reaction of our feelings. However, if we wish to know our feelings then we must seek to place a particular feeling within the context of all other feelings as we do in naming any phenomenon. This means observing our life of feeling, and thinking about it.

There is no better way to clarify the relationship between feeling and thinking than for me to introduce the reader to Steiner's book *Intuitive Thinking as a Spiritual Path* (RSE 3).[2] This book challenges us to observe and think about our inner world of experiences with the same clarity and accuracy that we bring to the outer world. Although it focuses on the nature of thinking, the book is anything but an abstract treatise detached from the practical concerns of daily life. Rather, it demonstrates for all spheres of life the practical significance of both outer and inner observation—in particular, the observation of thinking. On the surface, this book may not appear to speak directly to issues concerning the arts, but if the reader studies it with artistic questions in mind, every sentence can shed light on fundamental issues for the creative artist, as well as for the viewer of artistic works. From this perspective, it is a "philosophy of artistic activity and creative freedom." In chapter 3, "Thinking in the Service of Understanding the World," Steiner states:

> The content of sensations, perceptions, views, feelings, acts of will, dream and fantasy constructions, representations, concepts and ideas, illusions and hallucinations—the content of all these is given to us through *observation*.... For observation, pleasure is given in exactly the same way as the process that occasions it.

2. Previously translated as *The Philosophy of Freedom,* and *The Philosophy of Spiritual Activity.*

To feel sympathy and antipathy intensely is to live more fully than to have little or no feeling at all. However, there is a serious limitation to feelings of like and dislike. They tell us something about ourselves and little if anything about that to which we are reacting. It is one thing to know we like or dislike a certain a color or person; it is another to know why we feel the like or dislike. One person may love a green-yellow that another will hate. Usually, this is due to subjective associations that have nothing to do with the color itself but with our own previous experience. It can be that one person likes the coolness of a color that someone else dislikes. In becoming conscious of the warmth or coolness of a color, we transcend our subjective reaction and know the color itself as an objective quality.

Knowing Something Outside Ourselves

Often our feelings are a mirror by which we reflect our subjective reactions back onto the world, where we mistakenly project our feeling onto something out there. Feeling as an organ by which we perceive and thereby know the inner quality of what is outside ourselves is less understood or cultivated. Our feelings can become as transparent an organ of perception with regard to inner qualities as our eye is with regard to outer qualities. Knowing the quality of something else outside ourselves is possible only if a given quality is shared between ourself and the perceived other. This is easier to grasp with another human being, with whom we may assume we all share similar feelings, such as joy and sorrow, enthusiasm and apathy. Certainly, we do not have the same feelings for the same things at the same time.

Common experience suggests that my feelings belong to myself and yours to yourself. Yet if we look at the inner dynamic of our feelings, not at the different causes of them, we find they are similar in character. As an analogy, if we both create separate paintings, even if we choose different colors, we are both working within the common world of color. Similarly, whatever the different outer causes of our joy, we are both inwardly experiencing the spiritual quality of joy that is universal to all human beings. Perceiving your joy is simply one of the ways I may enter into it myself. We are spiritually united when we feel joy for the same reason, but also when it is for very different reasons.

We may readily grant that we feel what another person feels, and yet find it surprising that we feel something from looking at a material substance such as colored pigment. At first, feeling color may seem more difficult to understand than feeling another person's joy, but actually, it can help us discover the full reality of our feeling experience. Color itself is not created by us, not even by the paint manufacturer. It is a given dimension of the world that we have had no part in creating; we merely recognize and use it. That the material substance of color is a given aspect of the world is hardly a question, but is color only material substance?

What is the appeal of color? Why are we drawn to look at and use it? Because we recognize something of ourselves in it. When we begin to work with color, we must be careful about making statements such as yellow expresses joy, or red expresses anger, because these may be no more than subjective projections, associations, or symbols. Certainly, this can be the case; but there is another possibility, less understood but central to the arts.

Artistic Perception: Finding Ourselves in Color

We can look at a patch of color and, as an experiment, ignore whatever thoughts and associations—as well as all likes or dislikes—inevitably arise in us. It can be helpful to have a second patch of color next to the first, in order to make a comparison between the two. We simply hold the question, "What am I feeling from the color?" We can look at one color for a moment and then at the other, just as we might hold two objects in our hands to judge their relative weight. We need not try to analyze the relationship between the colors, but simply attend to what we feel. Sooner or later we observe something like the following, "I feel myself living into the color," or, "I feel the color coming to life in me." Only when the apparent duality between the color-out-there and myself-in-here is transcended, do we awaken to a direct feeling-experience of the warmth or coolness of a color.

I hope to show how this seemingly simple capacity to enter into the quality of a color, a form, or any other sense phenomenon, is the single most important discipline for the artist and, possibly, for

human life in general. This capacity to feel consciously the inner quality of something can be exercised in all sense impressions; there is no sensory experience that does not contain a qualitative dimension. We shall call this mode of observation artistic perception, both within and beyond the boundaries of the arts.

What is the significance of artistic perception, of entering into the inherent quality of sense impressions where we might experience colors, for example, as warm or cool, stimulating or calming? Such qualitative descriptions are no more projections or associations than saying it is warmer today than yesterday. Our experience of the warmth from the sun or a flame is unquestionably real to us, as is an object's heaviness or lightness. Of course, the warmth we feel from a red is not the same as what we feel when we put our finger over a flame. It is more akin to the warmth we feel when we are enthusiastic, passionate, or angry, when we even say, "I am fired up," or, "I am boiling."

More Than One Reality

Such statements are not metaphors; they are the expression of an actual reality. But they are not a physical reality, because it is not physical warmth we feel. If we hold the view that physical reality is the only reality, then we must regard physical warmth as real and inner warmth as delusion. Can we deny reality to a commonplace dimension of human experience such as inner warmth, just because it is not physical warmth and, therefore, does not lend itself to the quantifiable forms of observation and knowing as employed by science? Must we deny the validity of inner experiences because we presume only one reality is possible? Or can we contemplate the possibility of two distinct but complementary realities, as is suggested by the distinction between physical and inner warmth? Fundamental to an understanding of Steiner's views is his clear distinction between the world of outer, physical qualities and an independent world of inner, soul-spiritual qualities.

Steiner gives exact descriptions of four distinct worlds or dimensions of reality: the physical, the etheric, the soul, and the spirit worlds. The fullest introduction to Steiner's description of these four

realities is to be found in his book *Theosophy* (RSE 6). In chapter 3 the reality of feelings is discussed:

> Just as the matter and forces that compose and govern our stomach, heart, brain, lungs and so forth come from the physical world, so do our soul qualities, our impulses, desires, feelings, passions, wishes and sensations come from the soul world. The soul of man is a member of this soul world, just as his body is part of the world of physical bodies. (p. 77)

The World of Soul

Here we find an indication that points to the significance of artistic perception. Feelings neither originate from nor are limited to the confines of our own psyche but are drawn from an independent world of soul. The spectrum of color is also a pre-existing part of the created world. The recognition of these two given aspects of our experience can lead us to muse upon the following: both color and our life of feelings are creations of the gods. They are two manifestations of a common substance, not a physical substance, but a soul substance, that originates from the very being of the gods. The different qualities we know as the spectrum of our feelings, as well as of color, originate from the activity of different spiritual beings. This common origin makes it possible for us to live into color and recognize in it the spectrum of qualities that make up our inner life.

The Language of the Gods

Steiner's view suggests that the gods embedded color into the physical world to serve as a language between themselves and humanity. The language of the arts allowed the gods to speak to humanity long after we lost the faculty to perceive them directly.[3] We shall see that color and the other media of the arts are vehicles by which we can cultivate, once again, a direct relationship with the gods. Through learning to live into the qualities of color and all sense phenomena "the gods speak to us"—and we to them.

3. See *An Outline of Esoteric Science* (RSE 13).

Artistic Perception as Soul-Spirit Perception

Artistic perception is not seership of spiritual realities and beings in the direct and most developed sense. However, the arts are not merely symbolic languages or signposts capable only of pointing to spiritual realities. Artistic perception as described here is an actual, if only elementary, form of soul and spirit perception. Steiner makes it clear that the path of art is not the only way—but a most important one—by which a modern person, fully engaged in the world of the physical senses, can become more self-aware as a being of soul and spirit. Our soul-spirit nature originates in soul and spiritual worlds, as does every facet of physical existence. The physical and spiritual are not two irreconcilable worlds, but complementary realities. We must not think, however, that the physical and spiritual are homogeneous; in order to be clear about their interrelationship, we need greater exactness in distinguishing the one from the other.

Qualities of Form

Let us examine the way artistic perception applies to sculptural form.

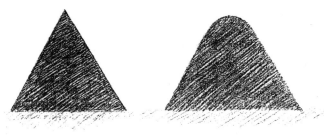

Figures 4a, 4b

In figure 4a, we have the silhouette of a pyramid or cone, which if we imagine it made of moist clay, can be rounded at the top to produce 4b. The idea of an angular point transformed into a convex curve is the principle that changes the one form into the other. We can also ask, "Does this change in form evoke a corresponding change in our feeling experience?"

If we actually made such a change in the form, it would be unusual if it did not stimulate a corresponding change in our feelings (i.e.,

"I liked it the way it was"). If we ask someone who likes the changed form, and another who dislikes it, to explain why, we are likely to get similar explanations from each. The one might say, "I like the relaxing softness I feel from the rounding; the sharp point feels too hard and rigid." The other might say, "I like the strength and wakeful clarity of the pyramid; rounding the point makes it too soft and weak." The two observers might use different words to describe their sympathy or antipathy, but in both cases they speak about a feeling of softening when the point is rounded, in contrast to a hardening when made into a point again.

To speak of a change in form as a change in the quality of softness or hardness is comparable to our description of color as warm or cool. Just as the warmth of a color is not physical, the softening or hardening we refer to has nothing to do with the softness or hardness of the physical clay. The translation of these qualities into like or dislike is our natural and subconscious habit. However, attending to the objective qualities of form or color, at the very least, opens an additional dimension of experience. This new dimension soon enhances our sense of relationship to the rest of the world. Any sense of estrangement we may feel toward nature or other people is largely related to our limited capacity to know the other—including plants, animals, and all natural processes—from within, as if we are the other or the other is ourself.

Moral Qualities

As a young man, Steiner was chief editor of Goethe's writings on natural science. Goethe's work with color and the natural sciences played a major role in the evolution of Steiner's lifelong effort to demonstrate the spiritual foundations of the natural world and human life. Goethe prepared the way for perceiving the spiritual within the physical through a particular method of color observation described in his *Theory of Color* (OA 11).[4] There he coins the term *moral qualities* to characterize the objective qualities he experienced in color. Unfortunately, in English the word *moral* has a different

4. See *Goethe's Approach to Color* (AA 44), chapter 3, "The Moral Effect of Colors."

connotation. In Goethe's usage it has nothing to do with good or bad but simply refers to the nonphysical and, in that sense, spiritual properties of color (the inner warmth or coolness).

This mode of observation that Goethe and, subsequently, Steiner developed is the same activity I am calling *artistic perception*, insofar as that observation attends to the "moral" or spiritual qualities of sense phenomena. We shall clarify the "moral" or spiritual qualities of graphic and sculptural forms through the sequence of forms below.

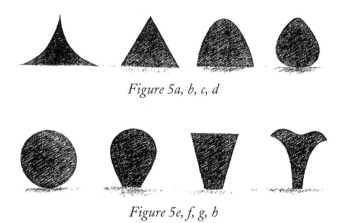

Figure 5a, b, c, d

Figure 5e, f, g, h

The Spiritual Qualities of Form

When we first look at the forms in figure 5, we naturally try to make sense of them by trying to name them. We recognize figure 5b as the silhouette of a cone or pyramid and 5e as a sphere or ball. Whatever names we give to each of these forms we are able, in addition, to recognize an ordered relationship in the sequence as a whole.

Forms 5a, b, and c are all widest at their bases and narrowest at their tops. Forms 5f, g, and h are the opposite, widest toward their tops and narrowest at their bases. While forms 5c and 5f are quite different as to where they are wide and narrow, both are composed entirely of convex curved surfaces. Likewise, forms 5b and 5g are straight surfaces, and 5a and 5h are concave surfaces. Therefore, the similarities and differences between these forms can be described in relation to five attributes:

i) the distribution of mass—the widest part is at the top, middle, or bottom of the form;

ii) the surfaces are straight or curved;

iii) the surfaces are convex or concave;

iv) all are symmetrical instead of asymmetrical;

v) their relative height and width remain equal.

Such an analysis of the various elements of these forms is possible through the activity of our thinking. What do we experience when we enter into them with our feeling—feeling which transcends like and dislike?

Let us look at forms 5c, 5d, and 5e. If we begin with the ball, form 5e, imagining it made of moist clay, we can carefully redistribute the clay so as gradually to lower the widest part from the middle toward the bottom until the widest part reaches the base. In this case, 5e is the first form and 5c the final form. Form 5d represents only one of the many forms that would arise through the orderly transition from 5e to 5c. What do we experience through this simple transformation?

Form as Object

First, we experience that forms are not unrelated to each other as our everyday experience of thousands of discrete objects would suggest. We distinguish a car, a tree, and a person largely by their different forms. Because these forms are visible to us through a material substance, we equate form with "objectness"; our experience of form as object leads us to equate form with the static and fixed. Yet, when we make a series of forms all in the same material, such as a lump of clay, we can more easily see that the form is independent of the material; the material is constant while the form changes. The material substance serves to make the nonphysical forms and interrelationships of forms visible to our sense-bound consciousness, but at a price. The material veils the living, dynamic nature of form by making it appear fixed and dead.

Color as Pigment

Color exemplifies the same problem. It appears to be a multitude of separate entities. We are more likely to be conscious of colors as discrete areas of paint on the surface of things, instead of as a world of living qualities dynamically related and moving into one another. We can be greatly helped toward seeing color as more than pigment by looking at or painting a color circle. In a color circle, we see one color, such as yellow, merge into yellow orange, middle orange, red orange, orange red, and so on, with no distinct boundary defining the end of one color and the beginning of another.

The forms of figure 5 are a sculptural equivalent to the spectrum of colors. As with color, this series embodies a spectrum of qualities. Both the individual forms and the series as a whole derive their inherent order from the world of ideas, on the one hand, and the world of qualities, on the other. In this sense, *form is a language of ideal qualities.*

The Language of Form

This language of form is not symbolic or metaphoric. If we look at the transition from the ball 5e to forms 5d and 5c, we experience something more than a change in ideas. There is a change in our feeling experience. We feel 5d giving in to the weight of gravity, drooping, or sagging. Relative to the ball, it is less buoyant. When the widest part of the form reaches the base as in 5c, there is less buoyancy when compared to 5d. As the widest part moves from the middle toward the ground, there is a sense of succumbing gradually to weight. In 5c we feel this process come to rest. The form may have lost much of its buoyancy, but it has gained stability; it is grounded.

With forms such as these, it is natural to associate them with known outer objects. Figure 5d may remind us of various buds or seeds, 5c of a beehive or gumdrop. However, what is less natural but, ultimately, of greater relevance to the arts, is to ask, "When do we feel like these forms?" At first we may feel uncertain about how to relate to this question, but with time we may recognize qualities in these forms that are familiar to our experience. For example, as a natural part of our daily rhythm, we feel more buoyant and energetic

at certain times and more sluggish and heavy at others. Different people experience varying degrees of buoyancy and heaviness. Whatever our individual differences, buoyancy and weight form the parameters of one dimension of our experience. In fact, we must distinguish three different kinds of buoyancy/heaviness. There is the heaviness of eating too much, or gaining body weight. That is different from the heaviness of being tired or sick, as compared to the buoyancy of healthy vitality. Sadness brings with it yet another source of heaviness, contrasted to the buoyancy of joy.

Until this century, when a sculptor wished to create a sculpture expressing inner qualities, such as tranquility or anguish, there was no recourse but to create the external human form in a gesture corresponding to the appropriate inner experience. The simple forms of figure 5, however, open a new possibility. Now we can create forms with no intended resemblance to any outer form, but that mirror directly the qualities of inner life. As we have seen with color, the elements of form also embody qualities belonging to our inner life. *The dynamic language of form is the language of the human spirit.*

Noise or Music

In this respect, the world of forms becomes an exploration and revelation of the human spirit in the same way that music is. The high and low tones of pitch and melody, along with the other elements of music, have outer physical properties, but the primary focus of our experience is not on their physicality. Noise is sound that is only physical, comparable to raw matter. In musical experience we feel ourselves lifted out of the physicality of everyday consciousness into a world permeated by the rise and fall, the expansion and contraction, of the human spirit. Just as the physical nature of the musical tone becomes transparent as we live purely in the dynamic qualities of the music, similarly, the apparent physicality of sculptural forms recedes from our awareness as we are moved by the inner dynamics of the form.

In spite of its apparent simplicity, this experience of the heaviness and buoyancy of forms leads us to some valuable insights. If a clay ball were placed on a scale, we would find that it has a physical weight. We could then transform the ball (5e) into the other forms

(5d and 5c) without adding or taking away any clay. From a purely quantitative view, the volume and weight of the clay would not change. How do we account for such an experience of heaviness when it is related only to a change in form?

From a strictly materialistic point of view, one would have to say that the constant physical weight is the only objective reality. The experience of a change in weight connected with a change in the form must be through some association or plain delusion. I have already commented on how these forms may remind us of other forms, but I have met no one who thinks the buoyancy they feel, say from form 5d, comes from comparing it with a bud. If anything, it is through the convex curve—in a bud, fruit, or balloon, as much as in a sculptural form—that expanding fullness expresses itself. Once again, as with the warmth of color or the softness of a form, the feeling of expansion we receive from a form is not based on a physical experience of expansion, as it is, for example, when we eat too much food. If it is not physical, then what is it?

In numerous places, Steiner speaks of the mineral element, the plant element (or what is living), and the animal element (what is conscious or sentient) in the human being. Only when we can distinguish these different elements can we understand what is uniquely human—that is, what is independent of these other kingdoms but works with and through them. The mineral, plant, and animal kingdoms are not only outside us, but they are also within us; they form aspects of our human organization.

> We can observe the human being in the same way that we observe minerals, plants, and animals, and as human beings we are related to these three other forms of existence. Like minerals, we build up our bodies from natural substances; like plants, we grow and reproduce; like animals, we perceive objects around us and develop inner experiences based on the impressions they make on us. Therefore, we may attribute a mineral, a plant, and an animal existence to the human being.[5]

5. Rudolf Steiner, *Theosophy: An Introduction to the Spiritual Processes in Human Life and in the Cosmos* (RSE 6), p. 26.

More Than One Reality

If we take the position that material reality is the only reality, then we are, in effect, assuming that the laws we observe in the mineral kingdom are the only laws in the world, including those governing the plant and animal kingdoms; we preclude the possibility that each kingdom has its own laws. Insofar as material substance is present in each kingdom, physical laws are certainly active in each. However, in all but the mineral kingdom it is what is active above and beyond physical laws that we must learn to perceive if we are to understand the plant, the animal, and the human being in their full reality.

In his *Theosophy*, Steiner describes the component of the plant that is not explained by physical forces. He speaks of an independent world of etheric forces with its own laws that imbue matter with the power of living transformation. Each living organism possesses, in addition to a physical body, "an etheric body" or what he sometimes calls "a body of formative forces" or "life body." All living organisms have such an "etheric body." According to Steiner, the animal consists not only of the mineral and etheric but also of the "astral," or "sentient" body. In addition to a physical, etheric, and sentient body, the human being is distinguished from the animal kingdom by a fourth member, the self-conscious individuality, or "I." Each of the kingdoms of plant, animal, and human can only be understood in the context of these nonphysical or supersensible realms of reality. According to Steiner, there is not just a world of matter and a world of spirit, but the spiritual is a reality as differentiated as the physical. Indeed, the many distinctions of the physical world originate in the diverse qualities and beings of the spiritual world.

Sculpture as Formative Forces Made Visible

Similarly, in regard to the visual arts, Steiner suggests we cannot fully understand their potential in human life as long as we perceive them to be merely outer physical mediums. Steiner speaks of the relationship of art to the spiritual, not in general, but in quite specific ways. For example, if we return to sculpture, it is possible to consider that the material substance of the clay is only one of two realities—

the form being the second reality. The form of a sculpture is made visible to our senses and our consciousness through the material substance. The distinction we have made between the form of a sculpture and its material substance Steiner attributes to two separate realities. The material substance of a sculpture belongs to physical reality; the qualities of its form belong to the world of etheric formative forces. The etheric is the world of softening, expanding, buoying-up that counteracts the hardening, contracting, and weighing down tendency of the purely physical. These are the forces that organize and, thereby, give form to matter. Both natural (living) forms and sculptural forms are nothing less than etheric formative forces made visible through the material substance they penetrate and, thereby, organize.

> For sculptors, the outer form of a human being must be the result of cosmic forces and inner forces.... Visual artists are steered away from imitating the physical human form, which in itself is only an imitation of the body of formative forces.... What we are shaping is the ether body; we are filling it out only with matter, so to speak.[6]

> When we develop the right feeling for beauty, this means that we are properly fitted to our etheric body, the body of formative forces.... However, we cannot be human beings in the true sense of the word if we have no feeling for beauty, because to have a sense of beauty is to awaken to the etheric body. To have no sense of beauty is to disregard, or remain asleep to, the etheric body.[7]

The Spiritual Substance of the Arts

We may now say that the origin and human significance of sculpture and the other visual arts arise from their spiritual substance made visible through their physical substance. A brief summary of our thoughts, thus far, may bring this into focus.

6. Rudolf Steiner, April 9, 1922 (L 8).
7. Rudolf Steiner, January 19, 1923 (L 9).

We encounter each art, initially, as part of the sense world. Each art consists of a medium that appears at first to be physical: the stone and wood of a building, the clay of a sculpture, the pigment and paper of a painting. The same applies to the performing arts: the musical instrument in music, the human voice in singing and recitation, or the moving body in acting and dance. Each art appears to be a physical medium inviting creative manipulation. The physical substance is, of course, a reality we must work with, but it is critically important to understand that it is not the only reality. It is the qualitative dimension expressing itself through the physical medium of each art and all sense phenomena that brings the human being into the realm of art, insofar as it raises the physical into the spiritual. The wood or clay may be the materials, but they are not the mediums of architecture or sculpture. The physical substances make visible the otherwise invisible elements of roundness/angularity, wideness/narrowness, and symmetry/asymmetry. The qualities of "dreamy expansion" in contrast to "wakeful contraction," or "grounded weight" *versus* "buoyant rising," contained within the above elements of form, are the true *medium* of sculpture and architecture. As living, dynamic qualities, they *mediate* between soul-spirit worlds and the physical world, between spiritual beings and human beings.

When we direct our attention to the elements of form, color, or other fields of perception and make a comparative observation of two colors or forms, we can awaken to a direct inner experience of their relative qualities. In this way, the physical world comes to life in our feeling experience, while avoiding the reactive feelings of like and dislike; we awaken to the reality of objective spiritual qualities. We shift from a mode of "speaking" to "listening," and ask: What is speaking to us through color and form? These practical activities lead us toward an answer to Steiner's question: When will the gods speak to us? Such an orientation to color and form develops an organ of perception in us whereby soul and spirit substance become as real for us as physical substance is already. This capacity for artistic perception as spiritual perception is the means by which artistic activity becomes spiritual activity.

IV. The Representative of Humanity

There are a number of reasons to focus now on Steiner's sculpture *The Representative of Humanity*. First, it demonstrates Steiner's own accomplishment in the arts. He did not spin unrealistic ideals or theories, but was committed himself to forging a practical path toward realizing artistic ideals. Second, it enables us to apply the way of viewing form as already outlined in chapter 3. And finally, as we develop a relationship to the forms of this complex and challenging sculpture, we discover a motif that leads us to new insights into many issues—particularly, the significance of beauty, creativity, and metamorphosis—not only for the arts, but for human life.

As the title *The Representative of Humanity* suggests, this sculpture is concerned with the inner reality and potential of the human being, with the mystery of our essential humanity. Such content is not unique to Steiner; works of art throughout the ages have portrayed or celebrated spiritual values, which in turn have given vision and meaning to the people of that culture. In our own time and culture, however, the arts are, at best, ambiguous in this regard. We will focus our study on this one work, *The Representative of Humanity*, because it most clearly demonstrates the potential Steiner saw for the arts to serve modern spiritual needs.

Before turning to an examination of *The Representative of Humanity* itself, I would like to direct the reader's attention to Steiner's perspective on history and, in particular, the history of art. This is an important dimension of Steiner's contribution in general, but it also sheds light on what he perceived to be the cultural and spiritual context of a work of art such as *The Representative of Humanity*. In his writings and lectures, Steiner described vast panoramas of human history in order to characterize significant developments in human consciousness. From his perspective, human history is the evolution of human consciousness. He places such emphasis on tracing the history of cultural developments in order to bring into focus the uniqueness of our

present consciousness. Steiner contrasts modern modes of consciousness with those of previous cultures. Dramatic transformations in the way humanity has experienced reality become evident. Not only do we develop a feeling for the forces from the past that have shaped our modern attitudes and values, but we are also presented with the questions and issues of our time in the context of the future we are creating.

Although Steiner's descriptions of the human story begin with events preceding those of recorded history, one of the most helpful means of seeing this evolution within the span of recorded history is to study the history of architecture, sculpture, and painting. The subject of the evolution of human consciousness as revealed through history and art is an area of inquiry unto itself to which this essay cannot do full justice. Steiner himself approaches it from many sides in numerous lectures and books; the bibliography provides only a few of the sources for a more detailed study.[1] Our purpose here is to gain some sense of the cultural context in which Steiner created *The Representative of Humanity*. Therefore, I will limit myself to an outline of the evolution of human consciousness from which emerge two interrelated insights.

First, Steiner describes in some detail a progression of cultural periods, which he identifies (with approximate dates) as the Indian cultural epoch (eighth–sixth millennium B.C.); the Persian epoch (sixth–third millennium B.C.); the Egyptian epoch (third–first millennium B.C.); the Greco-Roman epoch (first millennium B.C.–second millennium A.D.); the present, Fifth Post-Atlantean epoch (second–fourth millennium A.D.); to be followed by the Sixth epoch (fourth–sixth millennium A.D.); and the Seventh epoch (sixth–eighth millennium A.D.).

The student new to Steiner's ideas should understand that Steiner's descriptions of this panorama in no way span the beginning or end of human history. Also, the fact that he highlights certain

1. See Gottfried Richter, *Art and Human Consciousness* (AA 54). Rudolf Steiner's *Esoteric Science* (RSE 13) is the basic introduction to human and world evolution. Steiner gave a series of lectures (English available only in manuscript) entitled *Art History*, Dornach, Oct. 8, 19, 23; Nov. 1, 8, 15, 1916; and Jan. 24, 1917 (RSE 33). Also relevant are Steiner's *The Temple Is—Man!*, December 12, 1911 (RSE 15) and *Architectural Forms Considered as the Thoughts of Culture and World-Perception*, Sept. 20, 1916 (RSE 32).

cultures without mentioning many others does not imply he under-valued the unique nature of all cultures. Steiner names particular cultures because they were at the center or in the vanguard of significant developments in the evolution of human consciousness. The recorded history and artifacts of these cultures lend themselves to making this evolution readily visible. There is no question that all cultures, each in their own way and in their own time, play a vital part in the great mystery of human evolution.

Wherever we turn in the world, we find ample evidence that, in ancient times, human affairs were established on firsthand experience of spiritual realities. These included actual, not just metaphorical, spiritual beings, who were seen to shape and influence every facet of life. As history progressed, the human story was one in which a direct experience of spiritual reality progressively diminished, eventually transforming into spiritual belief and tradition. In our own epoch, even belief in the spiritual has lost its power. Material reality presents itself with such overriding force that most people, in spite of any beliefs they may still possess, base their actions primarily on the facts of the physical world. Steiner suggests that the loss of direct access to spiritual reality is at the root of all human tragedy. Yet, we have cause for hope: Steiner makes it clear that ultimate good will arise from this human drama. Such progress is not unlike the painful loss of early childhood innocence with the approach of adolescence. As adolescence is a necessary step to the potential maturity of adulthood, similarly, our loss of immediate spiritual insight and our fall into a matter-bound consciousness, with all its ensuing difficulties, present an opportunity for humankind to unfold a higher level of maturity.

The first insight we gain from Steiner's descriptions of human evolution is that humankind has descended from a consciousness that lived clearly in spiritual realities, such that physical reality was perceived as *maya*, or illusion. From such a consciousness we have evolved to a consciousness that now identifies almost exclusively with physical reality. Conscious awareness of spiritual realities is all but lost.

The reason for this apparent spiritual loss brings us to the second insight from Steiner's descriptions of human history. The full picture of this 15,000-year history is one of loss and, finally, of regaining a

conscious relation to the spiritual. Steiner's view sees humankind, despite all indications to the contrary, on the threshold of regaining a relationship to spirit beings and activities. If Steiner is correct, we might ask: what is the point of our losing conscious experience of the spiritual, if we are to regain it once again?

Occasionally, we may meet an older person who is wise, not merely in the worldly sense, but in ways of the human heart and mind. Such a human quality provides a hint of the spirituality Steiner sees in our future. If the spirituality of the young child is a gift, that of the adult is won only through suffering and inner effort. Qualities such as courage, forgiveness, steadfastness, and, ultimately, love are not just given to us; we must strive for them again and again. There is a profound reason for this: if such qualities were a natural part of being human, virtue would be compelled. We would be spiritual, but not through free choice. Spiritual development is not imposed on us as modern adults; rather we are given the opportunity to come to it in freedom.

This is the second and single most profound insight arising from the picture Steiner develops of human evolution: the gods allowed humanity, in the course of evolution, to lose direct perception of the spiritual realities out of which our very being is born and sustained in order that we may choose to take up the development of spiritual faculties in freedom. Precisely because we moderns are disposed toward a materialistic mindset, we are liberated from being compelled to act in accordance with spiritual laws. It is no play on words to say that we have been given the outer freedom to develop or not develop inner freedom.

The question of freedom arises in every domain of modern life, but with much confusion and chaos surrounding it. The arts are perhaps at the center of both the striving and the confusion. As we direct our attention now to *The Representative of Humanity*, it will be helpful to keep in mind this brief summary of Steiner's view of the evolution of human consciousness—in particular, the related issues of direct spiritual perception and human freedom. Thus, we may ask: Does our human dignity depend solely on outer freedom, or does our humanity equally depend on developing *inner* freedom? What is inner freedom and how is it developed? What is the spiritual basis of freedom?

How do we develop knowledge of spiritual realities? How can we develop the faculties that allow us to perceive the spiritual directly?

On first encounter with the complexity of *The Representative of Humanity* sculpture, many people turn to Steiner's lectures for explanations in the hope of a finding connection to it. Yet, we might consider that Steiner went to the considerable difficulty of creating this sculpture, because he felt he could bring to life certain realities through a sculpture that he could not express through words. A full appreciation of this sculpture cannot be found in explanations, but through our capacity to experience the forms. Therefore, what I offer here are not explanations, but only indications toward helping the reader discover a way of looking that leads to individual insight. We will begin by returning to the forms of figures 5a–h.

With each form, I have suggested two ways of describing our experience. The first simply states the dynamic qualities within each form. The second refers to common inner experiences familiar to all, which share these dynamic qualities. Every form expresses particular dynamics. Every human experience also manifests through particular dynamics. Therefore, it is possible to say that every inner experience has a form and every form is a picture of a human inner state or spiritual quality.[2]

Figure 5e

- Dynamic quality: buoyantly balanced between gravity and levity and between expansion and contraction
- Inner state: inner poise, quiet anticipation

2. See Annie Besant and C. W. Leadbeater, *Thought Forms* (OA 5); see also Steiner's *Theosophy* (RSE 6), chapter 3, section 6, "Thought Forms and the Human Aura." These sources discuss the objective spiritual forms that can be seen when one's attention is directed toward the inner experiences of other human beings.

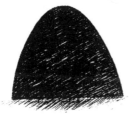

Figure 5c

- Dynamic quality: grounded but buoyed from within
- Inner state: pragmatic readiness, down-to-earth enthusiasm

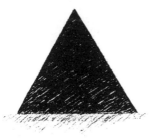

Figure 5f

- Dynamic quality: contained expansion. overcoming gravity
- Inner state: joyous anticipation, pride

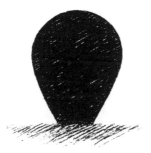

Figure 5b

- Dynamic quality: rigid but wakefully grounded
- Inner state: pragmatic clarity, stubbornness

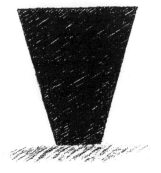

Figure 5g

- Dynamic quality: rigid but wakefully poised
- Inner state: abstract clarity, cool aloofness

Figure 5a

- Dynamic quality: surrendering to gravity, collapse of inner vitality
- Inner state: exhaustion, depression, apathy

Figure 5h

- Dynamic quality: climax of rising, inner releasing
- Inner state: hysteria, ecstatic joy

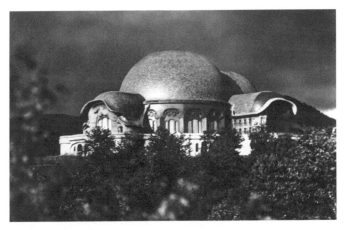

The first Goetheanum

We shall soon see how these elementary forms may enhance our experience of *The Representative of Humanity*. The photograph opposite shows a sculpture that is inherently complex. Presenting a three-dimensional sculpture in two dimensions creates certain problems, and to minimize any confusion we will begin with some facts before studying the forms themselves.

The sculpture, which is approximately thirty feet high, is made of laminated elm. This sculpture was intended to stand at the rear of the stage in the *Goetheanum*, a conference and performance center designed by Steiner. Most of the building's interior was made of carved wood. Steiner's lecture, *The Building at Dornach* (L6), offers his own description of the Goetheanum.

As with any work of art, *The Representative of Humanity* must be seen as a whole. Nevertheless, within that whole, six distinct parts can be identified as follows:

a. Upper Ahriman

b. Rising Lucifer

c. Representative of Humanity, or the Christ

d. Ahriman in cave

e. The Falling Lucifer

f. The Rock Being, or World Humor

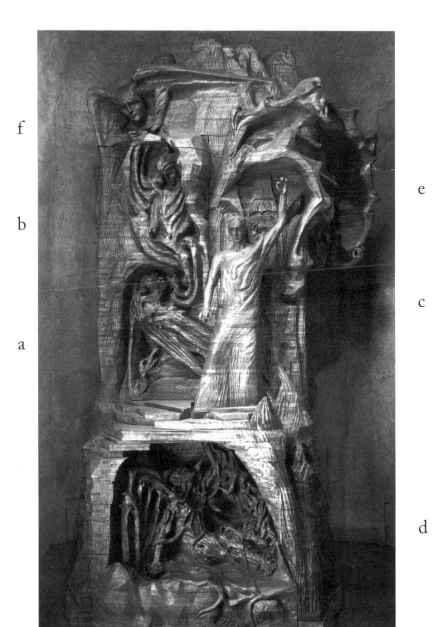

f

b

a

e

c

d

The Representative of Humanity
Rudolf Steiner's wood carving (height = 30 feet)

Whereas it is appropriate and helpful to use these names to designate the various parts, for some readers they may create difficulties. Many people have never heard of *Ahriman*. *Lucifer* and *Christ* can also be problematic names due to previous associations, positive or negative, that we may bring to them. If it were simply a matter of labels to identify the different aspects of the sculpture, it might be better to dispense with Steiner's designations and use others that are less controversial. But these particular names are unavoidable, because they portray particular spiritual beings known by these names. The archetypal significance of this sculpture speaks to what is essentially human in each of us, regardless of our philosophical or religious background. To find this significance, however, we must set aside our preconceptions and reactions. Openness to new insight depends on both the good will to set aside prejudgments and, in this case, our capacity to exercise a different way of viewing forms—as introduced through the form-spectrum of figure 5.

Inevitably, we are drawn to the central figure of *The Representative of Humanity* because of its human appearance. However, if judged naturalistically, it seems awkward, if not strange. It is a human form but not a normal one. Despite the fact that each of the other five forms can be seen to have some kind of head and arms, these other beings are not human and are probably unlike any other form familiar to us. What are we to make of them?

If these figures were presented as pure fantasy, then they would probably pose little difficulty for us, given the proliferation of fanciful beings that pervades popular culture. But, they are not intended as fanciful, but as spiritually real. To find a meaningful relationship to this sculpture, we must find something within our experience that resonates with these realities. One way to do this is to examine three parts of this sculpture as silhouettes.

It is not a coincidence that forms 6a and 6b stand next to 6c, inviting us to compare them. The Ahriman (6a) and Lucifer (6b) forms can be viewed together as one, but they can also be seen as separate forms. When we view them as independent forms in silhouette, we may discover their relationship to some of the forms in figure 5.

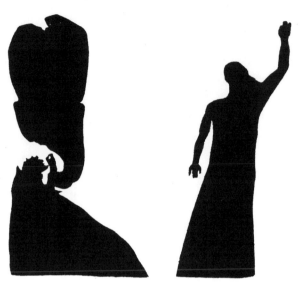

Figure 6 a/b and c

The Ahriman form (6a) is widest at its base and narrows to a point at the top. By comparison, the form of Lucifer (6b) is narrowest at its lowest extremity and widens toward its top. Thus, we may feel Ahriman to be drawn down by the weight of gravity, while Lucifer rises upward in opposition to gravity. Ahriman is made of pointed protrusions, shallow concavities, and numerous straight edges, within an overall asymmetrical, triangular form. All these elements create a bony, withered, and sclerotic feeling. Lucifer, in silhouette, is a large swelling convexity, but within that we find large concavities weaving together to make a rhythmic pattern of curved edges. These elements evoke an airy turbulence. Therefore, without knowing the names of these forms or any intellectual interpretations of their significance, we can experience the Ahriman form as embodying a sclerotic heaviness in contrast to the turbulent levity of the Lucifer form. When we see the two forms of Lucifer and Ahriman together as one form (figure 6a, b), we experience a dramatic tension between lifeless weight and airy uplift. When these dynamic qualities come alive within our experience, then such apparently foreign forms begin to mirror qualities that are quite familiar to us; in fact, we can recognize them as forming the parameters of our everyday experience.

Outer Portrait and Inner Portrait

Rodin's sculptural portrait of *George Bernard Shaw* (1906), and Brancusi's sculpture *Bird in Space* (1919) may help us connect inwardly to the forms of *The Representative of Humanity*. We may also see a relationship between Steiner's efforts and those of other modern artists. Although Rodin's stylistic signature adds something to Shaw's portrait that goes beyond merely copying, we do not doubt that Shaw looked like this. Brancusi's sculpture, on the other hand, goes well beyond naturalism. Even though it may be seen as a bird form, this is not the only way to view it. Indeed, *Bird in Space* was the subject of a historic legal battle in which the United States Customs challenged its status as a work of art altogether, because officials were unable to judge what it was. As far as they could tell, it might be a machine part.

Constantin Brancusi. *Bird in Space*. 1928. Bronze (unique cast), 54" x 8 1/2" x 6 1/2" (137.2 x 21.6 x 16.5 cm.). Given anonymously. Photograph © 1997 The Museum of Modern Art, New York.

We may view *Bird in Space* as an abstract or stylized bird form, as the title suggests, but more significantly we can experience it as a simple but powerful gesture of soaring upward. The dynamic quality of its form speaks directly to a comparable experience in our inner life. Brancusi's sculpture opens a new expressive possibility and, thereby, becomes a milestone in the history of sculpture. For example, Brancusi's *Bird in Space* could be seen also as a portrait of Bernard Shaw. This makes sense only when we distinguish between the outer and the inner man. An outer portrait conveys something of the personality, but no more than looking into a mirror reflects the full reality of a thinking, feeling individual. If only in his writing, Shaw was familiar with the inner experience of soaring into imaginative heights. Of course, I use Shaw only to make my point. Brancusi's sculpture makes tangible the otherwise intangible experience accessible to all human beings— that is, the capacity as creative spirits to soar in thought and feeling.

Auguste Rodin. *Bust of George Bernard Shaw.* 1906. Bronze, h. 15 1/2". Courtesy of The Rodin Museum, Philadelphia: Gift of Jules E. Mastbaum.

Brancusi's *Bird in Space* also demonstrates a new possibility for sculpture. Until the twentieth century, a sculptor who wished to express something of an inner nature had no other recourse but to create the outer human form in such a way that its outer gesture and style evoked a corresponding inner experience. Brancusi's sculpture is an excellent example of the new direction born in this century, in which sculptural forms can express any number of inner qualities—that is, to express a spiritual experience directly, as does music, without reference to or replication of any outer, sense-perceptible form.

Steiner's sculptural forms are to be seen and experienced in exactly this way. For example, we can ask ourselves, when do we feel like the Lucifer form? We might recognize in the expansiveness or swelling upward something similar to our experience of ecstatic joy or pride. Hysteria, arrogance, recklessness, self-indulgence, anger, and other forms of tumultuous passion all express themselves through an inner gesture of expansive lifting out of ourselves. Likewise, the contracted weight of the Ahriman form is to be found in experiences such as sorrow, despair, anxiety, apathy, and inner paralysis.

When we learn to observe the dynamic quality of all inner experiences we will find that they originate from one or the other of these two poles. If we never saw our outer appearance in a mirror or photograph and then one day we did see ourselves, very likely we would need to make some adjustments in order to inwardly identify ourselves with our appearance. We have a similar challenge with this sculpture. Can we recognize in the dynamic qualities of these forms a mirror of the dynamics that constitute our inner experience? Furthermore, can we embrace the possibility that the qualities with which we identify as our own feeling originate from particular spiritual beings?

It was central to Steiner's spiritual task to help modern humankind to experience the role of particular spiritual beings in world evolution. Time and again, he mentions the two beings, Ahriman and Lucifer, as having particular significance for humankind, both for good and evil. Ahriman and Lucifer refer to the great tempters of human nature and the sources of evil spoken of in many cultures, often by other names. Ahriman is associated with darkness, Lucifer

with light.[3] It is easier to see darkness as an expression of evil, a willful blindness before the light of truth and goodness. Although Lucifer is a familiar term in the West referring to the devil, we may be puzzled as to how light can be a form of evil. One of Steiner's most practical spiritual insights makes it clear that evil and good are not polarities; good stands between two forms of evil: that which is excessively light on one side and excessively dark on the other. This brings us to Steiner's reference to the central figure of his sculpture as a representation of the Christ that requires careful clarification if we are to find a meaningful relationship to it that avoids potential misunderstandings.

If we enter qualitatively into the central figure of Steiner's sculpture (as represented in figure 6c), we can experience in this form both weight and levity, expansion and contraction, held in a dynamic balance. In addition, we can sense a hidden truth, through the placement of this figure, that extends Steiner's contribution to the nature of good and evil: The spiritual being who makes it possible for the human form to arise, standing between the falling Lucifer above and the Ahriman in the cave below, and to transform the two potential sources of evil into good, is the Christ. The central figure reveals the reality that the human spirit acquires its true form through the *christic* capacity to harmonize the luciferic and ahrimanic spirits.[4]

Evil originates not from the mere existence of either ahrimanic darkness and contraction or luciferic lightness and expansion, but through the *compelling* nature of these spiritual forces. Spiritual bondage manifests through our getting stuck in one quality or the other—the too-expansive or the too-contracted—because we lack

3. The name *Ahriman* (from Zoroastrian ancient Persia) means "the evil spirit." It is associated with darkness, in contrast to *Ahura Mazda*, the "wise spirit" and the source of light. *Lucifer*, on the other hand, means "light bearer." If names were merely labels, it might be simpler to find less controversial names. Rodin's portrait sculpture can have no other name than *Bernard Shaw* because its form belongs to that individual; similarly, the names *Ahriman*, *Lucifer*, and *Christ* are unavoidable in Steiner's sculpture, since the quality of these forms belongs to those beings. It is not a problem that they are spiritual beings, because form, as distinct from matter, is spirit; a sculpture is spirit in matter. Thus, a sculpture may portray a particular spiritual being.

4. See lecture May 7, 1923 (L 10).

the necessary inner mobility to enter the opposite quality, or because we swing back and forth without control. Someone, for example, may be inclined toward serious reflection and thought that may serve well in certain situations but not in others. This is a form of unfreedom to the extent that such a person cannot find a lightness of spirit—for example, to engage in humorous or light-hearted conversation. Similarly, being able to engage only in superficial chatter, with no capacity for inner stillness and serious thought, is equally unfree. Even when we possess the capacity for both seriousness and lightness, we are unfree if we swing from one to the other without self-control.

This concept of evil and good did not originate with Steiner. Aristotle, in his *Ethics* (OA 2), discusses human virtue as existing between two opposite vices. His practical examples are very helpful in making this clear. One example has to do with the common trait of confidence. Most people regard self-confidence as desirable. Nevertheless, even those who know such confidence will, at certain times, feel a lack of confidence. On the other hand, some of us are sometimes susceptible to overconfidence. We discover not merely a polarity of confidence versus lack of confidence, but a triad, in which confidence maintains a state of dynamic equilibrium between underconfidence and overconfidence.

Humility and modesty are commonly associated more with low self-esteem than with confidence. Humility and modesty can be best understood as self-knowledge that neither inflates nor deflates our assessment of ourselves. Aristotle suggests that shyness and shamelessness are the two qualities on either side of modesty.

Courage is another human quality, the opposite of which is cowardice. When we look for the opposite of cowardice, however, we find not courage, but the tendency toward recklessness. In the popular culture of movies, for example, recklessness is often confused with courage. To be reckless is to be fearless. Although it may allow us to do something remarkable or even beneficial, to the extent that our fearlessness descends upon us without our own effort, it is not true courage. Inherent to courage is the effort of inwardly overcoming something—typically, fearfulness, but sometimes fearlessness.

To the extent that both fearfulness and fearlessness take hold of us uninvited and compel us without our willing it, we are unfree. Courage, along with all virtues, must be sought and willed each time anew. This leads us to discover a modern meaning for the concepts of virtue and vice, which counters any medieval, moralistic connotations. A vice is any quality that compels us and thereby makes us inwardly unfree. Similarly, a virtue is any quality in which we attain a degree of inner freedom through wrestling to counter an unfree quality. These examples can be summarized as follows:

VICE (unfree)	VIRTUE (free)	VICE (unfree)
underconfidence	confidence	overconfidence
shyness	modesty	shamelessness
cowardice	courage	recklessness
(over-fearful qualities)		(under-fearful qualities)

Aristotle gives a number of other examples, but perhaps these few are sufficient for us to establish that any and all qualities are part of a triad; some stand as the extremes at one pole or the other while others arise through the dynamic equilibrium of those polarizing extremes. Most significantly, we can distinguish those qualities that enslave us from those that liberate our humanity. How do we transform the qualities that compel us into ones that allow us to become the free spirits we really are? This is an artistic as well as a practical question.

Any number of circumstances may trigger our fear or recklessness. If we wish to overcome fearfulness or recklessness, we would mislead ourselves if we directed our efforts toward getting rid of the outer cause of our reaction. It is the fearfulness or fearlessness, as an entity in itself, that we must focus upon. However, to simply try to wish it away is unlikely to prove successful either.

Fear, whatever the outer catalyst, is our succumbing to the power of contraction and inner paralysis. We are gripped by the spiritual force, or more correctly, the spiritual being of Ahriman. To be reckless is to be overpowered by the spiritual qualities of overactive expansiveness—the spiritual being of Lucifer. If we have ever known even the slightest

success in overcoming cowardice, we can observe that we found our way to a spark of fire or enthusiasm. As a fearful person, we may feel that we are indulging in a degree of recklessness. In comparison to a truly reckless person, however, we are actually discovering courage. Likewise, to become courageous as a reckless person, we must find a measure of sobering coolness to dampen the raging fire that compels us. In so doing, we may feel that we are succumbing to cowardice, when, in fact, we are discovering courage.

A simple color exercise makes this point clear. Using watercolor pigment, we can make two patches of color, a yellow and a blue. We can then lay a pale wash of blue over the yellow; similarly, a pale wash of yellow may be layered over the blue. We repeat this process again and again until both patches are the same shade of middle green. Although in the end we seem to achieve the same result with both patches, nevertheless, we experience two very different processes. When the blue is added to the yellow, we experience the yellow-green that arises as a darkening of the yellow's lightness. On the other hand, we feel the blue-green that arises from the yellow added to the blue as a lightening of the blue's darkness. When the two patches become the same shade of green, we do not experience them as identical, because we arrived at the one through a process of darkening the light, whereas the other developed through a lightening of the darkness. In a similar way, the courage we achieve by overcoming fearfulness is very different from the courage of overcoming fearlessness.

Most of us accept fear and recklessness as natural human tendencies. Certainly, such traits are an inescapable aspect of our human nature. In this respect, we are all unfree, no matter how much outer freedom we may possess. However overwhelming and disheartening this fact may strike us at first, great meaning and purpose can be given to our life by the ideal of inner freedom and the simple striving toward it, even when there is little sign of progress. Inner freedom is not something accomplished or achieved once and for all, but a gradual process of strengthening and taking hold of the spiritual forces active within ourselves, as well as those in the world around us. The smallest effort and progress in transforming our recklessness or our fearfulness toward courage has great significance, certainly for ourselves and

those directly affected by us. Perhaps we can also make the imaginative leap to the thought that our modest inner efforts, ultimately, make a difference for the course of human and world evolution.

The Representative of Humanity is not merely a symbol of our humanity; it is a sculptural meditation, a tool for inner development. However, for it to serve this possibility, a particular kind of inner activity is necessary on our part. It requires that we exercise our capacity to attend to the objective qualities of the forms—a spiritual activity in itself. The moral qualities of form, or of any other sense impression, awaken within our consciousness only when we seek to harmonize two inner tendencies. The one inclination is to see such a sculpture as an object-thing, to which ideas are attached as labels. Interestingly, this tendency, which has an ahrimanic character, can be countered by actually intensifying our attention to the physical elements of the sculpture. In this way we become so inwardly active that the qualities of the forms come to life within us. The other inclination, having a luciferic character, expresses itself as feeling-reactions of like or dislike or as subjective and fanciful associations.

The whole human being becomes engaged when this inclination to feel only our own reactions is expanded to interest in the source of our like or dislike. In so doing, we may discover that it is a particular quality, such as heaviness or buoyancy in the form, that we like or dislike. We may continue to like or dislike it, but we now know the quality of the thing itself, not just our feeling reaction. In both the ahrimanic and luciferic inclinations, we are caught in ourselves and unable to enter the essence of what is outside ourselves; we are either too detached as a thinking onlooker or too identified with our feelings. In neither case are we free. However, when we take these one-sided and unliberated ahrimanic or luciferic qualities—which inevitably are our starting point—and balance them with their opposites, we begin to perceive spiritual qualities objectively. The inner mobility and balancing needed to experience the moral quality of sculptural forms and other phenomena is a third form of spiritual activity, which we will refer to as *christic*.

Our earlier distinction between matter and form finds its highest significance here. The material of a sculpture, such as the wood of

The Representative of Humanity, makes the forms visible. But the forms are not matter; they are pure spirit. In this way, artistic perception becomes spiritual perception. Through the artistic perception of *The Representative of Humanity* and other works of art, we develop an essential human capacity—the perception of soul-spiritual qualities. Direct perception of the spiritual, inasmuch as it is active within ourselves and the world, is the beginning of our freedom as human beings. *The Representative of Humanity* is a dynamic and thus a living representation of the universal human potential to be a free creative spirit. Through the spiritual activity of observing this art work, we may be stimulated to develop our capacity to become free, creative spirits.

Now we can clarify the role of spiritually free perception as it pertains to beauty and creativity in the arts and in other spheres of human life. As we take up these subjects, we shall draw upon our experience of *The Representative of Humanity* in order to grasp the relationship of ahrimanic, luciferic, and christic spirits in these realms of human experience. For such references to be fruitful, one should bear in mind that to speak of something as having an ahrimanic, luciferic, or christic character does not imply a value judgment of good or bad. Such thinking is fraught with potential misunderstandings; to grasp it in its true light requires subtle and flexible thinking.

Ahriman and Lucifer, on the one hand, are genuine threats to our humanity, to the extent that they compel our thoughts, feelings, and actions. Luciferic expansion and ahrimanic contraction sweep through us, overcoming our spiritual strength and inwardly enslaving us. Nevertheless, it would be a mistake to think that, because they are the sources of evil, we should try to eradicate or suppress their influence altogether. This is neither possible nor desirable.

One step toward freedom is to recognize that there is no sphere of existence—physical or spiritual—where we stand outside the influence of the luciferic and ahrimanic forces. It may seem, for example, as though we are unfree, because we are limited to a given spectrum of colors. We may wish we could invent a new color. Nevertheless, the truly creative painter does not feel limited, but finds freedom in

working within the given spectrum of colors, mastering their effects of balance and harmony. We can recognize the limiting influences of Ahriman and Lucifer and thus their potential to work against human welfare. It is precisely their potential to make us unfree, however, that creates the inner ground upon which we may develop freedom. As there is no courage without cowardliness or recklessness, so also freedom exists only insofar as it is regained in each moment from the ground of unfreedom. Freedom is not a fixed state, given or achieved once and for all; freedom is an ongoing spiritual activity, won anew in each circumstance.

V. Beauty, Creativity, and Metamorphosis

The preceding outline of Steiner's basic view and practice of the visual arts is an attempt to help us see the central importance of the way we observe the world. Artistic perception has been presented as the faculty for knowing the qualitative attributes of the world. Through such perception, we can experience the spiritual within the material substance of each art medium—indeed, in every sense impression. The focus was primarily given to sculpture, in part because the apparent prominence of the material in sculpture dramatically sets off the nonmaterial character of form. This emphasis on sculpture also provided the necessary foundation for a way of looking that is essential to an appreciation of Steiner's sculpture *The Representative of Humanity*. As a prime example of Steiner's creative accomplishments, this artwork is worthy of study for its own sake (AA 18). *The Representative of Humanity*, however, also offers a key to a variety of artistic issues, particularly the nature of *beauty* and *creativity*, which has concerned artists and philosophers for centuries. Steiner approaches beauty and creativity from many sides in his writing and lectures, but it is especially in his practice of art that he introduces the dimension of *metamorphosis*, perhaps his most important contribution to the arts. The motif of *The Representative of Humanity* illuminates these interrelated subjects, both as the specialized concerns of art, as well as issues of universal human significance.

Our discussion of these three concepts will lead us into realms of philosophical thinking, but I remind the reader that my own interest in beauty, creativity, and metamorphosis is that of a practicing artist and teacher of art, not a philosopher. The complex web of thought we will weave may, at times, seem to take us away from creative activity and its appreciation. In the end, however, we should find practical results from our exercises in thought. We are exploring these concepts not in order to apply them consciously in the

moments of creating or viewing a work of art, but in order that they lead us to a fundamental reorientation in our observation and experience of art.

The Three Faces of Beauty

> I hope to convince you that the theme I have chosen is far less alien to the needs of our age than to its task. More than this, if people are ever to solve the problem of politics in practice, they will have to approach it through the problem of the aesthetic, because it is only through beauty that individuals make their way to freedom.[1]

> The products made by our machines will first be formed artistically by his creative spirit, and thus supply for daily human needs the useful molded into noble beauty.[2]

I offer Schiller's quotation as a starting point to our discussion to indicate that we are not about to run away from the practical concerns of contemporary life. In our age of utilitarian pragmatism, it may seem like romantic idealism to suggest that beauty has any practical relevance to urgent social concerns. Nevertheless, the truth of Schiller's assertion can be elaborated.

In the previous chapter, we began to see that the question of inner freedom is at the heart of all human affairs. This implies that human welfare and progress depend on the dedication of a growing number of individuals to the slow and painful process of becoming free spirits: that is, self-directed liberation from compulsive inclinations. This question of human freedom is many-faceted, requiring many approaches. We take up beauty as one approach with surprisingly practical significance. To this end we will offer concrete evidence to support Schiller's claim that "through beauty ... human beings make their way to freedom." We shall begin with a deceptively simple question.

1. Friedrich Schiller, *On the Aesthetic Education of Man* (OA 29).
2. Rudolf Steiner, *The Soul's Awakening*, scene one (RSE 74).

Is the color red beautiful? Whether we say "yes" or "no," many people tend to interpret this question to mean, "do you like the color red?" Are these the same question? Does our personal feeling of pleasure or displeasure define beauty? In everyday discourse we tend to use the term *beauty* to refer to whatever pleases us and *ugly* for what displeases us. For example, we might say, "this red is more beautiful than that red," meaning the one is more pleasing than the other. There is a good deal of evidence to support the view that beauty is purely subjective, that "beauty is in the eye of the beholder." Thomas Aquinas declared beauty "as what gives delight to the mind."

We might ponder what it is in red (or any color) that delights us and makes it beautiful. Do all colors share something that makes them all beautiful? Can't we speak of the beauty of yellow and the beauty of blue as much as the beauty of red? In the world of forms is there not beauty in a curve as well as in faceted planes? How can differing colors or forms, each with distinct characteristics, all share in the attribute of beauty?

Earlier, we showed in considerable detail that color is not the physical pigment, just as form is not the clay; they are the spiritual qualities made visible to our senses through the material substance. Everything we have established thus far can lead us to consider the following: it is our subconscious experience of the spiritual shining or resonating through the qualitative dimension of sense impressions that we call the beautiful. *Beauty is another name for the spiritual within the physical.*

Noise is the antithesis of the beautiful in the realm of sound, because it remains solely physical. Musical tones are similarly physical, but they also possess qualities that lift sound beyond the purely physical. Someone may like noise, but that does not make it beautiful; similarly, someone may dislike a piece of music, but that does not make it less beautiful. Its beauty lies solely in its ability to move us to feel inwardly buoyed up or weighted down, whether we like it or not. We can express our subjective pleasure or displeasure for something such as a color without introducing the concept of beauty. To employ beauty as an expression of our personal preference merely obscures and demeans its full meaning and significance for human

life. Beauty is the only concept at our disposal to describe the subtle but objective delight we experience with the perception of nonphysical or spiritual qualities—for example, the weight of a musical tone or the warmth of a color.

> Beauty is not the divine cloaked in physical reality; no it is physical reality in a divine cloak. Artists do not bring the divine onto the earthly by letting it flow into the world; they raise the world into the sphere of the divine.[3]

Beauty is an experience of the soul-spiritual as it shines through physical substance. However, our experience of beauty depends on an inner activity of living into the material medium in such a manner that the duality of physical and spiritual is transcended; in this way, the physical is raised into the spiritual. The great diversity of the physical world originates from the diversity of forces and beings within the spiritual worlds and expresses itself through different qualities. The spiritual worlds are a unified reality, where there is, nevertheless, a great diversity of qualities of being. The apparent paradox that all the diverse qualities of colors and forms (such as warm/cold, light/heavy) share in the beautiful is explained by the fact that they share a common spiritual origin.

Whenever we experience beauty, we are raised into the spiritual world. We may be accustomed to interpret everything in our normal experience in exclusively physical terms, but the experience of beauty points beyond physical reality. Beauty does not originate in physical necessity; it serves no material purpose. The beauty of the different qualities of color and form become windows into the spiritual that underlies all creation, including our own humanity. In this sense, the beautiful qualities of the world can become a living proof of spiritual reality; the inner or spiritual rejuvenation that beauty offers us can be understood as spirit nourishing spirit.

Some people may challenge the value of attributing the experience of beauty to a spiritual world beyond conscious experience. Some

3. Rudolf Steiner, *The Aesthetics of Goethe's Worldview* (L 1).

might ask: If there *is* a spiritual reality of which we are a part, how can we know it? Beauty may begin as that which gives us pleasure; but if we become interested in knowing the source of our pleasure, beauty can be understood as an actual experience of the world of spirit within earthly reality. The pleasure in our experience of the beautiful can be attributed to the fact that our soul-spirit resonates with the soul-spirit of the world.

Beauty *is* in the eye of the beholder, not because of personal taste, but because the perception of the beautiful depends on how we observe the world. If we hear only sound, see only pigment or matter, and do not feel the *quality* of music, color, or form, then we cannot behold beauty. Likewise, when we experience only personal reactions or associations, we may have feelings, even pleasure, but such feelings pertain to us and not to the qualities of music, color, or form. Here also we do not behold beauty. The experience of beauty depends on our inner activity. In this context our inner activity has three possibilities:

1. Under-feeling is overly detached and objective; perceives the ugly.
2. Over-feeling is overly personal and subjective; perceives the ugly.
3. Balanced feeling harmonizes the objective and subjective; perceives beauty.

Again, we meet a triad of qualities, with two polarities balanced in the middle by a third. Following our method of the previous chapter, we can recognize in the activity of "under-feeling," an ahrimanic quality and in "over-feeling," a luciferic one. Relative to these two possibilities of "under-feeling" and "over-feeling," feeling per se is the activity of experiencing within ourselves the spiritual qualities belonging to sense impressions outside ourselves, or conversely, of knowing the spiritual qualities welling up from within ourselves with the objectivity we use for outer phenomena.

Through our study of *The Representative of Humanity*, we have come to see that any inner activity that reconciles the apparent

dichotomy of objective and subjective possesses what we might call a christic quality in the sense that the ahrimanic objectivity is harmonized with the luciferic subjectivity. The perception of beauty depends on such a harmonizing, or christic, form of spiritual activity. Just as we have seen that a virtue holds the balance between two vices, so beauty stands between two forms of ugliness. In order to attempt a clarification of this controversial dichotomy between beauty and ugliness, we will consider not only the way beauty is perceived but the way it is created. For example, there is a kind of beauty in thinking that is rigorously clear and accurate. Such thinking, which dazzles with its cool clarity, has beauty with an ahrimanic character. When it lacks all warmth and a sense of human relevance, however, such clarity becomes cold and abstract; its beauty withers and becomes ugly.

A spontaneous expression of feeling that has warmth and vitality can also be beautiful; its expansive warmth has a luciferic beauty. But if it lacks objective meaning and clarity and remains a formless froth of enthusiasm, then what was ripe with beauty becomes overripe and falls into the ugly.

Both the spontaneous expressionism of Kandinsky and the cool, cerebral abstraction of Mondrian can be experienced as beautiful. We have established that there are many kinds of beauty, which we experience, for example, with different colors and forms. It should not be surprising to speak of different forms of beauty in relation to different kinds of inner activity. Behind the creative vitality of expressionistic beauty lies a luciferic influence; behind the cool, precise beauty of abstraction is an ahrimanic influence. These two very different forms of artistic activity are saved from their one-sided starting points to the extent that the subjective origin of expressionism is objectified, or the cool objectivity of abstraction is enlivened through the warmth of individual experience. It is christic activity that balances one quality with a measure of its opposite and thereby transforms the potential of the ugly, overly personal, luciferic or the overly detached ahrimanic experience into an experience of beauty.

All qualities have a spiritual origin, but they can originate from different spiritual beings. As with the two vices on either side of a

virtue (cowardice—*courage*—recklessness), the luciferic and ahrimanic qualities are the two sources of ugliness. They are opposite extremes on either side of beauty. By themselves they constitute the ugly, but when harmoniously united, they each contribute something essential to beauty.

In his novel, *A Portrait of the Artist as a Young Man* (OA 14), James Joyce expresses, through the voice of Stephen Daedalus, the following perspective:

> The feelings excited by improper art are kinetic, desire or loathing. Desire urges us to possess, to go to something; loathing urges us to abandon, to go from something. These are kinetic emotions. The arts that excite them, pornographic or didactic, are therefore improper arts. The esthetic emotion (I use the general term) is therefore static. The mind is arrested and raised above desire and loathing. (p. 207)[4]

The idea of proper and improper art may convey a moralizing or seemingly dated perspective; however, when worked with in the sense with which we have been speaking, we may find it to have great significance for questions of art and human experience. Whether in relation to works of art or anything else, we are attracted through desire or repelled by loathing, and we are not free insofar as we are compelled to possess or reject something. What grips us with loathing, even when we like it (a horror film, for example) is commonly experienced as ugly. In the opposite extreme, the beauty that compels us to desire it is a false beauty. It may give pleasure and, in that sense, we may call it beautiful, but if we are compelled by desire we experience another form of ugliness—ironically, an ugliness that is commonly considered beautiful. Subjectively, beauty and ugliness may be used to describe pleasure and displeasure. Objectively, ugliness is that before which we are unfree, compelled either by desire or loathing. Through beauty, however, we are not compelled but inwardly free.

4. James Joyce's aesthetics are influenced largely by Thomas Aquinas. See OA 19, OA 22, OA 28.

What are the qualities that most often inspire an instinctive and, therefore, unfree attraction? To be passionately driven by creative impulses, however exciting or even spiritual they may seem, is inherently unfree. Ironically, it is the luciferic spirit that claims to be a "free spirit." The opposite is actually true when a sense of unrestrained abandonment floods through us beyond our control. Similarly, wherever abstract principles of efficiency and order exercise their compelling influence toward a "cool" standardizing and high-tech streamlining, we have another beauty that becomes ugly insofar as we are compelled to conform to its demand.

Ahrimanic Beauty	Christic Beauty	Luciferic Beauty
is ugly	is Beauty	is ugly
because	because	because
through loathing	neither repelling nor attracting us	through desiring
we become unfree	we remain free	we become unfree

The term *beauty* should not be applied to personal preference; the term *ugly* should not describe whatever we don't like. Just as beauty in nature and art is a way for the spiritual to reveal itself, so ugliness, too, expresses the spiritual. The ugly, however, is a spirituality that binds us to the objective realities of the physical world (the ahrimanic) or enslaves us to the subjective realities of our inner world (the luciferic). As such, the ahrimanic weighs us down with excessive loathing, whereas the luciferic buoys us up with excessive desire. These spiritual forces are necessary to human life but can work against it in their raw or extreme form. It is not through avoiding the ahrimanic and luciferic, but through trying to weave and harmonize them, that we exercise our capacity for spiritual freedom. Something is beautiful to the extent that its creation occurs through engaging the luciferic and ahrimanic qualities with a measure of freedom. Reconciling the beauty/ugliness dichotomy of ahrimanic and luciferic forms of spirituality in order to find the christic spirit in beauty is what raises the experience of beauty a prominent role in serving the development of human freedom.

When we experience the beautiful in the christic sense, we are not compelled by physical necessity; we are freed from physical necessity and become spiritually free. When we perceive the spiritual—if only in the cloak of beauty—we are more free than if we had no experience of the spiritual at all. This, in part, explains Schiller's claim that: "it is only through beauty that human beings make their way to freedom."

For us to realize the full relationship between beauty and freedom, we must become aware of the inner spiritual activity that creates the various forms of beauty. Thus, the criterion we use to determine whether something is beautiful or ugly is its spiritual quality to support or hinder inner freedom. When we find something or someone beautiful, it is because we experience the spiritual in that thing or person.

I leave the theme of beauty and ugliness with an unresolved question: Is something inherently ugly because it makes us unfree through loathing or desiring, or is it only ugly *as long as* we loathe or desire it? Is the experience of ugliness simply an opportunity to transform compulsion into freedom? In that case, does the ugly transform into the beautiful through our attaining inner freedom?

The mysteries of beauty present a task of the highest order. We cannot unveil her secrets through force, but neither should we abandon all hope of ever understanding her.

The Three Muses of Creativity

The freedom from all determinants leads to an indeterminacy so total that, finally, one has no reasons for choosing anything at all.... It means we no longer know where the truth lies.... But if all ideas are equal, what can vouchsafe to art its charismatic power and its moral authority? Arbitrariness is the pitfall of unlimited freedom.[5]

For several decades now, world literature, music, painting, and sculpture have exhibited a stubborn tendency to grow not

5. Suzi Gablik, *Has Modernism Failed?*, (OA 8, p. 77–78).

higher but to the side, not toward the highest achievement of the craftsmanship and the human spirit, but toward disintegration into frantic and insidious "novelty." If we, the creators of art, will obediently submit to this downward slide, if we cease to hold dear the great cultural tradition of the foregoing centuries together with the spiritual foundations from which it grew, we will be contributing to a highly dangerous fall of the human spirit on Earth, to a degeneration of mankind into some kind of lower state, closer to the animal world.[6]

Insofar as an action proceeds from the conceptual part of my individual being, it is felt to be free. Every other portion of an action, whether it is performed under the compulsion of nature or according to the requirement of an ethical norm, is felt to be *unfree*.[7]

Both Suzi Gablik and Solzhenitsyn express concern for dangers surrounding creative freedom. This may seem ironic coming from Solzhenitsyn, whose entire lifework has been a battle with the forces that would suppress freedom of expression. However, it is not ironic at all when we see that neither Gablik nor Solzhenitsyn advocates limits to freedom. The critical issue that they raise has to do with the way we use or abuse our freedom.

In many places in today's world, outer freedom remains a very real issue, won only through great courage and sacrifice. The importance of outer freedom to human dignity can hardly be overestimated or taken for granted. However, we can no longer afford to talk about freedom without making the distinction between the *outer freedom* to *do* as we choose and the *inner freedom* to choose or not to choose and to know the reason why. Steiner suggests that our freedom is complete only when we know the motives behind our choice. Freedom is a great human mystery. Not only is it possible for the human being to be utterly compelled in thought, feeling, and desire while remaining free of outer restraint, but it is equally

6. Alexander Solzhenitsyn, Address to National Arts Club, Jan. 1993.
7. Rudolf Steiner, *Intuitive Thinking as a Spiritual Path*, (RSE 3, p. 135).

possible to achieve inner freedom when all outer liberty is denied, such as when imprisoned.

The universal concern for freedom and self-determination originates in the depths of our humanity. So long as our focus is limited to external freedom, without attention to the much more critical factor of inner freedom, freedom becomes the source of our downfall rather than our crowning attribute. The collapse of communism in the Soviet Union and Eastern Europe in the late 1980s was a dramatic victory for outer freedom. The social upheaval that followed equally dramatizes the limitations of outer freedom when it is not complemented with inner freedom.

The so-called free West has little justification for smugness or superiority in this matter. Ironically, our preoccupation with outer freedom—believing it the key to social prosperity and well-being—distracts us from seeing the need to cultivate inner freedom. Capitalism prides itself on the principles of *free* enterprise and *free* trade, but the forces active in the stock market and advertising, to name only two spheres, hardly exemplify the human potential for inner or spiritual freedom. The union of capitalism with democracy is founded on the principle of freedom, but it remains incomplete, in fact, tragically flawed, so long as outer freedom is divorced from inner freedom.

Modern art is also a realm where outer freedom has been raised to the level of religious fervor. Nevertheless, we may ask: To what extent is the creative activity of modern artists based on freedom? Do artists distinguish between outer freedom and spiritual freedom? What does it mean for the individual artist, as well as for human culture, to have works of art created in complete outer freedom, but not in inner freedom? Does it matter whether the creative process is born from unfree drives, passions, and reactions? What would it mean for human culture if artists took up as their central task the cultivation of creativity that is grounded in inner freedom?

Steiner's views on art and human evolution may lead to the conviction that the value of a work of art lies not in its outer appearance but in the quality of creative activity that went into it—particularly, the degree to which it is born out of inner freedom. If exact observation and draftsmanship were the foundations on which an art was

mastered in the past, cultivation of inner creative freedom, grounded in an ever-growing self-knowledge, is the prerequisite discipline for the art of the present and foreseeable future. Therefore, clarifying the distinction between outer and inner freedom becomes critical to our understanding and cultivation of creativity in all spheres of life, including art.

Not everyone seems to be blessed with the same capacity for creativity. From a utilitarian perspective, the cultivation of creativity is desirable for society as a whole, because it is the source of new ideas that improve the quality of human life. For the individual, creativity is a means to recognition and, perhaps, economic reward. But creativity has an appeal, sometimes seductive, independent of any outer benefits.

> *Creativity ... is an essential part of being human,* a vital force without which we can exist, but not truly live.... Creativity [is] an ongoing flow within us and around us, to which we can all open if we are willing to let down our guard.... [To practice an art] is to explore the act of creation as a spiritual practice, as a way of awakening to our true nature and contacting the beauty and mystery of our lives.[8]

To be creative is to be transported in heart and mind from the mundane world to a world where thoughts and feelings take on an enlivened power of new meaning and relationships. Of course, today we have a body of scientific research that seems to prove the physiological basis of all thinking and feeling and, therefore, of creativity. For example, Betty Edwards in her books, *Drawing on the Right Side of the Brain* (OA 6) and *Drawing on the Artist Within* (OA 7), bases her remarkable results for teaching drawing as a way to school creativity on such scientific evidence. Exhaustive research has observed neural activity to dominate in the right side of the brain when subjects are engaged in nonverbal, synthesizing, intuitive processes such as drawing, compared with the verbal, analytic, and logical activity of the left side of the brain. Although the scientific evidence fixing the exact

8. Ann Cashman, *Yoga Journal*, Sept.–Oct. 1991.

location of these processes is less than definitive, there is a relationship that exists between the biological processes and what we experience as our inner life of thoughts, feelings, and creative impulses.

What seems to go unnoticed, however, is that there are two ways to interpret these observations. The one commonly assumed by many to be the only plausible interpretation is that thinking, feeling, and creativity originate from these physiological, electrochemical activities. Faithful attention to the facts, however, allows us to say only that we observe the physiological activity of the brain and nervous system occurring concurrent with inner experience. Physiological evidence alone does not show inner experiences arising from the physical processes. Such an interpretation is made in the belief that matter is the origin of the psychological and spiritual. By contrast, it is equally possible to interpret these physical processes as the vehicle by which the human spirit, existing independently of matter and engaged in thinking and feeling as a purely spiritual activity, is able to imprint itself into physical reality.

The view that creativity is a spiritual activity is not diminished or negated by the fact that physical processes are necessary mediators for spiritual expression in earthly existence. Just as the creative artist needs paper, canvas, or clay to make his or her thoughts and feelings visible to the senses, similarly the creative spirit needs the physical vehicle of our physical body to create within the physical world. The physical evidence is objective fact, but it cannot, in itself, prove that one of these two realities—matter or spirit—precedes the other. To expect a proof from external observation alone is misplaced; accurate inner observation is no less essential. If we have not experienced the independence of our creative spirit from bodily processes, it would be truer to our experience to refrain from judgment altogether. Conceivably, we might remain open to the equally logical possibility that in creative activity the spiritual does indeed precede the physical processes of our bodily organization.

The creative state—whether it descends unsought or through great anguish and effort—is so cherished because we are transported to an inner space, where we commune with thoughts and feelings of a different order than the everyday. The transcendent dimension

implicit in phrases such as "inner space" and "communing with" can be interpreted as mere metaphors or, as with beauty, such experiences can lead us from our earthbound consciousness to an actual world of spirit. The idea that spiritual beings are an integral part of human reality, its very source, has been introduced as fundamental to Steiner's worldview. We shall now consider the implications his views—in particular, the reality of a spiritual world and spiritual beings—have for human creativity.

Originality is commonly associated with creativity. Creativity is often recognized because it brings forth something new that did not exist before in our experience. Because it was previously nonexistent in the world of the senses, a materialistic orientation can only say that it arose from nothing—or, more likely, out of some rearrangement of what already existed, such as the work of earlier artists. Although such influence is often present, new developments in art, or any realm, are not fully explained when seen as rearrangements of what already exists. In writing this essay, I am not simply rearranging words in a new order, nor am I trying to say something unique just to be different, but because I want to clarify an aspect of experience that has not been made conscious before. My efforts are original not merely when something outwardly new is created, but, more significantly, when my inner activity is original.

As with freedom, we must distinguish between outer and inner originality. We must be careful not to confuse newness with originality. Something can be made that is outwardly new, but does not arise through original inner activity. For example, to merely rearrange the outer appearance of something may result in something novel, even though it did not arise through original inner activity. It is the absence of original inner activity that seems to concern Solzhenitsyn when he speaks of "a frantic and insidious *novelty*." Indeed, original inner activity need not result in something outwardly new. For this to make sense we must ask: What is original inner activity?

The word *original* has come to mean "new and unique," something coming into existence for the first time. However, the word derives from the word *origin*, as in "source." The word itself points to a world of origins, which for Steiner is not metaphorical but actual: the

realms of soul and spirit he describes in *Theosophy*. These worlds exist independently of the physical world, but in them the archetypes—the ideal thoughts and qualities that shape both physical and psychic reality—have their origin.

If all thoughts and feelings have their origin in soul and spirit worlds, how is original creative activity possible? If we hold to the conventional view that, to be *original*, the creation must originate in *me*, then Steiner's perspective makes originality an illusion. Alternatively, we may adapt our concept of originality to concur with the perspective Steiner gives us. To be original means to be actively engaged within the world of archetypal thoughts and qualities (*the world of origins*) through our own unique effort. At the same time, it has the stamp of the individual *through* whom (not *from* whom) it is born from the spiritual into the physical. But, if spiritual reality stands behind originality, is creative freedom possible? This question requires that we clarify our concept of freedom.

Inner freedom is not the result of avoiding all constraints, but of knowing why one possibility is chosen over another. I do not determine the given elements and natural laws of the world. In this respect, I am not free to exist in a different world. Can I find freedom within the limitations imposed by the world? I am free to paint with color or not. But when I paint, I must work with the existing world of colors. I am free to paint with certain colors and not with others, but I am not free if I remain unaware of the effect I create through a particular color or color combination. My inner freedom as a painter depends on my capacity to experience the expressive qualities of the various colors.

Although in one sense we are unfree about the nature of color as we meet it in the created world, this is insignificant compared to the freedom and self-realization we may feel within this world of color. Through color we can feel liberated from physically bound existence. We can experience our soul and spirit liberated to live and move within its own element, the world of soul and spirit from which it is born and can continue to be nourished.

The capacity to experience the spiritual aspect of color and form does not come without some inner effort. It is our unique individuality, or I, that must initiate this inner activity. Just as we can have a

sense of physical well-being through physical exercise, our spirit develops through the spiritual effort of artistic perception and creative forming. In all spiritual activity, including artistic creation, we are strengthening and developing the core of our being, our spiritual individuality.

Each individual human spirit is a great mystery, in that two apparently contradictory claims can be made, namely: 1) The human individuality is a God-given creation. 2) The human individuality realizes itself through its own striving for spiritual freedom. Our humanity is given to us in part as a birthright, but not in its completed form. Our humanity requires our own activity. It depends on what we make of ourselves—what we do with our limitations. We lose none of our sense of gratitude and wonder for the mystery of our being when we acknowledge that the self, as given to us, is limited and, therefore, unfree. This unfree self serves as the raw material that we may creatively transform to become free. Within this context, it is important whether we view creativity as a means to freedom from all restraints or as a way to become free within limitations beyond our control.

All creativity is not the same; we shall distinguish three types of creativity. First, there is the one most commonly understood as *creativity*, characterized by a torrent of thoughts and a rush of emotion, welling up from the mysterious depths of our subconscious psyche. In this case, the artist is akin to a river bed through which a creative force moves with a power that is channeled, but hardly resisted. The river bed is not the source of the flood nor does it have much control over it. Likewise, artists often have little control over when and how they are filled with such a creative surge. If the artist is neither the source nor the master of creative power, who is?

The same question can be asked concerning the second form of creativity. Initially, this form of creativity may be less recognizable as such, because it is associated more with scientific and technological fields than with the arts. In this century scientific-technological thinking has become a major influence in all spheres of life, including the arts. Here we encounter a force whose power is akin to the precision of a machine. Its magic and allure lie in its crystal-clear

logic, grounded in objective fact, dazzling and compelling us to submit to its certainty of truth and promise of benefit. A mathematician experiences a form of creative exhilaration in solving a difficult theoretical problem, as does an inventor or engineer when solving a practical problem such as the creation of a technological device. From where do such creations originate? Who inspires this form of creative activity?

In the first form of creativity, we feel swept along by a creative force independent of and greater than ourself. At most we may strive to not strive, as a way to find the inner door where this creative power awaits release. The second form of creativity seems to be inspired by physical necessity and physical laws of nature. We can observe ourselves trying to follow the tracks of an inner trail that leads to an idea that already exists. The fact that it eludes us only heightens our feeling that the idea we seek is actually attracting us to it, that we will discover it only when we conform our inner self to the nature of its being.

If we observe both kinds of creativity with care and without prejudice, the question of who inspires our creativity ceases to be strange or farfetched. In creative activity, one can experience standing before the threshold of a world of spirit and spirit beings in communion with an actual Muse. Once the reality of the Muses is no longer in doubt can we recognize the much more critical question: What Muse whispers in our ear or rages in our belly? With spiritual experience, as with physical experience, there is the possibility (and perhaps the necessity) to discern what is before us, who is speaking to us.

In everyday life, we do not speak of having a physical experience without characterizing the nature of that experience. Did I encounter a person or a thing? Which person? What was said? How was it said? Similarly, it is not sufficient in the case of inner experiences to say: I had an inner, spiritual experience. Inner experiences are infinitely diverse and require perhaps even greater discrimination than outer experience. To ask who inspires a thought or feeling is no different than to ask who is speaking to me in ordinary experience. As modern people, most of us are not constituted to perceive directly the spiritual beings that influence how we think and feel. One way we grow into this reality is to attend to the *quality* of our thinking,

feeling, and creative impulses. In the quality—more than in the content—of our thinking, feeling, and willing, the activity of distinct spiritual beings may be recognized.

The Greeks spoke of a different Muse that inspires each art. Steiner's description in *The Spiritual Being of Art* (L2) represents a similar view in a new form. The ancient Greeks, and Nietzsche at the end of the nineteenth century, spoke of Apollo (the god of light and order) and Dionysos (the god of wine and intoxication). Works of art were said to be Apollonian or Dionysian in acknowledgment of their respective influences. Through the course of time, the sense of being inspired by a god, or spiritual being, was lost. Later, art criticism began to speak of the equivalent phenomena more simply as "classical" and "romantic" styles. Steiner challenges us to regain, in a way appropriate to modern consciousness, the awareness of the spiritual beings behind these stylistic distinctions in works of art. Today, these two streams continue to define the parameters of artistic creation.

In his lecture "The Two Sources of Art: Impressionism and Expressionism" (L5), Steiner discusses two principal sources of creativity. He employs the modern terms *expressionism* and *impressionism* to describe two broad streams. The specific modernist styles that these terms originally refer to are only part of these two streams. Steiner's intention is to suggest that all possible artistic approaches belong to one or the other. By *impressionism* he means any artistic activity that originates in outer observation or experience that does not merely copy physical appearance mechanically. Such activity is raised to the artistic by employing the appropriate color and form to convey some of the inner quality of the external phenomenon. The inner finds itself in the outer, the objective speaks to the subjective.

Similarly, he describes *expressionism* as any creative activity that originates from inner spiritual impulses, but that are not mere representation of spiritual vision. This approach becomes artistic by raising the subjective into the universally objective by employing color and form that reflect exactly the emotions experienced. The outer is found in the inner, or the subjective is objectified. In both cases, the moral qualities of form and color form the bridge between outer and inner.

Steiner suggests that there are two boundaries where the artistic crosses over into the inartistic. The issue of art versus non-art is intimately connected to the question of human freedom. Steiner's elaboration of the two boundaries of art in their modern forms of expressionism and impressionism can help us to clarify the elusive mystery of human freedom.

The first boundary Steiner cautions against is *outer literalism*, or the mere copying of the outer world. The second is *inner literalism*, or merely illustrating spiritual vision.

Today, Steiner's views must also embrace nonrepresentational art, where we find neither an outer nor an inner copying and yet we meet equivalents of these two aberrations of art. All art, especially nonrepresentational art, can be seen as a record of inner experience. Therefore, we must learn to read the inner activity behind the stylistic quality of a painting or sculpture. One approach to nonrepresentational art arises when an artist allows subconscious impulses to well up as raw emotion; the inner experience becomes everything, and the resulting work is a record or perhaps a hallowed talisman of that experience. It is a variation of the inner literalism of the visionary, insofar as purely subjective emoting is not expressed in objective form.

Nonrepresentational art can also originate in abstract ideas, theories, or optical effects. This involves anything that arises through abstract thinking, or somehow remains detached from the qualities of form and color. This is a variation of outer literalism to the degree that abstract objectivity does not resonate as inner experience.

We may infer from Steiner's writings and from his sculpture, *The Representative of Humanity*, that particular spiritual beings, gods, or Muses inspire these different forms of creativity. The outwardly literal, in both realistic and abstract forms, springs from an ahrimanic impulse, whereas the inwardly literal, whether visionary or emotive, has its origin in the luciferic spirit.

Impressionism is the modern equivalent of the classical and Apollonian stream; expressionism belongs to the romantic and Dionysian stream of art. We can say that the Apollonian impressionistic stream derives from an ahrimanic impulse, and the Dionysian expressionistic from a luciferic influence. They may begin with

a dominant ahrimanic or luciferic impulse; but, significantly, they do not remain limited to their one-sided origins.

Impressionism goes beyond mere realism or abstraction as a result of the capacity of the artist or viewer to enter what is external and become spiritually united with it. We may paint a sunset or a patch of red while viewing it with detachment, or we may do so while feeling united with the fiery warmth of the sunset or the red's redness. An elementary form of the impressionistic approach is to view a patch of red pigment and experience not just material substance, but inner warmth and vitality.

Expressionism goes beyond the visionary and raw emoting insofar as the artist can find some inner distance from the spiritual forces welling up from within in order that they are expressed objectively through the appropriate colors and forms. I may feel a fiery vitality coming from within, and it may move me to put a color on the canvas without knowing why. Later, I may note whether or not the warmth or coolness of the color actually corresponds to the feeling I was expressing. If not, I was emoting instead of expressing. These are elementary examples, but they indicate how, if we train our capacity to perceive the moral qualities in each sphere of creative activity, we can discover the key to transforming both the ahrimanic and luciferic forms of creativity toward a human or christic creativity.

Impressionism is the outer experienced within, whereas expressionism is the inner experienced from without. Both can be said to support human development, because they avoid their one-sided spiritual origin—the ahrimanic of the impressionistic and the luciferic of the expressionistic. Impressionism balances the ahrimanic origin by permeating the outer with inner life, a luciferic quality. Steiner uses the term *intuition* for this capacity of living into outer reality. Similarly, expressionism balances the inner, luciferic surging with a cool, ahrimanic objectivity. In this case, *imagination* describes this objectified vision. The balancing of the ahrimanic and luciferic is possible only to the extent that the creative person gains a measure of inner freedom. Inner freedom defines the third form of creativity, the hallmark of the christic muse.

The problem with inner or outer literalism, whether representational or nonrepresentational, is that the human being is unfree. Literalism of outer reality and abstract thinking arises when we are bound by what is spiritually given and fixed as objective external reality. Literalism of inner vision and emoting arise when we are compelled by a purely personal and subjective spirituality within us. Both may seem to be creative, but surrendering to the exhilaration of either outer objectivity or inner subjectivity we sacrifice our inner freedom. Only creativity that balances its originating spirit with its opposite is free and, therefore, worthy of the human being.

Christic creativity seeks to create an objective, living reality—not a fanciful world, detached from human relevance, nor a world of abstract order that lacks the living reality human welfare requires. To be creatively free is to learn first to perceive the spiritual forces shaping the quality of human life. Then, in the freedom of that insight it is possible, in addition, to choose the spiritual forces or beings we allow to come to expression through our creative activity. This view of creative freedom expands our wealth of experience, while allowing creative artists to be responsible for the effects their creations have on both themselves and others.

There are many views on how, as a practical matter, our creative potential can be developed. Often various activities are recommended that attempt to suspend our critical faculties and release the wellspring of our subconscious. As wonderful and perhaps therapeutic as this may be, the foregoing considerations indicate that a more comprehensive picture of creativity is needed to realize our human potential. Human welfare and development ultimately depend on our ability to discern the spiritual consequences of our creativity.

Steiner's views can lead us to see that creativity originates not in an uninhibited will but in the quality of our observation. If our creative resources are weak, if we feel blocked, developing our creative spirit begins with paying greater attention to how we observe the world through our senses. Our discussion has elaborated the possibility of experiencing spiritual qualities within many varieties of sense phenomena. We saw that observing the qualitative dimension of the sense world leads us to perceive the realities of soul and spirit. Now we

can add that this same qualitative observation is the key to unlocking human creativity.

After years of returning again and again to the simplest color or form exercises, I marvel at how they not only stay alive but continue to unfold creative impulses. Red, yellow, and blue, roundness and angularity are my teachers and muses, inspiring me to creative initiative. If we can comprehend that the qualitative dimensions of the sense world are the speech of the gods, then perhaps it is not such a fantastic leap to see that these same qualities are also the muses who can inspire us to creative impulses. The cultivation of objective, qualitative observation can be recommended also for those who already possess some degree of creativity. Such observation helps to discern the difference between creative impulses that merely gratify the personal need to feel creative and those that respond to perceived needs in nature and human experience.

Metamorphosis: The Three Agents of Change

Beauty and creativity are issues that have surrounded the arts for centuries. Metamorphosis has always been an integral part of the performing, or *temporal*, arts. Through his own sculptural and architectural work, Steiner must be attributed with introducing metamorphosis of form as a new dimension for the visual, or spatial arts.

Metamorphosis means "change" (*meta*) of "form" (*morphosis*). Change of form is inevitable in art and in the world. Change is a great mystery from which we may instinctively shy away or consider beyond our comprehension. Even though we may never grasp the full complexity of change as a fundamental aspect of life, we owe it to ourselves to clarify it in any way we can. There are many forms of change that have various effects and implications for the quality of art and human life. Metamorphosis is one form of change, whose nature and significance become clear only in relation to other kinds of change.

The word *metamorphosis* is most often employed in the life sciences to describe the orderly transformations of living organisms from one condition to another, such as the development of a caterpillar into a

butterfly or a tadpole into a frog. When used nonscientifically, the word is usually more mysterious, even magical or bizarre. Kafka, for example, intended this nuance in the title of his novel *Metamorphosis* (OA 15), in which a young man is transformed overnight into a giant beetlelike insect as an expression of the alienation he feels toward other people. The Roman poet Ovid, in A.D. 8, gave poetic form to many of the Greek and Roman myths in *The Metamorphoses* (OA 23). This poem explores a variety of transformations, as in the presentation of the god Proteus who comes

> As a young man from the sea,
> Then as a lion, then a roaring boar,
> Or as a snake whom many fear to touch!
> Horns change you to a bull, or you might be
> A sleeping stone, a tree, or water flowing,
> Or fire that quarrels with water everywhere. (OA 23)

Even where the transformations are not so graphic, inner transformations—the metamorphoses in the hearts and minds of the gods that change destiny—unify the theme of this poem.

Early in his career Steiner became an editor of Goethe's scientific writings. He developed an intimate and extensive knowledge of Goethe's insights into metamorphosis as recorded in his *Metamorphosis of Plants* (OA 10). Goethe made detailed observations of plant development, through which he understood that every part of a plant is a metamorphosis of the leaf. Careful examination of the leaves of a plant and the order in which they grow reveals changes in form from leaf to leaf. Some plants make more dramatic "leaps" in form, whereas others change almost imperceptibly. Beyond the development of leaf forms themselves, Goethe saw every part of the plant— the flower petals, the stamen, pistil, fruit, and seed—as a metamorphosed leaf (RSE 4, p. 96).

Building on Goethe's biological methods, Steiner saw that a practical understanding of metamorphosis was vital not only in the life sciences, but for guiding all manner of developmental process, both outer and inner. He saw the arts as prime vehicles for fostering this

metamorphic thinking and capacity. In designing the Goe-
theanum—the building that became the world center of his work—
Steiner developed architectural forms from a living experience of the
laws of metamorphosis, and these permeated the Goetheanum and
all its parts. Metamorphosis permeated the first Goetheanum; every
detail was artistically integrated within the organic whole.

That building was destroyed by fire on New Year's Eve, 1922. It
was replaced by a second Goetheanum, which was also designed by
Steiner. In the main hall of the first Goetheanum there was a
sequence of seven capital motifs that clearly demonstrates Steiner's
use of metamorphosis.

*Model of the interior of the first Goetheanum
with the main hall to the right*

The story of these motifs began in 1907 when Rudolf Steiner, as
General Secretary of the German Section of the Theosophical
Society, hosted a conference in Munich. He took the initiative to
have the hall for this conference transformed artistically, the pri-
mary feature being seven painted pillars designed by Steiner. The
tops, or capitals, of the seven columns each consisted of a different
motif, which Steiner related to the qualities of the planets Saturn,
Sun, Moon, Mars, Mercury, Jupiter, and Venus. The order of these

planetary motifs follows the names and sequence of the days of the week: Saturn day, Sun day, Moon day, Mars day (or *Tiu*, the Germanic god of war, or Mars), Mercury Day (or Old English, Woden's day), Thursday (Thor, or Jupiter day), and Friday (Frigg, the wife of Odin, or Venus day). Steiner derived the order of these planetary motifs not from the days of the week, but from insight into the spiritual realities of world evolution—a reality generally unknown to contemporary humanity, but known to those of the distant past who named the days of the week.

Steiner's writings elaborate a vast and complex picture of world and human evolution, proceeding through seven great stages with the names of the planets in the above order.[9] Even where he does not speak directly of evolutionary stages, Steiner assumes that some understanding of cosmic evolution is necessary for comprehending other aspects of human life—the nature of reincarnation and karma and, in particular, the evolution of consciousness throughout history, as it is revealed through history, including the history of art. Steiner views human history as the outer manifestation of spiritual evolution. His artistic impulse arose from a deep understanding of human existence, from realities that artistic form can reveal in ways that the written and spoken word cannot. Steiner was adamant that there was nothing symbolic in the forms he created.

An examination of the seven motifs can help us to understand this better. When we ask ourselves only to describe what we see, we notice a sequence of forms, each different from the others, but nonetheless related. The thing common to all seven motifs is that in each we find forms from above interacting with forms from below.

The first motif is relatively simple: a smaller upper form pointing downward, almost touching the slightly larger but similar lower form pointing upward. Both forms are concave in going from point to base. It is appropriate to describe the form of the mass, but we can

9. In addition to what is contained in *An Esoteric of Occult Science* (RSE 13), Earth evolution is described more fully in Steiner's lecture cycle, *The Apocalypse of St. John* (RSE 68).

see that the physical forms also define and give form to the space between. The formed space is ovoid, egg- or bud-like and entirely convex, widest above the middle. When we move to the second motif, we still see upper and lower forms, but now they alternate rather than stand directly above each other. The upper form of the first motif becomes, in the second, a teardrop form moving downward. The lower form rises up into the bud-like space of the previous motif, becoming fuller at its base and differentiated into two lobes in its upper part.

Descriptions such as these, when written, can quickly become tedious, which is the very opposite of the effect produced by active observation. Let the above description serve as an example of the careful and exact observation that can help these forms come to life within us as dynamic qualities.

First capital motif (Saturn)

Toward this end, we may note that some of these forms are comparable to the forms of figure 5 in chapter 3, page 28. As we learned to enter the quality of this form sequence, we can do likewise with these planetary motifs. For example, we may note that the forms of the first motif are comparable to the forms of Figures 5a and 5h, whereas the form of the space between them is similar to that of 5f. Thus, we can characterize the forms of the first capital as lifeless stillpoints, whereas the space between them has a buoyant levity.

Second capital motif (Sun)

The forms of the second capital, especially the upper teardrop forms, are filled with inner vitality. The two-lobed lower form also appears life-filled as it reaches upward. In the motif of the third capital, this lower form becomes a receptive chalice, but with less vitality—more contracted and crystalline. Similarly, the upper still-point in the second motif becomes a delicate three-lobed form in the third, and a form of powerful vitality in the fourth motif. While this three-lobed upper form grows in vitality, the teardrop form that continued to descend from the second to the third seems in the fourth to merge into the base, creating an erect column, connecting above and below.

Third capital motif (Moon)

Fourth capital motif (Mars)

In the fourth motif the powerful main form and column constitute the lower part of this motif, entirely separated from the now independent upper part. With the fifth form, we meet a transformation that is more challenging to follow. The vertical element of the column of the fourth motif becomes the upright staff, and the three-lobed form coming from above weaves together to become the serpent-like forms. We can follow the new teardrop forms in the fifth and how they become inverted chalices in the sixth motif. The chalices of the sixth motif are not the same as those in the seventh; the chalices of the sixth become the upper curves of a harmonious undulating movement in the seventh, having been more at rest in the sixth motif.[10]

Fifth capital motif (Mercury)

10. See *Rudolf Steiner's Seven Signs of Planetary Evolution* (AA 30) and *The Great Hall of the Goetheanum* (AA 67) for other descriptions of these planetary motifs.

Sixth capital motif (Jupiter)

Seventh capital motif (Venus)

In this way, we move from form to form, living into the dynamic quality of each. From such feeling for the individual forms, we may begin to feel the quality of transformation between motifs and still wonder what it all means. What does this have to do with Saturn or the Sun? And what does this have to do with me? We must ask such questions and yet be open to the way we find answers. Modern culture tends to educate us to expect answers on demand, and we are not generally disposed to hold questions as something to live with, perhaps for years. As with any true work of art, this sequence of planetary motifs cannot be explained intellectually. The Saturn or Sun motifs do not have symbolic meaning. When we learn to live

in the individual forms as well as move through the transitions between forms with awakened feeling, we come to know and value not so much flashes of insight lighting up in our intellect, but the enlivening of our creative will needed to transform ourselves and the world.

We can infer that Steiner dedicated himself to creating artistic expressions of metamorphosis because he saw that it could stimulate us to an inner sensibility for transformation and growth in all spheres of human life. To experience this through works of art requires our own involvement over extended periods of time. The motivation to work with metamorphosis in art—or in any other sphere—may be enhanced when we see its importance for dealing with the forces of change in modern life. Toward this end, we must examine different kinds of change.

When I was about twelve years old, I developed an interest in mineralogy, which led me to grow a copper sulfate crystal. I picked a small crystal with an interesting shape and hung it in a supersaturated solution of copper sulfate. Over the next three to four weeks, I watched with wonder as the quarter-inch-long blue crystal grew to about two inches in length. It was pure magic to see the shape of the crystal gradually enlarge in perfect proportion to the original, only to enhance its beauty.

Years earlier I had an equally magical experience of a different kind. One day I picked up several fallen maple keys, or seeds, took them home, and planted them in our garden. A few weeks later three tiny seedlings emerged. Today I can visit the home where those seedlings now stand as mature maple trees, towering seventy-five feet into the air.

Two childhood experiences—both magical. What is the difference between the magic of a growing crystal and the magic of a growing tree? Both objects began at about a quarter-inch in length, but the crystal was just as special for growing to two inches as the tree for its growth to seventy-five feet. What is most remarkable is not the greater size of the maples, but that their form changed so dramatically in the process, whereas the form of the crystal did not. The crystal grew larger, but the shape, number, angle, and relative size of

its facets all maintained their relationship to each other as they enlarged. The maple seed also had a particular shape when placed in the ground but within days that shape had all but dissolved, and new shapes of roots, stem, and leaves appeared. At any given moment, the form of the tree appears static, when actually it is not. In observing any plant or tree over time, one sees the ever changing qualities of form—stretching, filling out, closing and opening, lifting up and weighing down, diversifying and simplifying.

Both the crystal and the maple seed changed quantitatively in size and weight, but the seed changed not only quantitatively but also qualitatively; its form metamorphosed. *Metamorphosis is change in quality.* The distinction between quantitative and qualitative change is fundamental to understanding metamorphosis as a special form of change; that differentiates the nonliving from the living.

Metamorphosis is significant also for animal and human life. Not only do these metamorphose in their outer forms as plants do, but they are also capable of inner transformations of sentience and consciousness. Particularly in human life, metamorphosis is the key to understanding all forms of inner and outer development, both of individuals and social institutions. More significantly, in order to bring about change in individuals and society in supportive rather than destructive ways, it is not enough to merely change things; we must develop the practical capacity to transform, or metamorphose, them.

A final look at the sculptural forms of figure 5 may be of help here if we ask: Do these forms metamorphose? We saw that the forms of this series could be developed without any change in the clay's volume and weight. In that sense, there is no quantitative change, only changes in form (convexity, concavity, straightness, width, and narrowness), which in turn produce qualitative changes, such as being weighed down or buoyed up. If the change in form were solely quantitative, then the word *change* would suffice for both changes in matter and form. The distinction we have made, however, between the quantitative change of matter and the qualitative change of form requires another concept—*metamorphosis.*

To the extent that the maker and viewer experience these and other forms as qualitative changes, they metamorphose. The simple

forms of figure 5 exhibit an elementary process of metamorphosis that applies also to more complex forms, such as Steiner's planetary sequence. Furthermore, we have seen that the qualities of such forms mirror the dynamics of our inner life. Experiencing the metamorphosis of qualities through the succession of such forms prepares us to observe how the dynamic nature of our inner life similarly metamorphoses from one quality to another.

Let us examine the nature of change in human affairs. There is a popular truism: The one thing that doesn't change is change itself. This saying reflects a general anxiety toward change. Too often we seem unable to control change, and consequently we attempt countermeasures (such as insurance and regulations) to guard against the unexpected. In our thinking, most of us recognize change as an inevitability. Nevertheless, a powerful force inclines us to avoid or inhibit change as much as possible, and this orientation may define our perspective on life to the degree that it becomes "conservative." This view of life, whether applied politically or otherwise, sees change and innovation as inherently "guilty until proven innocent." Bureaucracy, even within liberal institutions, resists change, and has no purpose but to regulate people and impose order where it is presumed chaos might otherwise wreak havoc. We may, on the one hand, recognize the need for social order, laws, and regulations. On the other hand, however, when we are caught in bureaucratic machinery, we inevitably feel demeaned and sense that our true individuality and humanity have not been met.

We might be resigned to the necessity of bureaucratic order in our lives and may even work as its agent, but few can sustain such an approach to life all the time. Sooner or later, we feel compelled to relax the hold of prescribed order and indulge in freedom and spontaneity. We need to experience our own thoughts, feelings, desires, and impulses in our own way and in our own time. A fundamental human need requires that we seek new experiences, whether through gossip, news, entertainment, a change of scenery, or in new faces. It is not uncommon for people to become desperate for change—any change! This compulsion for change is most dramatically revealed in the spirit of revolution.

Even if we are not so radical in our approach to change, there is probably something of a revolutionary in all of us whenever we want instant change—a new job, spouse, or car. Sometimes anything will do, so long as it is different and immediate. Instant and total change often seems justified, yet even when temporarily successful, it is rarely sustained. More often than not, negative side effects quickly become apparent. Revolution may force a short-term change in what people do and say, but it cannot bring about a true change, or metamorphosis, for which there must be an inner change of attitudes and values; and this ultimately depends on the development of new faculties and capacities.

Mechanical bureaucracy and revolutionary chaos are the two poles of change. They form the unavoidable parameters of change in our personal lives and social institutions. They both have a measure of necessity, as well as serious limitations. But we may look for a third aspect that arises through the harmonious interaction of these two poles. Change can occur without being stifling or chaotic, and such change may be termed *evolutionary*, as distinct from *revolutionary*. Evolutionary change is metamorphosis. How does metamorphosis apply to social change?

The activity and relationships of social life are shaped by our thinking—not just what we think, but more important, *how* we think, which determines how we speak and act. There are two poles in our thinking activity that, in their extremes, are considered pathologies; but they can help us recognize their profound influence as they manifest in less extreme forms in everyday life. We may refer to these two poles as *mechanistic thought* and *chaotic thought*.

It is not uncommon today to meet a compulsive talker who, to sustain such an outpouring, jumps from topic to topic with little or no apparent connection. This reaches an extreme when the person utters not only unrelated sentences but strings of words that do not form coherent sentences. We are taken from concept to concept, but with no meaningful relationship between them and no development of thought. This can hardly be called thinking. It is a chaos of concepts that, at best, evokes associations in the speaker or listener. Without intentional relationships between ideas, mental

activity consists of thoughts, but it is not thinking; it is chaotic thought.

We may also encounter someone whose thoughts we cannot follow. The individual words may make sense, but not the sentence, or perhaps sentences make sense, but not paragraphs. This may occur when the speaker lacks the right concepts or orderly thinking. Sometimes, however, it happens that the speaker conveys the intended meaning with complete accuracy, but the listener cannot understand due to a lack of vocabulary or experience.

Sometimes we may have difficulty understanding a lecture or book by someone who makes conceptual leaps we are unable to follow. We may be tempted to conclude that it is the lecturer who is not being clear enough. Steiner, for example, often makes leaps in thinking that defy the logic of normal comprehension. As we familiarize ourselves with his views, however, we find that we are able to fill such leaps with our own thoughts and thus make understandable a statement that otherwise remains beyond our comprehension. Such leaps in thought—which we all make at our own level—are based on the assumed knowledge of the listener, so that our statements do not become labored and repetitious.

Here we meet metamorphosis within the realm of thinking. In thinking we must find the relationship between two or more thoughts. Clearly, if there were to be no leaps between thoughts we would continually repeat the same thought for fear that, in moving to a second thought, we might lose the initial thought. This would be an extreme example of mechanical thought. A more common manifestation of mechanical thought involves procedures and laws that are followed without reflection regarding their appropriateness in the given situation. In such cases of mechanical thought, as with chaotic thought, there is thought but not thinking. Thinking occurs only when meaningful and life-filled relationships, or metamorphoses, are active in assembling a collection of thoughts. Thinking is metamorphosis of thought.

These two poles of thought—the mechanistic and the chaotic— mirror and are indeed the origin of two social forces, the bureaucratic and the revolutionary. (These terms are used to convey a narrower

and more negative connotation than they may otherwise deserve outside the present context.) Thinking that has subjective vitality without objective form belongs to the revolutionary spirit. Thinking with universal objectivity but lacking individualized life and meaning characterizes the bureaucratic spirit. Thinking that is worthy and expressive of our full humanity possesses both order and life, universal and individual resonance.

Metamorphosis in thinking consists in developing our capacity to make ordered, living relationships in our thinking by learning to avoid arbitrary and mechanical tendencies. This will not seem exotic or frivolous when we recognize that our capacity to exercise such thinking is the prerequisite for creating a living order among humankind. How we think—not just what we think—affects how we change ourselves and the world. We inflict much injustice and unintended harm through the two polar mind-sets and the subsequent behavior modes we broadly designated as the *revolutionary* and *bureaucratic*.

Where do these two forces of change originate? Again we can find practical insight through understanding the various spiritual beings behind human affairs. Chaotic change is inspired by the luciferic spirit, and mechanistic change originates in the ahrimanic spirit. Change is essential to our spirit's growth in realizing our full human potential. But the change inspired only by the revolutionary or the bureaucratic spirit does not support that end. Only when these two spirits interweave does a third spirit enter the arena of change, giving change a human countenance.

ahrimanic spirit	christic spirit	luciferic spirit
bureaucratic spirit	artistic spirit	revolutionary spirit
mechanistic change	metamorphic change	chaotic change

The christic spirit inspires the possibility of change as metamorphosis, either through permeating the bureaucratic spirit with personalized warmth or by infusing the revolutionary spirit with objective order. The artistic spirit is dynamically poised between the other two, neither negating nor succumbing to them, but drawing upon both and harmonizing the best of each.

When we are driven either by the revolutionary spirit or by the bureaucratic spirit we are unfree. We cannot, nor should we, eradicate the bureaucratic or the revolutionary spirit. Within the sphere of change, as with beauty and creativity, we are challenged to bend these two spirits to serve the development of our inner freedom. Metamorphosis is a formative activity and belongs to any sphere where the agent of change, human or spiritual, finds a balance between the mechanical and the chaotic, the bureaucratic and the revolutionary. We may summarize by saying: Metamorphosis is qualitative change arising through spiritual freedom.

This introduction to metamorphosis in concert with our discussion of beauty and creativity serves its purpose if it establishes a basis for addressing artistic issues in relation to the significant human concerns of our time. The principle of triads, which we encountered first through *The Representative of Humanity*, has guided us to practical insights in each realm that reveal their human significance. Some readers may be legitimately concerned that this principle forces the complexity of reality into a simplistic formula. This very real danger is, in fact, the ahrimanic temptation surrounding such a truth. The luciferic reaction, on the other hand, would be to dispel it all as nonsense.

As we confront the daunting enormity and complexity of real life as active participants, the principle of triad qualities serves as a spiritual lifeline that supports us in the face of potential inundation. A lifeline may be misused, however, and work against us; but such a risk is no reason to reject help altogether. To fruitfully apply this triad principle, we must cultivate an inner poise that avoids arbitrary self-expression as much as spiritual automatism. This path of creative activity embodies the living experience of metamorphosis, serving human and world metamorphosis.

VI. New Directions in Art

In the era of pluralism, when there are no longer any limits to what
we can imagine or produce, very few people, as far as I know,
have any real sense of what our art is for.[1]

Modern art began over a century ago with the promise of new vision and direction. As the century of modern art draws to a close, the art world seems to have lost its way. In the mid-1970s, many artists found themselves no longer identified with the heroic individualism of modernism. The term *postmodernism* designates this widespread inner shift of perspective and values among artists. Postmodernism can be characterized as a self-conscious denial or "deconstruction" of purpose, meaning, and originality. But to deconstruct the foundations of all thinking, and therefore of philosophy, is nevertheless a philosophy based on thinking. To devalue manifestoes and "isms" that give artists direction is itself a manifesto, but one that advocates a direction without having a direction. Meaning and purpose are fundamental to human nature. In one form or another they are unavoidable.

The postmodern rejection of purpose is, in part, a healthy reaction against a direction that makes art elitist and remote from the fullness of human life. To abandon all sense of purpose is neither possible nor desirable, but the search for a new sense is struggling to be born in many hearts and minds. Are we not seeking a sense of direction, both for human life and art that does not violate the uniqueness of the individual and the dignity of self-determination without egotistically violating our fellow humans or the other kingdoms of nature? Can we not aspire to cultivate a collaborative relationship to the Earth and cosmos as a physical and spiritual unity that enhances our creative freedom?

It is possible to follow the development of art to the present. It is more challenging, however, to predict its future. Individual artists must be true to themselves in following their artistic intuitions.

1. Suzi Gablik, *Has Modernism Failed?* (OA 8).

Individual integrity is supported through an understanding of one's cultural context. We gain a broad sense of direction when we are aware of the issues that have evolved over centuries to shape present art and culture, that are inherent to any artistic effort, now and into the foreseeable future. When we go for a walk, we do not know all that we will encounter. Much of the pleasure of the walk would be missing if we knew in advance everything we would experience. But there is another kind of pleasure in choosing the area or type of landscape we will visit. Similarly, to know the issues that have been shaping human culture over decades and centuries can enhance the freedom of the individual artist. What are these issues?

Although the purpose of this essay is not to analyze modern art, it is implicit in everything we have discussed that this century's art does have momentous purpose. Rudolf Steiner's views and practice of art are intimately united with the impulses that have arisen in the souls of many artists of his time. It must be noted that Steiner's own artistic work (from 1907 until 1924) was contemporary with, and sometimes influential in shaping, the development of some significant artists—most notably, Vassily Kandinsky.[2] Steiner was able to raise to the light of consciousness the spiritual forces shaping artistic creation that, for most others, emerged mysteriously from the subconscious. He offered spiritual context and meaning to the apparent cacophony of styles and manifestoes. It may be said that Steiner's views on art are limited to a certain extent by his times, that they do not apply to the circumstances that have arisen, for example, with the shift from modernism to postmodernism. Nevertheless, Steiner's perspective extended not only into a distant past, but also into a distant future. Steiner's contribution to the visual arts is relevant today and there is every reason to believe it will continue to be relevant for some time. It transcends the vagaries of passing trends, because the arts are seen within the deep spiritual currents underlying human evolution.

The most fundamental issue for the arts today is their spiritual foundation. Steiner articulates an objective world of soul and spirit

2. See Sixten Ringbom, *The Sounding Cosmos* (OA 27).

where the various artistic mediums are nothing less than the languages of the gods, mediating between the realities of the soul-spirit worlds and those of the physical world.

Our understanding of creative freedom depends entirely on perceiving the spiritual dimensions of freedom. External freedom in art, as in everything, is appropriate to the spiritual needs of our time, but by itself is incomplete and often illusory. Insofar as we are asleep to the spiritual forces shaping our experience of reality, we remain inwardly, or spiritually, unfree. Individual freedom depends not on being free from these spiritual forces (for that is not possible), but on becoming increasingly conscious of them as the qualitative parameters with which we work in shaping our art and our lives.

Through our study of Steiner's sculpture *The Representative of Humanity* we have seen that through our perception of the objective qualities of the sense world we awaken to the activity of spirit within the world of matter. When we experience any quality in the outer world or within ourselves, if we can place it in the context of a triad of qualities—as we did with the virtues and the corresponding two forms of vice, or with beauty and the two kinds of ugliness—then we have a key that opens the door to free spiritual activity.

Even when we understand and feel connected to such thoughts, it may be difficult to take them up in a practical way. The first step is to turn toward the artistic medium that attracts us and to cultivate a "listening eye and hand" for what speaks through the elements of that medium. The simplest of exercises, such as forming yellow and blue or roundness and angularity, when done repeatedly over extended spans of time, allows color and form to become our teachers, our muses. If we give ourselves to them with all our heart and will, they guide our artistic way into the future. If, at the same time, we strive to be attentive to the spiritual needs—usually unspoken—in the world, then many new opportunities will be found whereby the arts can realize their potential to serve human evolution. All that Steiner has said and done in relation to the arts can be summed up as a challenge in these two directions: to perceive and experience directly the spiritual in each artistic medium, and to perceive the spiritual issues and needs of our time.

From this general statement, we can outline some of the practical directions whereby the spiritual potential of the visual arts is employed to meet specific contemporary needs.

The Art of Education

We must permeate all levels of education with the artistic element.[3]

We have come to see that artistic activity is spiritual activity. This makes it possible to develop spiritual faculties and capacities through artistic activity. Exploring ways that each art can best serve such development becomes central for the artist and leads naturally to the teaching of art.

The teaching of art to anyone other than the aspiring professional artist is a relatively new development in our cultural history. Whereas in Zen Buddhist culture, both laypeople and master artists have for many centuries practiced the arts as a part of their path of inner development, in Western culture such potential of the arts is just beginning to be recognized. Teaching is often seen by artists as a necessary evil—a way to earn a livelihood when one cannot make a living selling one's art. But teaching art can be seen as an art in itself. Its fruits may not be as tangible as sculptures and paintings, but a certain reward lies in planting seeds that will unfold in students as new capacities of insight and creativity. For artists to concern themselves with the way artistic activities can best meet the inner needs of others—both children and adults—is a worthy vocation in itself.

Adults who do not consider themselves "artists" often face the challenge of overcoming a preconception that artistic activity is only for the naturally inclined and gifted. These obstacles can be overcome by recognizing the arts as an integral part of being human. The quality of our lives is enhanced simply by being inwardly active in an art, irrespective of the outer results. Adults must be free to decide whether or not to take up the arts, but that choice is truly free only when the potential value of artistic activity is recognized.

3. Rudolf Steiner, *The Younger Generation*, p. 117.

For children, the issue of choice is less appropriate. The most important thing is the understanding and attitudes of the parents and teachers. When the full potential of the arts is appreciated, they will become required courses like other essential disciplines, such as reading and writing. Recent research demonstrates the present educational bias to develop the analytical and verbal activity of the left-brain, leaving the synthesizing and intuitive activities of the right-brain underdeveloped (OA 6). Steiner points out the essential role of art for developing a healthy integration of all aspects of human faculties—thinking, feeling, and willing.

In establishing the school movement known as Waldorf education, Steiner developed a curriculum that incorporates the arts as an integral part of the child's experience, both as independent art and craft classes, as well as a way of learning in all other subjects. He also offered guidance to teachers concerning both the need and the way teaching could be taken up as an artistic discipline in itself.[4] It can be said that there is considerable opportunity for artists not only to meet the existing need for art in the Waldorf schools, but to permeate education in general with an artistic spirit. In addition, there are the possibilities for developing the role of the arts in public education, in teacher training, and in all aspects of adult and professional education.

Steiner provided the foundation for understanding and an example through which the arts can serve human development, including indications for specific art and craft activities for the various stages of childhood and adolescence. There is much yet to be done in penetrating and extending these indications.

The Art of Therapy

The arts also play an important role in healing where human development is abnormal and unhealthy. Art therapy is a developing profession most often used as a diagnostic tool or as a means of purging unhealthy forces within the subconscious. The therapeutic

4. For resources that provide more detailed descriptions of the way education can be practiced as an art see (AA 12, 13, 20, 23, 25, 28, 37, 46, 53, 63, 66).

potential of the arts is enhanced when the spiritual qualities of color and form are seen to offer a positive healing element to physical and psychic disorders. The specific qualities of each color and form may be used therapeutically just as a particular medicine may be prescribed to compensate for a particular inner deficiency. Some of Steiner's work in this area has been developed, especially in painting therapy and, from the performing arts, in curative eurythmy. This is largely an open field with much potential for development.[5]

The Art of Psychology

The domain of psychology spans normal education and therapy. Normal art education can be seen as empowering healthy children and adults with the faculties and capacities to know and shape their inner selves. What else is health but the inner strength and the creative spirit to manage our inner and outer lives? Our psychological health can be measured by the degree to which we are inwardly free in relation to the full spectrum of human qualities. Even the psychologically normal are, to a high degree, inwardly unfree. In the course of evolution more and more people will develop their capacity for inner freedom. The arts and artists have major roles to play in developing our potential to be spiritually free. With appropriate artistic guidance, the arts become the vehicles by which we can learn the art of becoming human. Learning to balance contrasting dynamics in color and form can awaken the capacity to harmonize the spiritual forces within ourselves and our environment.

During the past four hundred years, Western humanity has increasingly employed the methods of science—that is, the observation and quantification of phenomena through analytical thinking—as the way to know the world and ourselves. Whereas analytic thinking as a method of acquiring insight has its place in such fields as mathematics and physics, it has proven inadequate for knowing the living and sentient worlds. To the degree that the scientific method tries to reduce all that is living and conscious to quantifiable physical properties and forces, without seeing the need to

5. See (AA 15, 24, 38, 42).

develop other ways of knowing appropriate to these different forms of reality, it fails to meet the actual needs of human life. This is nowhere more obvious and destructive than in psychology and social science.

Can we gain self-knowledge in a way that does not fragment and kill our sense of being whole? Can we know ourselves in a way that does not paralyze our capacity to grow and develop our inner potentials? Steiner offers the following possibility:

> To realize this secret connection between art and life—especially with the human will element—is one of the very first requirements of future psychological education, and in future all education must be psychological. Judging from the way things are now, when all psychology has been driven out of ordinary people, those who establish our future psychology will have to be artists, who still retain a little of it, whereas otherwise it has vanished from our culture.[6]

Artists can contribute to a new psychology by cultivating artistic perception as the foundation for perceiving the living, qualitative nature of the human being. Such perception was outlined in chapter 3 of this introduction as the capacity to perceive objective qualities in color, form, and other sense phenomena. The observation of qualities must be cultivated with the same precision as exercised in quantitative, scientific observation. Unlike quantitative observation, however, qualitative observation connects the living dynamics of our inner nature with the corresponding dynamics of all living and conscious forms of reality. Through qualitative observation we can be inwardly, or spiritually, connected with all of reality. We know what is outside from within and what is within us from outside.

This ability to know the other from within and to know ourselves from without empowers us to know how to transform a situation in harmony with what we affect. We learn to metamorphose rather

6. Rudolf Steiner, "A Social Basis for Primary and Secondary Education," a lecture on June 1, 1919. See *Education as a Force for Social Change*, Anthroposophic Press, Hudson, NY, p. 179.

than trespass or violate human nature and human life. In other words, the capacity to experience the qualities of red, yellow, and blue is the same as the ability to perceive and know the joy or sorrow of another, as though it is our own.

More important, can we work with our own sorrow or joy, our own inward or outgoing nature, so that we are inwardly free in our ability to move from one quality to another? Such work with the qualitative dimensions of our own inner nature and that of others introduces the artistic into a realm that our culture generally regards as a domain of science. This is the art of psychology. Perhaps it can give new meaning to the traditional view that medicine is not just a science but also an art. It may happen in the near future that those with an interest in the inner well-being and growth of humanity will take up an art to develop this faculty for artistic perception and creativity. It would be a mistake to expect instant and radical change, but with patience and perseverance, new capacities can be nurtured through art. Psychologists would not merely diagnose but empower people with practical methods for developing the artistic faculties and capacities needed for self-transformation. Each individual would be guided to become an artist, shaping her or his own human potential.

The Social Art

Society is the great unfinished symphony of humankind. In her book, *The Re-Enchantment of Art* (OA 9), Suzi Gablik documents the work of several artists who represent a new artistic movement to step out of the studio. Instead of social comment on canvas, they direct their creative efforts to active social change. Joseph Beuys is of special interest because of his prominence in initiating this movement of social art, or "social sculpture" as Beuys described it. Furthermore, he credits Rudolf Steiner as a prime influence in his lifework, particularly his descriptions of evolution and the spiritual issues underlying modern social questions.

Social Art is a direction that counteracts the self-indulgent aspects of "art for the artist's sake." In light of the social needs of our time, these artists consider painting and sculpting in the traditional sense to be inadequate, if not frivolous. It is transparent that the demands

for social transformation require the creative resources of as many people as possible, artists and nonartists alike. If social renewal is to become a reality, we must recognize and cultivate concrete methods for developing the creative potentials of each individual. Toward this end, the traditional fine arts have a central role when used to develop the creative capacities needed in social spheres.

To effectively influence social renewal as artists, it is no longer enough to create paintings and sculptures that merely reflect the challenges of modern life or to portray social harmony and utopias. This kind of "commentary" is not the only way works of art can be socially relevant. The ideas outlined in this essay introduce an artistic path that develops the faculties essential to recognizing the spiritual dimensions of social issues. We can understand and solve the problems of social life only when we perceive the spiritual forces active beneath the surface of human affairs. We become conscious of these spiritual forces by attending to the quality of processes and interchange. By entering into the dynamic forces of social, cultural, political, and economic life, we begin to view social life as a realm of spiritual forces. Artistic perception can experientially know the spiritual forces of social life and thereby serve human welfare through a creative capacity that harmonizes and balances those spiritual forces.

We have shown why psychologists should develop their artistic capacity. The same reasoning applies to anyone concerned with a healthy social life—politicians, lawyers, teachers, social workers, and businesspeople, to name a few. Likewise, artists are called upon to see the need for directing their creative capacities, not only to canvas or wood, but also to the practical needs of our time. Artists have a new task: to create opportunities by which the visual arts can help nonartists develop the perceptual and creative capacities needed for the highest art of all—the *social art.*

Cultivating the potential creativity in each individual is a goal that most people understand and support, but few clearly see the different forms of creativity (discussed in chapter 5) and that the kind of creativity human beings develop affects the quality of social transformation. We should foster a creative attitude toward all dimensions of

human life, seeing each human life as a work of art that in turn shapes the collective creation of social life.

With respect to social sculpture it is especially important that we assess the value of the subjective, self-expressive form of creativity. Creativity can certainly arise as an impulse within us, but it must be balanced by an objective awareness of its qualitative effects on the world. In this way, social impulses may well up from within us in an "expressionistic" manner while avoiding the negative effects of visionary or emotive elements. In social life these extremes manifest as messianic leadership or capricious anarchy.

Social creativity is equally possible when approached from the opposite doorway—by perceiving a need outside oneself. In seeing such a need with empathy, as if inside it, we can awaken also to creative impulses. Such a beginning is the "impressionistic" approach to social creativity that avoids the errors equivalent to realism or abstractionism—that is, social dogmatism or determinism.

Artists are needed who are willing to enter institutions and communities to bring artistic activities in ways that address the most deeply felt concerns about modern society. For example, the commonplace conflicts that arise between people with very different values and ways of behaving can be addressed when an artist helps a community group to appreciate and harmonize different colors in a painting or form elements in a sculpture. Of course, we cannot expect miracles after engaging in an art once or twice; only when artistic activity becomes an integral part of our lives over sustained periods of time can we hope to see artistic faculties metamorphose into new social capacities.

The Art of Science

Historically, science and art are poles apart and seem to have little in common, either in purpose or method. As with all polarities, the activities of these two realms must be harmonized; each by itself is incomplete and one-sided. Scientists have given human culture an inner discipline of exactitude and objectivity for knowing the world. However, we have paid a price for this way of knowing and its technological benefits; we have become estranged from the

forces of nature and, more alarmingly, from our own inner being. This estrangement is exactly proportionate to our lost capacity to perceive the spiritual forces active in the world and in our physical and soul nature. This loss of spiritual insight originates in the detached-observer consciousness fostered by science in pursuit of objectivity.

Three to four hundred years ago, in order to cultivate objective discernment, scientists understandably but arbitrarily bracketed out all qualitative attributes of sense experience, giving validity only to quantitative dimensions of reality. "Understandably," because developing objectivity toward what can be quantitatively measured was a necessary step toward a consciousness based on direct insight rather than faith or superstition. For all the benefits of quantifiable objectivity, its consequences have been catastrophic in our failure to develop the same precision with regard to the *qualities* that pervade every aspect of the physical world. This tragic flaw of science continues to mar its potential to serve human life.

Through exact observation of qualities, we may know the soul forces active in the physical world. This faculty is precisely what we have tried to demonstrate as *artistic perception*. There are, at least, two directions for applying artistic perception in realms usually considered the domains of science. In the life sciences, artistic perception, as meant here, can experience the quality of color and form of living organisms as a way to know phenomenologically their inner nature in relation to our inner nature. Such insight is essential to discovering, for example, the relationship between the dynamic nature of particular illnesses and the formative dynamic of particular plants—a basis for determining their medicinal properties. Such qualitative seeing is also the foundation for an ecology based on insight into the spiritual dimensions that unite the separate kingdoms of nature into a single organism. Similarly, in developing and assessing technologies, artistic perception enables us to discern the qualitative effects they may have on our inner, spiritual well-being, beyond their potential physical benefits.[7]

7. See (AA 7, 17, 21, 26, 31, 57, 61, 62, 68, 70).

The Art of Art

We have outlined some of the areas where the artist can contribute to human life in new ways that do not involve the traditional activity of creating works of art, but instead lead to research, teaching, and counseling. Steiner has made profound contributions to the creation of original works of art, largely through his own practice of architecture, sculpture, and painting.

The first Goetheanum building, with its many integrated aspects, embodied many ideals for the future of the visual arts. In lectures, such as "Buildings Will Speak" (L3), Steiner revealed his vision for the arts. He stated ideals, such as "buildings will begin to speak"; "peace and harmony ... can be established only when (through architecture and the other arts) the gods speak to us." Steiner regarded his own efforts to realize his ideals to be only modest beginnings of a new art and culture that he assumed others would continue to develop. For these seeds of a new culture to mature as Steiner hoped, a growing number of artists and friends of the arts must dedicate themselves to deepening their understanding of the new directions he initiated.

Steiner demonstrated that our individual creative activity is not just personal. Our creations do not originate out of thin air or solely out of ourselves, but from an objective world of spirit with which we are intimately related in the depths of our being. He showed that our creations have significance beyond ourselves and beyond the recognition they receive. Works of art are vehicles of particular spiritual qualities, and in bringing these qualities into the sphere of human life, artists become responsible for the spiritual effects their work has on themselves, on others, and ultimately on human evolution.

Some will take this perspective as pretentious and self-inflating; others will find it intimidating and too great a responsibility to contemplate. From a spiritual perspective, the charge of the artist is no less consequential than that of physicians who hold patients' lives in their hands. This element of responsibility should temper, but not diminish, our creative joy. We may learn to welcome both "the agony

and the ecstasy" as equally essential to creative activity that strives to meet real spiritual needs.

Artists might take spiritual realities and beings as the subjects for paintings and sculptures, as Steiner did. He was very clear, however, that neither symbolizing nor illustrating spiritual visions is adequate to the inner needs of our time. Symbolism and visionary illustration may draw on the spirit as their content, but they are as husks that do not bear the living reality of the spirit.

Steiner developed from Goethe the deceivingly simple starting point of perceiving the "moral qualities" of color and form as the means by which to realize the world of spirit as a living reality. The experience of inner warmth and coolness in color was the ground from which the painter could learn to work with the living reality of the spirit. For Steiner this was only the starting point. He posed the challenge that the form given to color by the painter not be imposed as an independent element, but that form be derived from the color itself. As a further enhancement of its spiritual qualities, each color embodies an inner dynamic or formative gesture. To the extent that painters are attuned to the formative gesture of a color, they experience the color (not the pigment) as trying to reveal its inner nature through particular form characteristics. As examples, Steiner indicated that yellow exhibits a formative gesture of radiating outward, while blue tends toward an enclosing inward.

Unfortunately, too often such indications are taken as a formula and applied mechanically. This can happen only when we take Steiner's words without considering the faculty he exercised to describe such form gestures. Our task would be easier, but ultimately less meaningful, if we only had to execute rules for giving form to color. The essential challenge Steiner sets before us is to develop dormant faculties that enable us to perceive first hand and afresh in every moment the living gesture of each color and color relationship. Such humble beginnings may lead the painter into a world of motifs and imaginations filled with life-giving meaning. Steiner himself gave several series of "training sketches" to aid artists in developing motifs through direct perception of the spiritual qualities of color. Gerard Wagner and Beppe Assenza are two prime examples of painters

who, in their individual ways, developed their life's work from Steiner's indications and sketches.[8]

One further thought may establish the foundations for understanding Steiner's architectural direction. A building must typically serve certain physical requirements for human habitation, such as keeping out the elements and providing for an economical use of space and movement. In this sense we may speak of a physical functionalism. Steiner conceived a building as serving more than physical needs. For example, a school for children and an office building will have very different practical requirements in order to accommodate very different activities. Steiner extends these practical considerations; the shape and proportion of rooms, the amount and direction of light, and the color on the walls are all factors that gradually shape the inner life of those who occupy them, either supporting or working against their development.

The architect has the daunting but wonderful task of extending the disciplines of that profession to embrace a spiritual and psychological functionalism along with physical functionalism—to create a human-made environment that accommodates human physical needs in a way that equally nourishes and strengthens the soul and spirit. It should be noted that Steiner applied this principle not only to the building itself, but extended it to all the objects in our environment, such as furniture, tools, and other useful objects. He did not support the idea of mere decoration—simply making things pleasing to the eye—but advocated that usable objects be designed to *feel* beautiful by harmonizing the practical function with the psychological function appropriate to the human users.[9]

The urgent task of renewing culture requires that architects, sculptors, and painters individually begin to work with the spiritual qualities embodied in their arts. Their individual work will bear unimagined fruits when artists can also collaborate on common projects. The Goetheanum building embodies the ideal that, when

8. See (RSE 69, 70, 71, 72 and AA 5, 8, 9, 10, 11, 14, 19, 22, 32, 33, 35, 36, 37, 38, 39, 40, 43, 44, 47, 51, 56, 58, 59, 65, 69).
9. See (AA 3, 4, 6, 29, 49, 50, 54, 67). Also, see p. 306, "Works of Visual Art Created by Rudolf Steiner."

the separate arts are brought together to form one artistic whole, they will all the better serve human spiritual needs. The gods will speak to us and empower us with insight and creative will to form the world in the image of our spirit-filled humanity.

What is our art for? The answer to this question lies in our taking up the arts as a spiritual activity, for only then will "the gods speak to us."

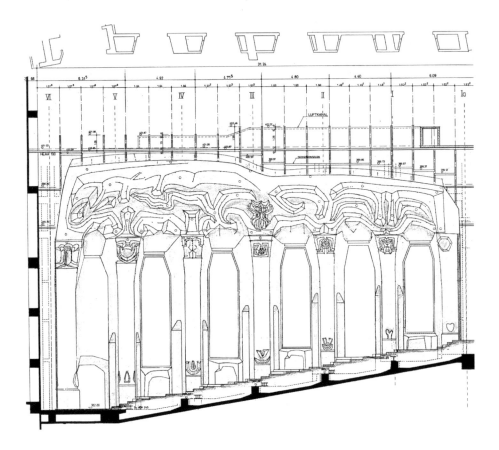

Elevation drawing of the south wall of the Great Hall.

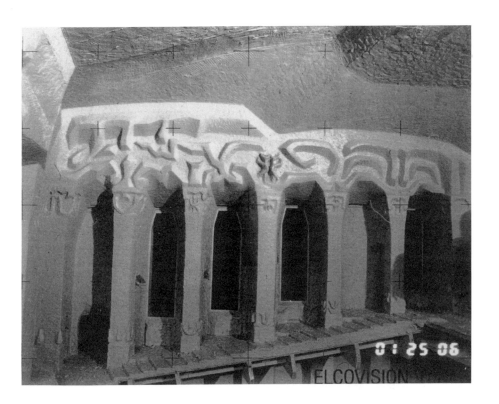

Plasticine model of the new interior of the Great Hall of the second Goetheanum,
designed by Christian Hitsch (completed in 1997).

LECTURES

RUDOLF STEINER

1. The Aesthetics of Goethe's Worldview

VIENNA, NOVEMBER 9, 1888

Preface to the Second German Edition:[1]

This lecture, appearing here in its second edition, was delivered at the Goethe Club in Vienna more than twenty years ago. In this re-issue of one of my earlier works, let me say that I have noticed that people have found changes in my views throughout my career as an author. Is the implied criticism justified, considering it is possible to reissue my more than twenty-year-old work without needing to change a single sentence? And in response to claims that my ideas have changed concerning, in particular, my anthroposophical, spiri-tual-scientific activity, I would like to say that the ideas developed in this lecture are a healthy foundation for anthroposophy. Indeed, it even seems to me that an anthroposophical perspective is especially called for to understand these ideas. There is scarcely any other school of thought that can really incorporate into its consciousness what is said here. I have developed what was behind my world of ideas twenty years ago in many and various directions since then; this, rather than any change in my worldview, is the way this matter actually stands.

1. This lecture was published as an article revised and annotated by Rudolf Steiner; it is contained in *Methodische Grundlagen der Anthroposophie: Gesammelte Aufsätze zur Philosophie, Naturwissenschaft, Ästhetic un Seelenkunde 1884–1901*, Rudolf Steiner Verlag, Dornach, 1989 (GA 30). ("GA" refers to the number used to catalog Steiner's works in German.)

At the end, by way of clarification, I have added a few comments [used as footnotes in this English edition], which could just as well have been written twenty years ago. Considerable work has been done in the field of aesthetics in the past two decades, and thus the question could be raised as to whether what was said in this lecture still applies today. It seems to me, in fact, to be even more applicable now than it was twenty years ago. With regard to the development of aesthetics, let me venture the strange statement that the thoughts expressed in this lecture have become even more true over the years, though they have not changed in any way.

RUDOLF STEINER
Basel, September 15, 1909

.

Nowadays a daunting number of books and treatises is appearing, with the purpose of ascertaining Goethe's relationship to the various branches of modern science and of modern intellectual life in general. Simply listing their titles would probably fill a substantial little volume. This phenomenon rests on the fact that we are becoming ever more aware of Goethe as a cultural factor with which every would-be participant in contemporary intellectual life must come to terms. To disregard him means to renounce the very foundation of our culture, to flounder around in the mire without having the will to rise to the luminous heights from which our culture's entire light shines forth. We can clarify where our culture is heading, we can become aware of which goals modern humanity must alter, only if we are able to connect to Goethe and his times at some point or other. If we do not establish this connection to the greatest mind of the modern age, we are simply pulled along by our fellow human beings and led as if we were blind. But if our vision has been sharpened through our connection to this source of culture, we see all things in a new context.

As gratifying as our contemporaries' efforts to link up with Goethe may be, we cannot claim that this always happens in the most fortunate manner. All too often they lack the much-needed objectivity that would allow them to immerse themselves in the full depth of

Goethe's genius before taking a critical stance. Goethe is thought outdated in many respects simply because we fail to recognize his full significance. We believe that we have gone far beyond Goethe, but in most cases the right thing to do would be to apply his comprehensive principles and his wonderful way of looking at things to the methods and facts of our own more advanced science. The point with Goethe is never whether the results of his research coincide with modern science to a greater or a lesser extent, but only how he approached the matter. His results bear the stamp of his times; that is, they go as far as the makeshift science and limited experience of his times permitted. However, his way of thinking and of stating problems is a lasting achievement, and we do it a great injustice if we treat it with condescension. But it is a peculiarity of our times to see the productive intellectual power of genius as something almost meaningless. How should it be otherwise in an age in which everything that goes beyond physical experience, both in art and in science, is frowned upon? For mere sensory observation only healthy senses are required, and genius is something quite superfluous.

However, true progress, both in the sciences and in art, has never been brought about either by observation of this sort or by slavishly imitating nature. Thousands and thousands of people can disregard an observation, but then someone comes along and discovers a magnificent law of science as a result of it. Probably many people had seen a swinging chandelier before Galileo did, but it took the head of a genius to see in it the laws, so significant for physics, that govern the motion of a pendulum. "If the eye were not sun-like, how could we see the light?" exclaims Goethe, by which he means that the only people who can see into the depths of nature are those who have the necessary potential to do so and the creative power to see more in the realm of fact than the mere outer phenomena. We do not want to recognize this.

We should not confuse the mighty achievements that we owe to Goethe's genius with the shortcomings of his research, which are due to the limited scope of experience at the time. Goethe himself used a very pertinent image to describe the relationship of his scientific conclusions to the advancements of research: He likened them to chess pieces that he may have moved across the board too daringly, but

which should make it possible to recognize the player's plan. If we take these words to heart, then we are confronted with a great task in the field of Goethean studies, namely to go back to Goethe's own intentions in each instance. His conclusions may be valid only as examples of how he attempted to solve his difficult problems with limited means. We must now attempt to solve them in the same spirit, but with our own greater means and on the basis of our richer experience. This will fructify all the branches of research to which Goethe turned his attention; what is more, they will all bear a common stamp and be part of a great and unitary world view. It would be foolish to deny the justification of mere philological and critical studies, but they need this other aspect as a complement. We must take possession of Goethe's wealth of thoughts and ideas and use them as our starting point for further scientific work.

At this point I take it upon myself to demonstrate the extent to which these principles apply to aesthetics, which is one of the youngest and most controversial of the sciences. Aesthetics, the science that deals with art and its creations, is not much more than a hundred years old.[2] Alexander Gottlieb Baumgarten came forward in 1750, fully aware that he was opening up a new field of science.[3] The efforts of Winckelmann and Lessing to arrive at a basis for judging issues of principle in art also belong to this same time.[4] Everything that had been attempted in this field up to that point cannot even be described as the most elementary beginnings of this science. Even the great Aristotle, that intellectual giant who exerted such a decisive influence on all branches of science, remained totally unproductive as far as aesthetics was concerned. He completely excluded the fine

2. *Rudolf Steiner*: We are speaking here of aesthetics as an independent science. Of course we can find commentaries on the arts by the leading minds of earlier times. However, how a historian of aesthetics could deal with these would be similar to how we deal with all of humanity's philosophical endeavors prior to the actual beginning of philosophy with Thales in Greece.

3. Baumgarten (1714–1762), philosopher; considered the founder of aesthetics as a distinct field of study; wrote *Aesthetica Acroamatica*.

4. Johann Winckelmann (1717–1768), archaeologist and art critic who brought the Greek aesthetics of neoclassicism into German culture; Gotthold Lessing (1729–1781), dramatist and critic.

arts from his field of study, which leads us to conclude that he had no concept of art. In addition, he knew no other principle than that of imitating nature, which also shows us that he never grasped the task of the human spirit in the creation of works of art.

The fact that the science of beauty only came into existence so late is no coincidence. It simply could not exist earlier because the necessary conditions were absent. What are these conditions? The need for art is as old as humanity itself, but the need to understand its task could only appear at a much later stage. The Greek mind, thanks to its fortunate constitution, drew satisfaction from the reality of our immediate surroundings, and although it brought forth an epoch in art that has not been surpassed, it did so out of natural naiveté, without needing to create in art a world that would offer a satisfaction that could come from nowhere else. The Greeks found everything they were seeking in reality itself; Nature bountifully provided everything their hearts desired, everything their spirits thirsted after. They never reached the point of having their hearts desire something that we seek in vain in the world around us. They had not outgrown Nature, so Nature met all their needs. They were inseparably united with Nature with their whole being; Nature worked in them and knew quite well what desires she could engender in them and then satisfy again. So for these simple people, art was simply a continuation of the life and activity within Nature. It arose directly out of Nature. Nature satisfied the needs a mother satisfies, only to a higher degree. That was why Aristotle knew no higher artistic principle than the imitation of Nature. There was no need to reach beyond Nature, because she was already the source of all satisfaction. The mere imitation of Nature, which would seem empty and meaningless to us, was completely adequate in this case. We have forgotten how to see in mere Nature the highest object of our spirit's desire. That is why mere realism, which offers us bare reality devoid of that highest object, would never satisfy us. This time had to come; it was a necessity for humanity as it continued to evolve toward ever higher levels of perfection. It was only possible for human beings to remain totally within Nature as long as they were not conscious of doing so. As soon as they recognized the Self in full clarity and realized that there

was a realm within them that was at least the equal of the outer world, they had to free themselves from Nature's bonds.

Now they could no longer fully submit to Nature, allowing her to do what she pleased with them, to create their needs and then satisfy them. Now they had to stand face to face with Nature, and this meant that they had more or less freed themselves from her and had created a new world within themselves, a world from which their longings and their wishes now flowed. Of course it had to be left up to chance whether or not Mother Nature would also be able to satisfy these new wishes that had been created apart from her. At any rate, a deep chasm now separates human beings from reality, and we must actively create the harmony that was once there in its original perfection. This results in the conflict between ideals and reality, intentions and accomplishments—in short, in everything that leads a human soul into a veritable spiritual labyrinth. Nature stands there bereft of soul, devoid of everything our inner being proclaims to us as divinity. The immediate result is that we turn away from all of Nature; we flee direct reality. This is the exact opposite of how things were for the Greeks. They found everything in Nature, where our worldview finds nothing.

We must see the Christian Middle Ages in this light. The Greeks were unable to recognize the nature of art because they could not grasp its transcendence of Nature, the creation of a higher nature in contrast to the immediate one. The science of the Christian Middle Ages was equally incapable of coming to a recognition of art because art could only work through the means offered by nature, and the scholarly mind could not grasp the possibility of creating works within godless reality that would be capable of satisfying the spirit that strives toward the divine.[5] In this case, as well, however, the

5. *Rudolf Steiner*: It might seem that this presentation states that medieval thought found "nothing at all" in Nature, and the great thinkers and mystics of the Middle Ages could be held up to refute this. However, this objection rests on a complete misunderstanding. It is not stated here that medieval thinking would not have been capable of forming concepts about the meaning of perception and so forth. It is only stated that the human spirit at this time turned to the spirit as such, in its primal form, and was unaware of any inclination to come to grips with the individual phenomena of Nature.

ineptitude of science did no damage to the development of art, for although science did not know what to think of them, the most glorious works of Christian art came about. Philosophy, which at that time was the handmaiden of theology, also had as little idea of how to clear a space for art within cultural progress as the "divine Plato," the great idealist among the Greeks, who had simply declared the fine arts and drama to be harmful. He had so little concept of the arts' independent mission that he tempered justice with mercy in regard to music only because it fosters courage during war.

At a time when spirit and nature were so intimately connected, it was impossible for a science of art to come about, nor could it come about at a time when they confronted each other as irreconcilable opposites. For aesthetics to come about required a time in which human beings who were free and independent of the shackles of nature saw the spirit in its unclouded clarity, a time in which it was once again possible to merge with nature. There was good reason for transcending the viewpoint of the Greeks, for we can never find the divine and the necessary in the sum total of coincidences that constitute the world into which we feel transplanted. We see nothing around us but facts that might just as well be different; we see nothing but individuals, while our spirit strives for what is archetypal and common to the species; we see nothing except the finite and the transient, while our spirit strives for the infinite and the immortal. Thus, if the human spirit that has been estranged from nature is to return to nature, this must be a return to something different from that sum total of coincidences. To Goethe, it meant going back to nature, but going back with the full riches of the developed spirit, on the cultural level of the new age.

The fundamental separation of nature and spirit does not correspond to the views of Goethe, who tries to see the world as one great whole, as a unified evolutionary chain of beings in which human beings are a link, although the highest link.

Nature! We are surrounded and embraced by her, incapable of stepping outside of her and incapable of entering more deeply into her. Without asking, without warning, she draws us into

her circling dance and sweeps us away until we are tired and fall out of her arms.

And in his book on Winckelmann,

> If healthy human nature were to work as a whole, if human beings were to feel the world as a great, beautiful, and worthy whole, if their harmonious comfort were a cause of pure and free delight to them, then the universe, if it could feel itself, would shout for joy at having reached its goal and would revere the pinnacle of its own being and becoming.

Here lies the true Goethean transcendence of nature, which in no way distances itself from the actual essence of nature. What he experiences in many especially gifted people in particular is foreign to him—"the quality of feeling a certain fear of real life, drawing back into themselves, creating their own world within and in this way directing their best accomplishments inward."

Goethe does not flee reality to create an abstract world of thoughts that has nothing in common with reality. No, he delves into reality to find the unchanging laws within its eternal changing, within its moving and becoming. He confronts the individual to see the archetype within. This is how the archetypal plant and the archetypal animal came about in his mind. These are nothing but the idea of the plant, the idea of the animal. They are no empty general concepts belonging to some dull theory; they are the organisms' essential foundations, rich and concrete in content, vivid and full of life. To be sure, they are not evident to the outer senses, but only to the higher ability to visualize that Goethe discusses in his essay on contemplative discernment. In the Goethean sense, ideas are just as objective as the colors and forms of things, but they are only perceptible to those whose perceptive ability is adapted to them, just as colors and forms are only present for those who see, and not for the blind. If we do not approach the objective world in a receptive spirit, it will not disclose itself to us. Without the instinctive capacity to perceive ideas, this will always remain a field that is closed to us.

In this respect, Schiller saw more deeply into the pattern of Goethe's genius than anyone else. On August 23, 1794, he enlightened Goethe on the essential underpinnings of his thought in the following words:

> You take nature as a whole in order to shed light on the individual thing; in the generality of nature's varied phenomena you seek out the grounds for explaining the individual thing. From the simplest organisms you ascend step by step to the more complicated, and finally you build up genetically the most complicated one of all, the human being, out of the materials of the entire structure of nature. By recreating the human being according to nature, as it were, you seek to penetrate the human being's hidden constitution.

This recreating is a key to understanding Goethe's worldview. If we really want to ascend to the archetypes of things, to what is unchanging within constant change, then we cannot contemplate the finished thing, because it no longer fully corresponds to the idea that is expressed in it. We must look back to the thing in the process of becoming; we must listen in on nature in the process of creating. This is what Goethe means when he says in his essay on contemplative discernment:

> If in the moral realm we rise into a higher region through faith in God, virtue, and immortality, and approach the primal being, then similarly, in the intellectual realm, envisaging an ever-creating nature makes us worthy to participate spiritually in its productions. After all, I pressed on untiringly to the archetypal, the typical, unconsciously at first, out of an inner urge.

Thus Goethe's archetypes are not empty schematics, but are the driving forces behind the phenomena.

This is the "higher nature" within nature that Goethe tries to take hold of. We gather from this that reality as it lies spread out for our senses to view is in no case something that a person who has arrived at a higher level of culture can find sufficient.

The central inner content of this world is revealed to us only when the human spirit transcends this reality, breaks through its shell and penetrates to the very kernel. We will never again be satisfied with individual natural events, but only with natural laws; not with individual things, but only with what they have in common. In Goethe this appears in the most perfect form imaginable. In him, too, the fact is established that for the modern spirit, reality or the individual thing offers no satisfaction, because only by going beyond it and recognizing the ultimate, which we revere as divine, do we find what science addresses as the idea. Whereas mere experience cannot reconcile these opposites because it possesses the reality but not the idea, science also cannot reconcile them because it has the idea but no longer the reality. Human beings need a new realm between the two, a realm in which the single thing rather than the whole represents the idea, a realm in which the single thing appears in such a way that the character of generality and necessity is inherent in it. Such a world, however, is not present in reality. We must create it ourselves. It is the world of art, a third realm that is needed alongside the realm of the senses and that of reason.

Aesthetics must find its task in understanding art as this third realm. The divine is lacking in natural things; human beings must implant it in them. Herein lies the great task of artists. It is up to them to bring the kingdom of God to this Earth, so to speak. This religious mission of art, as we may certainly call it, is expressed by Goethe in his book on Winckelmann in these glorious words:

> In that human beings are placed at the pinnacle of nature, they see themselves as another whole nature which in turn must also produce a pinnacle within. They improve themselves for this purpose by imbuing themselves with all the perfections and virtues, calling up choice, order, harmony, and meaning, and finally rising to the production of works of art which assume a glorious place alongside their other deeds and works. Once a work of art has been produced, it stands before the world in all its ideal reality and has a lasting influence, produces the highest possible effect. Because it develops spiritually from the totality of forces, it

absorbs everything glorious and worthy of honor and love, and by ensouling the human form lifts the human being up above the normal level, completes the circle of human life and deeds, deifies the human being for the present, in which the past and the future are included. Such feelings gripped those who saw Jupiter on Olympus, as we can learn from the descriptions, reports, and testimonies of the ancients. The god had become a human being in order to lift human beings up to divinity. They glimpsed the highest dignity and were inspired by the greatest beauty.

With this, art was recognized for its great significance in the cultural progress of humanity. It is characteristic of the powerful ethos of the German people that they were the first on whom this recognition dawned, and that for a century now all of the German philosophers have been struggling to find the worthiest scientific form for the unique way in which spirit and nature, ideal and real, merge in a work of art. The task of aesthetics is none other than to grasp this interpenetration in its essence and to study in detail the individual forms in which it manifests in the different branches of art. The credit for having first given impetus to this problem in the way that I have indicated and for having set in motion all the fundamental issues of aesthetics goes to Kant's *Critique of Judgment*, which appeared in 1790 and immediately struck a sympathetic chord in Goethe. In spite of the seriousness of the work that has been done on this subject, however, we must admit today that we have not found an all-round satisfactory solution to the challenges facing aesthetics.

Until the end of his life, the grand master of aesthetics, that keen thinker and critic Friedrich Theodor Vischer,[6] stood by his conviction that "aesthetics is still in its beginnings," thereby admitting that all efforts in this field, including his own five volumes on aesthetics, were more or less on the wrong track. This is indeed the case. If I may express my own conviction on the subject, this can only be traced back

6. Theodor Friedrich von Vischer (1807–1887), poet, critic, and professor at Tübingon who developed Hegelian aesthetics into theoretical foundation of Realism.

to the circumstance that we have continued to disregard fruitful seeds sown by Goethe in this field, because we did not take his science seriously. If we had done so, we would simply have expanded upon Schiller's ideas, which occurred to him while he was considering Goethe's genius and which he set down in his *Letters on Aesthetic Education*. These letters, also, are considered by writers—writers intent on systems—to be insufficiently scientific, and yet they are among the most significant works ever produced in the field of aesthetics.

Schiller takes Kant as his starting point. Kant determines the nature of beauty in several respects. First he investigates the reason for the enjoyment we experience through beautiful works of art, and finds this sensation of pleasure to be very different from any other. Compared to the pleasure we experience when we are dealing with an object that is useful to us, this pleasure is completely different. It is intimately connected to the fact that we want this object to exist. Our pleasure in something useful disappears when the useful object itself is no longer there, but the pleasure we experience in the face of beauty does not. This pleasure has nothing to do with possessing the object or with its existence. Accordingly, it is not attached to the object itself but only to our mental image of the object. In the case of a useful thing that serves a purpose, we immediately feel the need to transform the mental image into reality, but in the case of beauty, we are content with the mere image. That is why Kant calls taking pleasure in beauty an "interest-free" pleasure, one that is not influenced by any practical interest. It would be quite wrong, however, to see this as excluding the possibility that something beautiful may also be useful; that is only the case with regard to an outer purpose. This leads to Kant's second definition of beauty: "It is something that is purposefully shaped, but serves no outer purpose." If we perceive some natural object or product of human technology, our intellect immediately begins asking about its use and purpose and is not satisfied until the question, "What for?" is answered. In the case of beauty, the "what for" is inherent in the thing itself, and our intellect has no need to go beyond that.

This is where Schiller begins. He does this by incorporating the idea of freedom into this train of thought in a way that does great

credit to human nature. To begin with, Schiller juxtaposes two human urges that make their presence known unceasingly. The first is what he calls the "urge toward substance," or the need to keep our senses open to the influx of the outer world. A wealth of content flows into us without our being able to exercise any determining influence on its nature. Here, everything takes place as a matter of absolute necessity. What we perceive is determined from outside; we are unfree and subjected to it and must simply obey the commands of natural necessity. The second urge is the "urge toward form," which is none other than reason; it brings law and order into the confused chaos of our perceptions. Its activity organizes our experience. But in this, too, we are not free, Schiller maintains, because the activity of reason is subject to the immutable laws of logic. Rational necessity has us in its power, just as natural necessity has us in its power on the other side.

In the face of these two things, freedom seeks a refuge. Schiller points it in the direction of the field of art, bringing up the analogy of art and children's play. What is the essential nature of play? In play, we take the things of reality and change their relationships in arbitrary ways. No law of logical necessity sets the standard for this transformation of reality, as it does if we build a machine, for example, in which case we must subject ourselves strictly to the laws of reason. In play, only a subjective need is served. People at play connect things in ways that give them pleasure; they submit to no compulsion of any kind. They disregard natural necessity, for they have overcome its compulsion by putting what has been given to them to use in a completely arbitrary way. They also do not feel dependent on rational necessity, because the order they are giving to things is their own invention. Thus people at play leave the imprint of their subjectivity on reality while endowing their subjectivity with objective validity. The two urges have ceased to work separately, they have flowed together into one and have thus become free; nature is something spiritual, and spirit is something natural. Thus Schiller, the poet of freedom, sees art only as free play on a higher level, and exclaims enthusiastically, "Human beings are only fully human when they play, and they only play when they are human in the fullest sense of the word." Schiller calls the urge that underlies art the "urge

to play." In the artist, it creates works whose very sensory existence satisfies our reason, while at the same time their rational content is present as sensory existence. On this level, the quintessential human being functions in such a way that human nature works spiritually while the human spirit works naturally. Nature is elevated to the spirit; the spirit descends into nature. Nature is ennobled, whereas the spirit is drawn down from inaccessible heights into the visible world. To be sure, the works that come about in this way are not completely true to nature because in reality spirit and nature never coincide completely. In comparison to works of nature, therefore, works of art appear to us as a mere semblance. But they must be semblance, because they would otherwise not be veritable works of art. As an esthete, Schiller is unique in his concept of semblance in this connection; he is unsurpassed and unsurpassable.

We should have continued to build upon his work; by connecting to Goethe's observations on art, we should have expanded on what was to begin with only a one-sided solution to the problem of beauty. Instead, Schelling appeared on the scene with a fundamental view that completely missed the mark and introduced an error from which German aesthetics has not yet escaped.[7] Shelling, like all of modern philosophy, sees it as the task of the highest human striving to grasp the eternal archetype of things. The spirit steps over the real world, rising to the heights where divinity is enthroned and where all truth and beauty is revealed. Only the eternal is true, and only the eternal is beautiful. According to Schelling, therefore, actual beauty can only be seen by those who ascend to the highest truth, for these are one and the same thing. All sensory beauty is only a feeble reflection of that infinite beauty that we can never perceive with our senses. We

7. *Rudolf Steiner*: What is meant by Schelling's "fundamental view that completely missed the mark" is not the elevation of the spirit "to the heights where the divine is enthroned," but the use to which Schelling puts this in his consideration of art. It should be especially emphasized that what is said against Schelling here is not to be confused with current criticism of this philosopher and of philosophical idealism in general. It is possible to hold Schelling in very high regard, as in fact the author of this treatise does, and yet have many objections to certain details of what he accomplished.

can see where this is leading: Art is beautiful, not for its own sake and because of what it is, but because it reproduces the idea of beauty. The inevitable consequence of this view, then, is that the content of art is the same as that of science, because the basis of both is eternal truth, which is also beauty. For Schelling, art is only science that has become objective. The important question here is, what does our pleasure in a work of art connect to? Only to the idea that is being expressed, in this case. The sensory image is only a means of expression, the form in which a supersensible content is expressed.

In this respect, all writers on aesthetics fall in line with Schelling's idealism. I myself cannot agree with Eduard von Hartmann, the most recent historian and systematizer of aesthetics, when he says that Hegel is significantly ahead of Schelling on this point.[8] I say "on this point" because there are many other things in which he actually is miles ahead of him. Hegel also says, "Beauty is the sensory appearance or semblance of the idea," admitting that he too sees the expressed idea as the essential thing in art. This becomes even clearer in the following words: "The hard crust of nature and of the ordinary world discourages the spirit from breaking through to the idea more than is the case with works of art." Surely this is a clear statement that the goal of art is the same as that of science, namely to penetrate to the idea.

Art, it is claimed, seeks only to illustrate what science expresses directly in the form of thought. Friedrich Theodor Vischer calls beauty "the appearance of the idea" and thereby also equates art's content with truth. Whatever your objections to this may be, anyone who sees beauty's essence in the idea it expresses will never again be able to separate it from truth. However, it then becomes unclear what the mission of art should be, independent of science. It is said that by means of thinking, we experience what art offers us in a purer and less clouded form, not hidden behind a sensory veil. From the viewpoint of this aesthetics there is no escape, except through sophistry, from

8. Eduard von Hartmann (1842–1906), philosopher who synthesized the views of Schopenhauer, Kant, and Hegel into a theory of evolutionary history based on conflict between the unconscious will and unconscious reason.

the compromising conclusion that allegory is the highest form of the visual arts and didactic poetry the highest form of poetry. This aesthetics cannot grasp the independent meaning of art and has therefore proved unproductive. We should not, however, go so far as a result of this that we abandon any attempt at an aesthetics that is free from contradiction. Those who want to see all of aesthetics assimilated into art history go too far in this direction. Unless it rests on authentic principles, the science of aesthetics cannot be anything more than a bulletin board for notices about artists and their works, concluding with some more or less ingenious comments that are without value because they result completely from arbitrary, subjective reasoning.

From the other side, aesthetics has suffered by being compared to some sort of physiology of taste. By trying to investigate the simplest, most elementary cases in which people experience pleasure and then moving up to more and more complicated cases, "aesthetics from above" is counteracted with an "aesthetics from below." This is the path taken by Fechner in his *Introduction to Aesthetics*.[9] It is actually incomprehensible that a work like this can find admirers in a nation that produced a Kant. This aesthetics is supposed to proceed from investigating the experience of pleasure, as if every experience of pleasure were already an aesthetic one and as if we could distinguish the aesthetic nature of one sensation of pleasure from another by any other means than through the object that provoked it. We only know that pleasure is an aesthetic sensation when we can recognize the object as a beautiful one, because aesthetic pleasure is psychologically no different from any other pleasure. This distinction always depends on our understanding of the object. What makes an object beautiful? This is the basic question in all aesthetics.

In coming to grips with this issue, we do much better than the adherents of "aesthetics from below" if we follow Goethe's example. Merck once described Goethe's creative activity, saying, "Your endeavor, your single-minded direction, is to give poetic form to what is real. Others seek to make the so-called poetic or imaginative

9. Gustav Theodor Fechner (1801–1887), physicist, philosopher, and psychologist, founder of "psychophysics."

element real, and the result is nothing but nonsense."[10] This is about the same as what Goethe says in the second part of *Faust*, "Consider the *what*; even more, consider *how*."

This clearly states what is essential in art—not embodying something supersensible, but transforming sensory reality. Reality is not meant to be reduced to a means of expressing something; no, it is meant to persist in full independence, but to receive a new form, a form in which it is satisfying to us. As soon as we remove any individual thing from its surroundings and observe it in isolation, many things about it immediately seem incomprehensible to us. We cannot bring it into harmony with the concept, the idea, that we must necessarily take as its basis. In reality, its formation does not result from its own internal laws alone; the reality that borders on it also helps to determine it in a direct way. Only if the thing had been able to develop freely and independently, uninfluenced by other things, would it live out its own idea. Although this idea forms the basis of the thing, in reality its independent development is disturbed.

This idea is what artists must take hold of and start to develop. They must find a point of departure within the object for developing it in its most perfect form, although it cannot do this itself in nature. In each individual thing, nature falls short of its intention: Alongside this plant, it creates a second and a third and so on, none of which brings the complete idea to life in a concrete form. One of them expresses one aspect, the other a different one, to the extent that circumstances permit. Artists, however, must go back to nature's intention as it appears to them. This is what Goethe means when he describes his creative activity in these words: "I do not rest until I find a concise point from which much can be derived." The entire outer aspect of an artist's work must bring the entire inner aspect to expression, while in a product of nature, the former never measures up to the latter, which only the inquiring human spirit can recognize. Thus the laws that govern how artists proceed are no different from

10. Johann Heinrich Merck (1741–1791), writer, critic, and friend of Goethe; a cofounder of *Frankfurter Gelehrte Anzeigen,* he helped to further the *Sturm und Drang* movement.

the eternal laws of nature in a pure form, uninfluenced by restrictions of any sort. Thus, the basis of artistic creation is not what is, but what might be; not the real, but the possible. Artists create according to the same principles as nature, but they apply them to individual entities, while Nature, to use a Goethean expression, thinks nothing of individual things. "She is always building and always destroying," because she wants to achieve perfection, not in the individual thing, but in the whole. The content of a work of art is any sense-perceptible real content. This is the *what*. In giving form to it, artists strive to surpass the intentions of nature; they strive to achieve the results possible within nature's laws and means to a greater extent than can be done by nature itself.

The object an artist places in front of us is more perfect than it would be in its natural state, but its perfection is its own. There is no other perfection inherent in it. Beauty consists in an object going beyond itself, but only on the basis of what is already concealed within it. Thus, beauty is nothing unnatural, and Goethe can say with justification, "Beauty is a manifestation of secret natural laws that would have remained hidden forever if the beautiful thing had not appeared," or, elsewhere, "Those to whom Nature begins to disclose her revealed mystery feel an irresistible longing for her most worthy interpreter, Art."

If it is possible to say that beauty is something unreal and untrue, that it is a mere semblance because what it represents is not found to this degree of perfection anywhere in nature, it is equally possible to say that beauty is more true than nature, in that it presents what nature tries to be, but cannot. About this question of reality in art, Goethe said: "The poet [and we can apply his words equally to art as a whole] is dependent on representation. The ultimate representation is one that competes with reality; that is, when the spirit has made representation so alive that its presence is valid for everyone." Goethe says that "nothing is beautiful in nature unless truth gives a reason for it in accordance with natural law."

The other side of appearance or semblance, a being's surpassing itself, is expressed as Goethe's view in his *Prose Aphorisms*: "The law of plant growth appears in its highest manifestation in the flowers,

and the rose in turn is only the pinnacle of this manifestation. The fruit can never be as beautiful, since there the vegetative law retreats into itself, into mere law." This states quite clearly that beauty enters wherever the idea develops and expresses itself, wherever we perceive the law directly in external appearances. In the fruit, on the other hand, whose outer appearance is plump and formless because it betrays nothing of the law underlying the formation of the plant, the natural object ceases to be beautiful. That is why the same aphorism continues as follows: "The law that steps into appearances in the greatest freedom, according to its own inherent requirements, produces objective beauty which must of course find worthy subjects to interpret and understand it." This view of Goethe's is expressed most decisively in a statement in his conversations with Eckermann: "Of course artists must truly and reverently reproduce nature in detail ... but on the higher levels of the artistic process, in which an image becomes the actual picture, they have more leeway and can even proceed to fiction."[11] Goethe describes the highest task of art as "giving the illusion of a higher reality through appearances. It is a false striving, however, to make appearances so real that in the end only common reality remains."

Let us now ask about the reason for the pleasure we take in objects of art. First of all, we must be clear that desire that is satisfied by objects of beauty is in no way inferior to the purely intellectual desire we have for purely spiritual things. It always signifies a distinct decadence in art when its mission is sought in mere amusement, in satisfying a lower form of desire. Thus the reason for taking pleasure in objects of art can be no different from what makes us experience that joyful exhilaration that lifts us above ourselves when we face the world of ideas. What is it about the world of ideas that gives us such satisfaction? Nothing other than the inner heavenly tranquility and perfection that it conceals within it. No contradiction, no discordant note, stirs in the world of thoughts that rises up within us, because this world is an infinity in itself. Everything that makes this image perfect and complete is already inherent in it. The inborn perfection

11. III.108 of the conversations with Eckermann.

and completeness of the world of ideas is the reason for our exhilaration in confronting it.

If beauty is to uplift us similarly, then it must be fashioned after the pattern of the idea. And this is something completely different from what German esthetes of the idealistic school intend. It is not "the idea in the form of a sensory phenomenon." It is the exact opposite, a "sensory phenomenon in the form of the idea." Thus the content of beauty, its underlying material basis, is always something real and direct, and the form in which it appears is the form of the idea. As you see, the truth of the matter is the exact opposite of what German aesthetics says; German aesthetics has simply stood things on their heads. Beauty is not the divine in a garment of sense-perceptible reality; no, it is sense-perceptible reality in a garment of divinity. Artists bring the divine to Earth, not by letting it flow into the world, but by uplifting the world into the sphere of the divine. Beauty is a semblance because it conjures up before our senses the reality of an ideal world. "Consider the *what*; even more, consider *how*," because the *how* contains what everything depends on. *What* is given remains physical, but the *how*, the memory of its appearance, is the ideal. Where the sensory thing embodies the form of the ideal, the dignity of art also appears to the greatest extent. Goethe says this about it: "Perhaps the dignity of art appears in music to the greatest extent, because music has no material substance for which we have to make allowances. It is all form, and thereby uplifting and ennobling to everything it expresses."

An aesthetics that takes as its starting point the definition of beauty as "a sensory reality that appears as if it were an idea" does not yet exist. It must be created. It is absolutely possible to call it "the aesthetics of Goethe's worldview." This is the aesthetics of the future. Even one of the most recent interpreters of aesthetics, Eduard von Hartmann, whose *Philosophy of Beauty* is really an excellent work, subscribes to the old error that the content of beauty is the idea. He says quite rightly that the basic concept that any science of beauty must take as its starting point is the concept of aesthetic semblance. Yes, but is the appearance of the ideal world as such ever to be considered semblance? The idea is the highest truth; when it appears, it appears as truth and not as semblance. It is a real semblance, however,

when what is natural and individual, arrayed in an eternal and immortal garment, appears with the character of the idea, for this is something that is not given to it in reality.

In this sense, artists seem to carry on the work of the world spirit; they continue with creation when the latter relinquishes it.[12] They seem to us to be intimately related to the world spirit; art appears as a free continuation of the natural process. Thus artists lift themselves up above the reality of everyday life, and they also uplift those of us who are engrossed in their works. They do not create for the finite world; they grow beyond it. In Goethe's poem "The Artist's Apotheosis," he lets the muse call out to the artist:

And thus noble humankind works mightily
For century after century on its own kind,
For what good people can accomplish
Is not accomplished in the narrow space of life.
That is why we live on after death,
No less effective there than once we were in life.
The good deed and the lovely word
Strive on immortally as we strove mortally.
Thus too, the artist lives through time unmeasured.
Enjoy your immortality!

This poem aptly expresses Goethe's thoughts on the cosmic mission of the artist, as I would like to call it.

Who has grasped art as profoundly as Goethe? Who else has endowed it with such dignity? It speaks sufficiently for the full depth of Goethe's views when he says, "The greatest works of art that have been produced by human beings according to true and natural laws

12. *Rudolf Steiner:* Sensory reality is transfigured in art in that it appears as if it were spirit. To this extent, creating art is not an imitation of anything that is already present; it springs from the human soul as a continuation of the world process. Merely imitating the natural does not create anything new, nor does presenting in image form the spirit which is already present. We experience artists as really strong in their field, not if they give the impression of faithfully reproducing something real, but only if they force us to accompany them in creatively continuing the world process in their works.

are thus also the greatest works of nature. Everything arbitrary and imaginary collapses, for here is necessity; here is God." An aesthetics in the Goethean spirit certainly cannot be bad, and that probably applies to many other branches of modern science.

When Walter von Goethe, the poet's last descendant, died on April 15, 1885, and the treasures of Goethe's house became accessible to the nation, many people may have shrugged their shoulders at the zeal of the scholars who took every little remnant of Goethe's estate and handled them as precious relics that were not to be underestimated in any way for purposes of research. But Goethe's genius is inexhaustible. It is not possible to survey it in a single glance; we can only gradually get closer to it by approaching it from different sides. We must welcome anything that helps us do this. Even apparently worthless details gain meaning when we see them in connection with the poet's comprehensive worldview. Goethe's essence and the purpose that inspired everything about him and marked a high point for humanity appear to our souls only when we have run through the full riches of how they manifested in his life. Only when his purpose becomes the common property of all who strive spiritually, only when it becomes a general belief that we must not merely understand Goethe's worldview, we must live in it and it in us—only then has Goethe fulfilled his mission. This worldview must be a sign for all the members of the German nation and far beyond it for all those who meet and recognize each other as if in a common striving.

2. The Spiritual Being of Art

BERLIN, OCTOBER 28, 1909[1]

Let's imagine a broad, snow-covered expanse spread out in front of us, dotted with frozen rivers and lakes. Most of the nearby beach is also covered with ice, and massive blocks of ice are floating in the ocean. Here and there, low trees and thickets are totally covered with icicles and masses of snow. It is evening. The sun has already gone down, leaving behind the golden glow of sunset.

There are two female figures in view. Then, out of the sunset a messenger is born—sent forth, we might say, from higher worlds. He stands before the two women and listens intently to what they say about their innermost feelings and experiences.

One of the women stands there pressing her arms close to her body. Holding herself aloof, she speaks the words, "I'm freezing!" The other woman gazes out over the snow-covered expanse, the icy waters, and the trees covered with icicles. The words spill from her lips, "How wonderfully beautiful this countryside is!" She completely forgets her own feelings and is oblivious to the sensations of cold caused by the outer physical landscape. We feel warmth streaming into her heart, for she forgets everything that the physical influence of the cold could make her feel. She is inwardly overwhelmed by the incredible beauty of this very frosty landscape.

1. Contained in *Kunst und Kunsterkenntnis: Das Sinnlich-Übersinnliche in seiner Verwirklichung durch die Kunst*, Rudolf Steiner-Nachlaßverwaltung, Dornach, 1961 (GA 271). The illustrations in this lecture are by Assia Turgenieff (c 1890-1966), a Russian artist who developed the technique of shaded drawing; she also engraved the glass windows for the Goetheanum.

The sun sinks still lower, the glow of the sunset fades, and the two female figures fall into a deep sleep. The one who had felt the cold so strongly in her own bodily Self sinks into a sleep that could easily become the sleep of death; the other sinks into a sleep in which we see that the aftereffects of the sensation expressed in the words, "Oh, how beautiful!" are still resonating, thoroughly warming and revitalizing her limbs, even in sleep. And this female figure hears the youth who was born out of sunset's glow say to her, "You are Art!" And she falls asleep, taking with her into her slumber all the results of the impressions she had of the landscape that has been described.

A dream of a sort mingled with her sleep, and yet it was no dream. In a certain respect, it was reality, a unique reality whose form alone was related to dreaming. Until now, this woman's soul had barely been able to have a premonition of the reality that was now revealed to her. What she was experiencing was not a dream; it merely resembled one. She was experiencing what is known as "astral Imagination." And if we try to express her experience, we can only clothe it in the word-images of imaginative perception. In this moment, the woman's soul became aware that we can only speak in depth about the young man's characterization of her as Art if we clothe the experiences of imaginative perception in words. So let us now clothe in verbal pictures the impressions of imaginative perception in this woman's soul.

Dance

When her inner senses had awakened and she began to be able to distinguish things, she perceived a remarkable shape, a figure that was completely different in appearance from any spiritual figure our mere physical understanding can imagine. This figure lacked anything that might still recall the physical, sense-perceptible world. It reminded her of the physical world only in that it resembled three interconnected circles. These circles stood at right angles to each other as if one were horizontal, with the second running from front to back and the third from right to left. And what could be perceived flowing through these circles was something that reminded her, not of a physical, sense-perceptible impression, but rather of something purely of

the soul, something that can only be compared to the soul's sensations and feelings. But from this figure there also streamed forth something that could only be described as a deeply repressed and intimate sorrow at something. And when this woman's soul saw that, she decided to ask, "What is the reason for your sorrow?"

And then the answer was communicated to her by this spirit-like figure, "I have a particular reason for displaying this disposition, for I come from a lofty spiritual line. I appear before you now just as a human soul would do, but you must ascend high up into the kingdoms of the hierarchies if you want to discover my origin. I have descended here from higher hierarchies of existence. And because of this, the human beings on life's other side, in the physical world where we are not at present, have robbed me of the last of my offspring; they have taken away the last of my descendants and have chained it to a rock-like structure, after having first made it as small as possible!"

And the woman's soul came to ask, "Who are you, really? I can describe things only with words that remain in my memory from life on the physical plane. How can you make me comprehend your nature and that of your offspring, whom human beings have enchained?"

"Yonder in the physical world, people describe me as one of their senses, a very minor sense they call the sense of balance, which has become very small and consists of three not quite complete circles that are attached to each other in the ear. This is my last offspring. They have torn it away from me and taken it into the other world; they have taken away what it possessed here, namely the ability to move freely in every direction. They have broken each of the circles and have fastened each end securely to a base. As you see me here, I am not tied down. No matter which way you look at me, I display perfect circles; I am complete on all sides. For the first time, you are seeing my real form!"

And the woman's soul brought itself to ask, "What can I do to help you?"

And the spirit-like figure said, "You can help me only by uniting your soul with mine, by transmitting to me here everything that people in life on the other side experience through the sense of balance."

"Then you will grow into me and become as large as I am myself. You will liberate your sense of balance; as a spiritually free being, you will raise yourself above attachment to the Earth."

And the woman's soul did this. She became one with that spirit-like figure, and in doing so, she sensed that there was something that she had to do. So she put one foot in front of the other, changed repose into movement and movement into a dance and closed the circle of its form.

"Now you have transformed me!" said the spirit-like figure. "Now I have become what I only could become as a result of these actions of yours. Now I have become a part of you, and what I have become in this way is something that human beings can only suspect. Now I have become the art of dance. Because it was your will to remain soul and not to unite with physical matter, you were able to free me. And at the same time, your ordered steps have led me up to the spiritual hierarchies to which I belong, to the Spirits of Movement; and by completing the circle of the dance, you have led me to the Spirits of

Form. You have led my Self to the Spirits of Form. Now, however, you may go no further, for if you were to take even one more step than you have taken for me, then everything you have done would be in vain. For the Spirits of Form are the ones who are charged with bringing about everything in the course of earthly time. If you were to intervene in their task, you would negate everything you have just accomplished, for you would necessarily fall into the region of 'burning desire,' as the astral world is described by those who are beyond and telling you of the kingdoms of the spirit. If people act on what little they know of me in doing their dances, your spiritual dance would be transformed into one that springs from wild desire. However, if you stop short at what you have just done, then in closing the circle of your dance you reproduce in form those mighty dances that are performed in heavenly space by the planets and suns in order to enable the physical, sense-perceptible world to come about!"

Acting

The woman's soul continued to dwell in this state, and another spiritual figure approached her. It too was very, very different from what people with their physical, sensory understanding imagine the form of spirits to be. Something appeared in front of her that was actually like a figure enclosed in a plane without three dimensions. But there was something very distinctive about this figure. In spite of the fact that the figure was restricted to a plane, the woman's soul in its imaginative state could always see it from two sides, and it showed two very different aspects, one from one side and one from the other.

Once again the woman's soul asked this figure, "Who are you?"

And the figure said, "I come from higher regions. I have descended to the region that you call the region of the spirit. Here it is called the region of the archangels. I was obliged to descend to this level in order to come into contact with the physical, sense-perceptible realm of Earth. But human beings have robbed me of my last offspring. They took it away and imprisoned it over there in their own physical, sense-perceptible bodies, where they call it one of their senses. They describe it as the sense of self-movement, as what is alive in them when they move their own limbs and other body parts."

And the woman's soul asked, "What can I do for you?"

And this figure also said, "Unite your own being with mine, so that your being becomes one with mine!"

The woman's soul did so. She became one with this spiritual figure; she slipped completely inside it. Once again she grew in stature and her soul became great and beautiful. And the spiritual figure said to her, "Now that you have done this, you have won the possibility of endowing human souls on the physical plane with a particular faculty—a faculty that is exercised in one portion of the youth's characterization of you, for you have become what is known as the art of mime, the art of expression through mimicry."

Because she had fallen asleep only a short time ago, the woman's soul still remembered her earthly figure, and so she was able to pour everything that was now in it into form. And she became the prototype of acting.

"You may only take this to a certain point, however," said the spirit-like figure. "You may only go so far as to pour the movements you execute into form. If you were to pour your own wishes into it, in that very instant you would distort the form into a grimace, and the destiny of your art would be cut short. That is what the people yonder have been doing—they inserted their wishes and desires into their facial expressions in order to express the personal Self. You, however, are to allow only selflessness to come to expression, and then you can be the archetype of acting."

Sculpture

The woman's soul continued to dwell in this state, and another spiritual figure approached, one that revealed itself only in a line and moved only in a line. This spiritual form moving in a line was also sorrowful, and when the woman's soul noticed this, she asked, "What can I do for you?" The figure said, "I come from higher regions, from higher spheres. But I descended through the kingdoms of the hierarchies to the kingdom known to you who practice spiritual science as the region of the Spirits of Personality, of which human beings possess only a copy." And this figure also had to admit that it had lost its last offspring through its contact with human beings. It continued, "People over there on Earth call the last of my offspring their vital sense, their sense of life. It is what allows them to feel their own temperament, to feel what permeates them as the mood of the moment, the well-being of the moment. They experience it within themselves as what strengthens and consolidates their personal form. But human beings have enchained this sense within themselves."

"What can I do for you?" asked the woman's soul. And again the spiritual figure demanded, "Dissolve into my own being! Leave behind everything that comes from human selfhood, and dissolve into my form, flow together with me and become one with me!"

And the woman's soul did this. And she noticed that in spite of the fact that the figure extended only in one line, she herself was filled with strength on all sides. She now completely filled the body she had on Earth, which she still remembered and which now reappeared to her, but with new radiance and beauty. And then the

spiritual figure said, "Through this deed of yours you have accomplished something that once again makes you unique in the great realm after which you have been named. In this moment you have become something that people yonder possess, though only as a possibility: You have become the prototype of the art of sculpture!"

The woman's soul had become the prototype of sculpture. As such, through what she had taken in, and through that Spirit of Personality, she was now able to pour an ability into human souls, and thus she gave to human beings on Earth the ability to create in sculptural images, the capacity of sculptural imagination.

"However, you may not go one step further than you have already gone! You must remain completely in the form, for what is in you may only be led up as far as the spirits of form and their regions. If you go beyond that, you will function as the realm that stimulates

human desires. If you do not stay within the limits of noble form, then nothing good can possibly be produced in your field. However, if you remain within the noble structure of form, then you will be allowed to pour into that form something that will only be possible in the distant future. And then, although human beings are still far from achieving the form that will allow them to fulfill in purity what today is given over to completely different powers within them, you will be allowed to show them what human beings will become in a purified state on the Venus planet of the future, when their bodily form will have become a quite different one. You may show them how pure and chaste the human form will be in future in comparison to the human form of today."

And out of the changing sea of figures in the imaginative realm there appeared something like the prototype of the Venus de Milo.

"In shaping form you must stay within a certain limit. In the very instant that you go even a little beyond form and destroy the strong personality that must hold the human form together, you have reached the very limit of what is the beautiful in art."

Once again a figure appeared out of the changing, surging sea of the astral imaginative world. It was evident that its content had brought the outer human figure to the very edge where form repudiates the personality's coherence, where the personality would be lost if it were taken even one step further. The image that emerged from all the astral images was the figure of Laocoön.

Architecture

And the woman's soul experiences continued in the imaginative world. This time she came upon a figure that she herself knew was not present over there on the physical plane. Nothing of it was present on the physical plane; she was getting to know it for the first time. There were many things on the physical plane that reminded her remotely of this figure, but it was nowhere present in as complete a form as it was here. It was a wonderfully austere figure. Having been questioned by the woman's soul, it said that it came not merely from higher regions but from very distant regions indeed, but that for the moment it was obliged to work in the hierarchic realm that is

known as the realm of the Spirits of Form. "Human beings beyond," spoke this figure to the woman's soul, "have never been able to produce a complete representation of me or anything that fully corresponds to me, for my form as it is here does not exist on the physical plane. So they had to take me apart, and only by being taken apart have I been granted the possibility (if you accomplish what you are meant to do and unite with me) to enable you to implant a faculty for fantasy in human souls. But because this faculty is fragmented in human beings, the whole can appear only here and there, torn apart into individual forms. Because nothing of mine can be called a human sense, human beings have not been able to enchain me. All they could do was to tear me into fragments. They have also taken away my last offspring and torn it into fragments."

And once again, not shying away from the sacrifice of being torn to pieces herself, the woman's soul united with this spiritual being. Then it said to her, "Now that you have done this, you have once again become a single manifestation within the totality of your designation.

You have become the prototype of architecture, of the art of building. By pouring what you have just achieved into the souls of human beings, you are now able to give them the prototype of architectural imagination. However, you will only be able to provide them with an architectural imagination that shows the details of what will enable them to construct buildings that tend to become broader toward the bottom as they spread downward from the spiritual world, as represented by the pyramid. By leading them to apply the art of building to a temple of the spirit rather than to some earthly purpose, and by causing them to imprint this character on its exterior, you will enable human beings to make only a copy of what I am."

Just as the pyramid had appeared before, the Greek temple then emerged from the surging astral sea. And then still another figure appeared—not a figure thrusting downward so as to become broader toward the bottom, but an upward-thrusting figure, the third fragment of architectural imagination. What appeared was the Gothic cathedral.

Painting

And the woman's soul continued to dwell in the imaginative world. Another figure approached her, still more foreign and remarkable than the previous one. Something resembling warming love streamed out of it, and also something that could be frosty cold.

"Who are you?" asked the woman's soul.

"My name is known in its proper form only to those yonder on the physical plane who inform human beings about the spiritual world. They are the only ones who know how to use my name correctly, for I am called Intuition, and I come from a distant realm. In finding my way from this distant realm into the world, I descended from the realm of the Seraphim."

The figure of Intuition was seraphic in its being. And once again the woman's soul said, "What do you want me to do?"

"You must unite with me! You must dare to unite with me! Then you will be able to enkindle in human souls on Earth a faculty that is also a part of their imaginative activity. Through it, too, you will become a single entity within the larger whole of what the young man called you."

And the woman's soul resolved to carry out this deed. In doing so, she became something that, even in its outer form, was very far removed from the outer physical form of a human being, and quite foreign to it. Only those who had looked deeply into the human soul itself would have been able to assess what her soul had become, for although it had formerly still possessed something of an etheric nature, it could now at most be compared to something purely soul-like.

The spiritual seraphic figure named Intuition spoke: "Because you have done this, you can now equip human beings with the capacity for imagination in painting. You have become the prototype of painting, and this will enable you to enkindle this ability in human beings. Now that you yourself possess a painter's imagination, you will be able to bestow talent on their sense of sight. This sense, which is not touched by human selfhood but contains the synthesizing thinking of the outer world, will then be capable of recognizing the soul-being shining through the surface of things that otherwise appear lifeless and devoid of soul. This capacity of yours will enable people to ensoul everything that otherwise appears to them on the surfaces of things as color and as form. They will use it to make the soul speak through the form; through the color they conjure up on canvas, not only the outer sense-perceptible color will speak, but also its inner aspect, which moves outward from inner depths, like everything that comes from me. You will be able to give human beings an ability that allows them, through the light of their own souls, to bring soul movement even into lifeless nature, which otherwise manifests only in soulless colors and forms. What you will give them will allow them to transform movement into repose, to hold fast what is changeable in the outer physical world. You will teach them to hold fast the fleeting color that is briefly lit by the glancing rays of the rising sun, the colors that are present in lifeless nature."

And an image rose up out of the surging sea of the imaginative world, an image that represented landscape painting. And a second image arose, representing something else, and the spirit-like figure explained it, saying, "Through the capacity you give them, you will teach people to record what happens, what is experienced in human life over shorter or longer periods of time, in a minute or an hour or

in centuries, and what is compressed into one short moment. Even when the past and the future cross most powerfully, even when the two currents of the past and future come together, you will teach human beings how to record them as a point of undisturbed repose in the middle." And out of the surging world of imaginations, Leonardo da Vinci's painting of the Last Supper appeared.

"But you will also have difficulties, and your difficulties will be greatest when you allow human beings to apply this capacity of yours to things in which soul and movement are already present, to something they have already endowed with movement and soul from the physical plane. This is where you will most easily go astray, for here lie the limits of the possibility to still call their copies of your prototype *art*." And out of the surging sea world of imagination, the portrait arose.

Music

And the woman's soul continued to dwell in the imaginative world, and again a figure approached her, a foreign-seeming figure

that was similar to nothing that is found yonder in the physical world. It too might be called a heavenly figure that cannot be compared to anything on the physical plane. And the woman's soul asked, "Who are you?" The figure said, "Yonder on the earthly globe I have a name that can only properly be applied by those who bring messages of the spiritual world to human beings; they call me Inspiration. I come from a distant realm, but for now my place is in the region that they call the region of the cherubim when they speak of the spiritual world." This single figure from the kingdom of the cherubim emerged from the imaginative world. Once again, after the woman's soul had asked, "What can I do for you? What am I meant to do?" the figure said to her, "You must transform yourself into me! You must become one with me!"

And in spite of the inherent danger, the woman's soul dissolved into the being of this cherubic figure. In doing so she became even less similar to physical things on the earthly globe. While it could still be said that something at least analogous to the previous figure is present on the earthly plane, this figure from the realm of the cherubim must be described as possessing a being that was foreign to everything on Earth, as it were, so that it could not be compared to anything at all. And the woman's soul itself became quite unlike any earthly thing; it was evident that she herself had moved on with her whole being into a spiritual realm, that she now belonged to a spiritual realm that cannot be found in the world of the senses.

"Because you have done this, you are now able to implant an ability in the souls of human beings. When this ability dawns on human souls on the earthly globe, it will live in them as musical imagination. This ability of yours has become so foreign to the earthly globe that human beings will have nothing external on which to imprint what their souls sense under your inspiring influence. They must enkindle this for themselves in a new way, through a sense they otherwise know in quite a different guise: They must give the sense of sound a new form; they must find musical tones in their own souls. They must create out of their own souls as if they were creating from the heavenly heights! And when human beings create like this, what flows from their individual souls will be like a human reflection of everything that

can only flow and sprout in outer nature in ways that are incomplete and imperfect. From the human soul will flow something like a reflection of what trickles in springs, blows in the wind, and rolls in the thunder. It will not be a copy of these things but will step forth like a natural sister to meet all these glories of Nature that spring forth as if from unknown spirit depths.

"This is what will well up from human souls. It will give people the ability to create something that enriches the Earth, something new on Earth that would not have existed without this ability you have, something like a seed for the future on Earth. And you will give them the ability to express the living feelings in their souls that could never be expressed if people were dependent on what they have now, namely on thoughts and concepts. These feelings would shrivel up or freeze if they had to depend on concepts. Concepts are the deadly enemies of such feelings. For the sake of these feelings, you will give people the possibility of breathing their souls' inmost being out into their earthly surroundings on the wings of song, and of imprinting

something on these earthly surroundings that would otherwise not be there. All the complicated and powerful feelings, all the feelings that live in the human soul as if in a mighty world of their own, which could otherwise never be experienced in the external world in this form, all the feeling that could only be experienced by traversing world history and the heavenly spaces with one's soul—these many realms cannot be experienced in the outer world. If they were, if we attempted to know what individuals have always experienced here and there, all the opposing currents of the centuries and millennia would flow in. But these feelings will all be condensed through this ability of yours and will pour out into something that people have made their own in their symphonic musical works."

And the woman's soul grasped how what we know as Inspiration is brought down from the spiritual heights of the world, and how this is to be expressed by the normal human soul. She grasped that it can be expressed only through musical sounds. Now her soul knew that if spiritual researchers depict the world of Inspiration itself, and if this world is to be presented directly to human beings on the physical plane through physical means of expression and yet be more than a mere copy, it can only be presented as a musical work of art. And the woman's soul understood that a musical composition could present the mighty event of Uranus igniting his own emotion in the fire of Gaia's love, or could express what happened when Chronos tried to illuminate his inner spirit nature through the light of Zeus.

These were the deep experiences the woman's soul had as a result of her contact with the being from the realm of the cherubim.

Poetry

She then continued to find her way into what is called the imaginative world, and another figure approached her, again far removed from what exists on Earth. And when her soul asked, "Who are you?" the spirit-like figure answered, "Yonder in the physical world, only those who communicate spiritual events by means of spiritual science use my name correctly, for I am Imagination, and I come from a distant realm. But from this distant realm I proceeded to the region of the hierarchies that is known as the region of the Spirits of Will.

"What am I to do for you?" the woman's soul asked again. And this figure from the Spirits of Will also asked her to unite her own being with itself. And once again the woman's soul became quite unlike any ordinary soul; she was changed into a purely soul figure.

"By having done this, you are now able to breathe into human souls the faculty that human beings on the earthly globe experience as poetic imagination. You have become the prototype of poetic imagination. Through you, human beings will be able to express in their language something that they would never be able to communicate if they clung only to the outer world and tried to reproduce only things that are present in the outer physical world. Through your poetic imagination, you will give them the possibility of expressing everything that touches their personal will, and that could otherwise not stream forth from the human soul through any earthly means. On the wings of your rhythm and meter, through everything you will be able to give to human beings, they will express something for which language would otherwise be much too crude an instrument. You will give them the possibility of expressing what would otherwise be inexpressible."

And in the image of lyric poetry there appeared the events that had come to pass over the centuries, inspiring whole generations.

"You will also be able to sum up what could never be represented through any outer physical event. Your emissaries will be the bards and poets of all times. They will condense entire human cycles into epic poetry. On stage, you will conjure up before them the forms the will takes on when passions rage against each other. You will show them how human beings on this Earth would fight in vain, how colliding passions bring death to the one and victory to the other. You will give human beings the possibility of drama!"

And at this moment the woman's soul became aware of an inner experience that could only be described by using our earthly expression, "waking up."

Why did she wake up? She woke up because she saw, as if in a reflection, things that are not present on Earth. She herself had become one with the being of Imagination. What lives on Earth as poetry is a reflection of Imagination. Her soul saw Imagination's reflection in the art of poetry. This is what woke her up. Through waking, of course, she had to leave that dream-like spirit realm. However, she had at least entered a region that resembles, if only as a dead reflection, the life of spiritual imagination. That was what made her wake up.

Now that she had awakened, she could see that the night had passed. She was surrounded by the snow-covered countryside once again, the beach with the floating icebergs, the trees covered with icicles. On waking, she saw the other woman lying next to her who had suffered the paralyzing cold as a result of not being warmed through, as she had been, by the impression of the beauty of this snowy landscape. Now the soul of the woman who had experienced so much during the night realized that the other woman, who had nearly frozen to death because she could not experience anything in the spiritual world, was human Knowledge. And she looked after her in order to share something of her own warmth with her. She lavished care and attention on her, and the other woman grew warm with what her companion's soul had brought back from her experiences of the night.

Over in the east the sunrise was reaching up into the sky and into the landscape. The sun was announcing its coming, and the sunrise

grew ever redder and redder. Now that she was awake, the soul of the woman who had these experiences during the night could watch and listen to what the children of Earth say when they divine what can be experienced in the imaginative world. And in the chorus of the children of Earth, she heard the best of them uttering their inklings of something that they themselves do not know through Imagination, but can allow to flow out of their souls' most profound depths as a goal and standard for all of humanity. She heard the voice of a poet who had once divined the greatness of what the human soul experiences through the imaginative world. She now understood that she must rescue this half-frozen Science, that she must warm it and imbue it with what she herself was—and above all, with what she was as Art. She understood that she had to communicate to this half-frozen Science what she brought back as a memory of her dream that night. And she noticed how what had nearly frozen to death could become alive again with the speed of the wind when Science is able to receive her communications as knowledge.

Once again she looked toward the sunrise, and the sunrise became for her a symbol of the state from which she had awakened and also a symbol of her own imaginations. And she understood what the poet had said out of the wisdom of his divining. What she heard out of a new spirit resounded toward her from the whole Earth: Only through beauty's dawning shall you approach the land of knowledge!

3. Buildings Will Speak

DORNACH, JUNE 17, 1914[1]

My dear friends!

Even more than the last time I spoke to you here at the construction site, this occasion today brings to mind the words and the feeling that I expressed then, the feeling that we must have toward this building which is dedicated to the cause of our spiritual science. This calls for a feeling of great responsibility toward the great sacrifices our friends have taken upon themselves for the sake of the anthroposophical cause, and toward their rightful expectations of us. Today we are dedicating the first of our buildings to its intended purpose, so to speak. This is the best possible opportunity to be reminded of this responsibility by contemplations that can arise from the tasks assigned to us and the goals we can pursue.

My dear friends, today, here in this space whose immediate purpose will be to provide the glass windows for our building, we may and actually must be moved by the thought that our human capabilities are no match for what we must accomplish with these buildings. I believe that this is a good and healthy feeling to carry with us as we continue our work, for it is the only way we will accomplish our utmost, so to speak. If we always have the feeling of really being no

1. This lecture was delivered at the dedication of the glass-engraving studio adjacent to the Goetheanum, the conference and performance hall designed by Rudolf Steiner as world headquarters for the Anthroposophical Society. Contained in *Wege zu einem nuen Baustil* (*The Way to a New Architecture*), Rudolf Steiner Verlag, Dornach, 1982 (GA 286).

match for the actual task at hand, we will bring the beginnings of an artistic setting for our spiritual scientific work to completion in the way that our times and our means permit. Each time we come onto this construction site of ours, it is as if we felt surrounded by an attitude that is being instilled in us from all sides: "Do the best that your strengths and abilities will allow, for in comparison to what ought to be accomplished, you cannot do enough. Even if you do your very best, it is by far not enough."

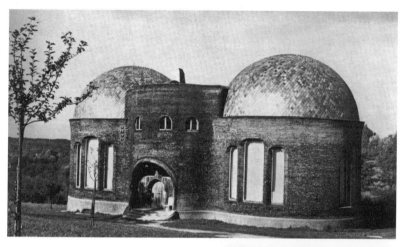

The studio where the glass windows were engraved for the Goetheanum.

When we look at the site of our building an indefinable feeling or presentiment of being surrounded by a great task ought to take hold of our souls. This should especially be the case now, when we are first handing this outbuilding over to our dear friend Rychter[2] and his colleagues to create works of art that will best serve as an organic component in the whole organism of our building.

When we step through the door into this room, won't we feel that as individuals in our present times, we are blessed indeed to be allowed to collaborate on a work such as these glass windows? And when we think of the function of these windows in our building, then a significant spiritual element, which we hope will whisper and rustle through these rooms increasingly, like surges of healing spirituality, will really fan us with its gentle soul breeze, so to speak.

And when this building is finished, we will perhaps often have an oppressive feeling that we may be able to clothe in the words: "How necessary, oh, how necessary it is to outgrow everything personal if framing our spiritual scientific cause in forms such as those intended here is to have any meaning!" But in a certain respect, this is what is satisfying about this building. Our dear friends the architects and engineers and all the members who are working on the building will surely be able to draw strength from the satisfying feeling that this building, in addition to being a cause of so much concern and effort, can also become a beautiful and wonderful means of education for us—something that teaches us to transcend everything personal. It truly asks that we do more than live out our personal feelings. As we go about our work and penetrate these individual forms with our thinking and feeling, we begin to sense ever new tasks, so to speak, which we did not even suspect before. We feel that something mysterious around us demands that we enlist the help of the best forces of our soul, our heart, and our reason in creating something that goes far, far beyond our own personalities. This building can teach us to accept tasks from what is coming about in our surroundings every

2. Tadeusz Rychter (b. 1873 in Poland) worked at Dornach (with Franciszek Siedlecki and Assia Turgenieff) from 1914 until 1920, when he went to live in Jerusalem with his wife Anna May; he returned to Warsaw in 1940 and disappeared in 1941.

day. It can bring home to us a feeling that resounds in the human soul with sacred tones: "The world's potentials are so much greater than what we little human beings are able to fulfill! How much greater the best that can come out of our being must become if it is to be a match for our tasks in the objective world; how much greater it must be than what we can encompass within the framework of our personal Self!"

The main building and its first outbuilding, which we are now dedicating, can be a means for us to learn this. The more they teach us, the more we will relate to them in the right way. Already now, when we enter the unfinished building, and especially when we enter these rooms which in a certain sense are an extension of the main building, we cannot help thinking of what our feelings should be as we enter. Won't the feeling often creep up on us that we want to bring everyone, all human beings, into rooms such as these? Having created something from which we exclude other people, do we deserve to have our holiest efforts surrounded by a setting like this? Would we not like best of all to bring everyone into it? Undoubtedly, we will especially want to bring in all those who will inherit the task of constructing other such buildings for humanity, if this building is to have imitators and followers.

My dear friends, I would like to link this thought to something else that suggests itself immediately. I am thinking of the many buildings that have been erected by architectural geniuses. They do not introduce any new style and contain no sparks of new spirituality, but they are creations of architectural genius nonetheless. However, they all have a characteristic feature in common: We may admire them from outside and in, but we never feel, as we will feel in our building, that we are enclosed as if by organs of sense. Why don't we feel like that? Because these buildings are mute, my dear friends; they do not speak. This is an expression I would like to substantiate for you tonight.

Let's look at buildings that really bear the stamp of our times. People seem to go in and out of them without living their way into the architecture, the forms, or the whole artistic aspect of the buildings. We feel that what ought to be expressed through such artistic forms must now be communicated to humanity through other means.

Nowadays we are more and more compelled to create order and security, peace and harmony, through outer laws, regulations and decrees. This does not imply a single syllable or thought of criticism, because this is how things have to be in our times. Nevertheless, this must be supplemented with something else, something that indicates progress, humanity's evolutionary progress in a different sense. Perhaps not all of this will be accomplished by our building, because we are actually only capable of erecting the first primitive beginnings of it. But once our intentions for this building have been taken up and developed in our culture, once what we are trying to do has actually been accomplished, we will fulfill the tasks the gods have assigned to us. If the ideas behind such works of art find followers in civilization, and if the people who go through the portals of such works of art allow themselves to be impressed by the language of these forms and learn to speak this language with their hearts and not merely with their reason, then these people will no longer wrong their fellow human beings. They will learn to live with their fellow human beings in peace and harmony. Peace and harmony will pour into their hearts through these forms. Buildings such as ours will be lawgivers, and their forms will achieve what outer institutions cannot.

My dear friends, regardless of how much people contemplate getting rid of criminality in the world by means of outer institutions and arrangements, for human souls in the future, true redemption—the true transformation of evil into good—will happen when art permeates human souls and hearts with a spiritual substance. If they allow themselves to be influenced by the quality of architectural and sculptural forms and the like, then they will stop lying if they are predisposed to lying; they will stop disturbing the peace of their fellow human beings if that was their tendency. Buildings will begin to *speak*. They will speak a language that people today do not even dream of.

Today people assemble in congresses to negotiate world peace. They believe that what is spoken from person to person can really create peace and harmony. But congresses do not create peace and harmony. Peace and harmony worthy of the human being will result only when the gods speak to us. When will the gods speak to us?

Now, under what conditions can human beings speak to us? They have to have a larynx; without a larynx, no one would ever be able to speak to us. We take what the gods of nature have given us in our larynx and incorporate it into the world as a whole when we discover the right artistic forms, through which the gods may speak to us. We must only understand how we are to become a part of this great dialogue. Admittedly, this will intensify our desire to enable all our fellow human beings to enter through these doors. Since this is a wish that we cannot fulfill as yet, it will give rise to a longing to work on behalf of our spiritual movement in ways that will make this ever more possible.

My dear friends, art is the creation of organs through which the gods can speak to human beings. I have already given many indications on this subject; I have already pointed out in earlier lectures that the forms of the Greek temple were built up so as to represent a dwelling for the gods. Today I would like to add something to this. Let us try to sense the form, the basic form of the Greek system of architecture, so to speak. We will find that what flowed out of Greek sensibilities into their system of architecture clearly had its origin wholly in the sense and meaning of the fourth post-Atlantean epoch. What did Greek sensibilities rest on? Certainly there is much that can be said about them, but I would only like to emphasize a single characteristic element.

Here we have [he begins the drawing below] the framework of the walls of the Greek temple, and here the horizontal elements bearing down upon them. If anything extends upward above the horizontals, it is put together in such a way that it is held together by its own strength; its forces balance each other, just as we put two beams together when we build.

What does this system presuppose about our sensibilities? It presupposes that we sense the Earth with its force of gravity down here [draws the arrow]. If we now translate our sense of

this into words, we may say that in the fourth post-Atlantean cultural epoch people sensed that the gods had given human beings the Earth as their stage, that divine strength streamed over into human artistic activity so that gravity could be overcome through the forces that the gods had given to human beings along with the Earth. This is expressed in the fact that the temple, the dwelling of the gods who gave the Earth to human beings, is created by systematically applying the force of gravity.

This dwelling for the gods cannot possibly be imagined apart from the Greek countryside, nor can the later Roman temples be imagined without the area that surrounds them. They belong together. I have already emphasized once before that a Greek temple is complete in itself, even when there are no people in it, because it is imagined as the dwelling of the god whose statue it houses. The people may live widely dispersed in the surrounding area, but even if no one enters the temple, it is a finished whole because it stands there in the landscape as the dwelling place of the god. And even when the temple eventually acquired decorative forms, we can still see in all the details of these forms, so to speak, that everything human beings affixed to these dwellings of the gods was deemed necessary out of reverence for the gods in question. As you recall, the last time I spoke to you, I tried to show that the motif of the column's capital developed out of the motif of a dance that was performed in honor of the gods of nature. Thus in the Greek capital, first in painting and later as sculpture, what was affixed to the dwellings of the gods in their honor was something people imagined as having been enlivened, like themselves.

Now let's skip a few things and proceed directly to the forms of the earliest Christian architecture. In moving from the Greek temple to the Christian church, there is one thought we must become aware of above all else. The Greek temple stands in the midst of the landscape and is part of the surrounding territory. The people are not in the temple, they live in the area around it. The temple belongs to the land and is thought of as the altar of the land. It blesses everything, even the most mundane occupations of the people in the countryside round about. Because the god sits or stands in his house as the lord,

taking part in the farm work and trade of the people living nearby, service rendered to the Earth becomes a divine office. People going about their business in the surrounding countryside feel united with the god. We might say that service to the Earth and worship of the divine have not yet been separated. The temple grows out of the human, sometimes all-too-human element; it participates in everything that goes on in its environs, whether holy or unholy. "Earth, be solid!" is people's attitude in the fourth post-Atlantean epoch, when they still have very close ties to the god-given Earth. The human I is still slumbering, as if in dream consciousness, and people still feel their connection to the group I of the whole of humanity. Then as people begin to grow out of their group I and to become ever more individual, they extract their service to the spiritual from the landscape and separate it from everyday life.

In early Christian times people no longer felt as they had in Greek times. Greeks sowing in their fields or working at their trades had a secure feeling in their souls: "Here is the temple where the god dwells. In staying in this place I am close to him and can ply my trade or work in my fields, for the god dwells in the temple." But then people became more individual and a stronger feeling of selfhood appeared in them. This caused something to separate itself out, something that had been prepared for a long, long time throughout ancient Hebrew times. It emerged especially strongly in Christianity. Within the human soul the need arose to separate worship of the divine from everyday life. The Christian church came about when the building was taken out of the landscape. The surrounding area became independent, and the building became independent within it, became a separate area of its own. While it might be said that the Greek temple was an altar for the whole countryside, the walls of the church now shut the landscape out. An enclosed space was created; those who performed the service kept to themselves within this space. The forms of the Christian church and of Romanesque architecture gradually accommodated this individual need for the spirit, and we only understand these forms correctly if we consider them from this viewpoint: The Greeks were so implanted into earthly existence as a whole that they could say to

themselves, "I can stay here by my hearth, here at my trade, here at my farm work, because the temple stands there like an altar for the entire countryside, and the god dwells within it." Christianity, however, gave rise to a different feeling, and its people said to themselves, "I must separate myself from my work, from my trade, because the church is where we seek God." The service of Earth and the service of heaven were individualized, you might say. The outer forms gradually came to resemble people's need for individuality, so that the Christian church tended more and more to assume a form that would not have been suitable in Greek or Roman architecture, a form whose very structure shows that the congregation belongs inside it, that it is meant to enclose the congregation. Then too, buildings separated from the congregation developed for the priesthood and the faculty. We might say that a separate world came about for those who sought the spiritual world in a territory that has now enclosed itself within walls. That's what came about! In earlier times, the Greeks and Romans had experienced the whole Earth in the way that Christians now experienced their church surrounded by walls. What the Greek temple itself once was has been transformed into the chancel. People then sought to make a copy of the world in the forms of the church, whereas earlier people took the world as it was and only provided what it did not reveal to their outer senses, namely the dwelling place of the god.

And now, my dear friends, Gothic architecture is basically only a side branch of what was already being prepared. The essence of Gothic architecture is that the function of support is taken away from the walls and the weight-bearing capacity is transferred to the buttresses.

But what is the origin of this whole mode of construction that has the weight resting on the buttresses, which have been shaped in a way that allows them to carry it? You see, the system of architecture in the Greek temple is based on a thought that is totally different from what has been sketched here.

In the case of the Greek temple, it is as if human beings themselves had climbed up out of the Earth along with gravity, had learned about gravity in the earthly realm and were now both using and over-coming gravity with their feet planted firmly on the Earth. This is the Greek temple, the dwelling of the god. When we move on to the buttresses of Gothic architecture, we are no longer dealing with the pure effect of gravity. Human beings are at work here. A Gothic building requires contributions from the crafts and from the skilled and unskilled trades. Out of the need to create a space that encloses the congregation, the need also arises to create something in which the art of the congregation, as it were, participates, so that in the individual forms we see the continuation of what people have learned, you might say. The art of the various craftspeople streams in; those who study Gothic architectural forms will see in them the art of the craftspeople in the city who contributed to them and worked together to make them.

In the old Romanesque churches we still see that the building is meant to house the congregation as well as the God. In the Gothic church we see a building constructed by the congregation to enclose the God, but one to which craftsmen have contributed. They do not merely enter the church; as its congregation, they help to build it. This is how human work flows together with the divine in Gothic architecture. Human souls no longer receive the divine as a matter of course; they do not merely unite with it and listen to the words of the spirit proceeding from the altar. Now they work together and present what they have learned to their God. Gothic churches, you might say, are a crystallization of handicraft.

We can quickly pass over what happened next, since it was basi-cally a revival of classical architecture. It is not necessary for us to speak about the Renaissance in this context. However, my dear friends, we do want to speak about what the fifth post-Atlantean age demands of us.

Let's look very carefully at the elements of support and weight in the Greek temple, and trace them to the point where they become crystallization of handicraft in Gothic architecture. If we imbue this with feeling, if we feel our way into it artistically, we must feel the

Greek temple as something at rest in itself within the earthly forces. The important thing here is that these buildings and all their forces rest within the earthly element. Wherever you look in a Greek temple, you find that it points to gravity, to its own close ties to the Earth. In every Greek temple we can study some aspect of gravity. Its very forms betray its close ties to the Earth.

Let me ask you to imagine—since this is the fastest way of getting to our goal—the basic form that everyone approaching our building from outside will meet immediately. I will just draw a rough sketch of it:

What is characteristic about this motif? If you compare it to the motif of the Greek temple, you will see the difference. The Greek motif is complete in itself; for example, if it is a wall, it is a self-contained perpendicular wall. Here in our building, this motif is not merely a wall. Rather, it makes sense only if the wall becomes alive, if it is not merely a wall but allows the entire thing to develop out of it. The wall is not merely a wall, it is alive. Just as concave and convex elements grow out of a living organism, these forms grow out of the wall, which thus becomes something alive. That is the difference.

Imagine the Greek temple. Although it may have many columns, the whole thing is governed by gravity. In this new drawing, however, there is nothing that confronts us merely as a wall. Here the forms grow out of the wall. This is the essential point. When we are finally able to walk around inside our building, we will find many sculptural forms, a continuous relief sculpture on the capitals, plinths, and architraves. What is the meaning of this? They grow out of the wall; the wall is the fertile ground without which they could not exist.

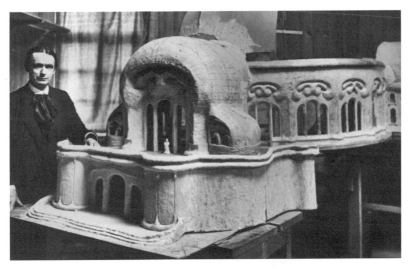

*Rudolf Steiner with the model of the west entrance
and adjacent window motifs*

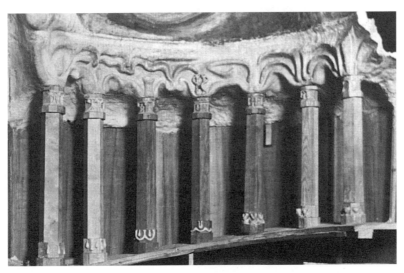

Rudolf Steiner's model showing the interior carving motifs

Now, my dear friends, we will find very many examples of relief carving in the interior of our building. All these forms, although not present elsewhere in the physical world, represent an ongoing evolution. It is as if we were to start with several forceful measures in the

back between the Saturn columns and continue in a symphonic and harmonious progression to the finale in the east. These are forms that are no more outwardly present in the physical world than melodies are. These forms are walls that have become alive. Physical walls do not become alive, but etheric walls or spiritual walls are indeed living.

I would have to talk for a long time to show that this is basically how the art of relief carving first assumes its true meaning, but I will only give you an indication of what I actually mean. A certain well-known modern artist has said some clever things about the art of relief. In elaborating his concept of the art of relief, he writes,

> In order to make this as clear as possible, think of two parallel glass walls with a figure between them. [In cross section it would be drawn something like this; we are looking in the direction of the arrow and can observe the figure through the glass walls.] This figure is parallel to the glass walls and its outermost points are touching them. Thus the figure occupies a space that is always equal in depth; the distribution of its parts within this space defines the space. In this way the figure, as seen from in front through the glass wall, merges into a unitary surface layer as the recognizable image of an object. Understanding the figure's volume, which would be quite complicated in itself, is made very much easier by grasping the simple volume that the entire space comprises. The figure dwells, so to speak, within a surface layer of uniform depth, and each of its forms tries to spread out on this surface; that is, to become recognizable.[3]

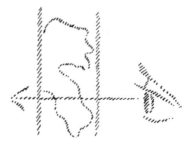

3. Steiner quoted this from Adolf Hildebrand, *"Das Problem der form in der bildenden Kunst,"* Straßburg, 1913.

What does all this mean? It means that the person in question is trying to arrive at a concept of sculptural relief. However, he makes it very clear (by saying that the relief is produced if we think of the wall in the background as a glass wall and what lies in front of it as being contained by another glass wall) that he develops this concept by taking the eye as his starting point. Thus he develops his concept of relief in reference to the eye, and in order to illustrate this he chooses the two glass walls on which the entire figure is projected, so to speak. Hildebrand's glass-wall concept stands in contrast to ours, which moves from something illustrated by means of glass walls and projections to something alive. In our view, we try to visualize the relief as something living, so that it is construed as a relief and nothing else. A relief has no meaning if we simply affix the figures to a wall. It has meaning only if we elicit the impression that the wall itself is alive and capable of bringing forth the figures.

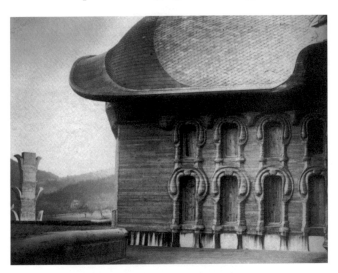

Terrace and north wing seen from the west

My dear friends, there is one relief that is already a very meaningful part of this whole world, but it is not possible for us to observe it properly. One relief does exist that has been built up according to the correct conception, namely that the walls produce what the relief represents. This relief is the Earth itself with its plant kingdom.

However, we would need to step off the surface of the Earth and out into space in order to study this relief. Earth is the living surface that brings forth its creations. Our relief must also be like this. We must be able to believe in the life of the wall just as we believe in the life of the Earth that brings forth the plant kingdom out of her womb. This is how a true art of the relief is achieved. To go beyond this is a sin against the principle of the art of the relief. If we look down on the relief of the Earth, we see human beings and animals wandering about on it, but they do not belong to the relief itself. Of course it is possible to add them to it, because the arts can be elaborated in all directions, but this is no longer a pure art of the relief.

Our building is intended to speak through the forms of its interior, but its speech must be that of the gods. My dear friends, think about how we human beings live on the Earth, directly on its surface. At this point we need not invoke any of our spiritual scientific teachings, we simply need to think about the paradise legend. If we human beings had remained in paradise, we would have seen the wonderful relief of the Earth and all its plant forms from outside. As it is, however, we were set down on Earth to live within this relief and cannot observe it from outside. We have moved out of paradise, and the language of the gods cannot speak to us because it is drowned out by the language of the Earth. If we listen to the gods' organs, the organs the Elohim of the Earth created and gave to human beings, if we listen to the etheric forms of the plants and shape the forms on our walls according to their laws, then we are creating larynxes through which the gods can speak to us, just as nature created the larynx in the human being for speech. If we listen to the forms on our walls, they are larynxes for the gods, and we are seeking the way back to paradise.

My dear friends, I will speak about the element of painting on another occasion. Today I would like to speak only about what is present in our relief-like and sculptural works of art, to which the building we are opening today is dedicated. We have tried to acquire a sense of how the relief can become the organ through which the gods can speak to us. Some other time we will have an opportunity to speak of how colors must become soul-organs for the gods. Our present age

has very little sense for the sorts of considerations that must ensoul us if we really want to fulfill our task with regard to our building.

We have seen how the Greek temple building was the dwelling-place of the god, and how the Christian church was an enclosure for the congregation trying to unite with its God. Now, what is our building meant to become? Once again, its ground plan and the form of the cupolas already demonstrate a characteristic feature of what it is meant to become:

It too consists of two parts, but the architectural forms of these two sections are of absolutely equal value. Here, there is no difference such as that between the chancel and the area that houses the congregation in the Christian church. The difference in size simply means that here under the large cupola, the physical element is greater, while under the small cupola we try to have the spiritual predominate. In itself, however, this form already expresses an uplifting toward the spirit. Accordingly, an organ is being created in this building so that the gods can speak to us. This must be expressed in every single detail.

I said that those who understand the building completely will forget how to lie and do wrong, and that the building will be able to serve as a lawgiver. You can study this in its individual forms. You will often find this characteristic motif in the architraves and other forms. [He begins to draw.]

Wherever it appears, it is never without inner value. Just as there is nothing in the human larynx that is without inner value, just as no word could be uttered if the larynx did not have a particular shape at the appropriate place, so too if you cut away here so that a concave form develops, with a roofing of a sort over it [he continues drawing], this corresponds exactly to the fact that this building is meant to be filled with the feelings of hearts that flow together in love.

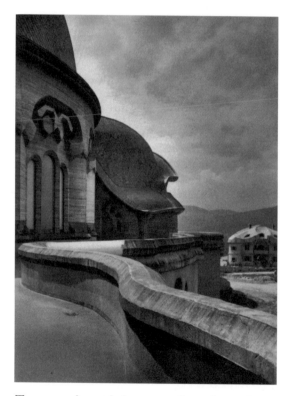

Terrace and west balcony seen from the northeast

Fundamentally, therefore, nothing in this entire piece of architecture works on its own. Nothing is arranged in such a way that it is there for its own sake. One form strives toward another; each one strives toward the other. Or, in the case of a threefold form, the central form combines the other two. Here is a rough sketch of the forms of the windows and doors:

Now, my dear friends, what lives in sculptural forms is three-dimensional; a relief consists in overcoming the two-dimensional surface and moving into the third dimension. This does not result from taking the standpoint of the observer, but from having a living sense of how the Earth lets plants grow up out of it.

When I come to speak about painting, we will see the significance of the connection between color and the inner soul element in the universe. There would be no sense in painting with colors if the color were not something more than what physics imagines it to be. It will be the task of a later presentation to explain the statement that color is the language of the soul of nature, of the soul of the universe.

Now, however, I still want to draw your attention to how our glass windows are meant to bring about the connection between the exterior and the interior. Although each window will be monochromatic, we will have windows of different colors in various locations. This expresses the fact that the connection between outer and inner must be ordered in a spiritual and musical way. Each monochromatic window itself will simply have an arrangement of thicker and thinner areas—that is, we will see areas where the material appears denser and more substantial and areas that are proportionally thinner. The light will shine in more strongly through the thinner areas of the windows and less strongly through the thick areas, resulting in deeper colors. It will be possible to sense the connection between spirit and matter in what the windows express.

The building's entire inner surface, however, is meant to try to speak, to be an organ for the speech of the gods, as it were. Just as we say that the human being has a larynx that makes speech possible, so too will we be able to sense that this entire carved relief is fashioned as an organ for the speech of the gods, who are meant to speak to us from all ends of the universe. The speech organs of the gods are all around us. What are we trying to do when we look for

a way of penetrating our walls that will turn them into organs of speech for the gods, so that these walls negate themselves through the very manner in which they are formed? In this case, we must strive to show that human beings are seeking the way to the spirit when they allow the gods to speak to them through the organs that are formed by breaking through the walls. This is also how we will look at these windows. In their colored shadings, they are meant to say to us, "Thus, oh human beings, you find your way to the spirit!"

This will show us the soul's relationship to the spiritual world at night, when it is outside the body during sleep. It will also show us the soul's relationship to the spiritual world in the disembodied state between death and rebirth. It will show us how human beings experience the "abyss" when approaching the threshold, and it will show us the stations along the way into the spiritual world. The windows will appear like formations of light itself, so to speak, showing us the secrets of initiation coming from the West. The characteristic thing here is that we are trying to create walls that cancel themselves out and negate themselves through the very manner in which they are formed. The content of the windows must show us how we break through the walls; they must show us figures we encounter when we seek the path to these spiritual worlds or walk it unconsciously. They must show us how we are to relate to the spiritual worlds.

Yes, my dear friends, when the Greek temple was built as a dwelling place for the god, and when in later times dwellings were built for congregations trying to unite with their God, these were all enclosures that were there in order to shut something off. Our building is not intended to shut anything off. Its walls are meant to live, and to live in a way that corresponds to the truth of the relief. This building's reliefs are to express what we would have experienced in the living relief of the plant world if we had not been expelled from paradise, so to speak. We would have become aware of the speaking relief that the Earth brings forth out of her womb in the forms of the plants, covering the geological structures of the mountains and leaving them bare only where they should be bare. Sitting there in our building, we will need to have the feeling that we can rest and that the gods will then speak to us. However, as soon as we make the

transition from the feeling of resting, of sitting quietly and having the gods speak to us, to the feeling of wanting to move and actively find our way to the gods, then we must break through the walls. And then we need to know what we must do in the spiritual world. When we break through the walls, these windows need to be there, challenging our souls to move and set out on the path to the sources of the speech we hear through the forms of the walls. When we sit in this building, we may come to feel that the organs of the spirits are around us, and that we must acquire the capacity to understand the language spoken through these forms. But we must understand them in our hearts rather than trying to figure them out intellectually.

If you begin to work out what these forms "mean," my dear friends, you're on the wrong track. This would not accomplish anything. You would be standing on the same ground, more or less, as those who interpret ancient myths and legends symbolically and allegorically and think that they are practicing theosophy. People who want to interpret myths and legends and even our forms in this way may be very clever and ingenious, but it's as if they were trying to look under people's chins in order to interpret the symbolism of the human larynx. No, we do not understand the language of the gods by trying to interpret our artistic forms—or myths and legends, either, for that matter—symbolically or allegorically by applying all kinds of tricks of human rationality. We will only understand the language of the gods when we try to understand it with our hearts. Then sitting here and hearing the spirits of the world speak to us will be a living experience for us. If in this way we understand how to enliven this sense of what the soul must do to find its way to the source of the language of the spirits, we will then turn our gaze to where walls are pierced by the windows. Where the walls have been broken through, we will see what lives in human beings when they set out on the path from the physical to the spiritual, either consciously or unconsciously.

With these words, my dear friends, I would like to conclude the observations I wanted to make today in collaboration with your hearts and souls on the occasion of commending this building to the care and conscientious work of our friend Rychter and his colleagues.

In receiving it, may they be aware of something of the holiness of their task, the holiness that has just been pointed out. It may be said that in the main building up there on the hill, we are still working to create speech organs for the gods, to show the people who will sit there that the gods can in fact speak to us through such organs. Next, however, we must develop a sacred longing to find the ways and the paths toward the places where these spirits are. What our friend Rychter and his colleagues will work on in these rooms will be carried up over the hill here and inserted into the spaces where the walls are pierced. These windows will set in motion the souls of those who will unite in that building and will show them the path that is the way to the spirit.

May this holy mood prevail in these rooms; as they etch each single line on the glass, may the people working here be aware that what they are creating will be listened to by people's souls up on the hill and will lead them to spirit places. May they say to themselves, "What we create in the shadings of the colored glass must make the sensations in these souls so active that it can point the way for them to the place from which spiritual worlds speak through the building's interior forms." Even if the difficulties are ever so great, even if some things do not succeed at all and others only very imperfectly, any success we have will be helped greatly if the feeling that has just been expressed prevails in these rooms.

My intention this evening, my dear friends, was not merely to present to you all kinds of things that serve to make art understandable. It was also to communicate, from my heart to yours, something of the feeling that I would always like to implant in you, the feeling I would always like to have permeating your hearts, a feeling that pulses inwardly with the holiness of this work on our building. This place of work—for that is what it is meant to be—will be dedicated better than can be done with words if, now that we are going out through the door again, we concentrate with all the forces of our hearts on loving the world of human beings and the world of the spirit, so that the way to the spirit can be found through what will be created in these rooms. This is the spirit from whom peace and harmony among human beings on Earth will proceed, if people find

their way to this spirit in love. But if everything is ensouled by this spirit whom I would like to invoke through these words here this evening, if all the work that is being done on the other side of the hill is filled with this spirit of love who is always also the spirit of true artistry, then the spirit of peace, harmony, and love will ray forth into the world from what covers this hill. This will bring about the possibility of successors to what is being created on this hill, so that many such centers of earthly and spiritual peace, harmony, and love will be able to flourish in the world. May we take up what is living in our work in this attitude of peace, harmony, and love; may this work itself appear to us as a living thing growing up out of the spirit of existence. While there were once buildings that served as dwelling places for the gods or for congregations, may ours now serve as speech organs for the spirit, as signposts for the spirit. The god dwelt in the Greek temple, the spirit of the congregation can dwell in the Romanesque or Gothic building, but in the building of the future the spiritual world is meant to *speak*. In the course of humanity's evolution, we have seen the house of earthly forces and earthly forms pass away; in the course of the Earth's spiritual evolution, we have seen the house of the human soul's togetherness with the spiritual world pass away. But now, my dear friends, let us build the house of speech, the speaking house, the house whose walls are all alive. Let us build it out of love for true art and therefore also out of love for true spirituality and for all of humankind!

4. The Sense Organs
and Aesthetic Experience

DORNACH, AUGUST 15, 1916

We have been learning about how human beings find their place in the world through the senses and life organs. We have been trying to understand some of the consequences of the reality underlying what we have understood.

First and foremost, we cured ourselves, as it were, of the trivial view characteristic of many who claim to be spiritually minded—those who refer to anything they think they should despise as "material" or "sensory." We saw that the lower organs and functions of human beings here in the physical world provide us with a reflection of loftier functions and interconnections. We had to recognize that the senses of taste and life as they are now are very much bound up with the physical, earthly world. The same is true of the senses of I-being, thought, and word. Nevertheless, we became accustomed to viewing the senses of self-movement, balance, smell, taste, and, to a certain extent, even the sense of sight—all of which, in the physical sphere of the Earth, serve the bodily organism only from within—as shadows of something that becomes greater and more important in the spiritual world after we have died.

We emphasized that the sense of self-movement allows us to move around in the spiritual world among the beings of the various hierarchies, in accordance with the forces of sympathy and antipathy that they exert on us and are expressed as the spiritual sympathies and antipathies we experience after death. Our sense of balance maintains not only the physical body's balance, but also our moral

balance with regard to the beings and influences present in the spiritual world. The same is true of the senses of taste, smell, and sight. Where a concealed spiritual element works into the physical world, we cannot explain this by turning to the higher senses but must turn instead to the so-called lower sensory domains.

Admittedly, many things that are very meaningful along these lines cannot be talked about at present, because current prejudices are so great that it immediately leads to misunderstandings and recriminations on all sides if we express these particularly significant things that are interesting in a higher spiritual sense. For the moment I will therefore have to refrain from using some important facts of life to point to interesting processes in the sensory domain.

In this respect, circumstances were more favorable in ancient times, although there was certainly not the possibility for disseminating knowledge that exists today. Aristotle could speak about certain truths much more openly than is possible today, when such things would immediately be taken personally, arousing personal sympathies or antipathies. You find truths in Aristotle's works that affect people deeply; it would be impossible today to expound upon them to a large audience. I pointed to these things in my last lecture by saying that the Greeks knew more than we do about the connection between our soul-spiritual and physical, bodily aspects, but without falling into materialism. In Aristotle's writings, for example, you can find very beautiful descriptions of the outer forms of people who are brave, cowardly, or prone to anger or excessive sleep. He describes in a certain quite correct way the types of hair, facial color, and wrinkles that people have if they are brave or cowardly or sleep too much, and so on. Even this would be difficult to present today, and there are other things that would be still more difficult. This means that today, when people have become so personal and therefore want to have the truth veiled from them in many respects, it is necessary to speak more in generalities if you have to represent the truth under certain circumstances.

Every human type and every human activity can be understood from a certain point of view if we ask the right questions in the right way and in the light of what we placed before our souls last time.

For example, we said that the sensory domains as they exist in human beings today are separate and self-contained, so to speak, just as the signs of the zodiac out there in space are fixed in contrast to the planets, which appear to rotate and change location relatively quickly. Thus the senses have fixed boundaries, we might say, while the life processes surge throughout the entire organism, moving through the individual sensory domains and imbuing them with strength for their work.

But we also said that during the ancient Moon period our present-day sense organs were still functioning as organs of life, and that our present-day life organs were essentially more soul-like in nature. Now think about something that has been repeatedly emphasized: There is a certain atavism in human life, a return, as it were, to habits and idiosyncrasies that were formerly quite natural, in this case during the Moon period. This is actually a relapse of a sort. We know that it is possible to relapse atavistically into the dream-like, imaginative way of seeing things that was current during the Moon period. Today this atavistic relapse into moon visions must be described as pathological.

Now, I beg you to keep strictly in mind that visions as such are not necessarily pathological. If this were the case, then everything that human beings experienced during the Moon period, when they dwelt only in such visions, would have to be described as pathological, and we would be obliged to say that human beings in the Moon period were undergoing a disease process, and a process of soul illness, at that. We would have to say that they were crazy during the ancient Moon period. Of course that would be utter nonsense; we cannot say that. The pathology lies not in the visions as such, but in the fact that their presence within the present-day earthly structure and functioning of human beings is intolerable, and that they are applied in a way that is not suited to them as moon visions. Please consider that a moon vision is actually only suited to lead someone to a feeling or an activity that corresponds to the Moon period. But if a person has a moon vision during the Earth period, and this vision results in actions that are only possible for an earthly body, the outcome is pathological. The person in question does these things only

because his or her earthly body cannot bear the vision that is penetrating it, so to speak.

Take the crudest possible case; something causes someone to have a vision, and instead of remaining quiet and looking at it inwardly, this person applies it to the physical world (although it is only meant to be applied to the spiritual world) and acts accordingly with his or her physical body; that is, the person goes on a rampage, because the vision permeates the physical body and imbues it with strength, which it is not meant to do. This is the crudest possible case. The vision is meant to remain in the region where it dwells, but that is not what happens if, as an atavistic vision, the physical body is unable to bear it. If the physical body is too weak to assert itself against the vision, then powerlessness results. If the physical body is strong enough to assert itself, then it damps down the vision, which then does not assume the character of falsely suggesting to the person in question that it is something similar to a thing or process in the sensory world, which is what a vision suggests to someone who becomes pathological as a result. Thus, if the physical organism is so strong that it can combat the lying tendency of the atavistic vision, then the person in question will be strong enough to relate to the world in a way similar to how this was done during the ancient Moon period, but will still be able to adapt such experiences to his or her present body.

What does this mean? It means that the person will make some inner changes in his or her zodiac of the twelve sensory domains, so that life processes rather than sensory processes are played out within it; or to put it better, the processes that are played out, although they border on sensory processes, transform these into life processes within the sensory domain, thus lifting the sensory processes up out of their current state of death and into life. As a result, when the person sees and hears, something is alive in these sensory processes, in the eye and the ear, that would otherwise only be alive in the stomach or on the tongue. Sensory processes are brought into movement, and their life is stimulated. It is perfectly acceptable for this to happen, and when it does, something is incorporated into these sense organs that is otherwise only possessed today to this

extent by the life organs. The life organs are inwardly imbued with the strength of sympathy and antipathy. Just consider how our entire life depends on sympathy and antipathy! We are constantly accepting one thing and rejecting another. The sympathetic and antipathetic forces that are otherwise developed by the life organs are once again instilled into the sense organs, so to speak. The eye not only sees the color red, it senses sympathy or antipathy along with the color. Once again, the sense organs are suffused with life; life streams back into them. Thus we can also say that in a certain respect the sense organs once again become domains of life.

Then, however, the life processes must also be changed; they are imbued with soul to a greater extent than they are during everyday life on Earth. The three life processes of breathing, warming, and nourishing are combined and ensouled, so to speak, and appear in a more soul-like manner. In our ordinary breathing, we take in crude material air; in ordinary warming, we take in warmth, and so on. Now, however, a symbiosis of a sort takes place in that these life processes form a unity when they are imbued with soul. They are no longer separated as they are in the body as it normally is today, but form some sort of connection to each other. An intimate association is formed between breathing, warming, and nourishing—not the crude aspect of nourishing, but something that constitutes the nourishing process. This process runs its course without our having to eat; it runs its course not only as it does when we eat, but also in connection with the other processes.

The four other life processes are united in the same way. Secreting, maintaining, growth, and reproduction are united and once again form something more like an ensouled process, a life process that is more soul-like. Then these two groups are also able to unite. It is not so that all the life processes work with each other directly, but they work together in separate groups of three and four, and the three then work together with the four.

This gives rise to three soul forces that also have the character of thinking, feeling, and willing. They are similar to thinking, feeling, and willing as these typically are on Earth, but not exactly the same. They are now different—not thinking, feeling, and willing as these

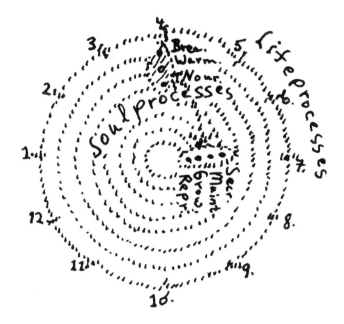

normally exist on Earth, but something different. They are more similar to life processes, but they are not separate as the life processes usually are. A person may tolerate reverting to the Moon state, as it were, without having visions, but something similar in which sensory domains become domains of life and life processes become soul processes. This process is a very subtle and delicate one.

It is not possible for a person to remain in this state indefinitely. If that happened, the person in question would be of no use to the Earth, since we are adapted to the Earth because our senses and life processes are as they have been described. In certain cases, however, it is possible for a person to reshape him or herself in the way described above. The result is aesthetic creativity if the will is more affected, or aesthetic experiences if perception and understanding are more affected. *Real aesthetic activity in a human being consists in having the sense organs brought to life and the life processes filled with soul in a particular way.* This is a *very important truth* about human beings, because it leads us to understand many things. We must look for this stronger life of the sense organs, this different life of the sensory domains, in art and in the experience of art. It is the same with the

life processes, which are more ensouled in the experience of art than they are in everyday life. Because in our materialistic age our way of considering these things is not in line with reality, it is also impossible to fully grasp the significance of the whole change that takes place in a person who is involved with something artistic. Today we think of the human being as a more or less defined and finished being. Within certain limits, however, human beings are malleable, as is demonstrated by the example that we have just considered.

Very far-reaching truths are contained in something such as this. To mention only one such truth, the senses that are most adapted to the physical plane must undergo the greatest change if they are to revert halfway to the Moon state, as it were. Because they are very strongly suited to the physical realm of Earth, the senses of I-being and thought and our coarse sense of touch must change completely in order to serve the constitution of someone returning partially to the Moon period.

The way we confront the I and the world of thoughts in our everyday life, for example, is useless to us in art. There are at most a few artistic sidelines in which our relationship to the I and to thinking can take place as it does in ordinary physical life on Earth. Portraying a person directly according to that individual's I as it exists in reality leads to no art at all. The artist must do something with that I—must go through a process of lifting it out of its specialized life within today's earthly processes, giving it some kind of general significance and universality. The artist does this as a matter of course. Similarly, the artist cannot artistically express the world of thoughts as this is done in ordinary worldly life, in which case, instead of producing poetry or any other work of art, the artist produces something instructional at best—something didactic that is never artistic in any real sense. In a certain sense, the way an artist changes reality leads to a re-enlivening of the senses along the lines presented here.

But there is something else that we must address as we consider this change in the senses. The life processes, as I said, work into each other. The planets can enter into conjunction with one another and their interrelationships are significant, but the signs of the zodiac stay in one place. Similarly, if the sensory domains move into the

planetary life of human beings, so to speak, they become mobile and alive and enter into relationships with one another. This is why artistic perception is never directed toward specific sensory domains in the way that ordinary earthly perception is. Here the individual senses also enter into certain relationships with each other. Let's take painting as an arbitrary example.

If our method of observation derives from real spiritual science, it becomes apparent that as far as ordinary sense perception is concerned, the senses of sight, warmth, taste, and smell occupy separate sensory domains. We keep them separate. In painting, a remarkable symbiosis or coming together of these sensory domains takes place, not only in their organs in the crude sense but also in the widening of these organs that I pointed out in earlier lectures.

The painter and the person enjoying painting not only see the content of the color, the red or the blue or the purple; in reality, they also taste the colors, but not with their crude organs of taste. For that, they would have to lick the painting with their tongues, which of course they do not do. But in everything related to the tongue, something subtly similar to the tasting process is going on. Thus, when you simply look at a green parrot and take it in through the sensory receptive process, you see the green color with your eyes. However, if you enjoy a painting, a subtle imaginative process takes place in something that lies behind your tongue and is still part of the tongue's sense of taste. This subtle process, which is similar to what happens when you taste and consume your food, participates in the process of seeing. Not the processes that take place on the tongue itself, but the more subtle physiological processes of what adjoins the tongue take place concurrently with the process of seeing, so that in a deeper soul sense of the word, painters really taste the color. And they smell nuances of color, not with their nose but with something that takes place on a soul level, deeper in the organism, in every act of smelling. Such amalgamations take place when the sensory domains move toward the life processes, move into the areas where the life processes run their course.

If we read a description that is only intended to inform us about how something looks or what happens with something, we allow our

sense of speech or sense of word to work. Through what it communicates, we are informed about one thing or the other. But if we listen to a poem in the same way that we would listen to something that is only intended to inform, we do not understand the poem. The poem becomes reality through our perceiving it with our sense of word, but if only our sense of word is directed toward it, we do not understand it. We must address it not only with our sense of word but also with our ensouled senses of balance and self-movement. These must have been imbued with soul. Here again, amalgamations and interactions between sense organs come about as the entire sensory domain moves into the realm of life. This must all be accompanied by ensouled life processes, by life processes that have been transformed into something soul-like and no longer work like ordinary life processes in the physical world.

If people listening to a piece of music take the fourth life process to the point where they start sweating, that goes too far. It no longer belongs to the aesthetic element; it is secreting taken to the point of actual physical secretion. In the first place, even though this is exactly the same process that underlies physical secretion, it is not meant to go this far but only to run its course as a soul process. In the second place, secreting is not meant to appear on its own, but in a combination of four—secreting, growth, maintaining, and reproduction—and with all of them taking place on a soul level. That is, the life processes become more soul-like processes.

On the one hand, spiritual science will have to orient earthly evolution toward the spiritual world. Without this, as we have seen from various things, humanity will go to wrack and ruin in the future. On the other hand, however, spiritual science must also restore our ability to understand the physical by means of the spiritual. As you know, materialism has prevented us not only from really reaching the spirit, but also from being able to understand the physical. The spirit dwells in everything physical; if we know nothing of the spirit, we cannot understand the physical. Just ask yourselves what those who know nothing about the spirit could possibly know about how all the sensory domains can be transformed into domains of life, or about how the life processes can be transformed so as to appear as soul processes.

What do modern physiologists know about these more subtle processes in the human being? Materialism has gradually brought us to the point where we get away from everything concrete and arrive at abstractions, and we are also gradually letting go of these abstractions. At the beginning of the nineteenth century, people still spoke of a vital force or life force. Of course, we can do nothing with an abstraction like this because we only understand the subject when we go into concrete details. If we fully grasp the seven life processes, then we possess the reality of the matter. That's why it is important to take hold of reality once again. Despite the fact that we may intend the very opposite, when we revive all kinds of abstractions—such as *élan vital*, or similar awful abstractions that say nothing and only acknowledge our inability to understand—we lead humanity deeper and deeper into "mystical materialism," which is materialism at its worst. For the sake of human evolution in the near future, it is essential that we have real knowledge and understanding, a real understanding of the phenomena that can only be the result of a spiritual world. We must really progress with regard to our spiritual understanding of the world.

To begin with, we must first look back to good old Aristotle, who was closer to the view of antiquity than we are. I want to remind you of only one characteristic fact about him. A whole library has been written on the subject of catharsis, which he tried to represent as the basis of tragedy. Aristotle said that tragedy is a coherent representation of processes in human life that arouse the emotions of fear and compassion as they run their course. However, at the same time that these emotions are being aroused, the way they run their course purifies the soul of them and leads to catharsis.

Much has been written about this in our age of materialism, because people simply have not had the organic needed for understanding Aristotle. The only ones who were right about this were those who grasped that Aristotle used the word catharsis in a medical or quasi-medical sense rather than in the modern materialistic sense. The life processes become soul processes; therefore, as far as aesthetic receptivity to the impressions of tragedy is concerned, the processes of tragedy really mean arousing the life processes that

accompany fear and compassion in our life, arousing them right down into the bodily element. Being purified means that these processes are then also imbued with soul at the same time, through tragedy. The entire soul aspect of the life processes is present in this definition of Aristotle's. If you read more about it in his *Poetics*, you will discover something like a living trace of this more penetrating understanding of the aesthetic human being. This does not come from our modern way of understanding things, but from the ancient mystery tradition. When you read Aristotle's *Poetics*, you comprehend much more about immediate life than can be understood these days by reading a treatise on aesthetics by various ordinary esthetes who only sniff around at things and discuss, but do not actually reach through to the things in themselves.

There is another significant high point in our understanding of the aesthetic human being in Schiller's *Letters on the Aesthetic Education of Man*, which were written in a more abstract age.[1] Only now do we have to add the element of the spiritual and the concrete to their idealism. But when we look at the more abstract element of Goethe's and Schiller's time, when we look into Schiller's letters on aesthetics, we find in their abstractions something of what has been said here among us—although here with us the process seems to be brought down into the material element to a greater extent. However, this is only because this material element must be even more strongly imbued with the power of the spiritual through intensified inner activity.

What does Schiller say? He says that human beings as they live here on Earth have two basic urges, the rational urge and the natural urge. The necessities of Nature make the rational urge function logically. We are forced to think in a certain way. We are not free to think, because what good does it do to talk about freedom in the area of rational necessity if we are forced, after all, to think that three times three is nine rather than ten? Logic signifies a strict rational necessity. Therefore, Schiller says that if human beings submit to the pure necessity of reason, they are subject to spiritual compulsion.

1. See bibliography (OA 29).

Schiller juxtaposes this rational necessity with the sensory need that lives in everything that is present in our urges and emotions. Here too human beings do not act out of freedom but obey a necessity imposed by nature. Then Schiller looks for a middle ground between rational necessity and natural necessity. He finds it emerges when rational necessity leans toward feelings that allow us to love and not to love. Then our thinking no longer obeys a strict logical necessity but rather the inner urge to shape our mental images, as is the case in aesthetic creation. At this point, however, natural necessity is transcended; we are no longer compelled by the demands of the senses as they are ensouled and spiritualized. We no longer want merely what the body wants. Our sensory enjoyment is spiritualized. This is where rational necessity and natural necessity draw close to each other.

Of course you must read this for yourselves in Schiller's letters on aesthetics, which are among the most significant products of philosophy in all of evolution. In what Schiller discusses in these letters, what we have just heard here is already present and active, but in abstract metaphysical terms. What Schiller calls freeing rational necessity from rigidity occurs when the domain of the senses is enlivened by once again being led back into the process of life. What Schiller calls the spiritualization of natural need (he might better have called it its ensouling) happens when what we have called the life processes function as soul processes. The life processes become more soul-like, and the sensory processes become more alive. This is what really takes place. It is present in Schiller's letters on aesthetics, but more in the form of abstract concepts, as if he had been spinning abstractions. That is how things still had to be in his time, when people were not spiritually strong enough in their thoughts to make their way down into the area where the spirit lives as the seer would have it. There spirit and matter are not contrasted; we acknowledge that the spirit permeates matter everywhere, that we can nowhere encounter spiritless matter. Thinking remains mere thinking simply because human beings cannot spiritualize thinking enough for their thoughts to master matter and thus fully penetrate material reality.

Schiller is not yet capable of realizing that the life processes really can function as soul processes, nor is he capable of seeing that what functions in the material element as nourishing, warming, and breathing can take shape, be raised to a soul level, and no longer be material, so that the particles of matter disperse due to the power of the concept used to understand material processes. Schiller is equally incapable of looking up to logic so as to not only let it work in him in mere conceptual dialectics, but also to experience the spiritual as its own process, so that it can really enter in a living way into what is otherwise mere knowledge. This happens in the development that can be achieved through initiation. Inherent in Schiller's letters on aesthetics, therefore, is his view that he does not really trust himself to approach concrete things. However, these letters pulse with something we understand more precisely when we attempt to grasp the living through the spiritual and the material through the living.

Thus we see evolution urging us onward in all fields toward what spiritual science is trying to accomplish. When a more or less conceptually structured philosophy appeared at the end of the eighteenth and the beginning of the nineteenth century, the desire for greater concreteness was alive in this philosophy but could not yet be achieved. Because its strength failed for the moment, we fell into crass materialism in the middle of the nineteenth century, taking our efforts and our longings for greater concreteness with us. However, we must grasp the fact that spiritualism cannot consist merely in turning toward the spiritual, but must also include overcoming the material element and recognizing the spirit in matter. This happens through knowledge such as this. You can see that it has completely different consequences, that aesthetic human beings take their place in Earth's evolution in a way that lifts them up above this evolution in a certain respect, into a different world. This is important. People who are aesthetically minded or aesthetically creative are active in a way that is not totally adapted to the Earth. Rather, such people lift the sphere of their being above the sphere of the Earth. This is how aesthetics allows us to penetrate many deep secrets of existence.

On the one hand, saying something like this touches on the loftiest truths, and on the other hand it can sound almost idiotic, crazy

or deranged. But we do not understand life by beating a cowardly retreat in the face of real truths. Take any work of art, perhaps the Sistine Madonna or the Venus de Milo. If it truly is a work of art, it is not entirely of the Earth. It is lifted out of earthly events as a matter of course. And what sort of force is living in it? What is alive in a work such as the Sistine Madonna or Venus de Milo? It is a force that is also present in human beings but is not wholly adapted to the Earth. If everything in human beings were adapted only to the Earth, they would never be able to live on any other plane, would never reach Jupiter, for instance. But not everything is adapted to the Earth, and those with occult sight know that not everything in the human being is in harmony with the earthly human being. These are mysterious forces that will one day give human beings the impetus to go beyond earthly existence. And art can also only be understood as such if we grasp that its task points beyond the mere earthly, beyond mere adaptation to the Earth, to where what is present in the Venus de Milo is real.

To arrive at an approximation of a real view of the world, it is absolutely necessary to keep one thing in mind as we go to meet the future and its spiritual demands. Today we still often live under the misconception that if someone or other says something that is logical and can be confirmed logically, then it is also necessarily of significance for life. But logic, or logistics, by itself is not enough. Because people are generally content to prove something logically, they maintain all kinds of worldviews and philosophical systems that can, of course, be proved logically. No one familiar with logic would doubt that they can be proved logically. But logical proofs contribute nothing for life. Rather, what we think through inwardly must be not only thought out logically, but must also correspond to reality. Mere logic has no validity; only what corresponds to reality is valid.

Let me clarify this through an example. Let's assume that you describe a tree trunk lying here in front of you. Because your way of describing it corresponds to outer reality, you can describe something very correctly and prove to anyone that something is actually lying here. However, you have in fact merely described a lie, because

what you described has no existence. It cannot really exist as a tree trunk that is lying there. The roots, branches, and twigs have been cut away from the trunk, but the piece that is lying there can only come into existence if its branches and flowers and roots come with it. Thinking of the trunk as something real is nonsense. As it manifests here, it is nothing real. It has to be taken together with its inner content, the impulses that enabled it to come about. We must be convinced that what is lying there in front of us as a trunk is a lie, because we only have a truth in front of us if we look at a tree. Logic does not demand that we see a tree trunk as a lie, but reality does. Reality demands that we only see a whole tree as a truth. A crystal is a truth because it can exist on its own in a certain respect, although only in a certain respect; here again, all of this is relative. A crystal is a truth, but a rosebud is a lie if we see it only as a rosebud.

You see, because we do not have this concept of what corresponds to reality, all kinds of things are developing as they are today. Crystallography and also mineralogy, in a pinch, are sciences that correspond to reality, but geology is not, because what geologists describe is as great an abstraction as that tree trunk. Even if it's actually lying there, it is an abstraction and not a reality. What the Earth's crust contains also includes what grows out of it, and is unimaginable without this. Thus it is essential for philosophers to appear who only permit themselves to think abstractions if and when they are also aware of the power of abstracting—that is, when they know that they are making mere abstractions. To think in accordance with reality rather than merely logically is something that must come more and more to the fore.

However, our world's entire evolution changes under the influence of thinking that corresponds to reality. What, from the standpoint of this thinking, is the Venus de Milo or the Sistine Madonna or another work of art? From the earthly viewpoint, it is a lie, not a truth. If we take these things as they are, we are not within the truth. So we need to change our vantage point. Only those who have moved out of the earthly sphere can consider a real work of art in the right way and can really stand in front of a Venus de Milo in a soul-constitution that is completely different from the one they have with

regard to earthly things. What is not real here jolts these people into the realm in which it is real, into the realm of the elemental world, where what is present in the Venus de Milo is real. Because the Venus de Milo possesses the power to tear us free from our merely materialistic way of looking at things, we become able to approach it in a way that corresponds to reality.

I do not want to pursue teleology in any negative sense; far from it. That is why I do not intend to say anything about the purpose of art, for that would be pedantic and philistine. We are not here to talk about the purpose of art. But what art becomes and what brings it about in life are questions we may answer for ourselves. There is no longer enough time left today to answer them completely, so I am simply going to suggest the answers in a few words. Often something can be answered by asking the opposite question, so what would happen if there were no art in the world? In that case, all the forces that now flow into creating and enjoying art would be applied to living in a way that does not correspond to reality. If you eliminated art from human evolution, you would have in its place a quantity of lies equivalent to the quantity of art that had previously existed!

In art, we already encounter the strange and dangerous circumstance that is present at the threshold to the spiritual world. Listen to what comes from beyond the threshold and you will hear that everything has two sides! People who have a sense for what corresponds to reality will, through an aesthetic view of the world, arrive at a higher truth, whereas those who have no sense for what corresponds to reality arrive at untruthfulness through their aesthetic view. There is always a fork in the road, and it is very important to keep this in mind. This is not only the case with regard to occultism, it is also the case with regard to art. A view of the world that corresponds to reality appears as a concomitant of the spiritual life that spiritual science is intended to bring about. Materialism is the cause of a view that does not correspond to reality.

As contradictory as this may seem, it is only contradictory if we judge the world according to what we ourselves imagine rather than according to what is real. We really are living in the midst of an evolution that is becoming further and further removed from the ability

to grasp even an ordinary sensory fact of the physical world. Materialism is the cause of this. In this regard, interesting experiments have been set up, all based on a materialistic way of thinking. But in this field as in many others, what comes from a materialistic way of thinking benefits the human capabilities that we need for a spiritual worldview.

The following experiment was performed: A certain scenario was agreed upon in advance. Someone was to give a lecture and to say something in the course of the lecture that would be insulting and injurious to someone sitting in the auditorium. (I am simply choosing an example; many such experiments were done.) This was agreed upon in advance. Every word of the lecture was spoken exactly as was agreed upon. The person sitting in the auditorium, the one to whom the insult was directed, was to jump up and a fistfight was to ensue, in the course of which the person who had jumped up was to pull out a revolver. That was how things were meant to develop, and it was discussed exactly how various details were to take place. Imagine this completely contrived scene being played out in all its details. Thirty listeners had been invited to attend, and they were no ordinary listeners, but law students in their final semesters and those who had already graduated. The fistfight took place, and these thirty people were then asked to describe what happened. To confirm that things had actually gone exactly as planned, a deposition was also taken from those who had been initiated into the whole process. Thirty witnesses were questioned. All thirty of them had seen it happen, and they were no donkeys; they were educated people who were meant to go out into life and investigate how fistfights and other things of that sort actually take place. Out of the thirty, twenty-six were completely wrong in their account of what they had seen. Only four of them did a halfway decent job. Only four! Experiments like this have been carried out for years to show what kind of weight the testimonies of witnesses in court can carry with regard to the truth. All twenty-six were sitting there; they could all say, "I saw it with my own eyes." We don't even think about what is required in order to correctly describe something that happens before our very eyes!

In order to arrive at a correct view of what happens before our very eyes, we must consider art, because people who are not conscientious with regard to sensory facts will never achieve the responsible conscientiousness that is necessary for grasping spiritual facts. Now see for yourselves whether, under the influence of materialism in today's world, we have much consciousness or much sense for what it means that out of thirty people who saw a so-called fact with their own eyes, twenty-six gave completely false statements about it and only four could give a halfway decent account of what happened. If you keep something like this in mind, you will feel the infinite significance of what a spiritual worldview must accomplish on behalf of everyday life.

Now, you may well ask whether things used to be different. In former times people did not possess our current way of thinking. The Greeks did not yet have this abstract way of thinking, which we actually must have in order to make our way in the world in a modern manner. But nothing depends on our way of thinking; everything depends on the truth. In his own way, Aristotle tried to think about people's aesthetic state of mind and the state of their lives in much more concrete concepts.

In still earlier Greek times, however, when people still had images rather than concepts, this state of mind was grasped much more concretely in an imaginative, clairvoyant way, in imaginations that still came from the mysteries. Then people said that once upon a time, Uranus had been alive. They saw him as everything human beings take in through the head, through the forces that even now, in the form of the domains of the senses, work outward into the outer world. Uranus—all twelve senses—was injured, and drops of blood fell into Maya, the sea, and the foam sprayed up. As we see it, the senses become more alive and send something down into the sea of the life processes. What foams up out of the blood of the senses pulsing down into the life processes that have become soul processes can be compared to what the Greek imagination saw foaming up out of the blood of the injured Uranus as it dropped into the sea. Aphrodite, or Aphrogenea, the goddess of beauty, took shape out of the foam. In this older version of the Aphrodite myth,

in which Aphrodite is the daughter of Uranus and the sea and arises out of the sea foam that is born out of the drops of Uranus's blood, you have an imaginative expression of the aesthetic state of human beings. In fact, this is the most significant imaginative expression of this state and even one of the most significant thoughts of humanity's spiritual evolution.

There is only one more thought that needs to be added to the great thought of Aphrodite in this older myth, in which she is not the child of Zeus and Dione but of Uranus, of his blood and the sea. This other imagination works its way even more deeply into reality—not only into elemental reality but also into physical reality. This must be grasped not only as imagination, but also physically and sense-perceptibly at the same time, and then added to the older imagination. To the Aphrodite myth, the myth of the origin of beauty within humanity, we would have to add the great truth of how archetypal goodness works into humanity through the trickling down of the spirit into Maya-Maria, just as Uranus's drops of blood trickled down into the sea, which is also Maya. This is the birth of what is to be the dawn of the unending rulership of the good, the dawn of the recognition of the spiritual that is both good and true, although it is born at first in a semblance, in beautiful semblance. This is the truth that Schiller meant when he penned the words,

> Only through beauty's dawning
> do you move onward into the land of knowledge!

Moral knowledge was what he primarily had in mind.

You see how many tasks—not merely theoretical tasks but real life tasks—accrue to spiritual science.

5. The Two Sources of Art:
Impressionism and Expressionism

MUNICH, FEBRUARY 15, 1918

"Those to whom nature begins to disclose her revealed mystery feel an irresistible longing for her worthiest exponent, Art." It was certainly out of a profound understanding of the world in general, and above all out of a deep feeling for art, that Goethe coined those words. Without being "un-Goethean," we might complete his statement by adding, "Those to whom Art begins to reveal its mystery feel an almost irresistible antipathy toward its least worthy exponent, the science of aesthetics."

Today, I do not want to present a scientific aesthetic way of looking at things. However, it seems not only permissible but fully in keeping with Goethe's view, as expressed above, to speak about art and the experiences we can have or may have had in relation to it, just as we like to speak of things we have experienced (or may be experiencing) in the company of a good friend.

The term *original sin* is often used in reference to humanity's evolution. I do not intend to discuss the question of whether or not the whole shadow-side of human life can be exhausted by speaking of original sin in the singular. It seems to me, however, that we must speak of two original sins having to do with art creation and appreciation. *Copying* is certainly one of them—that is, to merely imitate, or reproduce, an object of the senses. The other original sin seems to me to be the attempt to express, or represent, the supersensible through art. If we reject both the sensible and the supersensible, it becomes very difficult to approach appreciation or creation of art; yet this does seem to be in keeping with a healthy human sense of

the matter. Anyone who wants art to reflect only the sense-perceptible will not advance far beyond a refined form of illustration, which may indeed be raised to the level of an art, but can never become true art.

A sign of a soul life run wild, so to speak, is a contentedness with the mere illustration, or imitation, of whatever is provided exclusively by the world of the senses. On the other hand, demanding that art embody an idea, something purely spiritual, is a sign of being possessed, in a sense, by one's own understanding and reason. To represent a worldview through poetry or pictures corresponds to an uncultured taste and barbaric human sensibilities. Art itself, however, is firmly anchored in life. If this were not so, its process as a whole would not justify its existence. In contrast to a purely realistic worldview, all sorts of unrealities must be at play in art, as must the various illusions it introduces into life. Art must be deeply rooted in real life, because what it must bring into life is "unreal" to a certain way of understanding things.

It can be said that artistic feeling appears everywhere in life, beyond a certain boundary in our feeling, from a lower limit up to a different, higher one that must be developed in many people. Even when not in the form of art itself, it arises wherever the presence of something supersensible and mysterious is felt within the ordinary sensible existence we confront in the sense-world. It appears whenever a supersensible element (whether a pure thought, pure sensation, pure experience in the spirit) lights up before us in a form perceptible to the senses. This is the form in which the supersensible element chooses to present itself; it is not a question of our having clothed it in empty symbols or dead allegories. The ordinary sense-perceptible element in everyday life already contains a kind of supersensible element, as though spellbound, and this is perceived by anyone whose soul-attitude falls between the two boundaries mentioned above.

We can certainly say that, if someone invites us into a room with red walls, our assumption about the red walls has to do with artistic perception. When I am led into a red room and face the person who invited me there, it seems natural for that person to tell me all sorts

of things that I find valuable and interesting. If this does not happen, I feel that the invitation to the red room was a lie, and I leave unsatisfied. On the other hand, if someone receives me in a blue room and chatters so much that I cannot get a word in edgewise, the whole situation would make me uncomfortable, thinking that this person has conveyed a false impression to me through the very color of the room.

We come across countless examples of this in life. When we meet a woman in a red dress, we experience her as inauthentic if she is too modest. We experience a woman with curly hair as genuine only when she is somewhat impertinent; if she is not, we are disappointed. It goes without saying that this is not necessarily the way things are in real life; life has every right to lead us beyond such illusions. Nevertheless, within certain limits of mood and attitude, we tend to perceive things this way. Of course, such matters cannot be laid out in universal laws either; some people may feel very differently about them. The fact remains, however, that each of us, when confronting things in the sense-world, has a similar feeling that, enchanted within such things, there is something spiritual—a spiritual situation, condition, or mood.

Within this situation there is an inherent expectation of soul that often leads to bitter disappointment in life. And it certainly seems that this requires the creation of a special sphere in life that fulfills such needs. To me, art appears as this special sphere. What art fashions out of the rest of life satisfies just those feelings within the boundaries I've mentioned.

Perhaps the only way to realize what we experience in art is to look more deeply into what happens in the soul either during the creation of art or its enjoyment. If we have lived even a little with art and attempted to come to terms with it, we find that, in a certain sense, the soul-processes I am about to describe in the artist and the art lover are reversed, but are, nevertheless, fundamentally the same. Artists experience in advance what I am trying to describe. They experience one particular soul-process first, and then a second supersedes it. Those who love art, on the other hand, experience the second process first, and only then experience the process with which artists begin.

It seems to me that the difficulty in approaching the psychology of art is due to the fact that people are afraid to descend deep enough into the human soul to understand what it is that actually invokes the need for art. It may also be true that ours is the first age equipped to speak about this need somewhat clearly. Regarding many recent artistic trends, such as impressionism, expressionism, and so on, discussion often arises out of a need that has nothing to do with art. Regardless of what we may think of these trends, however, one thing cannot be denied; never before were artistic perception and life brought up from where they live within the subconscious depths of the soul. Since these artistic trends have appeared, however, these aspects have been brought toward the surface of consciousness. Because of what has been said about such things as impressionism and expressionism, more than ever before we are forced to become interested in the human soul processes that produce and appreciate art. In previous ages, scholarly esthetic concepts were completely divorced from what actually lived in art. More recently, the concepts that have found their way into art scholarship are very close to the creations of modern art in some respects—at least, when compared to former times.

The soul's life is indeed infinitely deeper than generally believed. Very few suspect that, within the subconscious and unconscious depths of our souls, we harbor numerous experiences seldom spoken of in ordinary life. We must descend even deeper into this soul life to discover the mode of soul life that lies between the two boundaries mentioned.

What I am saying today is not meant to be taken too exactly. Nevertheless, our soul life oscillates, as it were, between various conditions that fall into two more or less different types. On the one hand, there is something in the depths of the human soul that wants to flow freely upward, something that often torments the soul, although unconsciously. In a soul that is especially disposed to this direction, something constantly tries to release itself into consciousness as a vision but cannot do so. Indeed, in a person of sound constitution, it should not be able to do so. But, much more than we realize, a soul life predisposed to this mood always tries to transform

itself into vision. A "healthy" soul life simply means that our visionary urge remains just that—an inclination to vision that never actually arises.

This effort toward visions (which is present in each human soul) can be satisfied by offering the soul an external impression or form, such as a sculpture, instead of the pathological vision that cannot occur to a healthy soul. This external work of art, or outer configuration, thus confines in a healthy way what would otherwise be visions to the soul depths. We offer the soul the content of visions, but externally, so to speak. What we offer is truly a work of art only when the legitimate effort toward visions enables us to successfully guess which pictorial or sculptural form we must offer the soul to counterbalance its visionary urge.

It seems that many modern perspectives generally labeled "expressionism" come close to this truth, and their explanations come close to discovering what I have just said; but they do not go far enough. People do not look deeply enough into the human soul and are thus unfamiliar with this irresistible visionary urge present in all of us. When we survey artistic creation and appreciation, we definitely see that the source of one kind of artistic activity corresponds to this human soul need. That source is a certain constitution of the human soul—its urge to have visions welling up spontaneously as mental pictures from within.

This is only the one side, however; there is also another source of the artistic element. This other source arises because within nature itself, spread out around us, there are enchanted secrets that can be discovered only by learning to find our way into these outer mysteries through our feeling, rather than making scientific assumptions about them, which in this case is unnecessary.

When these deep mysteries in the nature around us are spoken out, they may seem very odd to modern human consciousness, yet there is something that will make them increasingly accessible in the future. There is more to nature than the growing, sprouting life that naturally delights a healthy soul. It also includes what we normally call death and destruction. Something in nature constantly destroys and overcomes one life by means of another. Those who sense this

can also perceive (and this is an excellent example) that the natural human figure, as it manifests in outer life, is indeed constantly and mysteriously destroyed by a higher kind of life. This is the secret of all life: constantly and everywhere, lower life is killed off by higher life. The form of the human body, permeated with the human soul and human life, is constantly killed and overcome. We could even say that there is something about the human form that would be very different if it were allowed to pursue its own life. It cannot, however, because a different, higher life exists within it, which kills this life.

Sculptors, when approaching the human figure, sense this secret, if only unconsciously. They discover that the human form wants something not expressed in the body, something destroyed by the higher life of the soul. Out of the human form, they conjure something absent in the actual human being, something concealed by nature. Goethe sensed this somewhat in speaking of "revealed mysteries." We can take this farther and say that this mystery underlies everything in the expanses of nature. Basically, no color or line out in nature appears without something lower being overcome by something higher. And the reverse can also be true; sometimes the higher is overcome by the lower. It is always possible, however, for us to break the spell and to rediscover what has actually been overcome. We then become artistically creative. When we encounter something that has been overcome and then released from its spell, and when we know how to experience it properly, it becomes artistic appreciation.

Let me say this more precisely. Much of Goethe's work that has not yet been brought to light contains very significant truths concerning the human being. Goethe's theory of metamorphosis, for example, begins with the plant's petals, which are merely transformed leaves, and proceeds to all of the forms in nature. When the contents of Goethe's theory of metamorphosis have been made available through a more comprehensive understanding of nature than was possible in Goethe's day—when a comprehensive view is able to unveil nature—this theory will have a much greater capacity for life and a much broader application. We may say that even Goethe's understanding of the theory of metamorphosis was very limited; it can be expanded.

Speaking further of the human figure, we can say, for example, that anyone who even superficially studies a human skeleton, finds that it really consists of two distinct members. (We could take this much farther, but it would lead us too far afield for today.) It is made up of the head and the body's skeleton, upon which the head merely rests, as it were. Taking this perspective a little farther, anyone who has a feeling for the metamorphosis of forms and sees how one form turns into another (in Goethe's meaning when he said that green leaf turns into colored petal) will be able to see that the human head is a whole unto itself. One sees that this is also true of the rest of the organism, and that one is a metamorphosis of the other. In other words, we could say that the rest of the human being, seen from a certain perspective, has the mysterious capability of being transformed into a human head. And the human head, we might say, contains the entire human organism, but in a rounded, more developed form.

But when we can perceive this and, inwardly, truly transform the human organism so that the whole becomes a head, and transform the human head so that it appears as an entire human being, it is a most extraordinary thing that, in each case, the results are quite different. What appears when we transform the head into an entire organism shows us the human being as an ossified, contracted, and narrowed being, taken to the point of sclerosis in every part, so to speak. And when we allow the rest of the organism to work on us so that it becomes a head, what appears is very unlike an ordinary human being. Only the form of its head still reminds us of a human being. Rather than rigidifying certain aspects of potential growth to form the shoulder blades, something appears that tries to become wings. It even tries to grow up over the shoulders, to grow up from the wings and develop above the head, where it appears as the beginnings of a head trying to take hold of the head itself. While this is happening, the aspect that would be an ear in an ordinary human figure expands and unites with the wings. In short, what appears is a kind of spirit form. This spirit form lies enchanted within the human form. It illuminates the mysteries of human nature when we expand the view of which Goethe had an inkling in his theory of metamorphosis.

This example demonstrates that in each of its parts, nature strives to become something quite different from what it presents to our senses—not merely abstractly, but visibly and concretely. If our perception is penetrating enough, we never feel that a form or anything else in nature lacked the possibility of becoming something very different from what it is. Such examples express with particular clarity that in nature, one life is always being overcome, even killed, by a higher life.

We only sense this human double—this duality in human growth; it does not manifest outwardly in us, because something higher, something supersensible, unites these two sides of human nature and balances them so that we see an ordinary human form. The reason nature seems so magical and mysterious to us—not outwardly and spatially, but inwardly and intensively—is that in each of its parts, the intention is infinitely greater than what can actually manifest, because nature assembles and organizes things so that higher life devours subordinate life, permitting only a certain degree of development. Whenever we simply turn our perception in the direction indicated, we find this revealed mystery, the magic that runs through all of nature. Just as our inner efforts move toward visions, this mystery, working from outside, stimulates human beings to transcend nature, to start somewhere and select something particular out of a whole, and then allow nature's intention for one of its parts to shine out. Although not a whole within nature itself, this part has the potential to become a whole.

Allow me to mention at this point that in the Anthroposophical Society's building in Dornach, near Basel, we attempted to accomplish sculpturally what I just described. Working in wood, we tried to create a sculpted group that represents what may be called a representative human being.[1] In this group, what is otherwise merely a potential, suppressed by higher life, is expressed by having the entire form become a gesture that is then brought to rest again. In this sculpture, we attempted to vivify the gesture that is ordinarily suppressed in the human figure and then to bring it to rest again (not

1. This refers to the statue, *The Representative of Humanity.*

the gesture the soul makes, but the gesture that is killed off in the soul, or suppressed by the soul's life). In other words, we attempted first to bring the surface of the human figure into movement through gesture and then bring it to rest again.

In this process, we very naturally came to sense our human asymmetry (the different shapes of our right and left sides) as the potential present in every human being but, as a matter of course, suppressed by higher life. We understood that this potential, this asymmetry, must be accorded greater prominence. In a certain sense, however, giving it greater prominence released what had been held together by a higher life. This connection then had to be reestablished on a different and higher level through humor, and we had to reconcile it with the naturalism of what approaches us from outside. By emphasizing asymmetry and transforming into gesture various things that must then be brought to rest again, we committed an inner offense against naturalism and had to atone artistically for it. We did this by showing what takes place when the human head metamorphoses into a somber, constricting figure, which in turn surrenders to the representative human being. This figure lies at the feet of the representative human being and can therefore be felt to be a member, or part, of that representative being.

Furthermore, we had to create another figure to portray something that seems necessary when the rest of the human figure (rather than the head) becomes as powerful as it might, were it not actually held in check by a higher life. This other figure shows what happens when something is not held back in its development but runs rampant. This may be seen in the potential of the shoulder blades, for example, which, in the formation of a human being, are unconsciously present as a certain luciferic element trying to escape from the human being's essential nature. If, within the human form, such potentials arise out of impulses and desires and assume actual shape instead of being overwhelmed by the higher life of reason and understanding developed and achieved in the human head, we gain the ability to release nature from its spell by again presenting, as parts, what nature does not allow to remain as parts, but destroys in order that such parts serve a higher wholeness.

The hearts of the viewers must achieve something already accomplished by nature. Nature has already done all of this; it has composed the human being by combining various individual elements into a harmonious whole. By releasing what lies spellbound in nature, we divide nature into its supersensible forces. There is no need for a dry, allegorical, or rational but inartistic search for a reasoned idea, something merely supersensible and spiritual behind natural objects. We simply ask nature: How would your individual parts develop if your growth were not interrupted by a higher life? Whereas a supersensible element is otherwise spellbound within the sense-perceptible, we become capable of releasing it from its sensory bonds. We learn to view the world in such a way that we experience the supersensible active within the sensible.

In all the various intentions and endeavors that are now only at the beginning stages and that are labeled *impressionism*, I think we may sense the longing of our time to really discover and give form to nature's secrets of this sort, to know the sensible-supersensible. We feel that what is actually taking place in art, in appreciating it as well as in creating it, must be raised to a higher level of consciousness now than was the case in earlier ages in the history of art. What is taking place now is something that has always been striven for—either the urge for vision is suppressed within but satisfied from without, or nature's inner, hidden process is made outwardly visible. In fact, these are the two sources of all art.

What is characterized by these two currents has always been the more or less unconscious aim of art, although in Raphael's time this striving naturally took a different form from that of Cézanne or Hodler in our day. Whether artists were conscious of it or not, they have always drawn from these two streams of art. In former times, it was completely natural for artists themselves to remain unaware of these sensible-supersensible forces that, working beneath the surface of their conscious soul life, strove to release nature from her enchantment.

Thus if we stand in front of one of Raphael's works and are willing to attempt to interpret what otherwise remains unexpressed down there in the obscurity of our subconscious, we always have the feeling

of coming to terms with something in the work of art, and indirectly with Raphael himself. This may give rise to the feeling, although it need not be expressed even within our own souls, that we were already together with Raphael during an earlier life on Earth and learned many things from him that entered deeply into our souls. Our connection to the soul of Raphael from centuries ago has become entirely subconscious but suddenly comes to life again when we stand in front of his works. We find ourselves face to face with something that took place long ago between our own souls and Raphael's.

We get no such feeling from artists of more recent times. Modern artists lead us in spirit into their studios, as it were, and what we meet there lies very close to consciousness and belongs to the immediate present. This is because the one process that seeks satisfaction in art is the longing, or the need, that has arisen in our time for mental pictures to rise in us, which are really suppressed visions. In the other approach to art, we are also confronted, although still in a rather elementary form, with the dissolution of what is otherwise united in nature. It is first dissolved and then put back together again, in an imitation of nature's own process.

This gives infinite significance to modern painters' attempts to study the various colors and the various shades of light and to discover how ultimately every effect of light and shade of color aims at becoming more than it can be when it is forced into a whole, where it is killed off by a higher life. How many different attempts they have made, starting from a feeling for this, to bring light to life, to deal with light in a way that releases what ordinarily remains spellbound within it when it has to serve to bring about ordinary processes and events in nature. We are only at the very beginnings in all this, but these beginnings correspond to a legitimate yearning and will probably enable us to experience how—speaking in purely artistic terms—something becomes first a mystery and then a revealed mystery. Expressed like this, it sounds rather trite, but many trite-sounding things conceal mysteries. We must simply draw closer to these mysteries, and especially to the ability to perceive them. What I am aiming at answers the question of why it is actually impossible

to paint fire and draw air. Clearly, we cannot paint fire in reality. We would have to have very unpainterly sensibilities to want to paint that glittering, glimmering life that can only be held fast by the light. And it should never occur to anyone to want to paint lightning, let alone the air!

On the other hand, we must admit that everything contained in the light conceals something that is striving to become like fire. It strives to be able to say something and to make an impression that wells up out of the light and out of each single shade of color, just as human speech wells up out of the human organism. Every effect of light has something to say, both to us and to each neighboring effect of light. In each effect of light is a life that is overcome and killed off by the larger context. If we guide our perception in this direction, we discover what the color is feeling and saying. This is what we are beginning to look for in this age of outdoor painting.

If we discover this secret of color, our perception widens and we find that what I have just been saying is basically perfectly valid, although not for all colors because the different colors speak in different ways. The warm colors, the reds and yellows, actually attack us and tell us a lot, while the blues provide the painting with the transition to form. Through the blue, we are already entering into the realm of form and of the form-creating soul. Often we have stopped halfway on the way to making such discoveries. Many of Signac's pictures give us so little satisfaction—although they may be quite satisfying in other respects—because the blue in them is always treated in the same way as yellow or red, for example, without any awareness that a blue patch placed next to a yellow one represents quite a different value from a red patch next to yellow. This appears rather trivial to anyone with a sense for color, and yet in a deeper sense these are secrets that we are just beginning to discover. Blue and purple are colors that take the picture right out of the expressive realm into that of inner perspective. It is quite conceivable to produce a wonderfully strong perspective without "drawing" in any way, simply through the use of blue alongside the other colors in the picture.

Proceeding still further in this direction, we then come to recognize that in drawing, outline is to arise from the color, to become

the deed of the color itself. If we wish to transform our use of color by bringing it into movement, so that in some mysterious way the drawing is inherent in the very way the colors are handled, we will notice that this is especially possible with blue but less possible with yellow or red, which are not suited to being handled in a way that contains inner movement and moves from one point to another. If we want a form that is inwardly in motion—in flight, for instance— and that may therefore alternate inwardly between being small and being large, and if we avoid taking rational principles or unjustifiable intellectual aesthetics as our starting point and instead allow ourselves to be guided by feeling perception, we will find ourselves absolutely obliged to make use of various shades of blue and bring them into movement. We will notice that it is only really possible for a line to come about, for a drawing to appear, for figures to come about, when we continue with what we began by allowing the blue tints to change into movement. Whenever we move from the realm of painting and color into that of figure and form, we carry the sense-perceptible over into something fundamentally supersensible. When we move from the warm colors through the blue, the drawing starts to happen somehow, and the warm colors provide the transition to something that is both sense-perceptible and supersensible, to something with a tinge of the supersensible. This is because a color always has something to say, always has a supersensible soul. The more we enter into the drawing, the more we find ourselves entering an abstract supersensible element which, since it is making its appearance in the sense-perceptible world, must therefore take on sense-perceptible form.

I can only give you a suggestion of these things today. Clearly, however, this is the way to understand how the creative, artistic use of color and drawing in one particular area already contains what I permitted myself to describe as being held spellbound by nature. From this spell we release the supersensible element that is concealed within the physical and killed off by a higher life.

If we look at sculpture, we will find that there are always two interpretations for both surfaces and lines. I will only be speaking about one of these interpretations, however. To begin with, healthy

sensibilities will not tolerate having a sculpted surface remain what it is in the natural human figure, for example, where it is killed off by the human soul, by human life—that is to say, by something higher. Having first spiritually extracted the life or the soul from the human form, we must then look for the life inherent in the surface, for the soul of the form itself. We discover how to find this when we bend the surface not only once, but twice, so that we have a double-bent curve.[2] We notice that by doing this, we can make the form begin to speak. We also notice the deep subconscious inclination to synthesize, in contrast a more analytical tendency. Sense-perceptible nature breaks down into something that is genuinely both sense-perceptible and supersensible and that is merely overcome at higher levels of life. Within the soul-boundaries of which we have spoken, we experience an elemental urge to free nature from enchantment—to break apart the supersensible elements that, in many different ways, are held together in sense-perceptible nature, as the many crystals of a geode may be broken apart. But just when this splitting or analyzing or breaking down of nature is at its most pronounced in our subconscious, the synthesizing tendency within us may also be especially strong.

The strange thing about this is that anyone capable of observing people in the right way will be able to make the discovery that we actually use one of our senses in a very one-sided way. When we see colors, forms, and effects of light, we are developing our sense of sight in a one-sided way. In the eye, something like a mysterious sense of touch is always present; the eye is also always feeling as it sees. In ordinary life, however, this is suppressed. Because of the eye's one-sided development, those who are able to perceive such things always feel the urge to experience the eye's suppressed sense of touch, as well as the sense of another's I-being and the sense of self-movement, which develops when we move through space and feel our limbs move. When we look at other people, we feel how these suppressed aspects of the eye are aroused in them, although they remain

2. This is commonly known as a "saddle-form," in which convex and concave curved surfaces interpenetrate.

quiescent. What is thus aroused in the person we are looking at, but is suppressed by the one-sided nature of the eye, is what sculptors try to take and transform.

To create such forms, which are in fact seen by the eye, but so dimly seen that they remain in our subconscious, sculptors make use of the point where the sense of touch passes directly over into the sense of sight. They must therefore at least attempt to first dissolve the static form, which is otherwise an object only to our one-sided sense of sight, and bring it into gesture. Having freed this gesture from enchantment, they must then bring it back to a state of rest. From one aspect, this soul process, which is active in us when we create or enjoy art—arousing something in one direction and bringing it to rest again in the other—is always like our inhaling and exhaling in ordinary life. When this process is extracted from the human soul, it sometimes makes a grotesque impression, although it also calls forth a feeling of the endless vastness of what lies spellbound in nature. The evolution of art, as is evident in certain initial attempts made in recent decades and especially in those of today, is moving in the direction of grasping these secrets and more or less unconsciously giving form to these things. There is no need to speak at length on these matters, for they will be worked out ever more in art itself.

It can even be said that certain artists have perceived something of what follows, whether consciously or unconsciously. The late Gustav Klimt, for instance, is best understood if we make these assumptions about his perceptions and reasoning. Some day we will perceive the following: Suppose someone feels the urge to paint a pretty woman. Some sort of image of her must then take shape in the artist's soul. However, a sensitive observer can perceive that the very moment the artist makes some inner image of her, she is spiritually, supersensibly robbed of her life. As soon as we decide to paint a pretty woman, we take something away from her and kill her in spirit. Otherwise, we would be able to simply look at the woman as she is in life without having to give form to what can be represented artistically. Artistically, we must first kill the woman and then summon up enough humor to inwardly bring her back to life. But in fact, a naturalistic artist cannot do this. Naturalism suffers from a lack of humor, and

thus presents us with many cadavers, with things that kill all the higher life in nature. And it lacks the humor to re-enliven what it has to kill in the first place. In the case of a charming woman, she often appears to have been not only mysteriously killed, but also ill-treated beforehand.

This deadening process always moves in one direction and is connected with the need to recreate the element of a higher life that overcomes what is trying to come into existence in nature. In the soul of both the creative artist and the art lover, there is always first a deadening and then a re-enlivening through humor. If we want to paint some fun-loving young peasant up on the mountain, there is no need to faithfully copy what we see. First and foremost, we must understand that our artistic conception has killed the young peasant, or at least stunned him, and that we must rouse this stiff image to life once again by supplying it with a gesture that brings the details of what has been killed off back into the context of the rest of nature. This is what Hodler attempted to do, and it is absolutely in line with the longings of today's artists.

It can be said that the two sources of art correspond to the most profound subconscious needs of the human soul. When we satisfy what tries to become a vision, but cannot be permitted to succeed in a healthy human constitution, this always develops into a more or less expressionistic form of art, although the name is of no particular importance. And it leads to impressionism when we create something that reunites the sensible-supersensible components, which have been dissolved, or imbue with new supersensible life something that one has robbed of its life. These two needs of the human soul have always been the sources of art. However, it is only in recent times that because of humanity's general evolution, the first need has been pursued in an expressionistic way and the second in an impressionistic manner. This will probably become especially pronounced as we hasten toward the future. Artistic sensibilities in the future will depend on expanding our feeling, not merely our rational consciousness, for these two directions. To avoid certain misunderstandings, it must be emphasized again and again that these two trends do not represent anything in the least unhealthy. It would be unhealthy for

humanity, however, if our visionary urge, which is completely healthy and natural within certain limits, were not satisfied through artistic expression. It would be equally unhealthy if what is always going on in our subconscious, namely the analyzing of nature into her sensible-supersensible elements, is not constantly imbued with a higher life by truly artistic humor so that we can recreate nature's creative accomplishments in our works of art.

I firmly believe that in many respects the artistic process lies very deep down in the subconscious; however, under certain circumstances it can be significant for our life if we have very strong and intense conceptions of the artistic process that can actually flow over into feeling and thus affect our souls in a way that no weak conceptions ever could. If these two sources of art make themselves felt in our souls in accordance with our feeling, we will realize how healthy Goethe's perceptions were when, at a certain moment in life (such things are always one-sided) he said that music represents the ultimate in art because it is totally incapable of imitating anything in nature; in its own element, it is both content and form. (As I said, this is one-sided, for every art can reach these heights. Characterizations, however, are always one-sided.) In its inherent element, every art becomes both content and form if we penetrate nature's secrets not through clever reasoning but in the manner indicated today, in which we discover the sensible within the sense-perceptible. I believe that the process taking place in the soul is often quite mysterious when we become attentive to this "sensible-supersensible" element in nature, to use Goethe's expression. And although he called this element a "revealed mystery," it can be discovered only when our subconscious soul-forces fully immerse themselves in nature.

On the one hand, there is the visionary tendency in the soul in which supersensible experience arises from within in an attempt to be released. On the other hand, there is the experience of the spiritual, or supersensible, in the outer world. The activity of perceiving the spiritual in the outer world can, for spiritual science, be called *intuition*, whereas the activity of making inner vision outwardly visible is *imagination*. Through imagination we place what is within us outside, so that the inner becomes outer in us. In intuition, however,

we move outside of ourselves and step down into the world. This does not become a reality, however, as long as we are unable to release what nature holds spellbound and always tries to overcome by means of a higher life. When we insert ourselves into the natural element that has been released from enchantment, we are living in intuitions. But inasmuch as these intuitions make themselves felt in art, they are connected with subtle experiences the soul can have when it becomes one with things outside itself.

This is why Goethe, speaking about his own art, which was actually highly impressionistic, could say to a friend, "I want to tell you something that may explain the relationship people have to what I have created. It cannot become popular. In reality, it can be understood only by those who have experienced something similar and have been in a similar situation." Goethe possessed this artistic perception. In poetic form, it is especially apparent in the second part of *Faust*, which is still not well understood. He was already capable of this artistic perception, of looking for the sensible-supersensible element in the recognition that every part in nature is attempting to transcend itself and become a whole, to metamorphose into something different with which it is united as a product of nature, but is then killed off by a higher life.

When we penetrate nature this way, we enter a true reality in a much higher sense than ordinary consciousness believes. What we discover offers the best proof that art need not succumb to the dual aberrations of merely copying the sense-perceptible or merely representing the spiritual. True art is capable of giving form to and expressing the sense-perceptible in the supersensible and the supersensible in the sense-perceptible. We become naturalists in the truest sense when we can recognize in the sense-perceptible the supersensible, because we grasp nature only when we perceive the supersensible active in the sensible. Thus, I believe a genuine feeling for art can take shape in our souls in a way that also stimulates our understanding and enjoyment of art. To a certain extent, we can develop our own ability to dwell in art, as artists. In any case, an intensive and profound study of the sensible-supersensible element and of its fulfillment in art will make comprehensible to us the

deeply felt words of Goethe, words that arose out of a profound understanding of the world. I opened this lecture with these words and will now bring it to a close with them. Once we are able to grasp in depth the relationship of art to genuine reality, including super-sensible reality, these words will provide a comprehensive picture of how human beings relate to art. We cannot possibly exist without the supersensible. Even the sense-perceptible would become dead for us if we did not live in the supersensible. Because of this, our own needs will lead us to make what Goethe said ever more of a reality:

"Those to whom nature begins to disclose her revealed mystery feel an irresistible longing for her worthiest exponent, art."

6. The Building at Dornach

BERLIN, JULY 3, 1918

In the weeks to come, we will draw conclusions from our recent considerations. Today I want to present something that connects them with the character of our building at Dornach, though a close connection may not be obvious.

Because of its special character, this building has a role in what we recognize as the spiritual evolution of humanity, in the present and into the future. This moment in human development between the present and future has a characteristic that until now was only a seed. We have tried to illuminate this from many different viewpoints. Today let's consider how the particular aims of spiritual science can be expressed through the building devoted to it.

To a certain extent, current events may be considered externally, as they are by those who base all their knowledge, or worldview, on purely exterior considerations. Nevertheless, there are cogent reasons for regarding today's events from an inner, spiritual perspective. These events—which have matured over long periods, and will continue in the future in a different form—may be pictured correctly when we observe them spiritually. I will begin with something that seems very material, and try to use it as a living example of how we may view spiritually certain impulses that are always active in us at the present time.

Among those rare individuals who in the last few decades have occasionally had an overview of events, we may find some technicians. One of these was Reuleaux who in 1884, from his own materialistic perspective, expressed some thoughts about certain characteristics of

contemporary culture.[1] He divided contemporary humanity into two groups. In one he placed those who are entirely restricted to a "natural" mode of life; in the other, those who pursued, as he called it, a "manganistic" way. He derived the term *manganistic* from "magic," or what endeavors to intervene through the cosmic forces in human life. I will briefly explore the basis of this categorization of humanity, from the current perspective.

In earlier times all humanity was, in a certain sense, "natural," and the greater portion still is. The rest, Europeans (especially those in Central and Western Europe) and Americans, are manganistic. Remember that this "natural" civilization still predominates in the world. It is significant that the so-called manganistic civilization has developed fully only during the last century.

The most paradoxical outcome of this new civilization is that many more "hands," as it were, have been hurried into earthly existence than there are human beings on the globe. This is because of the prodigious increase in use during the last fifty years of machines among the minority of humankind. Obviously, much work today is done by machine; but it is somewhat astonishing to calculate, as we can do, the extent to which mechanization is actually replacing human effort. One can figure how many million tons of coal are turned into machine power annually. By translating this coal output into terms of human power, one can calculate how many people would be needed to do that work. We find that to accomplish what the machines do would require no less than 540 million human beings working twelve hours a day. It is therefore not quite correct to say that there are only one and a half billion inhabitants on Earth, since machines have added 540 million to the population.

Thus, there are many more "hands" available than those of flesh and blood, because for a minority of humankind all this manganistic work is done by machines. Indeed, during the last century, the human race has not only increased to the extent shown by statistics, but the working power of 540 million more people must also be

1. Franz Reuleaux (1829–1905), in a lecture at the Lower Austrian Commercial Union, November 14, 1884.

considered. Truly, we Europeans and Americans (not counting Eastern Europeans) are surrounded by a form of labor that continually extends its influences over our daily life more than we think, and replaces human strength.

People in the West are extremely proud of this accomplishment, especially the following aspect. By simply comparing the output of machinery with that of the numerous peoples who live on a more natural level and make little use of machines, we find that Europe and America produce significantly more than all the rest of humanity. Here we can say that to accomplish the work done by the machines, 540 million people would have to work twelve hours a day. That is very significant. It is modern civilization's proud achievement and has various consequences.

To understand the underlying meaning of this, we need only look at an example of "natural" civilization projecting deeply into the "magical"—matches, for example. The oldest among us may still recall a time when matches were scarce, and when fire was wanted flint and steel were used to produce a spark for igniting tinder. This leads us back to a much older way of producing fire, when a great deal of human energy was used to twist a "burning stick" in another piece of wood to produce fire, which is now done with a box of matches. If we compare this "natural" method with today's manganistic method, we can see another peculiarity of our "magical" civilization. We have lost sight of the laws with which human beings were once in touch.

In looking at the example of the primitive way of producing fire, we see how such labor was inwardly related to human beings themselves and to their personal achievements. Fire resulted directly from their work and was intimately and personally connected with them. Today all of this is pushed to the background. Since a physical, mechanical, or chemical process replaces it today, nature's own process (in which the spiritual plays a part) has become remote from direct human action.

We constantly hear that, through some new technology, human beings have compelled natural forces to serve them. Such a statement is justified from one perspective, but it is extremely one-sided and incomplete. In everything accomplished by machine power (taking

this in a broader sense, which includes the use of chemical energy), not only is natural energy made to serve humanity, but the natural event in its deep connections with the essential impulses of the world is disregarded. When using machinery, the natural event is gradually withdrawn from human understanding, and this implies a robbery of humankind itself.

Through technology, something deathly spreads over nature's living face; the living thrill that formerly passed directly from nature into human labor is banished. As we consider how human beings extract death from nature to incorporate it into their "magical" civilization, you will not be very surprised if I now relate spiritual science with what is a purely natural science.

From his viewpoint, Reuleaux correctly asserts that humankind's latest advance consists of harnessing nature's forces to its service. Ultimately, however, we must remember that machines literally replace human strength. It is not simply a question of a process that causes visible results, but it is very important, from the spiritual perspective, in that it creates 540 million imaginary people. Human energy is crystallized in all this; human intellect, but only human intellect, has been poured into it and works in it. We are surrounded by intellect detached from the human being. As soon as we free what should be connected with humanity, the forces that we know through spiritual science as *ahrimanic* take possession of it. The 540 million imaginary people on the Earth are just so many receptacles for ahrimanic forces, and this fact must not be ignored.

Connected with the purely external advance of our civilization are the ahrimanic forces—those same forces found in the Mephistopheles nature, since this is closely allied with Ahriman. Furthermore, nothing exists in the universe without its opposite; never one pole without the other. The ahrimanic in such things as the machinery of earthly industry is balanced exactly in the spiritual realm by the luciferic element. The purely ahrimanic is never found alone; but, to the same degree that it manifests visibly on Earth (as just described), the luciferic element also appears, woven through this entire civilization, which is already permeated with the ahrimanic. To the same extent that the imaginary "hands" are brought

into existence and the ahrimanic civilization hardens on Earth, spiritual correlations work into the human will, or human intentions, impulses, passions, and dispositions.

Here on Earth are ahrimanic machines, and within the spiritual stream enfolding us, for each machine is a luciferic spiritual being! As we produce our machines, we descend into the realm of death, which has for the first time become outwardly visible in this ahrimanic civilization. Invisible to this ahrimanic civilization, a luciferic one arises as its reflection. This means that, to the same degree that machines are manufactured, earthly humankind is permeated in its morality, or ethics, and its social impulses with Lucifer's mode of thinking. One cannot arise without the other; that is the pattern of the world.

We can see, therefore, that the point is not to "flee from Ahriman" or "avoid Lucifer." Their condition of being at opposite poles is necessarily connected with the development of modern civilization. Considered spiritually, this is the activity of our culture, and henceforth we will have to view matters increasingly from this perspective.

Now, it is very interesting that, while he outlines it so clearly, Reuleaux the engineer also refers to various other things and waxes enthusiastic over the "magical advance" of humanity—and from his perspective, his enthusiasm is fully justified; as I always reemphasize, spiritual science has no reason for being reactionary. In particular, he mentions that modern human beings—especially in the European and American civilizations—who are placed as such within a new world, urgently need stronger forces to cultivate the spiritual life. Ancient human beings, with their "natural" culture, were much closer in their personal working life to the intimacies of nature. Of course, Reuleaux doesn't use the terms *luciferic* and *ahrimanic*, but describes only what I mentioned at the beginning of this lecture. It is very easy to discriminate between what I have added and what the scientist of the modern materialistic world says.

Reuleaux indicates, for example, that if art is to grow further, it needs stronger esthetic impulses than required during times of a more instinctive development. An interesting belief is at the back of his mind (the naive belief, as he puts it) that when confronted with machinery's assault, which he readily admits destroys art, the soul will

need to attain a more profound experience of esthetic laws. In his naivete, he has no inkling that before this can happen, the human soul must be inspired by stronger artistic forces than those of the past. Even though technology fights against everything spiritual won by humanity, it is a misconception to assume that this may be compensated for solely through a profound experience of past spiritual forces; that is impossible, definitely impossible. What is really necessary are, with the emergence of human civilization on the physical plane, other stronger, more spiritual forces playing into spiritual life. And failing that, human beings will inevitably, for all practical purposes, fall victim to materialism, even though in theory they may work against it.

You can see, therefore, that if one begins with the impulses of contemporary culture and reflects on the inner nature of current events, it may be concluded that art needs a new stimulus, the influx of a new impulse. Furthermore, if we are firmly convinced that our anthroposophical spiritual science, when properly directed, will bring a new impulse into the old spiritual culture of humanity, we may certainly conclude that art will also share in this stimulus.

Such was the goal of the project (obviously very imperfect) for our building at Dornach. Of course, its imperfections must be acknowledged; it is merely a first attempt. Perhaps we are justified, however, in our belief that it is the first step on a path that must continue. When we ourselves are no longer in the physical body, others who follow in this work will perhaps do it better. But the impulse for the Dornach building had to be given now. The building will be properly understood only by those who, instead of applying an absolute standard, familiarize themselves somewhat with its history. I will speak of this today, because we are continually confronted with antiquated misconceptions.

You are aware that in Munich, since 1909, our work has included the presentation of certain mystery plays. Their goal is to reveal through dramatic art the forces active in our worldview. Courses and lectures (always well-attended) were scheduled around these artistic presentations in Munich. Among our friends, therefore, the idea arose to provide an appropriate home for our spiritual endeavors. Please remember that this suggestion came from them, not from me.

The building really began because of the shortage of space observed by a number of our friends, and it is obvious that, once such a building was conceived, it was bound to be constructed according to our worldview. In Munich, only an interior structure was specifically envisioned, because it would be surrounded by several houses, occupied by friends who could settle there. The houses would have closed in the building, so that it would have been very plain and out of view.

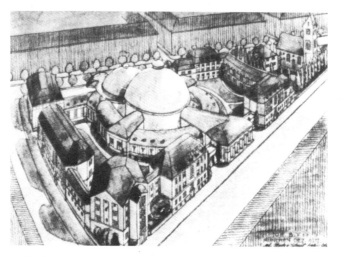

Architect's drawing for the proposed building in Munich
by Carl Schmid-Curtius

The whole building was conceived of as a piece of "inner architecture." *Inner architecture*, in this case, has meaning only when it provides an enclosure, or frame, for what happens within. It was to be genuinely artistic, however—not a copy, but an artistic expression of the activities within. I have always compared (perhaps lightly but not inappropriately) the architectural concept of our building with that of a cake mold, which is for the sake of the cake inside. The outer shape is correct only when it encloses and molds the cake properly. In this case, the "cake mold" is the frame for the whole activity of our spiritual science, for the art that belongs to it, and for everything spoken, heard, and experienced within it. All of that is the "cake," and everything else is the "mold." It must be expressed in the interior architecture. That was the initial idea.

After great difficulty in the arrangements for building on the site already acquired in Munich, we discovered that we were opposed—not only by the police or local authorities, but by the Munich Society of Arts. Indeed, it was done in such a way that we felt our establishment in Munich was objected to by these worthy individuals, who, nevertheless, would not tell us what they really wanted. We were thus continually obliged to change our plan, and this really could have continued for a decade. Finally, the day came when we were forced to give up our hopes in Munich and, instead, use a building site in Solothurn, which was provided through the kind offer of one of our friends.

Thus, it happened that, in the Canton of Solothurn, on a hill in Dornach, near Basel, we began to build. We gave up the idea of encircling houses, and the building had to be visible from all sides. The impulse arose, and the zeal was there, to do it quickly. Without fundamentally recasting the scheme already sketched for the interior, all I could do was try to combine the exterior with the preexisting plans for the inside. This gave rise to many deficiencies (and no one was more conscious of this than I), but that is not the main issue. As I have said, the great thing is that we took the first step.

Now I would like to draw your attention to a few thoughts that will clarify the peculiar characteristics of this building, and thus you may see the relationship between it and our whole movement, scientific as well as spiritual. The unbiased listener will first be struck by the fact that the partition walls are obviously conceived very differently than those of ordinary public buildings. Artistically, walls that enclose a building have typically been thought of as "closing off" space. Walls, or boundary walls, are always conceived of in this way, and the architectural and ornamental work on walls has always related to this idea—that the purpose of an outer wall is to enclose. This dogma is breached in the Dornach building—not physically, of course, but artistically. The concept of the outer wall, as it appears there, is not for the purpose of closing off space, but to open up the space to the universe, or macrocosm. Anyone who stands in this space should feel, through the very walls, that the building expands into the universe, or macrocosm. Everything should represent relationships to the universe. That is the concept in the formation of the wall itself.

The same is true of the pillars, which in several ways complement the walls and all of the carved work—the pillars' bases and capitals and the architraves. This is the concept of a wall that is transparent to the soul, the very opposite of a wall that encloses space. Anyone standing inside should experience the freedom of the infinite universe. Naturally, if anything is to be done within this space, the enclosure is physically present. The forms of the physical enclosure, however, can be regarded in such a way that, negating themselves, they are dissolved through their artistic makeup.

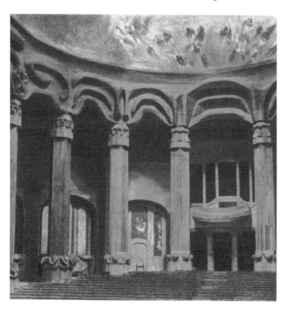

First Goetheanum interior

Everything else is related to this. The laws of symmetry and proportion usually followed when building must be disregarded in light of this primary concept. Strictly speaking, the Dornach building has only one axis of symmetry, going from west to east, and everything is ordered along this axis. The pillars, a certain distance from the walls, are each given different capitals motifs; only in pairs, right and left are the capitals and moldings alike. Starting at the main entrance, the first two pillars are the same, in capital, base, and architrave. The second pair vary in the design of their pillars, capitals, and architrave, and so

on throughout the length of the building. In the subjects of the capitals and bases, therefore, it becomes possible to depict *evolution*. The capital of each pillar always evolves from the previous one, just as the organically complete form develops from the incomplete. The ordinary symmetrical equality is dissolved into a progressive development.

The entire building consists of two main parts, whose ground plans are essentially circular, enclosed above by domes. The domes are cut, however, so that they conjoin one another. Their bases thus form incomplete circles, each lacking a small segment, where they are joined.

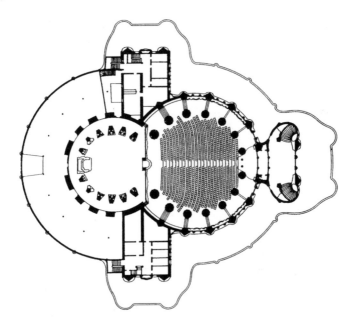

Plan of first Goetheanum at auditorium level

The whole is built to form two circular spaces—a larger and a smaller. The larger space is for the auditorium, the smaller is for the mystery plays and similar events. The rostrum and curtain are located where the two circles unite. Technically, it is very interesting work to make the two domes intersect and cut into each other. The building, which is completely in wood, rests on a concrete substructure that contains only cloakrooms with concrete steps leading to the main building.

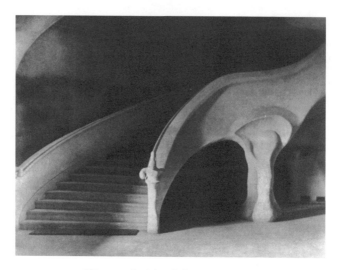

The north side of the west stairs

Along each wall of the greater space under the large dome, there are seven pillars, with six in the smaller space. Thus, in the latter, which forms a kind of platform, there are twelve pillars, compared to fourteen in the larger space. The sculpted designs of the pillars develop progressively, in a way that amazed me as I worked on them. While I made the model and shaped the pillars and their capitals, I was astonished at one thing in particular. It is not a matter of something "symbolic." People who have spoken and written about the building are incorrect when they speak of various inserted symbols, and that anthroposophists use symbols. No symbol, such as they speak of, can be found in the entire building.

Each part of the whole arises from the concept in its entirety. Not even the smallest part signifies (I use *signify* in its worst sense) anything that is not related to the concept of art. This unbroken development of the designs on the capitals and architraves arose from artistic perception—one form out of its predecessor. As I developed one from the other, a reflection of evolution arose out of itself, a reflection of the true evolution of nature, though not as Darwinism understands it. This was not the intention, but it arose spontaneously. Thus, I recognized with amazement how, for example, particular human organs are simpler than those in certain species of lower

animals. I have often pointed out that evolution does not consist of complication; the human eye is more perfected because it is simpler than the eye of an animal. I noticed that after the fourth of these designs, a simplification was necessary. The one that was more perfect emerged precisely as the less complex.

This was not the only thing that struck me. Comparing the first pillar with the seventh, the second with the sixth, the third with the fifth, I was surprised to see that a remarkable correspondence came to light. In the carvings there are naturally some raised surfaces, with others that are hollowed out. These were elaborated upon purely through intuition and visual sense. Nevertheless, by taking the capital and base of the seventh, and thinking of the whole and its separate parts, one could superimpose the high surfaces of the seventh on the hollow surfaces of the first, and vice versa. The raised surfaces of the first exactly fitted the hollow surfaces of the seventh. I mean this as a matter of convex and concave, of course. Symmetry resulted, not merely from the external, but from within. In fact, during this interchange and through working it out sculpturally, something arose as though bringing architecture into movement and sculpture into repose. It was wood carving and architecture simultaneously.

The entire building has a concrete foundation, with inner motifs that will surprise people when they first visit. Naturally, they come with preconceived ideas, comparing it with what they have seen elsewhere, and they are astonished. Many, not knowing what to make of it, have called it "futuristic." The lines of the concrete portion are designed according to the capacities of the new material, concrete, to express artistic form. Within the concrete frame, however, the attempt is made to construct pillar-like supports. These came, on their own, to look like elementary beings, gnome-like and growing up out of the fissured earth, while at the same time supporting the weight above. Thus, it can be seen that they are for support, but that they bear the heavier part, push it, throw it back, while they do this differently for the lighter parts. Such is the substructure of the wooden section.

In Munich, our only consideration would have been inner architecture, but windows were necessary for the Dornach building. To understand these, I would ask you to first try to grasp the whole idea

of the wooden building. By itself, it really has no claims to being artistic; it is not a work of art. It is artistic, however, in relation to the pillars, walls, and windows. The entire building, which is to have no decorative character and be constructed without decorative purpose, is intended to arouse through every line and contour certain experiences and thoughts in those who see it. The eye—the *sensitive* eye—must trace the direction of the lines and contours. The *soul's* inner experience, when one's gaze takes in the artistic efforts, is aroused first by a "work of art" carved in wood. It arises first in human feeling. The concrete foundation and the wooden portion are the preparation for it. The human being must bring a work of art into being through appreciation of the forms. What has been worked into the wood is the more "spiritual" aspect of the building, so to speak. A work of art really comes into existence only when the soul of the listener or speaker is inwardly receptive.

It was then necessary to provide windows for the space between each pair of pillars. A certain quality of work in the glass was necessary in order that the windows carry the idea of the building. The appropriate designs were etched into plain, colored sheets of glass with something like a large dentist's drill. Thus, enough was ground away to vary the thickness in the thick sheets of glass, and this produced the design. Each sheet is of one color, and the colors are arranged to produce a harmonious sequence.

From the entrance, one may see in the building a window of the same color on each side of the axis of symmetry, so that the color harmony evolves. Yet, the window, as a "work of art," is incomplete; it becomes complete only when the sun shines through it, so that in the window scheme something is created as a work of art through the cooperation of living nature, from outside. Etched into these sheets of glass you will find much of the content of our spiritual science, imaginatively perceived—the dreaming human being, one who is awake to true being, various creation mysteries, and so on. All of this—in terms of perception, not in symbols—is artistically intended, yet completed only by sunlight.

Thus, through yet another means we tried to transcend the sense of enclosed space. In the wood carving, architecture, and sculpture,

pure forms are used to give the soul the impression of overcoming enclosed space and going beyond it. Initially, this effect is conveyed directly to the senses through the windows. Union with the sunlight shining through, streaming from the cosmos through the visible world, is related to these windows. There is a certain correspondence between these two parts of the whole. Through the collaboration of light and etched glass, an external work of art manifests for the soul, whereas carved wood provides a spiritual element that is experienced as a work of art within the human soul itself.

Rudolf Steiner's motif for the violet window in the north; sketch and finished window by Assia Turgenieff

The third aspect is the paintings in the domes. Their subjects are also taken from our spiritual science. The paintings express the substance of our worldview, at least as it relates to a grand macrocosmic period of time. This is the physical "part," so to speak, because in painting (for certain inner reasons that would take us too far afield) one must present everything directly. Color itself must express what it has to convey, and so also the lines. Only through the *content* can the endeavor be made to go beyond the borders of the dome into the macrocosm; this is how it

is arrived at. Everything painted there really belongs to the macrocosm, and its meaning is presented directly to the eye.

We tried to produce the light force necessary for painting the designs by using colors derived from pure vegetable substances, which have their own light force. Of course, if it hadn't been for the war, we might have had greater success; but it was only a beginning. Naturally, the whole style of painting had to fit our view. In attempting to paint the spiritual essence of the world, we are concerned not with forms that are considered externally illuminated, but with self-luminous forms. This requires a very different approach to painting. For example, the human aura cannot be painted in the same way as a physical shape, which is drawn with light and shade according to the light source. With an aura we are concerned with something self-illuminated, and therefore the character of the painting must be very different.

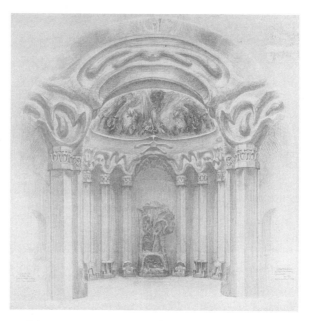

View of the small cupola by William Scott Pyle

In a few rough strokes and to the best of my ability without a model, I have given you some idea of what our building is intended to be. It is as a whole oriented from west to east, the axis of symmetry

lying in that direction between the pillars and cutting into the small circular space containing the stage at the east end. There, between the sixth pillar on either side, stands a group of figures carved in wood. This group is intended to represent artistically something that I would say lies at the heart of the worldview we hold based on spiritual science—something that must necessarily enter humanity's spiritual perspective, now and in the future. Humankind must learn to understand that everything important for shaping world destiny and human life flows within these three streams: the ordinary spiritual stream into which human life is placed; the luciferic stream; and the ahrimanic stream. Within everything—in the foundation of the physical world as much as in the manifestations of spiritual events—divine evolution interweaves with luciferic and ahrimanic evolution. This is expressed in our carved group (again, not symbolically, but artistically). A group carved in wood.

The idea for this came to me, but I believe that what I have understood as thought is not yet clear to me in terms of its occult basis. It may well be, however, that future spiritual investigation will reveal this. Nevertheless, it certainly seems correct to me that it is better to portray ancient themes in stone or metal, and all Christian themes in wood (and ours is primarily Christian). I must confess that I have always been inclined to think of the group in Rome at Saint Peter's— Michelangelo's *Pieta*—as being made of wood. Only in this way do I believe it can represent what it should express; and this also applies to other Christian sculpture I've seen. There is no doubt something behind this feeling, but I have not arrived at the reason for it, yet. Therefore, our group has been conceived and executed in wood.

The leading figure is a kind of representative of humanity, a being expressing humankind's divine manifestation. I am glad whenever anyone, looking at this figure, has the feeling that it represents Jesus Christ. It seemed to me inartistic to take an underlying approach such as: "I will carve a figure of Jesus Christ." I wanted to produce just what I did. The result may be a feeling in the beholder that it is Jesus Christ; I would be very happy if that were true, but the artistic idea did not intend a representation of Him. The idea is based strictly on artistic form, or manner of expression. To begin by carving a figure of Jesus

Christ would have been merely descriptive and programmatic. The artistic thought must be based on form, or at least sculpture.

The group as a whole is about thirty feet high (eight and a half meters), and the main figure is raised somewhat, with rocks behind and below (see page 44). From the rocks below, which are a little hollowed, an Ahriman figure grows, half lying within a hole in the rock with its head above. Upon this slightly hollowed rock stands the main figure. Above the Ahriman figure and to the left of the viewer, a second Ahriman figure rises from the rocks, and in this way the Ahriman figure is repeated.

Above the figure to the left is a Lucifer figure. A kind of artistic relationship exists between the Lucifer above and the Ahriman below. Nearby, above the main figure and to the viewer's right is another Lucifer figure. Lucifer is thus represented twice as well. This other Lucifer, because he is injured, is falling. The right hand and arm point to Ahriman below and cause him to despair. The whole group is designed (and I hope it conveys this experience) so that the central figure is not in the least adversarial, but is intended by its gesture to express only love. Lucifer and Ahriman cannot endure such love near them. As it comes near, Ahriman feels despair, the destruction of his very being, and Lucifer falls. Their inner nature is revealed in their gestures.

Of course, these figures were not easily created, because—partially in the case of the main figure and completely for Lucifer and Ahriman—the spiritual had to be depicted; and spirit is most difficult to express in carving. The intention, however, was to accomplish what is especially necessary for our purpose—to evoke the significance of the form (though it must remain an artistically conceived form) in gesture and countenance. Human beings can use gesture and countenance only in a very limited sense. Lucifer and Ahriman are all gesture and countenance. Spiritual figures are not limited by form; there is no such thing as a complete spiritual figure. Any attempt to model spirit is just like trying to model lightning. The form of a spiritual being changes from moment to moment, and this must be considered. Try to hold a spiritual shape still, even for a moment (as one might when representing a form at rest), and you will be unsuccessful; the result will be a mere frozen figure. In such cases, therefore, gesture

alone must be reproduced. This is entirely true of Lucifer and Ahriman; it also had to be attempted somewhat in the central figure, which is of course a physical form, Jesus Christ. Now I would like to show you a few pictures to give you an idea of the main group. [Some slides were shown.]

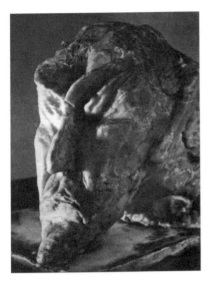

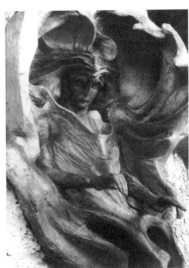

Model for the head of Ahriman *The Lucifer figure*

First is the head of Ahriman, exactly as the figure initially came to me—a person who is all head (recall the threefold division of the human being into head-being, breast-being, and limb-being), and therefore an instrument for the most skilled inventiveness, intellectuality, and craft. The Ahriman figure is intended to express this; his head, as you see it here, is true spirit, to use a paradox. (But you know how often a paradox results from a spiritual description.) He is actually like the model—faithful in spirit, artistically true to nature; he had to sit for his portrait!

Next is Lucifer, as seen on the left. To understand him, we must picture what appears in a very peculiar way as his form. The most ahrimanic characteristic in human beings must be eliminated; the head vanishes. But the ears and muscles of the ears, or outer ear, are substantially enlarged and, of course, spiritualized. They are depicted

as wings that form an organ entwined around the body, with wings spreading at the same time from the larynx. Thus, the head, wings, and ears form a single organ. These wings, or head organ, present themselves as the figure of Lucifer, who is an extended larynx. The larynx becomes a complete figure, which connects, through a kind of wing, with the ear. We must imagine Lucifer, therefore, as a being who receives the music of the spheres—takes it in through this ear and wing combination. Without any help from the individual, the cosmos, or music of the spheres itself, speaks through this same organ, whose frontal extension is the larynx. This is another metamorphosis of the human form—an organ comprised of larynx, ear, and wing. Thus, only the head is indicated.

As for Ahriman, when viewing the figure at Dornach, you will discover that it is developed from what one imagines as form. Lucifer's head, however, appears (although you can hardly imagine your own in this form) as something of the greatest beauty. Ahrimanic nature is intellectual, or clever, but appears ugly in the world. Between them, they comprise everything in the world. Youth and childhood are more luciferic, and old age is more ahrimanic. The impulses of the past lean toward the luciferic, whereas those of the future lean toward the ahrimanic. Women are more inclined to Lucifer, and men to Ahriman. These two streams embrace everything.

Above Lucifer an elemental being arises, as it were, from the rock. The group was complete, but when released from its framework, it was noticed, oddly enough, that its center of gravity (as viewed, of course) seemed too far to the right. Something therefore had to be added to correct the imbalance, evidently brought about by karma. It was not a matter of merely adding a mass of rocks, but of following through the idea of the carving. Therefore, this elemental being sprang into existence, growing in a sense from the rocks.

One notices something about this being, although it is only slightly indicated. In this being one may see how asymmetry comes into play and how directly spiritual forms are in question. It's expression is limited in the physical; the left eye is not very different from the right; the same is true of the ear and nostril. But as we enter directly into the spiritual realm, the etheric body is seen to work in a completely

different way on the other side. The left side of the etheric body is very different from the right—a fact that becomes evident immediately when attempting to portray spiritual forms. When you walk around this being, you get a different perspective from each viewpoint. But, in this asymmetry, you see a kind of necessity, since it expresses the demeanor of the being peeking over the rocks and looking down with a kind of humor at the group below.

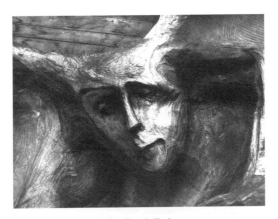

The Rock Being

There is good reason for this humorous air of looking over the rocks. The proper attitude for rising into the higher world is never sentimental; mere sentimentality is useless for one who wants to work upward to the spiritual heights in the right way, because it always has the flavor of egoism. When the highest spiritual subjects are being discussed, you know how often I mix something with our considerations—not to take you out of the mood, but simply to banish any egoistic sentimentality. Genuine ascent to the spiritual must be endeavored with purity of soul (which is never devoid of humor), not with an egoistic, sentimental motive.

As for the central figure's head in profile, it showed itself out of necessity. The head also had to be asymmetrical, because in this figure the intention was to show more than how the right and left hands, the right arm, and so on reflect the soul's inner being, but how in a being who lives entirely in the soul, as Jesus Christ did, this reflection is seen also in the shape of the brow and in the figure as a whole, and far more

so than it could in the demeanor of an ordinary human being. We tried reversing the slide (contrary to the way it really is) to see if its appearance would be very different. This proved to be the case—the impression was different. The artistic intention of the asymmetry will be apparent only when the head of the central figure is completed.

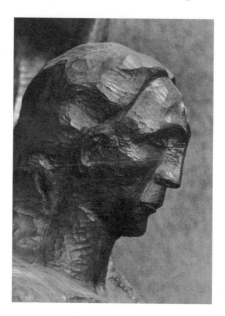

The Christ head

It is correct to say that, in working out something like this, all artistic issues must be considered; the smallest part is connected with the far-reaching whole. Take, for example, how the surface is handled. Life especially must be engendered here. The surface is curved once and curved again. This particular handling—doubling the curve— draws life from the surface itself, and is perceived only in its fashioning. Thus, what we were aiming for involved not just what was represented, but a particular artistic approach to the subject. The intent was not to represent the ahrimanic, the luciferic, or human nature by copying in a narrative style, as it were. Rather, they must be taken hold of through the fingertips chiseling the surface, through the entire artistic molding. The expansion that people feel when extending their view into the spiritual widens again on the other side into the artistic.

This group is placed at the east end of the building in the space for the stage. Above it spreads the vault of the smaller dome, decorated as I have described, continuing the theme of the group through painting. The Christ, Lucifer, and Ahriman are all there, and we have tried to make the colors artistically expressive in themselves. The variety of treatment shows how all these aspects can be brought out purely through artistic means.

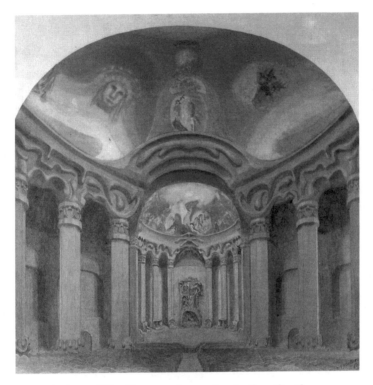

Painting of The Group sculpture in the first Goetheanum

All this was accomplished only because a number of our friends worked on the building with great devotion. Very odd things have been said about the building. Perhaps one day, however, due credit will be given to the way the friends of our movement—especially the artists—gave themselves with selfless devotion and found their way wonderfully into this cosmic view clothed in artistic form. The

building is incomplete, of course. Except for the group, it might have been completed if these catastrophic world events had not stood in the way.[2]

I wanted to present to you, in brief, disjointed sentences, an idea of our intentions, and I hope you have acquired at least some small idea of the building that, we may all expect, will one day stand completed in Dornach. The goal of doing this is to insert an artistic rendering of our cosmic view into the spiritual life of the present and future. People will see that this view is not merely a theory, but consists of real living forces. Perhaps it could be called a theory if we had produced something symbolic. But, since this perspective can give birth to art, it is different; it is something vital. It will give birth to still other things; it must fructify other domains of life. There is widespread longing for a spiritual life appropriate for our time, but in this realm we encounter much that is visionary, irrational, barren, and of little value. I hope that people will learn to distinguish between what is born from the demands of the present spiritual age and what arises from confusion and the like. We see so-called spiritual movements springing up everywhere like mushrooms. But one must learn to distinguish between what truly springs from the genuine forces of human spiritual development and what is erroneous talk about spiritual things; there are many forms of this today. Naturally, we notice it, since it shows that people are working toward the spirit. If we keep our eyes open, we will see this desire everywhere for spiritual things.

A metaphysical novel by a Mr. Korf has just appeared—terrible stuff. It is actually a mischievous piece of propaganda for the "star in the East." I hope that such things, which express in their own way a distortion of human metaphysical aspirations, will be distinguished from those created from the essential strivings of one's being, precisely adapted to our time.

2. Steiner refers to World War I, which made it difficult to travel and created a shortage of materials.

7. The Supersensible Origin of the Arts

DORNACH, SEPTEMBER 12, 1920

In order to meet the requirements of evolution, humankind must achieve an expansion of consciousness with regard to all domains of life. At present, human beings relate their deeds and actions only to events that take place between birth and death; what takes place between birth and death is all we wonder about. But for our life to become healthy again, it will be essential for us to take an active interest in more than just this particular period of life, which we anyway spend under quite exceptional circumstances. Our life encompasses not only what we are and do between birth and death, but also what we are and do between death and rebirth. In the present materialistic age we are relatively unaware of the influence of the life we have spent between death and rebirth, prior to the present life we entered by way of conception and birth. We are equally unaware of how things that occur during our present life in the physical body point toward the life we are going to lead after death. Today we will point out a number of things that show how certain cultural areas will acquire a quite new relationship to the whole of human life through the fact that human consciousness must and will extend to embrace our life in the supersensible worlds as well.

I believe that a certain question may arise in our minds if we consider the entire scope of our artistic life. Today, let's take a look at supersensible life from this viewpoint. This will lead us to something that we will also be able to put to good use later, when we turn our attention to social life.

The generally recognized fine arts are sculpture, architecture, painting, poetry, and music; on the basis of our anthroposophical life and knowledge, we are in the process of adding to these the art of eurythmy. The question I have in mind, the question that might occur to us with regard to our artistic life, is "What is the actual positive reason for introducing art into our lives?" It is only during our materialistic age that art has come to deal with the immediate reality of life between birth and death. But of course in this materialistic age we have forgotten the supersensible origin of art, so our aim now, more or less, is to copy what our senses see out there in nature. But those who really have a deeper feeling for nature on the one hand and for art on the other will certainly not be able to agree with this naturalism, with art copying nature. For we must question again and again whether even the best landscape painter, for instance, can in any way conjure up the beauty of a natural landscape on canvas. Faced with even a very well executed naturalistic painting of a landscape, anyone of sound taste must have the feeling I expressed in the prologue to my first mystery drama, *The Portal of Initiation*—that no copy of nature will ever equal nature itself. People of fine feeling will inevitably find something repellant in naturalism. They will surely only see justification in the aspect of art that transcends nature in some way and attempts, at least in the way the subject is portrayed, to supply something other than what nature itself can present to us. But how do we human beings come to create art in the first place? Why do we transcend nature in sculpture or in poetry?

If we develop a sense for the interconnectedness of all things, we will see how in sculpture, for instance, artists work to capture the human form in a very particular way. Through the way they mold the form, they attempt to give expression to what is specifically human. We will see that their statues cannot simply incorporate the natural human form as it stands before them, imbued with the soul and with the breath and flush of life, with everything we can see in the human being in addition to the form itself. But I believe that sculptors of human figures will gradually achieve an elevated and very particular way of feeling. There is no doubt in my mind that

the Greek sculptors had this; it has simply been lost in our naturalistic age.

It seems to me that sculptors who work on the human form have a quite different feeling while shaping the head than while fashioning the rest of the body. In the work of the sculptor, these two things—sculpting the head and sculpting the rest of the body—are totally dissimilar. To put it rather drastically, I might say that in working to sculpt the human head, sculptors have the feeling of being constantly sucked in by the medium as if it were trying to absorb them, while in fashioning the rest of the body artistically, they have the feeling of pushing into it from outside, of pressing and poking it everywhere without justification. They have the feeling that they are fashioning the body and modeling its shapes from the outside. In fashioning the body, they feel that they are working from the outside in, while in fashioning the head they feel that they are working from the inside out.

It seems to me that this feeling is specific to sculpture. It was certainly still felt by Greek artists and has only been lost in our naturalistic age now that we have become enslaved by the model. If we orient ourselves toward the supersensible in our intention to sculpt the human form, we must wonder where such a feeling comes from.

Much deeper questions are connected to all this, but before I go into it any further, there is something else I would like to mention. Just think about the strong feeling of a certain inwardness that we get when we experience sculpture and architecture, in spite of the fact that these appear to be externally fashioned from external materials. In architecture, we have an inner experience of dynamics, of how a pillar supports a beam or leads over into the form of its capital. We have an inner experience of external form. And in the case of sculpture our experience is similar.

But this is not the case with music, and especially not with poetry. In the case of prose, we can just about manage to retain the words in our larynx, but in the case of poetry it seems very clear to me—again, to put it rather drastically—that words cast in iambic or trochaic rhythms and put into rhyme soar, so that we have to run after them. They populate the atmosphere around us more than that within us.

We experience poetry much more externally than architecture or sculpture, for instance. And the same is probably also true of music if we apply our feeling to it. Musical tones also enliven our entire surroundings. We actually forget space and time, or at least space, and are lifted out of ourselves in a moral experience. We don't have the urge to run after the figures we create, as is the case in poetry, but we do have the feeling that we must swim out into an indeterminate element that is spreading out everywhere, and that in the process we ourselves are dissolving.

You see how we begin to distinguish certain nuances of feeling in connection with the whole essence of art. These feelings are quite specific in character. I believe that what I have just been describing to you is something that can be appreciated by people who have a subtle appreciation of art; however, this is not the case if we are looking at a crystal or some other natural mineral, for instance, or a plant, an animal, or even an actual physical human being. Our feelings and sensations with regard to the whole external realm of physical nature as perceived through our senses are quite different from the feelings and sensations that arise in connection with our experience of various types of art, as just described.

Supersensible knowledge can be described as a transformation of ordinary abstract knowledge into a seeing knowledge that points to experiential knowledge. It is nonsense to require the same sort of logical, pedantic, narrow-minded proof of things in higher realms as is desirable in the crasser realms of the sciences, mathematics, and so forth. If you live your way into the feelings that arise when you enter the realm of art, you gradually come to remarkable inner states of soul. Very specific subtle states of soul arise if you really inwardly experience tracing the dynamics and mechanics in architecture or the rounded forms of sculpture. Your inner feeling life follows a remarkable path. As you move along it, you are confronted with a soul experience that is very similar to memory. If you experience remembering or memory, you will notice how much your inner sensing of architecture and sculpture resembles the inner process of remembering, although remembering happens on a higher level. In other words, by way of your feeling for architecture and sculpture, you gradually

approach the soul experience known to spiritual research as remembering prebirth conditions. In fact, the way you live in relationship to the entire cosmos between death and a new birth—feeling yourself move as soul-spirit or spirit-soul in directions that intersect the paths of certain beings and maintain an equilibrium with others—such experiences are remembered subconsciously for the time being, and this is what architecture and sculpture reproduce.

And if we reexperience this singular state of affairs in sculpture and architecture and do so with inner presence of mind, then we discover that our real aim in sculpture and architecture is none other than to somehow conjure, in the physical sense-world, the experiences we had in the spiritual world before conception and birth. If we do not build houses merely according to utilitarian principles, but really make them architecturally beautiful, we fashion their dynamic proportions as they arise from our recollections of the experiences of equilibrium and rhythmically moving forms that we had in the time between death and our new birth.

In this way, we discover how human beings actually came to develop architecture and sculpture as forms of art. Our experiences between death and rebirth were floating around in our soul. We wanted to somehow bring them forth and have them standing visibly in front of us, and so we created architecture and sculpture. That humanity brought forth architecture and sculpture in the course of cultural evolution can essentially be attributed to the fact that life between death and rebirth goes on working and that within us we will it to be so. Just as the spider spins, so human beings desire to bring forth and give form to their experience between death and a new birth. Prebirth experiences are carried over into the world of the physical senses. What we see if we survey the architectural and sculptural works of art created by humankind is nothing other than an embodiment of unconscious recollections of our life between death and rebirth.

Now we have a realistic answer to the question of why human beings create art. If we were not supersensible beings who enter this life through conception and birth, we would surely not engage in either sculpture or architecture.

And we know what singular connections exist between two—or let's say three—successive lives on Earth. In its formative forces, what is now your head is a transformation of the body—not including the head—that you had in your previous incarnation, while what is now your body will transform itself into your head in your next incarnation. The human head, however, has a completely different meaning: The head is old; it is the former body transformed. The forces experienced between a person's most recent death and present birth shaped this external form of the head, but the body is the carrier of forces that are now brewing and will take on form in the next incarnation.

This is why sculptors feel differently about the head than about the rest of the body. In the case of the head, they feel somewhat as if it were trying to pull them into itself because it is formed out of the previous incarnation by forces that are embedded in its present form. In the case of the body, sculptors feel more as if they would like to get inside it while modeling it, to press themselves into it, because the body contains the spiritual forces that lead beyond death and into the next incarnation. Sculptors sense this radical difference in the human form between what belongs to the past and what belongs to the future especially keenly. The art of sculpture expresses the formative forces of the physical body and how they carry over from one incarnation to the next. On the other hand, what lies deeper down—in the etheric body, which is the bearer of our equilibrium and of our dynamic forces—comes out more strongly in the art of architecture.

So you see, it is impossible to grasp human life in its entirety without looking at supersensible life; that is, without seriously answering the question of how we come to develop architecture and sculpture. People's unwillingness to look at the supersensible world stems from the fact that they also do not attempt to look at the things of this world in the right way.

Generally speaking, what are people's attitude toward the arts that reveal a spiritual world? Very much like that of a dog toward hu-man speech, actually. The dog hears human speech and presumably supposes it to be a bark. Unless it happens to be a particularly intelligent performing animal, such as the one that excited a lot of interest some

time ago among people who concern themselves with such useless tricks, it doesn't understand the meaning that lies in the sounds. This is the attitude of human beings toward the arts, which really speak about the supersensible world we once experienced: We do not behold in them what they really reveal.

Let's look at poetry, for instance. Poetry emerges clearly for those who can really feel their way into it, although we must keep in mind—to paraphrase Lichtenberg—that ninety-nine percent of the poetry that is written is unnecessary for human happiness on this globe and is not really art. The real art of poetry emerges from the whole human being. And what does poetry do? It is not content to stop at prose, but shapes it by bringing meter and rhythm into it. It does something that ordinary prosaic people consider superfluous to their way of life—it adds form to something that would convey the intended meaning even without the form. If you listen to a really artistic recitation of poetry and begin to sense what the poet has made out of the prose content, you will again discover the remarkable character of this sensation. We cannot experience the mere content of a poem, its prose content, as poetry. What we experience as poetry is how the words sweep along in iambus, trochee, or anapest and how the sounds are repeated in alliteration, assonance, or various forms of rhyme. We experience many other things in how the prosaic content has been given form. This is what must be brought out in recitation. But nowadays, when people give a recitation that merely brings out the prose content, however profound, they think they are being artistic!

Now if you can really look at this special nuance of feeling that comprises your feeling for poetry, you will come to the point of saying that this does indeed go beyond ordinary feeling, because ordinary feeling adheres to things in the world of the senses, while shaping things poetically does not. I expressed this earlier by saying that when words have been given poetic form, they dwell more in the atmosphere around us, or that we want to rush outside of ourselves to really experience the poet's words.

This happens because in poetry we are giving form to something that cannot be experienced between birth and death. We are giving

form to something that is of the soul, something we can do without if we only want to live between birth and death. It's quite easy to live your entire life with only a dry prosaic content. But why do we feel the need to add rhythm, assonance, alliteration, and rhyme to this dry prosaic content? Because we have more within us than we need to make it to our death, and we want to provide a form for this excess while we are still living. Thus we anticipate the life that will follow death. Because we already carry within us what is to follow after death, we feel the urge not only to speak but to speak poetically. Therefore, just as sculpture and architecture are connected with life before birth, with the forces that we carry with us from our prebirth life, so poetry is connected with life after death, with the forces that are already present in us for our life after death.

It is primarily the I-being, as it lives this life between birth and death and then passes through the gates of death and continues to live, that already carries within it the forces that give expression to the art of poetry. And the astral body, already alive here in the world of sound, is what shapes the world of sound into melody and harmony, which we do not find in life in the external physical world. This astral body already contains within it what it will experience after death. You know that the astral body we carry within us lives on only for a while after death before we lay it aside. Nevertheless, this astral body contains the actual element of music. It contains it in the way it experiences music in its life-element, the air, between birth and death. We need air if we are to have a medium for experiencing music.

After death, when we reach the point of laying aside the astral body, we also lay aside everything of a musical nature that reminds us of this life on Earth. But at this cosmic moment music is transformed into the music of the spheres. We become independent of what we formerly experienced as music through the medium of the air; we lift ourselves up and live our way into the music of the spheres. What we experience here as music in the air is the music of the spheres up there. The reflection of this higher music makes its way into the element of air; it condenses into what we experience as earthly music. We imprint it on our astral body, on what we give

form to and reexperience as long as we have an astral body. After death, when we lay aside our astral body, the musical experience in us—if you will pardon the banal expression—switches over to the music of the spheres. In music and poetry we anticipate what our world and our existence will be after death. We experience the supersensible world in two directions. This is how these four forms of art present themselves to us.

And what about painting? There is another spiritual world that lies behind the world of our senses. Crudely materialistic physicists or biologists speak of atoms and molecules lying behind the world of the senses. But it is not molecules and atoms, it is spiritual beings. It is a world of spirit, the world we pass through between falling asleep and waking up. This world, which we bring with us out of sleep, is what really inspires us when we paint and what makes us altogether capable of depicting on canvas or walls the spiritual world that surrounds us in space. For this reason, we must take great care to paint out of color rather than out of line, because the line is a lie in painting. The line always belongs to the memory of life before birth. If we are to paint in a state of consciousness that has expanded into the world of spirit, we must paint what comes from color. And we know that color is experienced in the astral world. When we enter the world we pass through between falling asleep and waking up, we experience this element of color. And when we want to create color harmonies and put color on canvas, what urges us on is the experience of pushing what we have gone through between falling asleep and waking up into our waking physical bodies, allowing it to flow into our waking physical bodies. This is what we attempt to paint on our canvases.

Here again, what appears in painting is a depiction of something supersensible. Thus in each case the arts point to the supersensible. For anyone with an appropriate sense for it, painting becomes a revelation of the spiritual world that borders us in space and permeates us from space. This is the world we find ourselves in between falling asleep and awakening. Sculpture and architecture bear witness to the spiritual world where we lived between death and a new birth, music and poetry to how we will go through life after death. This is how

our participation in the spiritual world makes its way into our ordinary physical life on Earth.

If we have a narrow-minded view of the arts we create during life and see them as being connected only to the period between birth and death, we actually deprive artistic creativity of all meaning. For artistic creativity most certainly means carrying supersensible spiritual worlds into the physical world of the senses. We bring architecture, sculpture, painting, music, and poetry into the world of physical experience simply because we feel the pressure of what we carry within us from pre-earthly existence, because when awake we feel the pressure of what we carry within us as a result of our spiritual life during sleep, and because we feel the pressure of something already in us that will shape us after death. That people usually do not speak about supersensible worlds simply stems from the fact that they do not understand the world of the senses, either. And above all, they do not understand something that was once known to the spiritual culture of humanity before it was lost and became an external phenomenon, namely art.

If we learn to understand art, it becomes a real proof of human immortality and of life before birth. This is what we need in order to expand our consciousness beyond the horizon of birth and death, so that we can link what we have during life on the physical Earth to the life that transcends the physical plane.

If we work creatively out of such knowledge as the spiritual science of anthroposophy, which aims to understand the spiritual world and to receive it into our ideas and thoughts, into our feelings, perceptions, and will, it will prepare the ground for an art that synthesizes in some way what precedes birth and what follows death.

Let's consider the art of eurythmy, where we set the human body itself in motion. What exactly are we setting in motion? We are setting the human organism in motion; we are making its limbs move. The limbs, more than any other part of the human body, are what passe over into the life of the next incarnation. They point to the future, to what comes after death. But how do we shape the limb movements we bring forth in eurythmy? In the sense realm and in the supersensible realm we study how the larynx and all the speech

organs have been brought over from the previous life and shaped by the intellectual potentials of the head and the feeling potentials of the chest. We directly link what precedes birth with what follows death. In a certain sense, we take from earthly life only the physical medium, the actual human being who is the tool or instrument for eurythmy. But we allow this human being to make manifest what we study inwardly, what is already prepared in us as a result of previous lives; we transfer this to our limbs, which are the part of us where life after death is being shaped in advance. Eurythmy shapes and moves the human organism in a way that furnishes direct external proof of our participation in the supersensible world. In having people do eurythmy, we link them directly to the supersensible world.

Wherever art is developed on the basis of a truly artistic attitude, it bears witness to our connection to the supersensible worlds. And if in our time we human beings are called upon to take the gods into our own soul forces, as it were, so that we no longer wait in pious faith for the gods to give us one thing or another, but try instead to take action as though the gods were living in our active will, then the time has indeed come, if humankind will only experience it, when we must take the step from external, objectively formed arts, as it were, to an art form that will assume quite different dimensions and forms in the future, an art form that portrays the supersensible world directly. How could it be otherwise? Spiritual science itself wants to present the supersensible directly, so it is bound to use its resources to create an art of this kind.

As for its educational applications, people who are educated along these lines will gradually come to find it quite natural to believe that they are supersensible beings, because they move their hands, arms, and legs in such a way that the forces of the supersensible world are active in them. It is the soul of the human being, the supersensible soul, that begins to move in eurythmy. It is the living expression of the supersensible that comes to light in eurythmy movements.

Everything spiritual science brings us is really in inner harmony with itself. On the one hand, it brings us these things so that we may more deeply and intensely comprehend the life we are engaged in, so that we may learn to turn our gaze to the living proof of the reality

of existence before birth and after death. On the other hand, it introduces our supersensible element into our will.

This is the inner cohesiveness underlying an anthroposophically oriented spiritual scientific striving. This is how spiritual science will expand human consciousness. It will no longer be possible for people to make their way through the world as they have been doing in the age of materialism, when they have been able to survey only what takes place between birth and death. Although they may also believe in something else that promises bliss and redemption, they can form no concept of this "something else." They can only listen to sentimental sermons about it; in actuality it is empty of content. Through spiritual science, human beings are meant to receive real content from the spiritual world once again. We are meant to be released from the life of abstraction, from the life that refuses to go beyond the perceptions and thoughts that lie between birth and death, from a life that at most takes in some indefinite verbal indications of the spiritual world. Spiritual science will infuse us with a consciousness that will widen our horizon and enable us to be aware of the supersensible world even as we live and work in the physical world.

It is true enough that we go through the world today knowing at, say, the age of thirty that the foundation for what we are now was laid in us when we were ten or fifteen. This much we can remember. If we read something at age thirty, we remember that the present moment is linked to the time twenty-two or twenty-three years ago when we were learning to read. But what we do not notice is that between birth and death we constantly have pulsing within us the experiences we underwent between our last death and our present birth. Let's look at what has been born out of these forces in architecture and in sculpture. If we understand this correctly, we will also be able to apply it to our lives in the right way and to achieve once again a sense of how prose is fashioned into the rhythm, meter, rhyme, alliteration, and assonance of poetry, even though this may be considered superfluous to ordinary prosaic life. Then we will form the right link between this special nuance of feeling and the immortal kernel of our being which we carry with us through death. We will say that it would be impossible for anyone to become a poet unless all human

beings possessed the actual creative element of the poet, namely the force that already resides within us but does not become outwardly alive until after death.

This draws the supersensible into our ordinary consciousness, which must expand again if humanity does not intend to sink further into the depths we have plunged into as a result of a contracted consciousness that makes us live only in what happens between birth and death, allowing us at most to hear preaching about what is present in the supersensible world.

You see, we encounter spiritual science everywhere, whenever we speak about the most important cultural needs of our time.

8. Anthroposophy and the Visual Arts

THE HAGUE, APRIL 9, 1922

What I have to say today will, in a certain sense, be a break in the flow of this lecture series. Today I will attempt an overview of artistic creativity from the perspective of scientific observation. On the other hand, it will become evident from the content of this lecture that it is no mere interlude between what I have said during the past few days and what I have to say in the days to come; indeed, it will contribute to illuminating this as a whole.

After the anthroposophical movement had been active for some time, the conviction grew in a number of its members that the movement should have a building of its own. Eventually, due to all kinds of circumstances that I need not mention here, a site was selected on a hill in the Juras in Dornach, near Ba sel, Switzerland, and the Goetheanum, the Free School for anthroposophical spiritual science, is now being erected there. Although not completely finished, it is at least usable for lectures and some of our work can be carried out there.

At this point I would like to speak only about the inner circumstances that led to this building. If any other contemporary cultural movement had decided to erect a building of its own, what would have been done to make the building come about? They would have consulted an architect, or several architects, and would have erected a building in the classical style or the Renaissance style or the Gothic style or any of the other traditional styles of architecture. Artists would have been called upon to create paintings and sculptures to decorate the building, according to what is being done here and there nowadays in the various arts.

None of this could happen in the case of the Dornach building of the Free School for Spiritual Science. That would have contradicted the entire intent and the innermost nature of the anthroposophical worldview. This worldview has no intention of being theoretical in a one-sided way or of being something that expresses universal laws in a collection of ideas. Instead, it attempts to be something that arises from, and exists for, the whole human being. On the one hand, it attempts to be easily expressible in the thought forms we are accustomed to as representing any other worldview, but it also attempts to be something much more comprehensive. It wants to be able to speak from the whole scope of human nature—not just from a theoretical and scientific spirit, but out of an artistic spirit and out of a religious, social, or ethical spirit—and to do so in each instance in a way that is absolutely in line with real-life interests in the areas in question.

I have often expressed the task that was foreseen for the Goetheanum in Dornach in a rather trivial way by comparing it to a nut with the kernel inside and the shell all around it. We cannot possibly imagine that the furrows and convolutions of the shell result from different laws than the furrows and convolutions of the kernel. Both issue from a single being, as it were. The shell that covers the nut results from the same laws as the kernel itself. When the Dornach building with its double cupola was being built, the issue was to create, in architecture, sculpture, and painting, a shell for the work of the anthroposophical worldview that would be carried out inside it. Just as it is possible to stand at the podium in Dornach and use the language of thoughts to speak about what can be seen in supersensible worlds, it must also be possible to allow the architecture, sculpture, and painting that frame this anthroposophical worldview to proceed from the same spirit.

There is a great danger involved in this, namely the danger of having ideas about things and then expressing these ideas outwardly in a form that is simply symbolic or even crudely allegorical, as is frequently the case when worldviews attempt to make the step into outer representation. The symbols or allegories that then come about are not artistic at all; on the contrary, they make a mockery of truly

artistic sensibilities. Above all else, it must be stated that the anthroposophical worldview wants nothing to do with this symbolical or allegorical non-art or anti-art. This worldview intends to take as its source an inner cultural life so rich that it can find fulfillment in authentic artistic creations rather than in allegory or symbolism. There is not one single symbol or allegory to be seen in Dornach. All the artistic representations are derived from the artistic process of seeing, from the process of molding forms, from creating out of the element of color in painting. This all came about because of a fully artistic view that had nothing to do with what is usually expressed by people coming and asking, "What does this mean? What does that mean?" There is not one single form in Dornach that is intended to "mean" something in this sense. Each single form is supposed to *be* something in a real artistic sense; it is intended to express itself, to mean itself. The people who are now coming to Dornach and claiming that there is something symbolic or allegorical to be seen there are imposing their own biases on this building; they are certainly not conveying what has come about through it. The same spirit—not the theoretical spirit but the living spirit—that speaks from the podium or from the stage is also absolutely intended to speak out of the building's artistic forms, out of its sculptural forms and out of what is represented in it in painting. The shell is meant to proceed from the same being as what functions as the kernel within it—that is, the worldview itself, which is expressed in the spoken word.

In the last two lectures, I took the liberty of stating that the anthroposophical worldview is claiming its place in humanity's evolution as something new. If this is indeed the case, it is also quite natural that what is expressed in the building's architectural, sculptural, and painted forms could not be anything that preexists. None of the fine arts applied in it could express something that was already there. There could be no artistic flashbacks to antiquity, to the Renaissance, to Gothic art. The anthroposophical worldview had to demonstrate that it was productive enough to generate its own artistic style with regard to the fine arts.

Of course, when your heart and soul are involved in an intention or effort of this sort, you become quite modest. You become your

own worst critic. I am absolutely certain, therefore, that if I had to build that building in Dornach a second time, some things that often seem imperfect or even defective to me now would be done differently. But that is not the essential point, at least not for today's lecture. What is essential is the intention, the effort, that I have just characterized, and that is what I want to talk about today.

When we talk about the visual arts in this context—the visual arts that the anthroposophical worldview is obliged to create now that friends have been found to make the sacrifices that make the building in Dornach possible—when we talk about the visual arts in this sense, then the most important thing is to understand the human form. After all, this is what everything in the visual arts aspires to and takes as its starting point. It is essential to understand it in a way that will then really enable us to create the human form, the human figure, as such.

Yesterday I also spoke about one particular element, the element of space, as a cosmic element that nonetheless proceeds from the nature of the human being. I spoke yesterday about the three dimensions of space. Ultimately, we determine all the configurations underlying the world on the basis of these three dimensions, which can be derived from the human figure. But if we speak of space as I did yesterday, we never actually manage to grasp space in the way that is needed for sensitive artistic creativity, especially for a fully conscious pursuit of sculpture, which is ultimately the basis of all the visual arts. If we see three-dimensional space as concretely in our mind's eye as was the case in yesterday's presentation, we realize that the space we arrive at cannot possibly be the space we are in when we attempt to sculpt the human figure, for example, even though this also takes place in space—and here we do use the same word, after all. This is not the way to arrive at the space we occupy as sculptors. We come to the conclusion that sculptural space is a totally different space. In saying this, I am touching on a secret of our human way of viewing the world, a secret that has been totally lost to our contemporary way of looking at things. Please allow me to begin by briefly describing a seemingly very abstract and theoretical view. The sole purpose of this view is to direct us toward something that will then be able to appear to our mind's eye in a much, much more concrete way.

To apply the space I spoke of yesterday to the things of this world, we use geometry—Euclidean geometry, to begin with. As you know, we begin by assuming the existence of a point in concrete space. As I described yesterday, we must naturally assume this point to be within the human body. We then assume the existence of three perpendicular axes passing through this point, and we relate any given area of space to the point by determining distances from the axes or from the three planes they form. We thus arrive at geometric coordinates for anything occupying our space. Or, in the case of the mathematics of motion, it becomes possible for us to describe the motion of an object.

Alongside this space, however, there is definitely a space of a different sort. This is the space sculptors enter. The secret of this space consists in starting not from a point to which we can then relate everything else, but from the very opposite of this point. What is that? The opposite of the point is none other than an infinitely distant sphere. Looking up at it would be somewhat like looking up at the blue firmament, if there were such a thing. Imagine that instead of a point, I have a hollow sphere. I am positioned within this sphere and relate everything in it to the sphere itself. Instead of describing things in relationship to a point by means of coordinates, I describe them in relationship to this hollow sphere. If I tell you only this much about it, you are quite right in saying, "Yes, but describing something in relationship to a hollow sphere like that is somewhat nebulous. When I try to think about it in these terms, I can't form any mental image of it." And you are quite right; you do not form any mental image.

However, there is a human faculty that is capable of relating to the cosmos in the same way that we related to the human being or the *anthropos* yesterday. Yesterday we looked inside the human being to derive the three dimensions and saw how we could characterize the human being according to them: One dimension runs in the direction of the body's elongation; everything that falls in the plane described by our outstretched arms lies in the second dimension; everything that runs from front to back or vice versa lies in the third dimension. Within the three dimensions, the position of the anthropos-organism is by no means arbitrary. On the contrary, considered

in this way, the human organism is shaped and formed in a very particular way.

It is also possible to relate to the cosmos in a similar way. What happens inwardly, in our souls, when we do this? Well, imagine yourself standing out in a field on a clear starlit night. You can survey the starry heavens freely on all sides, and as you do so, you see portions of the vault of the heavens where the stars are concentrated as if in nebulae. You see other areas of the heavens where the stars are more separate from each other and form what we call the constellations, and so on. If we approach the starry heavens only with our rational, intellectualizing view, we will get nowhere, but if we approach the heavens as whole human beings, we will perceive in a different way. Nowadays we have lost this perceptive possibility, but it can be acquired anew. We sense one thing in an area of the heavens where the stars are very close together, almost forming a cloud, and something else before the constellations. We sense one thing with regard to an area in the heavens where the moon is shining. We sense a difference in a night when there is no moon, when there is a new moon, and so on. Not only can we sense our way concretely into the human organism in order to arrive at the three dimensions of space, where space itself is something concrete, something connected to the human being, we can also acquire a view of the cosmos, of our cosmic environment. Only now, rather than looking inside ourselves in order to arrive at the three dimensions, we look out into the wide expanses and attend to its configuration. By moving from our usual way of looking at things—which is still adequate for geometry—to the perception required for these expanses, then we arrive at a view that I described yesterday and the day before as "imaginative knowledge." I will still need to speak about how this imaginative knowledge develops.

Any mere attempt to record what we see in the great expanses of the universe, a mere record of the starry heavens such as astronomers construct today, will get us nowhere. But if we face the cosmos in full understanding and as whole human beings, then images begin to develop in our souls in response to these collections of stars, images such as can be seen on maps from the days when Imaginations were

still arising out of the old instinctive clairvoyance. Then we get an Imagination of the entire cosmos, something that can undergo infinite configurations. This is the counter-image of what I demonstrated yesterday as the human basis for the three geometric dimensions of space.

Essentially, people today have no inkling of how people looked out into the universe in ancient times when human beings still possessed an instinctive clairvoyance. Nowadays we believe that the different pictures or images or Imaginations of the signs of the zodiac are the products of fantasy. They are not. They were sensed, they were seen, when people turned to face the cosmos. Human progress demanded that this living imaginative view fade away and be replaced by the intellectual view that set us free. If we want to be fully human, however, we must struggle to regain a view of the cosmos that moves toward Imagination again, but this time we must do it in full consciousness rather than instinctively.

What we get in trying to arrive at a concept of space by starting from the starry heavens is not a space that can be described exhaustively in three dimensions. It is a space that I can also suggest only through the use of an image: If I were to indicate the space I talked about yesterday by means of the image of three lines standing perpendicular to each other [he draws them in the center of the sketch below], then I would now have to indicate this other space by sketching configurations such as these everywhere, as if forces that lie in planes were approaching the Earth from all points of the universe and exerting a sculptural influence on the formations on the Earth's surface.

We arrive at a concept such as this by advancing from what the physical eye can see in a living being, and in the human being in particular, to what I have just called Imaginations, in which the cosmos rather than the physical human being discloses itself in image form and bestows space of a new sort upon us. As soon as we have advanced to this possibility, we are able to observe a second human body, a body that an older, instinctive clairvoyance called the "ether body," although it would be better to call it the body of formative forces. This body, which is supersensible but does consist of a fine etheric substantiality, pervades the human physical body. The physical body can be studied by looking for the forces that flow through it within the space it occupies. However, we cannot study the ether body, the body of formative forces, by taking this space as our starting point. [He points to the center of the sketch.] We can study this body only when we comprehend that it is built up from the entire cosmos, that these planar forces, which approach the Earth from all sides, also approach human beings and shape their formative-force bodies from outside.

This is the only way that the visual arts came about in times when they still originated in the elemental and natural world. Intuitive sight will see this in a work such as the Venus de Milo, whose creation was based, not on studying anatomy or calling on the forces that can be understood only from within the space of the physical body, but on the ancient knowledge of the formative-force body that pervades the physical body and is shaped from out of the cosmos, out of a space that is as peripheral as earthly space is central. An earthly being takes on *beauty* in the original meaning of the word—through the forces working inward upon it from the periphery. Beauty is the imprint of the cosmos, with the help of the etheric body, on a physical, earthly being.

When we study a physical, earthly being according to pure, dry truth, we derive what it is in terms of ordinary physical space. But if we allow a being's beauty to affect us, if we attempt to heighten its beauty through the art of sculpture, then we must be aware that the stamp of beauty upon it stems from the cosmos. It is the disclosure of how the entire cosmos works in an individual being. Of course, we

must also sense how this cosmos comes to expression—in the human form, for example.

If we can enter the human form through imaginative observation, our soul's attention first turns toward the formation of the head. If we survey the formation of the head in its totality, we do not understand it by attempting to explain it merely from within itself. We understand it only when we have an immediate understanding of it as having been brought out of the cosmos by way of the body of formative forces.

Progressing to the formation of the human chest, we can arrive at an understanding of its form only when we can imagine how the human being lives on Earth, encircled by the stars of the zodiac. (That the Earth, according to modern astronomy, merely appears to be encircled in this way is neither here nor there as far as these matters are concerned.) While we relate the head to the pole of the cosmos, we relate the formation of the human chest—since this does indeed take place along the repeating line of the heavenly equator—to what runs its course in various ways during the sun's yearly and daily cycles.

Only when we move on to the human limb system, and to the lower limb system in particular, do we get the feeling that it belongs to the Earth rather than to the cosmos, and that it is connected to the Earth's gravitational force. If we apply a sculptor's sensibilities to the formation of the human foot, we see that it is adapted to Earth's gravity. The whole configuration of how the knee mediates between the lower leg and the thigh belongs to the Earth's dynamic and static states. Here we see how gravity works outward from the Earth's center into the universe.

We get a feeling for this when we look at the human form through the eyes of a sculptor. We need all the forces of the cosmos—the whole sphere, so to speak—if we want to understand what is expressed so wonderfully in the formation of the head. To understand what comes to expression in the formation of the chest, we need what courses around the Earth at the equator, so to speak. And to understand the human lower limb system and the adjacent metabolic system, we must confine ourselves to the forces of the Earth,

for in this respect the human being is bound to the Earth's forces. In short, we come to see the connection between living space, space imagined as a living whole, and the human form.

People in many circles today, including artistic groups, will probably laugh at this way of viewing matters. I can easily understand why. But laughing at such things shows ignorance of the real history of human evolution. On the other hand, those who truly immerse themselves in the sculptural art of ancient times can see how the sculptural forms created then were permeated with feelings, which the sculptors developed from their imaginative view of the starry heavens. In the oldest works of sculpture, the cosmos is shown in the human form.

To be sure, we must see "knowledge" not in a merely intellectual sense, but as knowledge connected to the whole scope of the human soul-forces. We become sculptors—if in fact we really are sculptors—for elemental reasons, and not just because we have learned to follow old stylistic forms to give form to something that we no longer know anything about but was known in other stylistic epochs when people still had a connection to the living creative process. We do not become sculptors by clinging to tradition, although that is mostly what happens today, even among accomplished artists. We become sculptors by reaching back in full consciousness to the formative forces that first led to the visual arts. We must have cosmic feelings once again. We must once again feel the cosmos and be able to see a microcosm, a miniature world, in the human being. We must be able to see the stamp of the cosmos in the human forehead. We must see that the nose, along with the entire respiratory system, receives its stamp from the periphery, from what encircles the Earth along the celestial equator, in the zodiac. Only then do we get a feeling for what we have to represent. We do not create by merely imitating a model; we create by immersing ourselves in the force used by nature to form and create the human being. We shape things as nature does. However, all our artistic and creative sensibilities, our whole mode of feeling, must be able to adapt to this.

Faced with a human form, we first turn our artistic gaze to the head with the intention of sculpting it. We will then make the effort

to shape this human head in all its details and to treat each surface with loving care: the forehead, the arch of the eyebrows, the ears, and so on. We will make an effort to shape the lines that run across the forehead and above the nose as lovingly as possible. Depending on what we are trying to create, we will make an effort to shape the nose in one way or another. In short, we will attempt to shape with loving care each individual plane that relates to the human head.

In contrast, if we were to make a great effort to sculpt human legs, that would constantly go against the grain. I may be saying something that sounds heretical to many people, but I do believe that what I have to say harks back to natural artistic sensibilities. We would like to shape the human head as lovingly as possible, but not the legs. We would like to hide them, to eliminate them from our artistic forms, so we try to cover them with various articles of clothing, with something that is sculpturally more in keeping with what is expressed in the head. A human figure with accurately chiseled legs or calves, for example, is actually something disagreeable in a sculptor's view. I know this sounds heretical, but I also know that the more heretical it sounds, the more I am speaking on an elemental artistic level. We really do not want to see properly chiseled legs. Why not? Simply because anatomy and the understanding of how the human being is shaped are different for sculptors than they are for anatomists.

Strange as this may sound, there are no bones or muscles as far as the sculptor is concerned. For the sculptor, there is simply the human figure that receives its shape from the cosmos with the help of the body of formative forces. Within the human figure the sculptor sees forces, effects of forces, lines of force, and interacting forces. For me as a sculptor it is impossible to think about the skull as I shape a human head. Instead, I shape the head from the outside, as it receives its imprint from the cosmos, and I shape what supplies me with the corresponding curves of the head according to dynamics and forces that impel the form from within outward, counteracting the forces working in from the cosmos. As a sculptor, I do not think about bones when I am shaping the arms, but about the forces that are at work when I bend my arm, for example. I am concerned with lines of force and with the unfolding of forces rather than with the

actual muscles and bones. The thickness of an arm depends on what is alive in it, not on the amount of flesh and muscle on the bone. In order to sculpt something beautiful, we tend above all else to adapt human beauty to the cosmos, which is possible only in the case of the head because the lower limbs are adapted to the Earth. So we want to leave the limbs out. When we are sculpting a human figure artistically, we would like to lift it up off the Earth. If we were to emphasize the development of the lower body too strongly in sculpture, we would turn it into a heavy, earthly being.

Again, looking at the head alone, only the upper portion—the wonderfully domed skull—is formed in the image of the cosmos. Because this dome is different in each individual, there is no such thing as generic phrenology, but only an individual phrenology. But how the eyes and nose are shaped is already similar to the shaping of the human chest system. That is, they are shaped in accordance with the periphery, the circle of the equator. This is why, in representing the eyes in any sculptural work that depicts the human being, we cannot make use of color to represent a deep or superficial gaze, but must restrict ourselves to shaping eyes that are large or small, slit-like or oval, more straight or less so. How we make the transition from the eyes or the forehead to the shape of the nose, how we allow it to show that the person is seeing and inserting his or her entire soul into the seeing process, is different if the eyes are slit-like, oval, or straight. There are wonderful expressive possibilities in how a person breathes through the nose, and we merely need to sense this fact to know that in the form of the chest as it is created out of the cosmos, the individual human being takes what breathes in the chest and beats in the heart and sends it up into the eyes and nose, where it is expressed in image form. What a human being is like in the head is in fact expressed only in the dome of the skull, which in its form is an impression of the cosmos. A person's reaction to the cosmos, which is a question not merely of taking in oxygen and behaving passively, but of personally taking part in the substance and bringing one's individual being forth in the chest to confront the cosmos, comes to expression in sculpture in how the eyes and nose are formed.

And when we shape the mouth—oh, when we shape the mouth, we are actually shaping the whole inner person as he or she confronts the cosmos. We are shaping how the person reacts to the world as a result of his or her metabolic system. In shaping the mouth—the chin and everything else that belongs to the mouth—we are shaping a spiritualization of the limb or metabolic person in the form of an image that works outward. When we consider the human head from the sculptor's viewpoint, we have the entire human being in front of us, according to the nature of the different systems of the body: The sensory-nervous system is present in the remarkable dome of the skull. In the formation of the eyes and nose, we have the person of courage, to put it in Platonic terms; the person in question confronts the outer cosmos with the inner individuality's heart-related courage. The configuration of the mouth, because it does still belong to the head, is also impressed on it from outside, but the impression working from outside is counteracted by the inner nature of the person in question, which forces its way outward from within.

These are merely brief and sketchy indications for your further consideration; but I am sure they have helped you to see that it's not enough that sculptors understand the human being only through copying a human model. They must also be able to inwardly reexperience the forces working through the cosmos to shape the human figure, and must be able to create from the same forces that are active when a human being is shaped from the fertilized egg in the mother's body—not only by forces present in the mother's body but also by cosmic forces working through the mother. And sculptors as they create must also be able to understand what is revealed to an ever greater extent by the individual human entity as we shift our view downward. Above all, they must be able to understand how the human being's wonderful outer covering, the form of the skin, comes about as the result of two types of forces, the forces that work in from all sides, from the periphery of the cosmos, and what works centrifugally outward in opposition to the cosmic forces. For sculptors, the outer form of a human being must be the result of cosmic forces and inner forces. They must have a feeling for this in all details.

In art, unless we have a feeling for the medium and know what a particular substance is suited for, we will create only superficial illustrations rather than sculpture. Therefore, if we are sculpting a human figure out of wood, we will know that when sculpting the head up above, we must have the feeling that the form is pressing in from the outside. That is the secret of creating the human figure. When I shape the forehead, I must have the feeling that I am pressing in from the outside, shaping from outside, while at the same time forces from within oppose me. In repressing the forces working from within, I do so only as strongly or weakly as is suggested by the cosmic forces that determine how the head is to be formed.

Moving to the rest of the human body, however, I get nowhere by shaping it from without inward. There I must have the feeling of being within it. When I move on to the formation of the chest, I must shift to the inside of the human being and sculpt from within. This is very interesting.

The inner necessity of artistic creativity makes us shape the head from the outside in, imagining ourselves working inward from the periphery. But when we shape the chest, we must shift to the inside and impress the form on what is outside. With regard to what is still further down, we have the feeling that it becomes indistinct and must only be suggested.

Very frequently, modern artistic creativity regards things such as what I have just presented as inartistic musings. However, being able to take one's place as an artist within the whole creative universe is solely dependent on being able to artistically experience these very things in one's own soul. When this happens, visual artists are steered away from imitating the physical human form, which in itself is only an imitation of the body of formative forces. They then feel the need that was felt so strongly by the Greeks, who would never have produced the noses and foreheads they did merely by copying them. Rather, things such as I have just described formed an instinctive basis for Greek art. We can return to a truly fundamental artistic sensitivity only when we can enter nature's creative forces in this way with all of our feeling, with total inner perception, or cognition (if I may call it that). In that case, however, we are really looking at the

ether body itself rather than at its imitation, the outer physical body. What we are shaping is the ether body; we are filling it out only with matter, so to speak.

At the same time, however, what I just described is the way out of a theoretical view of the world and into a living perception that can no longer be considered theoretically—although we cannot construct sculptural space through analytic geometry in the same way that we can construct Euclidean space. Through imaginations, however, we can perceive this space, where the world of forms lives and out of which forms constantly emerge. By perceiving this space we can really begin to create forms in the visual arts, both architectural and sculptural.

At this point, in order to reduce misunderstandings in an area that is easily misunderstood, I would like to insert a comment that seems important to me. If we have a magnetized needle with one end pointing toward magnetic north and the other end toward magnetic south, it will not occur to us, unless we wish to appear amateurish, to explain the needle's alignment as a result of forces inherent in it or by considering only what is contained within the steel. That would be ridiculous. We consider the whole Earth in order to explain the needle's alignment; we go beyond the needle itself. Embryology today is guilty of such amateurism; it looks at the human embryo only as it develops inside the mother's body and claims that all the forces that shape the embryo are inherent in the mother's body. In reality, however, the whole cosmos is working, by way of the mother's body, on the configuration of the embryo. The sculptural forces of the entire cosmos correspond to the forces of the Earth in the case of the magnetic needle's alignment. Just as I must consider more than simply the needle itself, I must also go beyond the mother's body when considering the embryo. I must turn to the entire cosmos for assistance. Likewise, I must immerse myself in the entire cosmos if I want to understand what guides my hand and my arm when I attempt to sculpt the human form.

You see, an anthroposophical worldview leads in a straight line of development from merely theoretical considerations to artistic ones, for we cannot possibly consider the ether body in a purely theoretical

way. We must, of course, possess the spirit of science in the sense in which I described it yesterday, but if we are to move on to consider the body of formative forces, what weaves in mere thoughts must be transformed into Imaginations. We can no longer grasp the outer world merely through thoughts or through natural laws; we must grasp it in Imaginations. And if we then become productive, this leads to artistic creativity.

A strange thing happens if we survey the kingdoms of nature in the awareness that such a body of formative forces exists. The mineral kingdom has no body of formative forces. The plant kingdom is the first kingdom to possess it, and animals and human beings also have their bodies of formative forces. However, a plant's body of formative forces is very different from an animal's or a human's. The peculiar fact of the matter is that it goes against the grain if you imagine yourself equipped with the artistic sensibility of a sculptor and try to sculpt plant forms. I tried to do this recently, at least in a relief, but it is simply not possible to sculpt plants. At most we can capture some traces of the plants' gestures in our imitations of them, but we cannot sculpt plants. Imagine sculpting a rose or any other plant with a long stem— it's impossible. Why? Because when we think of the sculptural form of the plant, we instinctively think of its body of formative forces. It is present in the plant just as the physical body is, but it receives its shape directly. Nature has set the plant in front of us as a sculptural work of art, and there is nothing we can do to change it. Any sculpting of plants would be amateurish and bungling in comparison to what nature brings forth in the physical body and formative-force body in a plant. We must simply leave the plant as it is, or consider it in a sculptural spirit as Goethe did in his plant morphology.

On the other hand, it is possible to sculpt animals, although artistic creativity in sculpting animals is different than it is with regard to human beings. We simply need to have an understanding of which process shapes the animal. When we sculpt beasts of prey, for example, we must grasp that they are primarily creatures of the breathing process. We must see them as breathing beings and create everything else around that, so to speak. However, if we want to sculpt a camel or a cow in an artistic way, we must take the process of digestion as

our starting point and adapt the whole animal figure to that. In short, our artistic eye must show us the essential thing. More precise differentiation of what I have just indicated in general terms will make it possible for us to sculpt all the different animals. Why is that? Now, plants possess the etheric body. It is created in them out of the cosmos. It is complete in itself, and I cannot change it. The plant stands there in nature as a sculptural work of art. It contradicts the whole sense of the world of facts if I sculpt plants out of marble or wood. It is more nearly possible to do so in wood because wood is closer to the nature of plants, but even that is inartistic. Animals, however, confront the cosmic shaping that works from outside with their own nature. In the case of the animal, the ether body is not shaped exclusively out of the cosmos, but is also shaped from the inside.

And in the case of the human being—well, I just said that it is only with regard to the domed skull that the ether body is shaped out of the cosmos. I told you how the refined breathing system works to counter it through the eyes and nose and how the entire metabolic organism counteracts it in the formation of the mouth. In this case, what comes out from within the human being, the actual human element, works against the cosmos, and the boundary of the human form is the result of these two influences, the human and the cosmic. The human ether body originates from within. By artistically immersing ourself in this inner aspect, we are able to freely sculpt the human form. We can investigate the way an animal forms its ether body out of its inner being, and how courageous or cowardly, suffering or jubilant human beings attune their ether bodies to their soul life. We can immerse ourselves in all of this in order to give form to the ether body. With the appropriate sculptural understanding, as has been described, we will be able to shape the human figure in a great variety of ways.

Thus we see that, although ordinary scientific considerations can be appreciated scientifically, when we move on to study the ether body or imaginative body, we approach something that is of itself artistic. You may object that art is not science. However, I said the day before yesterday: if nature, the world, and the cosmos themselves are artistic, presenting us with things that can only be grasped

artistically, then we are wasting our breath declaiming that it is illogical to become artistic in attempting to understand these things. These things will not reveal themselves to an understanding that does not embrace the artistic. We can understand the world only by going beyond the limits of what can be understood through thoughts alone. Instead, we must aim for a universal grasp of the world that finds the wholly organic, natural transition from observation to artistic perception and even to artistic activity. This artistic activity then speaks out of the same spirit that pronounces the more theoretical terms and ideas we use to express what we see in the world. Art and science then derive from the same spirit. In art and science we have two sides of one and the same revelation. In science we view things in such a way as to express what we see in thought forms, whereas in art we view them so as to express what we see in artistic forms.

What has come to expression in the building in Dornach in both sculpture and painting, for example, had its origin in this inner attitude of spirit. I could also say a lot about painting, for in a certain sense it too belongs to the visual arts. In painting, however, we move to a greater extent into the soul element, which is directly expressed in how the soul colors the ether body rather than in what lives in the ether body itself. Here, too, we would see how the anthroposophical worldview once again leads us upward to something elementally artistic and creative, while today we are actually living only out of tradition, old stylistic forms, and old motives in religion as well as in art, although the onlookers and most of the artists are not aware of this. We believe we are being productive and creative today, but we are not. We must once again find the way to immerse ourselves in nature's creativity, so that we will really create original and elemental works of art.

Such an attitude led quite naturally to the art of eurythmy growing from the soil of anthroposophy. What a particular group of organs reveals of human nature in the sounds of human speech and song can be extended to the whole human being—if in fact we really understand it rightly. In this context, all our religious documents speak to us out of old instinctive clairvoyant insights. It is significant that the

Bible says that Jehovah breathed the breath of life into human beings, indicating that in a certain respect, the human being is a being of breath. I pointed out yesterday that in earlier stages of humanity's evolution, the prevalent view was that the human being was a breather, a being of breath. What the human breath-being becomes in the formed breathing of speech and song can once again be given back to the entire human being, to the entire human body. Because in a certain sense each individual organ and system of organs is an expression of the entire being, the way in which the vocal cords, tongue, palate, and other organs move during speaking and singing can be transferred to the entire being. Then something such as eurythmy can come about. In the process, we simply need to remember the inner character of the Goethean theory of metamorphosis, which has not been sufficiently acknowledged. Goethe quite rightly sees the entire plant in a single leaf. In a primitive way, the entire plant is contained in the leaf, and the plant in turn is only a complicated leaf. In each individual organ Goethe sees the metamorphosis of an entire organic being, and the entire organic being is a metamorphosis of its individual members. The entire human being is a complicated metamorphosis of a single system of organs, the larynx system. If we understand this, then we are in a position to develop visible speech and visible song out of the entire human being, through the movement of human limbs and of groups of people in motion, with all the validity and natural necessity of song and speech that come about through a system of organs. In this case, we stand within nature's creative forces. We immerse ourselves in how the forces of human nature work in speaking and singing. Having grasped these forces, we can then transfer them to the forms of the entire body's movement, just as we transfer the forces of the cosmos to the stationary human figure in sculpture. In poetry or song or some other form of art that can be similarly expressed out of the soul, we bring to expression what lives within the human being, but it is also possible to express this content by means of the entire human being, in visible speech and visible song.

I would like to say that we create out of two poles. The one arises when we create the human form in sculpture, creating the microcosm

out of the entire macrocosm. When we immerse ourselves completely in the human being's inner life, tracing its inner mobility, by entering our thinking, feeling, and willing and everything that comes to expression through speech and song, we create sculpture in movement. We may say that the whole wide universe is condensed into a wonderful synthesis when we create a work of sculpture, and that what is concentrated deep within the human being, as if in a single soul-point, strives outward into the widths of the universe in the formed movement that human beings create out of themselves in eurythmy. In the art of eurythmy or sculpture in motion, we have the human responses from the second pole. We see the widths of the universe turn toward the Earth and flow together into the human figure at rest: This is the art of sculpture. When we immerse ourselves spiritually in the inner aspect of the human being and perceive what flows outward from the human being to confront the forces of the universe that flow in from all sides to shape the human form, we develop eurythmy accordingly.

We might say that the universe presents us with a great task, and its successful completion is the beautifully sculpted human figure. However, our own inner aspect also presents us with a great task. We plumb infinite depths when we apply our soul's inner gaze lovingly to the inner aspect of the human being and immerse ourselves in it. This human inner aspect, however, wants to reach out into the distance; in swinging movements and rhythms it attempts to express outwardly what is condensed into a point in our souls, just as the sculpted human form, which in cosmic terms is but a point, attempts to condense all of the secrets of the cosmos. The sculpted human form is the answer to the great question the universe asks of us. And when our human art of movement becomes cosmic, when our movements take on a cosmic quality, as they do in eurythmy, then a universe of a sort is born out of the human being, at least figuratively speaking.

We have the two poles of the arts in front of us in the ancient art of sculpture and the new art of eurythmy, which we must now create. We must enter the spirit of art in this way in order to really see the justification for the art of eurythmy. We must also find our way back

to how sculpture first found its place among humankind. We can well imagine the shepherds out in the fields, gazing wakefully into the starry distances in the middle of the night, unconsciously taking into their souls the cosmic images formed by the structured Imaginations of the stars in the heavens. What developed in the hearts and minds of these early human beings was inherited by their children and grandchildren. It grew and developed in the souls of their grandchildren and became the ability to create sculpture. The grandparents experienced the beauty of the cosmos, and the grandchildren created beautiful sculpture out of the forces that the human soul had taken up out of the cosmos.

Anthroposophy must not look upon the secrets of the human soul only theoretically; it must also experience and identify with all the human soul's tragedy and jubilation and everything in between. And it must be capable of seeing not only tragedy, jubilation, and everything in between, but also the stars as they appeared to clairvoyant vision in ancient Imaginations, when their formative forces were taken up by the human soul. Similarly, we must be able to take what we see within the human soul and communicate it through outer movements. That is when eurythmy comes about.

This lecture today was intended as only a brief indication of how a natural transition exists between what anthroposophy is in conceptual terms and what it intends to be in a very direct way, in visual arts that do not allegorize or symbolize but really create with form. Having grasped this, we will then discover art's remarkable connection to science and religion. We will see science on one level, religion on another, and art between them. We will see the science to which we human beings basically owe all our freedom. Without science, we would never have come to complete inner freedom. Unbiased examination will allow us to see what we have won for the human individuality, what the quintessential human being has gained through coming to science. We and we alone have unbound ourselves from the cosmos by means of thought, but this is what has made us human individualities. Living in natural laws, we take them into our thoughts; we become independent in the face of nature. In religion, we want to give ourselves away, to find the way back to the essential

foundations of nature. We want to dissolve into nature again, to sacrifice our freedom on the altar of the universe, to give ourselves up to the divinity, to possess the breath of sacrifice in place of the breath of freedom and individuality. Between science and religion, however, stands art—especially the visual arts—and everything that has its roots in the realm of beauty.

Through science, we become free individual beings. In religious observance we offer up our individual well-being. On the one hand, we maintain our freedom, whereas on the other we anticipate the act of sacrifice. In art we find the possibility of maintaining ourselves by sacrificing in a certain way what the world has made of us. In art, we shape ourselves as the world has shaped us, but we create this form out of ourselves, as free beings. In art, too, there is something that redeems and frees. In art, we are individuals on the one hand, though, on the other, we sacrifice ourselves. Just as we can say that the truth frees us when we grasp it in a conceptual-scientific or spiritual-scientific way, we must also say that in beauty we rediscover our connection to the world. As human beings we cannot exist without living in freedom within ourselves, nor can we exist without finding our connection to the world. In the freedom of thoughts, we find our individuality; and by lifting ourselves up into the realm of beauty, the realm of art, we find it possible to reconnect with the world in such a way as to create out of ourselves what the world has made of us.

9. Truth, Beauty, and Goodness

DORNACH, JANUARY 19, 1923

Down through the ages, through all of conscious human evolution, truth, beauty, and goodness have been regarded as the three great ideals of humankind. It may be said that these three ideals are instinctively seen as the great goals, or to put it better, the lofty characteristics of human striving. It is true that in olden times more was known about the nature of human beings and about their relationship to the world than is the case today. Accordingly, people were also able to speak more concretely about things like truth, beauty, and goodness than we are today in this age that is in love with the abstract. But now anthroposophical spiritual science makes it possible to point more concretely to such things once again. Admittedly, when this transcends everyday life, it is not always in line with the tendencies of our time, which prefers to have such things inexact, undetermined, and nebulous.

Today we will clarify how the content of the words *truth*, *beauty*, and *goodness* is connected with the nature of the human being. Looking at the human being with the eyes of the soul, the first thing we must observe is the physical body. Nowadays this physical body is actually only observed in an external way. There is no awareness of how it is built up in all the details of its form and activity during pre-earthly existence. It is certainly true that in pre-earthly existence, human beings live in a purely spiritual world. However, as I mentioned in recent lectures, in this spiritual world and in concert with higher spiritual beings we work out the physical body's spiritual prototype, its spiritual form. What we carry around with us on Earth as a

physical body is simply an image, a physical image of the spirit germ, so to speak, that we ourselves worked out during pre-earthly existence.

Keeping this in mind, we must realize that although we feel our physical bodies here on Earth, nowadays we do not summon up much consciousness of what is involved in feeling them. We speak about truth, and yet we scarcely know that our feeling for truth is connected with the general feeling we have of the physical body. When we face a simple fact, we can either conscientiously form a concept that conforms to the fact exactly and is therefore true, or, conversely, whether out of inaccuracy or inner carelessness or out of direct antipathy to the truth—that is, out of untruthfulness—we can also form a concept that is not connected with the fact, that does not coincide with it. When we consider the truth about a fact, we are in accord with the feeling we have of the physical body and even with our feeling of the physical body's connection to pre-earthly life. However, if either out of carelessness or out of untruthfulness we form a concept that is not in accordance with the fact, we tear a hole in what connects us to our pre-earthly life, as it were. If we succumb to falsehood, we sever something of what connects us to our life before birth. During life before birth, we weave what might be described as a delicate spiritual fabric which then condenses to form the copy that is the physical body. It might be said that the physical body is connected to pre-earthly existence by many threads and that succumbing to falsehood severs these threads. The purely rational consciousness we possess today, at the beginning of the age of the consciousness soul, does not perceive this. That is why contemporary human beings succumb to so many illusions about their connections to the surrounding world and its existence.

Today we usually see our physical state of health as a purely physical matter. But succumbing to falsehood and thus severing the threads that link us to pre-earthly existence have definite effects on the physical body, especially on the constitution of the nervous system. In actual fact, our feeling of spiritual existence in the world comes from the feeling we have of the physical body. Having this inner feeling of spiritual existence is only possible if the threads that bind the physical body to pre-earthly existence are not severed. If they are severed, we must create a substitute for this healthy spiritual

feeling of existence. We do this unconsciously. We are then actually dependent on providing ourselves with a sense of existence that we derive from any of the many conventional, well-established opinions. However, humankind has also gradually gotten into a state of inner uncertainty with regard to this feeling of spiritual existence, and this penetrates even the physical body. Indeed, is there still very much evidence left today of this feeling of pure spiritual existence, which is increasingly present the further back we look in history?

Just consider the many means by which people today try to "be something"—by any means except their primal, inner spiritual life. Perhaps we want to "be something" by achieving some sort of professional designation. Let's say we want to be a clerk or a notary. We then believe that we *exist* simply through having been able to apply a conventional name to our being, whereas what really matters is to ascribe existence to ourselves out of our own inner feeling, regardless of any external circumstances.

What is it then, that reinforces our feeling of existence? You see, here on Earth we actually live in a world that is only an image of true reality. In fact, we only understand this physical world correctly if we see it as an image of actual reality. But we must feel the true reality within ourselves; we must feel our connection to the spiritual world. And we can only do this if everything linking us to our pre-earthly existence remains intact.

This is reinforced by a penchant for absolute truth and truthfulness on our part. Nothing strengthens our true and primal feeling of existence as much as this sense of truth and truthfulness. To feel duty-bound to examine the things we say before saying them, to feel duty-bound to first seek out the limits within which these things can be said—this contributes to really inwardly consolidating a feeling of existence worthy of a human being. This feeling of existence is connected with the fact that we feel spirituality within the physical body, and we must therefore acknowledge the close relationship between the physical body and the ideal of truth.

As I mentioned in other lectures recently, we acquire our etheric or life body, the body of formative forces, only shortly before descending from our pre-earthly existence into life on Earth. We gather together

the forces of the etheric world, so to speak, in order to form our own etheric body. Here again, if I may put it like this, humankind in earlier times was more fortunate in this regard than we are today. Contemporary humanity does not have much feeling for the etheric body. On the contrary, you get the feeling that the very idea of the existence of the etheric body is scoffed at. However, we can develop a stronger feeling for the etheric body through the experience of beauty.

When truth and truthfulness become a real experience for us, we are in a certain sense fitted to our physical body. When we develop the right feeling for beauty, this means that we are properly fitted to our etheric body, the body of formative forces. Beauty is related to the etheric body in the same way that truth is related to the physical body.

What I have just said will be most clear to you if you think of the inherent significance of some truly beautiful creation of art. This actually applies to all the arts. When you are faced with the reality of a single human being in a physical body of flesh and blood, you know this person to be one among many. A single individual actually makes no sense without all the many others who are necessarily present in his or her surroundings. The individual belongs to these many others, and they belong to him or her. Just consider how few roots a single earthly individual would have in physical existence without these other people. In contrast, if we depict a person in art—in sculpture, painting, or drama—we strive to create something sufficient unto itself, something self-contained, something that encompasses a whole world in itself, so to speak, just as a real human individual actually embraces the whole world in his or her etheric body through having gathered together etheric forces from the whole world in order to form an etheric body within earthly existence.

In the past, humankind had a great feeling for beauty (as it was then imagined, of course), much greater than we have today. However, we cannot be human beings in the true sense of the word if we have no feeling for beauty, because to have a sense of beauty is to awaken to the etheric body. To have no sense of beauty is to disregard, or remain asleep to, the etheric body.

Contemporary human beings feel no trace of all this in their consciousness. But the ancient Greeks, as they approached the temple or

beheld the statue of the god inside, would grow warm, feeling something like inner sunlight within themselves. They even felt, as if receiving a gift of some sort, how forces streamed into them and into the different organs of the body. Greeks who entered the temple and beheld the statue of the god could wholeheartedly say, "I never feel the formation of my fingers, right down to their very tips, as clearly as when I enter the temple where the statue of the god stands in front of me. I never feel the dome of my brow pressing outward above my nose as strongly as when I enter the temple where the statue of the god is." In the face of beauty, the Greeks felt inwardly imbued with feeling, inwardly warmed and illumined, inwardly endowed with divinity, we might say. This was nothing other than the experience of feeling oneself in the etheric body.

The Greeks also had a very different feeling about ugliness. As modern human beings, we experience ugliness at most in a very abstract form—in the face, perhaps, if we wanted to localize it. The Greeks felt a chill through the whole body when they encountered ugliness, and extreme ugliness even gave them goose bumps. Feeling the etheric body in this real way was something that was still very much present in olden times. But we have lost some of our humanity in the course of our evolution. All these things I have spoken of, all these former experiences, remain unconscious for modern human beings, whose tendency is wholly toward the head, which contains the organ of rational and abstract understanding.

We might say that through enthusiasm for truth and truthfulness human beings develop, in the depths of the unconscious, at least some feeling for pre-earthly existence. An age in which no such feeling exists also has no real sense of truth and truthfulness. However, strongly and resolutely developing a feeling for truth does connect us strongly to our pre-earthly existence again. In a certain way, this also makes us somewhat sad, because we experience the present on Earth more intimately. If in our inner life we are not only honest but also develop a great enthusiasm for truth and truthfulness, we will always initially feel a little sad in confronting the present, and will only be comforted when a feeling for beauty illumines and warms our soul. Beauty gives us back our joy in place of the sadness that always assails

us when we develop great enthusiasm for truth and truthfulness. In an intimate and subtle way, this enthusiasm is always telling us that truth is only to be found in our pre-earthly existence, that we have only an echo of it here on Earth. In leaving our pre-earthly existence behind, we have lost the possibility of being embedded in the essence of truth in the right way. Only through our enthusiasm for truth and truthfulness can we really maintain our connection with pre-earthly existence.

Through a true and genuine feeling for beauty we can, as it were, reestablish a link with pre-earthly life during life on Earth. In all aspects of education, in all our outward manifestations of culture and civilization, therefore, we should never underestimate the significance of beauty. A cultural environment full of nothing but ugly machinery, smoke, and unsightly chimneys, where beauty is entirely lacking, is a world that does not want human beings to create a link to their pre-earthly existence, so to speak. It may be stated, not as an analogy but in absolute truth, that a purely industrial city is a delightful abode for all those demons who want to make us forget our pre-earthly existence in the spiritual world.

But in giving in to beauty we will have to pay the price of realizing that beauty by its very nature is not rooted in reality. For example, the more beautifully we are able to fashion a human form in painting or sculpture, the more we must confess to ourselves that this does not correspond to any outer reality in physical existence. It is only the consolation afforded by a beautiful semblance, as it were, a consolation which therefore really only lasts until the moment we pass through the gates of death.

Now the world of spirituality in which we were fully involved during pre-earthly existence is always present; just stretch out your hand and you will be reaching into it. But although this world is always present, the link we create to it when we are aglow with enthusiasm for truth and truthfulness is a link that exists only for the deepest level of our unconscious. For earthly life itself, on the other hand, we create a link to the world of the spirit through our enthusiasm for beauty.

In a higher spiritual sense, saying that we should be truthful means that we should not forget that we once lived a pre-earthly life in the spiritual world. Saying that we should be warmly enthusiastic about

beauty means that in our soul life we should create at least an image of a new link to the spiritual world of pre-earthly existence. But how can we develop a real force that can lead us directly into the world of spirit that we left simply through becoming human beings who have descended from pre-earthly existence into life on Earth?

We develop this force when we fill ourselves with goodness, with the goodness that makes us consider the other person first, the goodness that makes us want to go beyond knowing only about ourselves, being interested only in ourselves, and feeling only what goes on within us, the goodness that enables us to enter with our own souls into the entirely individual and unique being and experience of another person. This goodness comprises a number of forces in the human soul. And these are forces of a sort that imbue us with something that really only pervaded us in our full humanness during pre-earthly life. Beauty provides the image of a link to the spiritual world we left for the sake of earthly existence, and we reunite ourselves and our earthly life with our pre-earthly existence by being good human beings. Good human beings are those who are able to enter with their own souls into the soul of another. Fundamentally, all morality, all true morality, depends on this ability to enter with one's own soul into the soul of another. Without morality it is impossible to maintain a real social configuration of humankind on Earth.

Once realized, this morality leads to very significant impulses of will, which then become reality in the form of highly moral deeds. However, it begins as an impulse permeating and taking hold of the soul when we are able, for instance, to feel moved at the sight of a worried frown on another person's face and at least our own astral body assumes the same worried frown. Goodness dwells in the human astral body just as our feeling for truth and truthfulness manifests in being properly implanted in the physical body, and just as warm enthusiasm for beauty is revealed in the etheric body. The astral body cannot be healthy or take its place in the world in the right way if the individual is unable to permeate it with what comes from goodness.

Truth has a relationship to the physical body, beauty to the etheric body, and goodness to the astral body. This presents us with something concrete concerning these three abstract concepts of truth,

beauty, and goodness, so we can now relate what is instinctively meant by these three ideals to the actual quintessential human being.

The point here is that these ideals attempt to express the extent to which individuals are actually capable of living up to the full human potential. They are capable of this if they inhabit their physical bodies not merely in accordance with nature or convention but as human beings dedicated to truth and truthfulness. But individuals can only worthily express the full potential of being human if, through their feeling for beauty, they grow ever more able to shape the etheric body into something that is alive for them. Individuals undeniably lack the right feeling for beauty unless they feel stirring within them something of what I described as the Greeks' natural experience in the face of beauty. My friends, we can either stare at something beautiful or we can be inwardly moved by the beauty in it. In fact, most people today only stare at beauty, so nothing is stirred in the etheric body. Staring at something does not mean we experience it. But the moment beauty is experienced with living inwardness, the etheric body also is quickened.

We may do good first of all because it is a matter of habit for us, or because we may be punished if we do something very wrong, or because others respect us less if we do wrong, and so on. It is also possible, however, to do good out of a genuine love for goodness in the sense I described some decades ago in *Intuitive Thinking as a Spiritual Path*. Such an experience of goodness within a human being always leads to acknowledging the human astral body. In reality, we actually only know the reason for goodness if we have some feeling for the astral body in a human being. Our recognition of goodness or talk about goodness will always remain abstract unless our enthusiasm for the good—for true and genuine goodness, for goodness that is lovingly understood—leads us to experience the astral body.

Therefore the experience of goodness is not, as is the case with beauty, merely a link to pre-earthly existence in the form of an image that lasts only until we pass through the gates of death. The experience of goodness really unites us with the world that I have said is always there—all you need to do is stretch out your hand and you will be reaching into it. Experiencing goodness is a real link. It points directly

into the world that we will enter when we pass through the gates of death. When we live in true goodness, there are forces present in what we practice on Earth that will persist beyond the gates of death.

Essentially, our sense for truth and truthfulness remains in us—if in fact it does—as a legacy from our pre-earthly existence. Our sense for beauty remains with us—if in fact it does—because we want to keep at least an image of our pre-earthly connection to spirituality as we go through earthly life. In truth, we have an inner need to not sever our connections with the spiritual world but rather to maintain a true link with it through the goodness that we develop within us as a human strength.

Being truthful means that we have the right connection to our spiritual past. Having a sense for beauty means that we do not deny the connections to the spiritual world in our present physical existence. Being good means to create a seed for a spiritual world in the future.

Thus we may say that the three concepts of past, present, and future—to the extent that they play a part in a fully human life and are understood quite concretely—acquire significant content through these other concepts of truth, beauty, and goodness.

Untruthful people deny their spiritual past; liars cut the threads that connect them to their spiritual past. Philistines who disregard beauty want to create a place on Earth where the sun of the spirit does not shine on them, where they can walk about in spiritless darkness, as it were. People who deny goodness renounce their spiritual future—but would then like to have this spiritual future bestowed upon them after all in some other way, by means of some external remedy.

It was indeed a profound instinct that grasped the three ideals of truth, beauty, and goodness as the greatest ideals of human striving. But only now in this day and age when these ideals have become little more than empty phrases, are we once again in a position to fill them with their true content.

10. Christ, Ahriman and Lucifer

DORNACH, MAY 7, 1923[1]

DR. STEINER: Good morning, gentlemen. Have you thought of something for us to talk about today?

QUESTION: Could you say something about the being and nature of Christ, Ahriman, and Lucifer in their relationship to human beings?

DR. STEINER: We'll need to explore the nature of the human being in general and from a different angle. Otherwise, this will seem somewhat superstitious to you.

I would like to say something based on what we have already discussed. You see, according to contemporary consciousness, it's as if the human being were thoroughly homogeneous; but this is not the case. Each of us is really in a continual state of coming to life and dying. We are not born only at birth, nor do we die only at death, but (as I have often explained to you) we are constantly dying and coming to life again.

Looking at our head, for example, we find that the entire inside of the head actually consists of nerve tissue. As you know, nerves otherwise run throughout the organism like threads, but the inside of the head is all nerve.

The inside of the head, the inside of the forehead, is all nerve, a great mass of nerves, and part of this mass of nerves continues down

1. A lecture given to the workers at the Goetheanum.

the spinal cord. From there, however, the nerve threads run through-out the whole body. That is, what runs in threads throughout the body is present in the head as a uniform mass of nerve tissue.

Now, if you look inside the human abdomen, you'll also find a great many nerves there, in the so-called solar plexus. This still con-tains a great deal of nerve tissue. But in our arms and hands and legs and feet, the nerves taper off and become quite thread-like.

But if you look at something totally different, at the blood vessels, you'll find that they are quite thin and delicate in the head. In con-trast, the blood vessels in the neighborhood of the heart are very strongly developed, and there are thick veins in the limbs. And so we can say that we have the nervous system on the one hand and the blood system on the other.

Now, the fact is, we are born anew out of our blood every day and every hour. Blood always signifies renewal. So if we had only blood inside us, we would be like beings that are constantly growing and getting bigger, are always vigorous, and so on. But if we consisted only of nerves, you see, we'd be constantly worn out and tired. Actu-ally, we would be constantly dying off. So we have two opposing principles within us—the nervous system, which is constantly mak-ing us grow old and even delivering us into the hands of death, and the blood system, which is connected to the digestive system and is constantly making us young.

What I've just explained to you can be taken still further. As you know, we sometimes say that people become calcified in their old age, that calcification or sclerosis sets in. When their veins calcify, as this process is called, the walls of their blood vessels harden and have difficulty moving. If the calcification is especially pronounced, then the person has what's known as a stroke. Having a stroke simply means that the blood vessels calcify and can't function any longer.

What's really happening to a person who is calcifying or becoming sclerotic? It's as if the walls of his or her blood vessels were trying to turn into nerves. This is a very strange thing. Our nerves must be constantly dying off, so to speak. Throughout our entire life, they must be in a condition that blood vessels should never be in at all. Our blood vessels must always be fresh and young, and our nerves

must constantly tend toward dying off. In contrast, if people have nerves that get too soft and aren't calcified enough—if I may put it like that—then they go crazy. So you see that our nerves aren't allowed to be like blood vessels, and our blood vessels aren't allowed to be like nerves.

Now, this forces us to conclude that the human being contains two principles. One is the nerve principle, which causes us to constantly grow older. From morning till night, we actually always grow a bit older each day, and during the night everything is refreshed by the blood. This goes on continually, like the swinging of a clock pendulum: growing old, growing young; growing old, growing young. Of course as we grow older from staying awake from morning till night and grow younger again from sleeping from night until morning, there's always a bit left over. Although things improve overnight, there's always a bit of growing older left over to accumulate, and when the amount is large enough, the person in question actually dies. That's how things stand; there are two things in the human being that work against each other—growing old and growing young.

Now that I've explained it to you from the standpoint of the body, let's look at ourselves from the standpoint of the soul. You see, when the process of growing young takes place too strongly in people, they get pleurisy or pneumonia. The fact is that things that are quite all right or even excellent when they stay within their limits lead to illness when they get out of hand. Illness in human beings is merely a case of something we always need getting out of hand. Fever comes from the process of growing young becoming much too strong in us. We can't tolerate it any longer; we become too fresh in our entire body, and then we get a fever, pleurisy, or pneumonia. Now, we can also look at this whole thing from the standpoint of the soul. You see, it's also possible for people to either dry up in their souls or to have the soul equivalent of what happens in the body during a fever. This involves certain human qualities that we don't like to hear about because so many people today have them—people become pedantic or overly conventional. There are people like this all over the place today. It does happen, you know. Teachers, for example, should always be very fresh and lively, but it's easy enough for teachers to dry

up. This is the same as when our blood vessels calcify or dry up. Drying up in our souls is also possible.

But we can also become overly soft in our souls. That happens when someone becomes too much of a fanatic or a mystic or a theosophist. What are people like this trying to do? They don't want to think properly; they try to use their imagination to reach out into all sorts of worlds, but without thinking properly. This is the same thing as getting a fever in the body. Becoming a mystic or a theosophist means getting a soul fever.

However, we always need to have both of these conditions in us. We can't understand anything if we aren't able to use our imagination, and we can't work together on anything if we aren't a little pedantic about categorizing all kinds of things, and so on. If we take it too far, we become pedantic or overly conventional, but if we do it in just the right amount, we are simply good souls. So you see, there's always something in us that must be present in the right proportion, but if it gets out of hand it causes illness, either in the body or in the soul.

Gentlemen, the same is true of the spiritual. We cannot always sleep, we also have to wake up sometimes. Just think what a jolt it is to wake up! Imagine how it is when you're sleeping: You lie there knowing nothing about your surroundings. If you're sleeping soundly, someone can even tickle you and you don't wake up. Think of the difference—once you're awake, you see and hear everything around you. This is a very big difference. We must have the inner strength to wake up, but if it's too strong and we're always waking up and can't sleep at all, for example, then the strength for waking up is too strong in us.

Then again, there are people who can never wake up properly at all. These people spend their entire lives walking around half awake and dreaming, wanting to be asleep. These people can't wake up. We need to have the ability to fall asleep properly, but this must also not be too strong in us, or we would sleep forever and never wake up again.

Thus, we can say that there are three ways of distinguishing certain conditions in the human being. The first relates to the body. There we have the nervous system on the one hand, which is something with a constant tendency toward hardening or calcification. So we say:

	hardening
in body :	calcifying

Now, with the exception of a few of you sitting here, you're all old enough so that you must have calcified your nervous systems a bit. If you still had the nervous systems you had when you were six months old, you would all be crazy. You can't have a nerve system that is that soft any longer. Only people who are insane have child-like nerve systems. So we need to have the hardening or calcifying force within us, but on the other hand, we also need to have the softening or rejuvenating force. These two forces must balance each other out.

	hardening	softening
in body :	calcifying	rejuvenating

If we look at this from the level of the soul, we can say that hardening corresponds to pedantry, conventionality, materialism, and dried-up rationality. We need to be able to grasp all this: We need to be a bit conventional, or we would all be jumping-jacks. We need to be a bit pedantic, or we wouldn't be able to keep our things in order; we would hang our coats in the oven or up the chimney instead of hanging them in the appropriate closet. Being a bit conventional and a bit pedantic is quite all right, but it must not get too strong. But we also have forces in our souls that lead to visionary fantasy, fanaticism, mysticism, and theosophy. When all these forces become too strong, we become visionaries and fanatics. That must not happen, but we must also not do away with fantasy completely. I once knew someone who hated any fantasy whatsoever. He never went to the theater and certainly not to the opera, because he said that it was all not true. He had no fantasy at all. But if we have no fantasy at all, we get all dried up; we sneak through life instead of being real, proper human beings. This must not be taken too far, either.

	pedantry	fantasy
	conventionality	fanaticism
in soul:	materialism	mysticism
	dried-up rationalism	theosophy

Now, if we look at it from the standpoint of the spirit, the hardening force is present in waking up. When we wake up, we take our body firmly in hand and make use of our limbs. And the force that is the softening or rejuvenating process in the body is present in falling asleep. We sink down into dreams and no longer have our body in hand.

	waking up
in spirit:	falling asleep

We can say that human beings are always in danger of going too far in one direction or the other, of falling into either the softening process or the hardening process.

If you have a magnet, you know that it attracts iron. We say that there are two kinds of magnetism in the magnet, and that's true; there is positive magnetism and there is negative magnetism. One attracts a magnetic needle; the other repels it. They work as opposites.

Now when it comes to physical or bodily things, we don't hesitate at all to give things names. We need names. I've just described something to you in terms of the body, the soul, and the spirit. This is something you can all perceive at any time, and you can be quite clear about it. However, we need names. In the case of positive magnetism, we must clearly see that it is not the iron itself, it's something in the iron. Something invisible is there inside the iron.

Someone who doesn't acknowledge the presence of something invisible in the iron will say, "You really are stupid. Is there supposed to be magnetism in that piece of iron? That's a horseshoe! I shoe my horse with it!" Well, this person is really the idiot for not believing that there is something invisible in the iron, and for shoeing a horse

with it. That horseshoe can be used for very different purposes if it's magnetic.

But, you see, there is likewise something invisible, or supersensible, within the hardening process. And we call this invisible, supersensible, being-like presence (which you can observe if you have the gift for it) *ahrimanic* forces. Thus, the forces that constantly want to turn the human being into some kind of corpse are ahrimanic. If ahrimanic forces were the only ones present, we would constantly be turning into corpses, and we would be pedantic, totally hardened human beings. We would be constantly awake and would not be able to sleep.

The forces that soften and rejuvenate us and lead us to imagination are the *luciferic* forces. These are the forces we need so as not to become living corpses. But if the luciferic forces were the only ones present, we would remain children for our entire life. Luciferic forces must be present in the world so that we aren't all gray-haired by the age of three. These two opposing forces must be present in each human being.

	Ahrimanic	Luciferic
in body	hardening	softening
	calcifying	rejuvenating
in soul	pedantry	fantasy
	conventionality	fanaticism
	materialism	mysticism
	dried-up rationalism	theosophy
in spirit	waking up	falling asleep

Now, the important thing is that these two opposing forces must be balanced out. Neither of them must get out of hand. Where does the balance lie?

As you know, when we write the date today, we write "1923." It's characteristic of the whole time from the beginning of the Christian era until now that humanity is in danger of succumbing to the ahrimanic forces. Consider the fact that wherever there is no spiritual science, people are educated in an ahrimanic way. Our children enter the elementary schools and have to learn things that must seem quite peculiar to them and that aren't interesting to them, as I've already pointed out. They've always seen their father, and they know what he looks like—that he has hair, ears, and eyes—and then they're supposed to learn that *F-A-T-H-E-R* means their father. This is totally foreign to them, and they have no interest in it. The same is true of everything they're supposed to learn in elementary school in the very beginning.

This is why we must once again establish sensible schools where children begin by learning things they can be interested in. If instruction were to be continued as it's carried out today, people would age very early. They would soon become old and senile, because that's what the ahrimanic forces do. The way children today are educated in school is totally ahrimanic. In general, the whole evolution of humanity during these nineteen hundred years has tended toward the ahrimanic. Prior to that, it was different.

If you go back, let's say, to the time between the year 8000 B.C. and the beginning of the Christian era, things were different. Then, people were in danger of not being able to grow old. In those times, there were no schools in the modern sense. Schools existed only for people who had already reached a respectable age and wanted to become real scholars. There were schools for these people in ancient times, but there were no schools for children. Children learned from life; they learned what they saw. There were no schools for them, and no effort was made to teach them anything that was foreign to them. In those times, the danger existed that people would fall totally into the luciferic element, namely into fanaticism. And in fact that did happen. As I've already told you, there was much wisdom in these

ancient times, but of course the luciferic element first had to be reined in; otherwise people would have wanted to tell ghost stories all day long. That was something they especially enjoyed doing.

We can say that in very ancient times, approximately from 8000 B.C. to the beginning of the Christian era, there was a luciferic age, which was then followed by an ahrimanic age. Let's look at this luciferic age. The people who were the scholars in these ancient times had certain concerns. They lived in buildings shaped like towers, one of which was the tower of Babel, as it was called in the Bible. These scholars said: We're leading the good life here. Our fantasy has free play, and we would always like to slip off into the realm of ghosts, into the luciferic element. But we also have our telescopes, and we look out at the stars and see how they move. This reins in our fantasy, because I can't make a star move in a particular direction by looking at it and imagining that it will move as I wish. This reins in my fantasy.

So these scholars knew that their fantasy was reined in by the phenomena of the world. And they had their instruments of physics. They knew that although they could imagine making a huge fire by taking a very small piece of wood and heating it slightly, if they really did it, they would get only a small fire from the little piece of wood. The actual purpose of these ancient educational institutions was to rein in people's rampant imagination. Their scholars worried about all the other people who could not become learned, and so they disseminated teachings, some of which were honest and some dishonest. These were the religious teachings of antiquity, which had their origin in science. However, the priests became degenerate, of course, and so the dishonest teachings came down to posterity, while the honest ones have been lost for the most part. But the purpose of all this was to rein in the luciferic element.

And you all know how it is with the ahrimanic element. Today's science is striving increasingly for the ahrimanic element. Actually, all of our science today is something that makes us dry up, because this science really knows only the bodily aspect of things, the calcified material aspect. That is the ahrimanic element in our entire civilization.

Between these two things stands the *christic*, or Christ-like, element in the true sense of the word. You see, gentlemen, we know

too little about what is really christic in the world. The so-called "Christian" element in the world is something we have to fight, of course. The Being I mentioned last time—who was born at the turning point of time and lived for thirty-three years—was not as people describe Him. He actually intended to provide all of humanity with teachings that would make it possible to balance the ahrimanic and luciferic elements. To be Christian, or christic, means to seek the balance between the ahrimanic and the luciferic elements. It is really not possible to be Christ-like by being what people today often call "Christian."

For example, what does it mean to be christic in a bodily sense? It means to acquire knowledge about the human being. Human beings can also become ill. What does it mean if a person gets pleurisy? It means that there is too much of the luciferic in that person. Knowing this, I must think as follows: If I have a pair of scales, and one side rises too much, I need to remove some weights on the opposite side. If it then sinks too much, I need to add weights on the other side. When a person has pleurisy, it means that the luciferic element is too strong and the ahrimanic too weak, and so I need to add something ahrimanic to restore balance.

Knowing that this person has pleurisy, what can I do to help? Let's say I take a piece of birch wood, which grows quickly in the spring. Birch is very good wood, especially the part close to the bark, because there are very strong growth forces present in the bark. I kill them off by burning the birch wood, and then I have birch charcoal. What have I done to this fresh birch wood that constantly rejuvenates itself? I've turned it into something ahrimanic. So now I make a powder out of this birch charcoal and administer it to the person who has pleurisy, who has too much of the luciferic. I've added something ahrimanic to balance this out. Administering birch charcoal in a case of pleurisy, when there is too much of the luciferic element present, is like adding something to the scales when one side goes up too much. I've mineralized the birch wood and made it ahrimanic by turning it into charcoal.

Or take the case of a person who looks so tired and crippled that a stroke seems imminent. There is too much of the ahrimanic element

in this person. I need to administer something luciferic to bring about a balance. What will I do in this case?

Take a plant; its root, as you know, is hard and contains a lot of salts. It is not luciferic. The stem and leaves are not quite luciferic either. But if I go even farther up, one finds a flower that emits a strong fragrance. Just like fantasy, which tries to escape, the fragrance also tries to escape from the plant. Otherwise, I would be unable to smell it at all. So I extract the luciferic juice from the blossom and administer it appropriately. This balances the ahrimanic element, and I am able to cure the person.

What does modern medicine do? It conducts tests. Along comes a chemist who discovers *acetylphenetidine*. (I don't need to explain what that is—just to say that it's a complex substance.) Now they take it to a hospital where there are, say, thirty patients. They give all thirty patients acetylphenetidine, take their temperatures, measure and take notes, and if something comes of all this, they consider this substance a medication. But they have no idea of what's actually going on inside the human body. They don't even peek inside the body.

We are doing the right thing only when we know that in pleurisy, too much of the luciferic element is present and we need to administer something ahrimanic, while in the case of a stroke too much of the ahrimanic element is present and we need to administer something luciferic. This is what humanity lacks today. In this sense, humanity is not Christian enough, because balance is the Christ-like element. I am showing you what constitutes the christic element in all bodily healing. It consists in seeking the balance.

You see, this is what I also wanted to represent in the wooden figure that is going to stand in the Goetheanum. Up top is Lucifer, the luciferic element. In the human being, this is fever, fantasy, falling asleep. Down below is the ahrimanic element, everything that wants to become hard. Between the two stands the Christ.

This is what brings us to what we ought to do in medicine, science, sociology—everywhere. Part of being human today is to understand how the luciferic and ahrimanic elements work in human nature. But what do people understand of these things? A very famous clergyman named Frohnmeyer once lectured in Basel

and elsewhere about this wooden figure. He hadn't actually bothered to look at it, but had read something written by someone who may also not have seen it personally, but was simply copying what some third person had written about this sculpture that is luciferic on top, has Christ in the middle, and is ahrimanic on the bottom. As you know, there are three figures arranged one above the other; actually, there are even more because Ahriman and Lucifer are both represented twice. However, this Pastor Frohnmeyer knew so much about it that he wrote that this man Steiner is making something shocking out there in Dornach—a Christ-figure that has luciferic features up above and animal characteristics down below. Well, the Christ figure doesn't have any luciferic features at all, but a thoroughly human head. He got that mixed up; he thought it had luciferic features up above and animal characteristics down below. And the lower portion of the Christ isn't even finished yet; it's still just a chunk of wood!

This is how this truth-loving Christian pastor described the matter, and now the whole world says that it must be true because a pastor said it. It's difficult to refute such things when people don't want to understand. They always go running to the pastors because they believe what pastors say. But there you have an example of slander that is so pathetic you can hardly imagine anything worse.

These people have very strange views. At the time when Pastor Frohnmeyer wrote all this, Dr. Boos was still here at the Goetheanum. As you know, Dr. Boos tended to go at everything with a cudgel. (Opinions may differ as to whether it would be more appropriate to use a cudgel or a hand brush. A hand brush is softer, more luciferic; a cudgel is harder and more ahrimanic. It all depends on what you want to use.) In any case, Dr. Boos told Frohnmeyer the truth with a cudgel, so to speak. And then, who got a letter from Frohnmeyer? I did! I got a long letter from Dr. Frohnmeyer saying that I should make sure that Dr. Boos didn't behave so badly toward him. Just imagine what kind of concepts these people have! It's absolutely inconceivable. They slander somebody, just as I've told you, and afterward they ask that same person to take measures against the one who set the record straight!

That's exactly the difficulty with the general public—ordinary middle-class people are unwilling to see for themselves in these things but simply accept what comes to them. The fact that the people in question stand in some sort of official relationship to them makes it right. That's why our civilization is so terribly frivolous and so nasty in many instances.

The point is that our whole way of thinking today must start to flow in new channels, so that we realize once again that all this talk about being Christian doesn't amount to anything. Instead, we must be factual about it. That is, we must understand how the practice of medicine can become christic. We know, for instance, that someone has demonstrated quite precisely that people who have eaten sugar regularly, perhaps as children, tend to get liver cancer, which is a case of the liver becoming ahrimanic. We must then know that we need to administer a corresponding luciferic element. Just as we distinguish between warmth and cold, we must distinguish between becoming luciferic and becoming ahrimanic. When our limbs become rigid, we become ahrimanic, don't we? And if we then apply warm compresses, that's something luciferic that works against it. Similarly, we must know how things stand with a person's constitution, in all areas and under all circumstances. Then the practice of medicine becomes christic.

Education and the school system must also become christic. That is, we must educate children in a way that doesn't make them elderly already in their earliest childhood. In school, we must begin with things that are close to children's hearts, with things they're interested in, and so on.

You see, in using the terms *ahrimanic*, *luciferic*, and *christic*, there is nothing superstitious about them if we view things this way; they are completely scientific.

How has historical evolution proceeded? As you may know, from the earliest Christian times until into the twelfth, thirteenth, or even the fourteenth centuries, Christians were forbidden to read the Bible. Reading the New Testament was forbidden; only the priests were allowed to read it. The faithful in general were not allowed to read the Bible. Why was that? Well, because the clergy knew that the

Bible had to be read in the right way. The Bible came about in a time when people thought pictorially rather than the way we think now. Therefore, the Bible has to be read in the right way. If people were to read the Bible without being properly prepared for it, they would conclude that the four Testaments, the Gospels according to Matthew, Mark, Luke, and John, contradict each other. And why do they contradict each other? This, gentlemen, is something we simply need to understand in the right way. Any semi-intelligent person, even in the fourth or fifth century, could have seen that the Gospels contradict each other. Of course they do.

Imagine that I take a photograph of Mr. Jones from the front, and show the picture to all of you. You would recognize him from the picture. But then someone comes along and takes a picture of him from the side so that you see his profile. Suppose I showed that picture to you, and you said, "That isn't Mr. Jones; he looks very different. You have to look at him from the front; he looks like such and such. What you're showing me from the side is not Mr. Jones!" Nevertheless, it is Mr. Jones; the pictures merely show him from two different sides. And what if I photographed him from behind? Would you say, "That's not him; he has a nose, not just hair!" But this is what he looks like from various sides.

Similarly, if we "photograph" spiritual events from different sides, they also look different. We have to know that the Gospels depict events from four different sides, so they must indeed contradict each other, just as pictures of Mr. Jones taken from the front, the side, and the back are different from one another.

But now a time has come when people no longer accept having to prepare to read the Gospels. Today we no longer prepare for anything. While we're in school, we prepare by allowing ourselves to be trained, but once we're fourteen or fifteen years old and the training is over, there's nothing more to prepare for and we have to understand everything. At least, that's the normal opinion nowadays.

And then (why shouldn't it come to this) people see that the people here at the Goetheanum who are going in to be prepared are not children, but old men with bald heads. It's a school where old people go instead of children! It must be some kind of nuthouse! That's

what they say, you know, because they cannot imagine that people still want to learn. This is how things are today. And it is what we ourselves have to be clear about: In order to read something like the Gospels, we must be properly prepared to do so, because it's meant figuratively. It's just like wanting to read a Chinese manuscript—we would first have to learn the characters. If we wanted to take the Gospels just as they stand, it would be absurd, just as the Chinese manuscript is nothing but scribbles if we don't approach it rationally. But if we understand these things in the right way, we will conclude that the whole christic element urges us to learn to bring the ahrimanic into the right balance with the luciferic in each instance, not letting the one rise above the other.

This is why anthroposophy is not embarrassed to speak about what is Christian in this sense of the word. It emphasizes that being Christian does not consist in constantly having the name of Christ on your lips, and so on. People accuse anthroposophy of speaking so little of Christ. Well, I always say that anthroposophy speaks so little of Christ because it knows the Ten Commandments. You others speak about Christ so much because you don't even know the commandment, "Thou shalt not take the name of the Lord thy God in vain."

When a Christian pastor preaches today, the name of Christ is uttered repeatedly. But it should only be uttered when people really understand what's in question. This is what is distinctive about anthroposophy. It really wants to be Christian in the right sense, without superstition, without pious affectation, but in a really scientific way. In this sense, it merely tries to be truly scientific. And this is how it also views what inserted itself between the luciferic times of old and our ahrimanic modern times. It sees this event in Palestine as setting the standard for the history of the world. When people once again really understand what actually took place there on Earth, they will come to themselves again, you might say. With their totally superficial science, people nowadays are outside themselves.

We will have more to say about this next Wednesday at nine o'clock. This is what I wanted to say today in response to your question. I believe it makes the whole subject understandable.

BIBLIOGRAPHY

Rudolf Steiner on Art and Related Matters in English (RSE)

1. 1886 *The Science of Knowing.* Spring Valley, NY: Mercury Press, 1988.

2. Nov. 8, 1888 "The Aesthetics of Goethe's Worldview" (L 1).

3. 1894 *Intuitive Thinking as a Spiritual Path: A Philosophy of Freedom.* Hudson, NY: Anthroposophic Press, 1995.

4. 1897 *Goethe's World View.* Spring Valley, NY: Mercury Press, 1985.

5. 1898 "Truth and Verisimilitude in a Work of Art." *The Forerunner,* vol. 3, no. 1 (1942).

6. 1904 *Theosophy: An Introduction to the Spiritual Processes in Human Life and in the Cosmos.* Hudson, NY: Anthroposophic Press, 1994.

7. 1904 *How to Know Higher Worlds: A Modern Path of Initiation.* Hudson, NY: Anthroposophic Press, 1994.

8. May 18, 1907 *Occult Seals and Columns.* London: Anthroposophical Publishing Co., 1924.

9. Sept. 13–16 *Occult Signs and Symbols.* Spring Valley, NY: Anthroposophic Press, 1972.

10. June 11, 1908 *The Influence of Spiritual Beings upon Man.* Spring Valley, NY: Anthroposophic Press, 1961.

11. Oct. 23–27, 1909 *The Wisdom of Man, of the Soul, and of the Spirit.* New York: Anthroposophic Press, 1971.

12. Oct. 28 "The Spiritual Being of Art" (L 2).

13. 1909 *An Outline of Esoteric Science.* Hudson, NY: Anthroposophic Press, 1997.

14. May 12, 1910 *Metamorphoses of the Soul,* vol. 2. London: Rudolf Steiner Press, 1983.

15. Dec. 12, 1911 *The Temple Is—Man!.* London: Rudolf Steiner Press, 1979.

16. Feb. 13, 1913 "Leonardo DaVinci: His Spiritual Greatness at the Turning Point of Modern Times." manuscript. Ghent, NY: Rudolf Steiner Library.

17. May 19 "Raphael's Mission in the Light of the Science of the Spirit." *Anthroposophical News Sheet*, vol. 3, nos. 29–32 (1935).

18. Jan. 8, 1914 "Michaelangelo." manuscript. Ghent, NY: Rudolf Steiner Library.

19. June 17, 1914 "Buildings Will Speak the Language of the Gods" (L 3).

20. Oct. 10–25 *The Building in Dornach. Stages in Historical Development and a New Impulse in Art.* manuscript. Ghent, NY: Rudolf Steiner Library.

21. Dec. 28 *Art as Seen in the Light of Mystery Wisdom.* London: Rudolf Steiner Press, 1984.

22. Dec. 29, 30 Ibid.

23. Jan. 1, 1915 "Moral Experience of the Worlds of Colour and Tone" in *Art as Seen in the Light of Mystery Wisdom.* London: Rudolf Steiner Press, 1984.

24. Jan. 2 "The Goetheanum and the Music of Its Architecture" in *Art as Seen in the Light of Mystery Wisdom.*

25. Jan. 3 "The Future Jupiter and Its Beings" in *Art as Seen in the Light of Mystery Wisdom.*

26. Feb. 5–7 *Problem of Death in Connection with the Artistic Understanding of Life.* manuscript. Ghent, NY: Rudolf Steiner Library.

27. May 18 *Christ in Relation to Lucifer and Ahriman.* Spring Valley, NY: Anthroposophic Press, 1978.

28. July 29, 1916 *The Riddle of the Human Being; the Spiritual Foundations of Human History.* London: Rudolf Steiner Press, 1990.

29. Aug. 6 Ibid.

30. Aug. 15, Ibid. "The Sense Organs and Aesthetic Experience" (L 4)

31. Sept. 2-3 Ibid.

32. Sept. 20 "Architectural Forms Considered as the Thoughts of Culture and World-Perception." manuscript. Ghent, NY: Rudolf Steiner Library.

33. Oct.–Jan. 1917 *The History of Art: A Course of Nine Lectures.* manuscript (w/slides). Ghent, NY: Rudolf Steiner Library.

34. Feb. 15, 1918 "The Two Sources of Art: Impressionism and Expressionism (L 5).

35. May 6 "The Sources of Artistic Imagination and Sources of Supersensible Knowledge." manuscript. Ghent, NY: Rudolf Steiner Library.

36. July 3 The Building at Dornach (L 6).

37. Nov. 9, 1919 *The Influences of Lucifer and Ahriman: Man's Responsibility for the Earth.* North Vancouver, BC: Steiner Book Centre, 1976.

38. Jan. 23–25, 1920 *The Building at Dornach.* manuscript. Ghent, NY: Rudolf Steiner Library.

39. Aug. 8 "Man's Twelve Senses in Their Relationship to Imagination, Inspiration and Intuition." manuscript. Ghent, NY: Rudolf Steiner Library.

40. Sept. 12 "The Supersensible Origin of the Arts" (L 7).

41. Nov. 26 "The Shaping of the Human Form out of Cosmic and Earthly Forces." *Anthroposophical Quarterly*, vol. 17, no. 1 (Spring 1977).

42. Dec. 5 *Colour.* London: Rudolf Steiner Press, 1992.

43. Dec. 10 Ibid.

44. Feb. 28, 1921 "The Dornach Building." manuscript. Ghent, NY: Rudolf Steiner Library.

45. Apr. 9 "Psychology of Art." manuscript. Ghent, NY: Rudolf Steiner Library.

46. May 6–8 *Colour.* London: Rudolf Steiner Press, 1992.

47. June 29 *The Architectural Conception of the Goetheanum.* New York: Anthroposophic Press, 1938.

48. July 22 *Man as a Being of Sense and Perception.* London: Anthroposophical Publishing Co., 1958.

49. Aug. 23 "Anthroposophy and Art." *Anthroposophy Monthly*, vol. 1, nos. 7–8 (1921).

50. Oct. 22 "The World of the Senses and the World of Thoughts and Their Beings." manuscript. Ghent, NY: Rudolf Steiner Library.

51. Feb. 17, 1922 "The Passage of the Human Soul and Spirit through the Physical Sense-Organization." manuscript. Ghent, NY: Rudolf Steiner Library.

52. March 31 "Changes in the Human World Conception." *Anthroposophy Movement*, vol. 6 (1929).

53. Apr. 9 "Anthroposophy and the Visual Arts." (L 8).

54. Aug. 2–9 *The Human Being in Body, Soul and Spirit.* Hudson, NY: Anthroposophic Press; London: Rudolf Steiner Press, 1989.

55. Sept. 16,17 Ibid.

56. Dec. 2 "Human Utterance through Tone and Word." *Art in the Light of Mystery Wisdom.* London: Rudolf Steiner Press, 1970.

57. Dec. 4 "Memory and Love." *The Golden Blade* (1983).

58. Jan. 1, 1923 "Lecture after the Fire." *Anthroposophical News Sheet*, no. 10.

59. Jan. 19 "Truth, Beauty and Goodness" (L 9).

60. Mar. 25 "Education and Art" (written outline of lecture). London: Anthroposophical Publishing Co. 1923.

61. Apr. 9 "What Was the Purpose of the Goetheanum and What Is the Task of Anthroposophy?" manuscript. Ghent, NY: Rudolf Steiner Library.

62. May 7 "Christ, Ahriman, and Lucifer" (L 10).

63. May 18,20 *The Arts and Their Mission*. Spring Valley, NY: Anthroposophic Press, 1964.

64. June, 9 In *Seven Lectures to the Workers*. manuscript. Ghent, NY: Rudolf Steiner Library.

65. July 29 In *Colour*. London: Rudolf Steiner Press, 1992.

66. Aug. 24 "Concerning Art and Its Future Task." *Anthroposophic News Sheet*, vol. 4, nos. 4–5 (1936).

67. Jan. 4, 1924 In *Rosicrucianism and Modern Initiation: Mystery Centres of the Middle Ages*. London: Rudolf Steiner Press, 1965.

Collections of Lectures by Steiner:

68. *The Apocalypse of St. John*. New York: Anthroposophic Press, 1977.

69. *Art as Seen in the Light of Mystery Wisdom*. London: Rudolf Steiner Press, 1984.

70. *The Arts and Their Mission*. trans. Lisa Monges and Virginia Moore. New York: The Anthroposophic Press, 1964.

71. *Colour*. Sussex: Rudolf Steiner Press, 1992.

72. *Ways to a New Style of Architecture*. ed. H. Collison. London, 1927.

73. *Foundations of Human Experience*. Hudson, NY: Anthroposophic Press, 1996.

74. *Four Mystery Dramas*. Vancouver: Steiner Book Centre, 1973.

Anthroposophic Authors (AA)

1. Barfield, Owen. *Saving the Appearances: A Study in Idolatry*. New York: Harcourt, Brace & World, 1957.

2. Baravalle, Hermann von. "The Geometry of Shadow"; Bermlen, D. J. van. "A Drawing Lesson with Rudolf Steiner." Spring Valley, NY: Mercury Press, n.d.

3. Barnes, Henry. *A Life for the Spirit: Rudolf Steiner in the Crosscurrents of Our Time*. Hudson, NY: Anthroposophic Press, 1997.

4. Bayes, Kenneth. *Living Architecture*. Hudson, NY: Anthroposophic Press, 1994.

5. Bemmelen, Daniel van. *Rudolf Steiner's New Approach to Color on the Ceiling of the First Goetheanum*. Spring Valley: St. George Publications, 1980.

6. Biesantz, Hagen-Klingborg, Arne. *The Goetheanum: Rudolf Steiner's Architectural Impulse*. London: Rudolf Steiner Press, 1979.

7. Bockemühl, Jochen. *In Partnership with Nature*. Wyoming, R.I.: Bio-Dynamic Literature, 1981.

8. Boos-Hamburger, Hilde. *Creative Power of Colour*. London: The Michael Press, 1973.

9. ———. *The Nine Training Sketches for the Painter (Nature's Moods) by Rudolf Steiner*. London: Rudolf Steiner Press, 1982.

10. ———. *Die Farbige Gestaltung der Kuppeln des ersten Goetheanum*. Basel: Verlag R. G. Zbinden & Co.,1961.

11. ———. *Aus Gesprachen mit Rudolf Steiner uber Malerei*. Basel: Verlag R.G. Zbinden & Co., 1954.

12. Clausen, Anke-Usche, Riedel, & Martin. *Plastisches Gestalten in verschiedenem Material* (in German). Stuttgart: J. Ch. Mellinger Verlag, 1969.

13. ———. *Plastisches Gestalten in Holz*. Stuttgart: J. Ch. Mellinger Verlag, 1972.

14. Collot d'Herbois, Laine. *Colour, Part One: A Textbook for the Painting Group "Magenta."* Driebergen: The Netherland's Stichting Magenta, 1979; part 2, 1981.

15. ———. *Light, Darkness and Colour in Painting-Therapy*. Dornach, Switzerland: The Goetheanum Press, 1993.

16. Easton, Stewart C. *Man and World in the Light of Anthroposophy*. Spring Valley, NY: Anthroposophic Press, 1975.

17. Edelglass, Maier, Davy, & Gebert. *The Marriage of Sense and Thought: Matter and Mind*. Lindisfarne Press, 1997.

18. Fant, Klingborg, Wilkes. *Rudolf Steiner's Sculpture in Dornach*. London: Rudolf Steiner Press, 1975.

19. Fletcher, John. *Art Inspired by Rudolf Steiner*. Mercury Arts Publications, 1987.

20. Gerbert, Hildegard. *Education Through Art*. Spring Valley: Mercury Press, 1989.

21. Grohmann, Gerbert. *The Plant*. London: Rudolf Steiner Press, 1974.

22. Groddeck, Marie. *The Seven Training Sketches for the Painter by Rudolf Steiner*. London: Rudolf Steiner Press, 1982.

23. Hauck, Hedwig. *Handwork and Handcrafts from Indications by Rudolf Steiner*. London, 1968.

24. Hauschka, Dr. Margarethe. *Fundamentals of Artistic Therapy*. London: Rudolf Steiner Press, 1985.

25. Heydebrand, Caroline von. *The Curriculum of the First Waldorf School*. Forest Row: Steiner School Fellowship Publications, 1989.

26. Husemann, Armin. *The Harmony of the Human Body: Musical Principles in Human Physiology*. Floris Books, 1994.

27. Husemann. Armin. *Knowledge of the Human Being through Art: A Method of Anthroposophical Study*. Spring Valley: Mercury Press, 1990.

28. Junemann, Margrit & Fritz Weitmann. *Drawing and Painting in Rudolf Steiner Schools*. Stroud: Hawthorn Press, 1994.

29. Kemper, Carl. *Der Bau* (in German). Stuttgart: Verlag Freies Geistesleben, 1966.

30. Kempter, Friedrich. *Rudolf Steiner's Seven Signs of Planetary Evolution*. Spring Valley: St. George Publications, 1980.

31. Klocek, Dennis. *Drawing from the Book of Nature*. Fair Oaks, California: Rudolf Steiner College Publications, 1990.

32. Koch, Elizabeth & Gerard Wagner. *The Individuality of Colour*. London: Rudolf Steiner Press, 1980.

33. Koch & K. Theodor Willmann. *Gerard Wagner: Die Kunst der Farbe* (German text). Stuttgart: Verlag Freies Geistesleben, 1980.

34. König, Karl. *The Human Soul*. Spring Valley NY: Anthroposophic Press, 1973.

35. Kutzli, Rudolf. *Creative Form Drawing* (3 workbooks). Stroud: Hawthorn Press, 1992.

36. Mackler, Andreas. *Anthroposophie und Malerei*. Koln: DuMant Buchverlag, 1990.

37. Martin, Michael. *Der Kunstlerisch-Handwerkliche Unterricht in der Waldorfschule* (in German). Stuttgart: Verlag Freies Geistesleben, 1991.

38. Mayer, Gladys. *Colour and Healing*. East Grinstead, Sussex, England: New Knowledge Books, 1976.

39. ———. *Colour and the Human Soul*. East Grinstead, Sussex, England: New Knowledge Books, 1978.

40. ———. *The Mystery Wisdom of Colour: Its Creative and Healing Powers*. East Grinstead, Sussex, England: New Knowledge Books, 1975.

41. McDermott, Robert, ed. *The Essential Steiner: Basic Writings of Rudolf Steiner*. New York: Harper Collins, 1984.

42. Mees-Christeller, Eva. *The Practice of Artistic Therapy*. Spring Valley: Mercury Press, 1985.

43. Merry, Eleanor C. *Art: Its Occult Basis and Healing Value*. London, 1961.

44. ———. *Goethe's Approach to Colour*. London: Michael Press, 1977.

45. McDermott, Robert. *The Essential Steiner*. San Francisco: HarperSan Francisco, 1984.

46. Muller, Brünhild. *Painting with Children*. Stuttgart: Floris Book, 1987.

47. Oling-Jellinek, Elizabeth. *Vom Wesen der Farbe in der Eurythmy und Malerei Rudolf Steiner*. Dornach: Engelhardt Verlag, 1972.

48. Raab, Rex. *Edith Maryon: Bildhauerin und Mitarbeiterin Rudolf Steiners* (in German). Dornach, Switzerland: Philosophisch-Anthroposophisher Verlag, 1993.

49. Raab, Klingborg, & Fant. *Eloquent Concrete*. London: Rudolf Steiner Press, 1979.

50. Raab, Rex. *Die Waldorfschule Baut* (in German). Stuttgart: Verlag Freies Geistesleben, 1982.

51. Raske, Hilde. *The Language of Color in the First Goetheanum: A Study of Rudolf Steiner's Art*. Dornach, Switzerland: Walter Keller Verlag, 1983.

52. Richards, M.C. *Centering: In Pottery, Poetry and the Person*. Middletown, CT: Wesleyan University Press, 1962.

53. ———. *Towards Wholeness: Rudolf Steiner Education in America*. Middletown, CT: Wesleyan University Press, 1980.

54. Richter, Gottfried. *Art and Human Consciousness*. Spring Valley: Anthroposophic Press, 1982.

55. Roggenkamp, Walter & Hildegard Gerbert. *Bewegung und Form in der Graphik Rudolf Steiner*. Stuttgart: Verlag Freies Geistesleben, 1979.

56. Rosenkrantz, Arild. *A New Impulse in Art*. London: New Knowledge Books, 1967.

57. Schad, Wolfgang. *Man and Mammals: Toward a Biology of Form*. Garden City, NY: Waldorf Press, 1977.

58. Schindler, Maria, *Pure Colour*. London: Rudolf Steiner Press, 1989.

59. Schroff, Lois. *Experiencing Color Between Darkness and Light*. Herndon, Va.: Newlight Books, 1985.

60. Schutze, Alfred. *The Enigma of Evil*. Edinburgh: Floris Books, 1978.

61. Schwenk, Theodor. *Sensitive Chaos*. London: Rudolf Steiner Press, 1965.

62. Sloan, Douglas. *Insight-Imagination: The Emancipation of Thought and the Modern World*. Westport, CT: Greenwood Press, 1983.

63. Spock, Marjorie. *Teaching as a Lively Art*. Hudson, NY: Anthroposophic Press. 1985.

64. Soesman, Albert. *The Twelve Senses*. Stroud: Hawthorne Press, n.d.

65. Steffen, Albert. *The Crisis in the Life of the Artist*. New York: Adonis Press, 1943.

66. Stockmeyer, E.A. Karl. *Rudolf Steiner's Curriculum for Waldorf Schools*. Stuttgart: Verlag Freies Geistesleben, 1982.

67. Thal-Jantzen and MacDonald. *The Great Hall of the Goetheanum.* W. 68: The Art Section of the School of Spiritual Science, 1995.

68. Weihs, Thomas J. *Embryogenesis in Myth and Science.* Edinburgh: Floris Books and Spring Valley: Anthroposophic Press, 1986.

69. Witzenmann, Herbert. *Beppe Assenza.* London: Rudolf Steiner Press, 1979.

70. Zajonc, Arthur. *Catching the Light.* Oxford: Oxford University Press, 1993.

Other Authors (OA)

1. Arguelles, Jose. *The Transformative Vision.* Fort Yates: Muse, 1992.

2. Aristotle. *Ethics.* trans. J.A.K. Thomson. New York: Penguin Books, 1953.

3. Arnheim, Rudolf. *Art and Visual Perception.* Berkeley and Los Angeles: University of California Press, 1974.

4. ———. *Visual Thinking.* Berkeley and Los Angeles: University of California Press, 1969.

5. Besant, Annie & C.W. Leadbeater. *Thought Forms.* Wheaton, Ill.: The Theosophical Publishing House, 1975.

6. Edwards, Betty. *Drawing on the Right Side of the Brain.* Los Angeles: J.P. Tarcher, Inc., 1979.

7. ———. *Drawing on the Artist Within.* New York: Fireside Book, Simon and Schuster, 1986.

8. Gablik, Suzi. *Has Modernism Failed?* New York: Thames and Hudson, 1984.

9. ———. *The Re-enchantment of Art.* New York: Thames and Hudson, 1991.

10. Goethe, Johann Wolfgang von. *The Metamorphosis of Plants.* intro. Rudolf Steiner. illus., Dennis Klocek. Wyoming, RI: Bio-dynamic Literature, 1983.

11. ———. *Theory of Colour.* Cambridge and London: The M.I.T. Press, 1970.

12. ———. *Goethe's Botanical Writings.* Woodbridge, CT: Ox Bow Press, 1952.

13. Gsell, Paul. *Rodin on Art and Artists.* New York: Dover Publications, 1983.

14. Joyce, James. *A Portrait of the Artist as a Young Man.* New York: Signet Classic, Penguin Books, 1991.

15. Kafka, Franz. *The Metamorphosis.* New York: Bantam Books, 1972–1988.

16. Kandinsky, Vassily. *Concerning the Spiritual in Art.* New York: Dover Publications, 1977.

17. Kuspit, Donald. *The Cult of the Avant-Garde Artist*. Cambridge: Cambridge University Press, 1994.

18. Lipsey, Roger. *An Art of Our Own*. Boston and Shaftesbury: Shambala, 1989.

19. Maritain, Jacques. *Art and Scholasticism*. trans. J.P. Evans. Notre Dame: Univ. of Notre Dame Press.

20. Moffit, John. *Occultism in Avant-Garde Art: The Case of Joseph Beuys*. Ann Arbor: U.M.I. Research Press, 1988.

21. Nietzsche, Friedrich. *Thus Spoke Zarathustra*. New York: Penguin, 1966.

22. Noon, William T. *Joyce and Aquinas*. New Haven: Yale Univ. Press.

23. Ovid. *The Metamorphoses*. trans. Horace Gregory. New York: Mentor Book, Viking Press, 1958.

24. Postman, Neil. *Amusing Ourselves To Death*. New York: Penguin Books, 1985.

25. Read, Herbert. *The Origins of Form in Art*. New York: Horizon Press, 1965.

26. Regier, Kathleen J. *The Spiritual Image in Modern Art*. Wheaton, Ill.: The Theosophical Publishing House, 1987.

27. Ringbom, Sixten. *The Sounding Cosmos*. Abo: Abo Abademi, vol. 38, #2, 1970.

28. Ryf, Robert S. *A New Approach to Joyce*. Berkeley: Perspectives in Criticism Series, University of California Press, 1962.

29. Schiller, Friedrich. *On the Aesthetic Education of Man*. trans. E. M. Wilkinson and L.A. Willoughby. Oxford: Clarendon Press, Oxford University Press, 1967.

30. Stachelhaus, Heiner. *Joseph Beuys*. trans. David Britt. New York: Abbeville Press, 1987.

31. Stone, Irving. *The Agony and the Ecstacy*. Garden City, NY: Doubleday, 1961.

32. Thompson, D'arcy Wentworth. *On Growth and Form*. Cambridge: Cambridge University Press, 1961.

33. Tuchman, Maurice. *The Spiritual in Art: Abstract Painting 1890-1985*. New York: Abbeville Press, 1986.

Works of Visual Art Created by Rudolf Steiner

Compiled by David Adams

Architecture

In each of the following projects Rudolf Steiner created primary design elements in the form of sketches and models and worked in conjunction with other architects or builders in completing and executing his designs. Approximately twenty scale models and numerous sketches by Steiner related to most of these projects survive in the archives at the Goetheanum in Dornach.

Interior decoration of the Kaim-Sall (later called the Tonhalle) during the Congress of the Federation of European Sections of the Theosophical Society, Munich, May 18-21, 1907.

With execution by E. A. Karl Stockmeyer. Model Building, Malsch (near Karlsruhe), Germany, 1908-1909 (1.74 meters high). Restored 1958–1968 by Albert von Baravalle.

With execution by Carl Schmid-Curtius. Basement meeting room, Theosophical Society House, Landhausstrasse 70, Stuttgart, 1910-1911 (destroyed except for sandstone columns presently in pergola at Husemann Klinik, Weisneck [near Freiburg in Breisgaul], Germany; and painted apocalyptic seals in archives at Rudolf Steiner Halde, Dornach).

With Carl Schmid-Curtius. Design for Johannesbau, Munich, 1911-1912 (never built).

First Goetheanum, Dornach, Switzerland, 1913-1922 (destroyed by fire Jan. 1, 1923). Design work included extensive surrounding landscape architecture.

Glashaus (glass engraving studios), Dornach, 1914.

Heizhaus (central heating building), Dornach, 1915.

Haus Duldeck (private home), Dornach, 1915-1916.

Haus Vreede (private home), Dornach, 1919-1921.

Haus van Blommestein (artist's home and studio), Dornach, 1919-1920.

Three "Eurythmy Houses," Dornach, 1920-1921.

Haus de Jaager (artist's home and studio), Dornach, 1921-1922.

Transformatorenhaus (transformer house), Dornach, 1921.

Rudolf Steiner-Halde: Eurythmeum and extensions to Haus Brodbeck, Dornach, 1923-1924. Further extensions in 1935-1936 under Ernst Aisenpreis, architect.

Verlagshaus (publishing house), Dornach, 1923-1924.

Eurythmeum and Internat (boarding house) at First Stuttgart Eurythmy School, Stuttgart, 1923-1924 (on the grounds of the Stuttgart Waldorf School).

Second Goetheanum, Dornach, 1924-1928.

Haus Wegman (private home for medical doctors), Arlesheim, Switzerland, 1924. Purchased in 1930-1931 by the nearby Klinisch-Therapeutischen Institut.

Haus Schuurman (private home), Dornach, 1924-1925.

Revision of facade design for schoolhouse in The Hague by Hermann Ranzen-perger, n.d.

Sculpture

The Three Kabiri, 1917, cast plaster from clay original, heights: 21 cm., 34 cm., and 46 cm. Archive, the Goetheanum, Dornach (for a performance of Goethe's *Faust,* Part 2).

With Edith Maryon (1872-1924). Relief plaque of subjects drawn from Steiner's Mystery Dramas, n.d.

With Edith Maryon. *The Group (The Representative of Humanity),* 1914-1926, elm wood, ca. 9.5 m. (ca. 30 feet) high (including seven sketch scale models, one full-size model, and six detail studies in plasticine and wax, 1914-1917). Archive, the Goetheanum, Dornach. Intended to stand on the stage in the Goetheanum.

Two-Dimensional Artwork

Sketches for seven "Apocalyptic Seals," 1907, pastels (executed in oil on canvas by Clara Rettich in 1907 and in 1911; Steiner's sketches for the first, fifth, and sixth seals have not survived).

"Physiognomies": twelve caricature drawings of profile heads, n.d., pencil.

Instructions for two paintings ("Michael" and "Raphael") executed in oil by E. A. Karl Stockmeyer, 1911.

Weaving Light, 1911, tempera, 102 x 67.5 cm (for use in the mystery drama, *The Souls' Probation).*

Two Studies for the Ground Colors of Both Cupolas of the First Goetheanum, probably 1912-1913, pastel, 50 x 64 cm. and 50 x 37 cm.

Layout for the Window Motifs and Painting Motifs of Both Cupolas of the First Goetheanum, pencil, 33 x 43.5 cm.

Twenty-three sketches for the murals on the large cupola of the first Goetheanum, June-December 1914:

The Elohim Work Creatively into the Earth; Light-Beings Radiate Light into It, pastel and pencil, 33.5 x 25 cm.

The Senses Arise, Eye and Ear Become, pastel, 34 x 24.5 cm.

The Senses Arise, Eye and Ear Become, pencil, 32.5 x 23 cm. *Jehovah and the Luciferic Temptation—Paradise,* pastel, 45 x 31.5 cm.

Jehovah and the Luciferic Temptation—Paradise, pencil, 45.6 x 31 cm.

Lemuria, pastel, 25.5 x 19 cm.

Lemuria, pencil, 25.5 x 18 cm.

Atlantis, pastel, 43 x 29 cm.

Atlantis, pencil, 32 x 24.5 cm.

The Indian Human Being, pastel, 44 x 27 cm.

The Indian Human Being, pencil, 44 x 31 cm.

The Persian Human Being, pastel, 44 x 32 cm.

The Persian Human Being, pencil, 30.5 x 28.5 cm.

The Egyptian Human Being, pastel, 44.5 x 31 cm.

The Egyptian Human Being (first version), pencil, 45 x 31 cm.

The Egyptian Human Being (second version), pencil, 45 x 31 cm.

Greece and the Oedipus motif, pastel, 34 x 24. 5 cm.

Greece and the Oedipus motif, pencil, 34 x 2 4 cm.

*God's Wrath and God's Sadness—*T, pastel, 24 x 34 cm. *God's Wrath and God's Sadness—*1, pencil, 24 x 32 cm. *The Round of Seven—*A, pastel, 45 x 30 cm.

*The Round of Seven—*A, pencil, 44 x 31 cm.

*The Circle of Twelve—*0, pastel and pencil, 22.5 x 34 cm.

Twenty-three sketches for murals on the small cupola of the first Goetheanum, June-December 1914:

The Representative of Humanity between Lucifer and Ahriman (The Central Motif), pastel, 42 x 52 cm.

The Slavic Human Being with Doppelgänger, Angel, and Centaur, pastel, 49 x 63.5 cm.

Head of a Centaur, pastel, 30 x 37 cm.

The Slavic Human Being and the Persian-Germanic Initiate, pastel, 41 x 27.5 cm.

The Slavic Human Being and the Persian-Germanic Initiate, pencil, 37.5 x 26.5 cm.

Athena-Apollo, pastel, 21 x 32.5 cm.

Athena-Apollo, pencil, 21 x 30 cm.

Faust, pastel, 25 x 23 cm.

Faust, pencil, 19 x 25.5 cm.

The Egyptian Initiate, pastel and pencil, 44 x 29.5 cm.

Page of Studies on the Face of Christ, pencil.

Ahriman in the Cave (drawn after the sculpted model for "The Group"), pencil.

Ahriman in the Cave (drawn after the sculpted model for "The Group"), pencil.

Study of Hands for the Central Motif (*Hands of Christ and Ahriman*), pencil.

Studies of Lucifer, pencil.

Studies of Eyes and Brow (probably for the Lucifer Motif), pencil.

The Persian-Germanic Initiate—Lucifer in Profile, pencil.

A Small Centaur from the Persian-Germanic Motif, pencil.

Head Studies for Greek Culture, pencil.

Three Studies for the Inspiring Being over Apollo, pencil.

Faust with the Angel and Hand at Upper Right, pencil.

Three Studies of an Angel, pencil.

Six Head Studies, pencil.

Mural painting on the small cupola of the first Goetheanum (entire southern [right-hand] half and part of northern half), summer 1918-October 1919, layered, plant-based watercolor on papier mâché over cork.

Sketch for stage curtain of first Goetheanum, 1914, pastel, 30 x 43 cm. (executed by William Scott Pyle).

Sketch for stage curtain for eurythmy performances, 1918-1919, pastel, 41 x 30 cm.

The Three Kabiri, pencil, January 28, 1918 (drawing of his own sculpture).

Sketch for Louise van Blommestein, watercolor, n.d. (lost)

Two sketches for "Pedagogical Youth Course," Stuttgart:

> *Sunrise*, October 1922, watercolor.
>
> *Moonset*, October 1922, watercolor.

Seven sketches for the painting curriculum at the Fortbildung School (or, Friedwart School, a secondary school) in Dornach, 1921-1924:

> *Sunrise*, pastel, 54 x 60 cm.
>
> *Sunset*, pastel, 49 x 62 cm.
>
> *Trees in Sunny Air*, pastel, 35 x 66 cm.
>
> *Trees in Storm*, pastel, 35 x 72 cm.
>
> *Head Study ("Portrait")*, pastel, 50 x 60 cm.
>
> *Sunlit Tree by Waterfall*, pastel, 56.8 x 65.5 cm.
>
> *Mother and Child*, February 28, 1924, pastel, 95 x 72 cm.

Exercise sketch for Hilde Boos-Hamburger, 1924, watercolor.

Twenty-four sketches for the curriculum of the painting school of Henni Geck, Dornach, 1922-1924:

> *Sunrise 1*, pastel, 21 x 16 cm.
>
> *Sunset 1*, pastel, 23.5 x 19 cm.
>
> *Sunrise 2*, pastel, 36 x 27 cm.
>
> *Sunset 2*, pastel, 31 x 22 cm.
>
> *Shining Moon*, pastel, 24.5 x 17.5 cm.
>
> *Trees 1 (Blooming or Fruiting Trees)*, pastel, 25 x 25 cm.
>
> *Trees 2 (Summer Trees)*, pastel, 27 x 18.5 cm
>
> *Moonrise*, pastel, 29.5 x 21 cm.
>
> *Moonset*, pastel, 34.5 x 25 cm.
>
> *Group Soul (The Human Being)*, December 2, 1922, pastel, 29 x 46 cm.
>
> *The Seer between Marianus and Gabrilein*, March 1923, pastel, 74.5 x 54 cm.
>
> *"Distance and Life Come into Being,"* (*Archangel Looking at Planetary Conditions*), May 1923, pastel, 66 x 68 cm.
>
> *The Threefold Human Being*, June 1923, pastel, 52.5 x 70 cm.
>
> *The Human Being in Spirit*, July 1923, pastel, 49 x 74 cm.
>
> *The Spirit in the Human Being*, July 1923, pastel, 59.5 x 98.5 cm. *St. John's Imagination (Reddish Form with Sun and Moon)*, July 1923, pastel, 56 x 72 cm.

Druid Stones, September 1923, pastel, 72.5 x 88.5 cm.

The Human Being in Relation to the Planets, October 1923, pastel, 67.5x 91.5 cm.

Elemental Beings, November 1923, pastel, 64 x 72 cm.

Adam Kadmon in Early Lemuria, December 1923, pastel, 70 x 100 cm. *Three Kings Motif,* December 1923, pastel, 55 x 65 cm.

Ground Colors for "Moonrider," January 1924, pastel, 67 x 87 cm.

The Moonrider, January 1924, watercolor, 65 x 98 cm. (ground colors by Henni Geck; theme from *The Dreamsong of Olaf Asteson;* executed for a eurythmy poster).

New Life (Mother and Child), February 1924, watercolor, 66.5 x 100 cm.

Easter (Three Crosses), April 1924, watercolor, 66 x 98.5 cm.

Sketch for a Eurythmy Poster (Three Crosses), Easter 1924, pastel.

Archetypal Plant, May-June 1924, watercolor, 66.5 x 100 cm. (for a eurythmy poster).

Archetypal Human Being (Archetypal Animal), July-August 1924, watercolor, 130.5 x 75.5 cm. (for a eurythmy poster).[1]

Engraved Colored Glass Windows

Forty-two sketches for nine engraved, colored glass, three-light windows for the first Goetheanum, 1913-14 (executed 1914-1918 by Assia Turgeniev following instructions from Steiner): one red window and two each of green, blue, violet, and peach-blossom windows. After Steiner's death these motifs were rearranged within each window and executed again by Turgeniev for the second Goetheanum.

Graphic Art

Seven "Planetary Seals": *Saturn, Sun, Moon, Mars, Mercury,* 1907; *Jupiter, Venus, 1911.*

Four "Mystery Drama Seals" on title pages for his mystery dramas: *The Portal of Initiation, 1910; The Soul's Probation, 1911; The Guardian of the Threshold, 1912; The Soul's Awakening,* 1913. Published in Berlin.

Invitation card to Theosophical Society events in Munich, including *The Portal of Initiation,* 1910.

Membership card for the Johannesbau-Verein in Munich, ca. 1911.

Membership card for the Anthroposophical Society, 1912-1913.

Corner letterhead design for the administration at the Goetheanum, 1918.

Corner design for brochure, *Die Kernpunkte der sozialen Frage* ("The Essential Point of the Social Question"), 1919. Also used for the weekly periodical

1. Full-size color reproductions of most of the above sketches are available from Rudolf Steiner Verlag, Goetheanum, Dornach, Switzerland.

Dreigliederung des sozialen Organismus ("Threefolding of the Social Organism") and for the first edition of Steiner's book *The Renewal of the Social Organism* (*also* published as *The Threefold Social Order*).

Corner design for folder for the weekly *Dreigliederung des sozialen Organismus*, ca. 1919.

Title design for the weekly periodical *Soziale Zukunft* ("Social Future"), 1919.

Four end-vignettes (for use at the end of articles in periodicals), 1919.

Loan certificate design and trademark for the corporation Die Kommende Tag ("The Coming Day"), 1919.

Trademark design for the book publishing business of Die Kommende Tag, 1919.

Book cover corner designs for *Truth and Science, The Renewal of the Social Organism* (second edition), and Ludwig Polzer-Hoditz, *The Struggle against the Spirit,* 1919.

Membership card for the Verein des Goetheanum, 1919-1920.

Design for invitation to the first anthroposophical conference of medical doctors, 1920.

Revised corner design and new corner design for weekly periodical *Dreigliederung des sozialen organismus,* 1920.

Invitation to "Anthroposophischen Hochschule" course at the Goetheanum, 1920. Later used as letterhead for the corporation Die Kommende Tag.

Design for sign at the Goetheanum, 1920.

Study and corner design for the corporation Die Kommende Tag, 1920 or 1921. Also used with added lettering for the Verein des Goetheanum.

Letterhead design for the Goetheanum, n.d.

Trademark/letterhead design and two packaging vignettes for the Internationalen Laboratorien, Arlesheim (later called the Klinisch-Therapeutisches Institut); 1920. Used since 1924 by Weleda AG.

Trademark design for Klinisch-Therapeutisches Institut, Stuttgart, 1921. Now used by Weleda AG. Also letterhead design for same institute, 1921.

Corner design/letterhead and medicine bottle graphic for the pharmaceutical corporation Futurum AG, 1921.

Membership card for the Anthroposophical Society Branch at the Goetheanum, 1921.

Corner design/letterhead for the Anthroposophischer Hochschulbund, 1921.

Study and masthead design for the weekly periodical *Das Goetheanum,* 1921.

Masthead design for the weekly periodical *Was in der Anthroposophischen Gesellschaft vorgeht* ("What Is Happening in the Anthroposophical Society"), 1921.

Masthead design for the monthly periodical *die Drei* ("The Three"), 1921.

Book cover corner designs for Julius Mosen, *Ritter Wahn;* Hermann von Baravalle, *Zur Pädagogik der Physik und Mathematik;* and Claude de Saint Martin, *Ecco homo,* 1921.

Design for Klinisch-Therapeutische Institut, Arlesheim (later the Ita Wegman-Klinik), 1922.

Masthead design for the weekly periodical *Anthroposophie, Österreichischer Bote von Menschengeist zu Menschengeist* ("Anthroposophy, Austrian Herald from Human Spirit to Human Spirit"), 1922.

Attendance card for the Second International Congress of the Anthroposophical Movement for the Resolution of the Problem East versus West, Vienna, 1922.

Study and book cover corner design for Edward Bulwer-Lytton, *Vril*, 1922.

Membership card for the Anthroposophical Society,1923-1924.

Membership card for the First Class, School of Spiritual Science, 1923-1924.

Letterhead design for the Goetheanum, 1923-1924.

Book cover corner design for *Theosophy*, 1923-1924.

Design for a eurythmy performance poster, pencil, n.d.

Plant motif corner design, n.d.

Two corner designs for folders for the periodicals *Das Goetheanum* and *Was in der Anthroposophischen Gesellschaft vorgeht*, 1924.

Book cover corner design for Gunther Wachsmuth *The Etheric Formative Forces in Cosmos, Earth, and Man*, 1924.

Book cover corner design for *The Calendar of the Soul*, 1925.

Suggested designs for pictorial initial capital letters to be used in publishing, n.d.

Jewelry [2]

Planetary seals and Mystery Drama seals executed in various metals.

Rings: Twenty-five executed designs, one unexecuted sketch (1924), three revisions of designs by Bertha Meyer-Jacobs.

Pendants and lockets: Twenty executed designs, three revisions of designs by Bertha Meyer-Jacobs.

Crosses and rose-crosses: Five executed designs, two unexecuted sketches (1924), and revision of one design by Bertha Meyer-Jacobs.

Necklaces: Three executed designs.

Brooches: Three executed designs.

Headbands: Two executed designs.

Incense burner, 1911.

Belt buckle, 1913, silver and turquoise.

Umbrella handle-grip, 1915, silver.

Emblem, 1918, silver.

2. Most of the designs created between 1908 and 1924 and summarized here were given to and executed by Bertha Meyer-Jacobs. A complete, chronological listing of Steiner's jewelry designs may be found in *Kleinodienkunst als goetheanistische Formensprache*. Dornach: Rudolf Steiner Verlag, 1984.

Cravat pin, 1918, gold and diamonds.

Memorial medallion to doctors and nurses who served in the First World War, 1918, silver.

Other Work in the Visual Arts

Designs for stage scenery and dramatic costumes, beginning 1907.

Numerous recommendations for complete fine arts and crafts curricula for grades 1-12 in the Waldorf schools, including more than twenty drawings of embroidery designs during lectures to Waldorf school teachers, 1919-1924.

Inauguration of the pedagogical and remedial art of "form drawing" in the Waldorf school, including numerous specific form drawings, 1919-1924.

Interior color plans for three Waldorf schools: Stuttgart, 1920 (partial) and 1922; Goethe School, Hamburg, n.d.; and New School, London, n.d. Also recommendations by grade level for pictorial wall decoration in Waldorf school classrooms.

Furniture design:

Interior furnishings of first Goetheanum (including auditorium seats, speaker's podium, twelve "zodiacal thrones," several radiator screens, an outdoor concrete bench, and, in collaboration with architect Hermann Ranzenperger, several pieces of furniture and interior design for the upstairs White Hall.

Interior furnishings, both free-standing and built-in, for Haus Duldeck, 1915-1916; Haus de Jaager, 1920-1922; and Eurythmeum, 1923-1924.

Music stand, wood, n.d.

Revision of entrance design for existing house by Hermann Ranzenperger.

Revision of design for a bed by Hermann Ranzenperger, executed in oak and cherry.

Thirty-five sketches for eurythmy figures with color indications, pencil, 1922 (executed in painted wood by Edith Maryon).

Approximately 1,100 colored chalk drawings on black paper executed 1919-1925 to illustrate points spoken about in lectures. Although artistic in character, these drawings were not intended as independent works of art.

INDEX

Acting, 139-41
Aesthetica Acroamatica, 116
Aesthetic activity, 181-82
Aesthetic creation, 186
Aesthetic laws, 219
Aesthetics
 Fechner on, 128
 function of, 188
 of Goethe's worldview, 113-34
 in Greek imagination, 193-94
 history of, 116-28
 and pleasure, 128
 and the sense organs, 176-94
 Vischer on, 123
Aging, 282-83
Ahriman, 281-95
 in *The Representative of Humanity*,
 229-35, 291-92
Ahrimanic age, 289
Ahrimanic element, 289-90,
 292
Ahrimanic forces, 217-218, 287-88
Ahrimanic stream, 229
Allegory, 128, 252
Animal sculpture, 265-66
Anthropos, 254
Anthroposophical Society, 154
Anthroposophy, 154, 246, 248, 270
 and Christianity, 295
 foundation for, 113
 and the visual arts, 250-71

worldview of, 229, 252, 253, 264-
 65, 267
 See also Spiritual science
Antipathetic forces, 180
Aphrodite, 193-94
Aphrogenea, 193
Archangels, 139
Archetypal goodness, 194
Archetypes, 120, 121, 126, 141
Architectural genius, 157
Architecture, 143-45, 238-41
 anthroposophical worldview in,
 251-52
 Christian, 160-62
 equilibrium in, 242
 Gothic, 162-63, 175
 Greek, 159-64
 inner, 220
 pre-birth forces in, 240-49
 Roman, 160
 Romanesque, 161, 163, 175
 in social transformation, 158
 See also Goetheanum
Aristotle, 193
 catharsis in, 185-86
 limitations of, 116-17
 truths in, 177
Art
 and anthroposophy, 219, 250-71
 in Christian Middle Ages, 118-19
 color in, 196-97

death and destruction in, 200-13
dramatic, 219
enjoyment of, 182, 209
evolution of, 209
feeling in, 240
God in, 134
Greek, 117-18, 263
history, 128
and nature, 117, 130, 238, 257
original sin in, 195
Platonic view of, 119
as play, 125-26
pleasure in, 131
principle in, 116
as proof of immortality, 245
psychology of, 91
and reality, 213
reason for, 241
of relief carving, 164-69
and religion, 270-71
religious mission of, 122-23
role of gods in, 159
and science, 270-71
in social transformation, 158
sources of, 204, 210
spiritual being of, 135-53
supersensible origin of, 212, 237-39
as transformation, 129
true, 212
truth in, 190
understanding, 189
visionary urge in, 199
Artistic life, 237
Artists
humor of, 210
modern, 205
soul processes in, 197-98
Art-lovers
humor of, 210
soul processes in, 197

Astral body
goodness in, 278-79
in melody and harmony, 244
Astral world, 245
Atavism, 178

Babel, 289
Balance, 138, 184, 287-95
Christic element of, 290-91
Baumgarten, Alexander Gottlieb, 116
Beauty, 130-32, 272-280
etheric body in, 275-76, 278-79
Hegel on, 127
origin of, 194
and pre-earthly life, 277
as spiritual connection to present, 280
See also Aesthetics
Bible, 268, 289, 293, 294
Birth, 281
Blood system, 282-83
Blue, 206, 207
Body
calcifying force in, 284-85
dimensions of, 254
during pre-earthly existence, 272-76
hardening forces in, 284-88
incarnation of, 242
rejuvenating force in, 284-85
in The Representative of Humanity, 202-3
sculpting of, 242, 258, 263-65
sickness of, 290-91
softening forces in, 285-88
and spiritual existence, 273-74
and truth, 273-75, 277-79
See also Etheric body
Building. See Architecture
Buttresses, 162-63

Cancer, 293
Catharsis, 185-86
Cézanne, 204
Cherubim, 147, 150
Christ, 229-31, 233, 235, 281-95
Christian, 291, 295
Christian church, 161, 169
Christian Middle Ages, 118
Christian themes, 229
Christic education, 293
Christic element, 289-95
 in *The Representative of Humanity*,
 291-92
Christic practice of medicine, 293
Chronos, 150
Churches, 161, 163, 169
 See also Architecture
Color, 146, 196-97, 205, 208
 blue, 206-7
 in Goetheanum, 226, 227, 252
 meaning of, 205-7
 in Nature, 200
 purple, 206
 red, 180, 196-97, 206-7
 spiritual aspect of, 245
 supersensible soul of, 206-7
 yellow, 206-7
Concepts, 149
Concrete, 225
Conventionality, 285-87
Cosmos, 258, 263, 266
Creation mysteries, 226
Critique of Judgment, 123
Crystallography, 190

Dance, 136-39
*Das Problem der form in der
 bildenden Kunst*, 166
da Vinci, Leonardo, 147
Death, 199-200, 202, 207-8, 217,
 281

life after, 237, 241, 244
Dione, 194
Dornach building. *See*
 Goetheanum
Drama, 152, 275
 mystery, 219, 223
Drawing, 206-7

Education
 as Christic practice, 293
 effect of beauty of, 277
Elohim of the Earth, 168
Ensouling, 180, 184, 187
 See also Life processes
Equator, 258, 259, 261
Equilibrium, 241, 242
Esthetics. *See* Aesthetics
Etheric body, 232-33, 257, 264,
 276
 in architecture, 242
 and beauty, 275, 278-79
 in human being, 266
 of plants, 266
Euclidean geometry, 254
 See also Geometry
Euclidean space, 264
Eurythmy, 238, 246-47, 267-70
Evolution, 190-91, 268
 depicted in Goetheanum, 223
 divine, 229
 historical, 293-94
 human, 259
 of nature, 224
 spiritual, 194, 214
Evolutionary history, 127
Evolutionary progress, 158
Expressionism, 195-213
 visionary urge in, 199, 210

Falsehood, 273-74
 See also Truth

Fanaticism, 285-87
Fantasy, 285-87
Faust, 129, 212
Fechner, Gustav Theodor, 128
Fever, 283-84
Form, 146, 208
 cosmic forces in, 262
 human, 253, 258-59
 static, 209
 through poetry, 243-44
 See also Body
Frankfurter Gelehrte Anzeigen, 129
Freedom, 124-25
Future, 280

Gaia, 150
Galileo, 115
Geology, 190
Geometry, 254, 255, 264
God, 134
Gods, 247
 language of the, 154-75
Goethe, 133, 195, 213, 265
 aesthetics of, 113-14
 importance of, 114
 on his art, 212
 on metamorphosis, 200-1, 268
 on music, 211
 "revealed mysteries" in, 211
 Walter von, 134
 worldview of, 119-21, 132, 134
Goetheanum, 154-75, 214-36,
 250-51, 281
 anthroposophical principles in,
 221-36
 artistic elements of, 252
 as a school, 250-51, 294-95
 attitude of spirit in, 267
 history of, 219-21
 as means of education, 156
 motif of, 164

relief carving in, 164-69
The Representative of Humanity in,
 202-3, 229-36, 291-92
 windows of, 156, 165, 171-72,
 174, 226-27
Goodness, 272-80
 archetypal, 194
 in astral body, 278-79
 beyond death, 279-80
 body's relation to, 278-80
 as spiritual connection to future,
 280
Gospels, 294, 295
Gothic architecture, 145, 162-63,
 175
Gravity, 164
Greek architecture, 159-64
Greek art, 117-18, 263
Greek experience of beauty, 279
Greek imagination, 193-94
Greek sculptors, 239
 See also Temples

Harmony, 122, 189
 in architecture, 158
 musical, 244
 in nature, 118
 spirit of, 175
 through spiritual science, 247
Hartmann, Eduard von, 127, 132
Head, 258, 276
 impression of cosmos in, 258
 incarnation of, 242
 metamorphosis of, 201
 nerves of, 281-82
 sculpting of, 239, 242, 259-63
Health, 273-74, 290-91
Hegel, Georg Wilhelm Friedrich,
 127
Hildebrand, Adolf, 166-67
Hodler, 204, 210

Human form, 238-39, 253
 See also Body, Head
Humor, 203, 209-11, 233

Ideas, 131
 in Goethean sense, 120
Imagination, 152, 211, 284
Imaginations, 265, 270
Imaginative knowledge, 255-59
Impressionism, 195-213
 of Goethe's art, 212
 sense-perceptible/supersensible
 components of, 204-11
Incarnation
 of head, 242
 of limbs, 246-47
Inspiration, 150
Interconnectedness, 238
Introduction to Esthetics, 128
Intuition, 145, 211-12
*Intuitive Thinking as a Spiritual
 Path*, 279

Jehovah, 268
Jesus Christ. *See* Christ

Kant, Immanuel, 123, 127
 nature of beauty in, 124
Karma, 232
Klimt, Gustav, 209
Knowledge, 259
Korf, 236
Kunst und Kunsterkenntnis, 135

Laocoon, 143
Larynx, 159, 170-73
 incarnation of, 246-47
Last Supper, 147
Laws
 of art, 129
 of nature, 130

Lessing, Gotthold, 116
Letters on Aesthetic Education, 124-
 26
*Letters on the Aesthetic Education of
 Man*, 186-87
Lichtenberg, 243
Life after death, 244-45
Life processes, 180-88, 193
Light, 208
 in Goetheanum, 228
 in modern art, 205-6
Limbs, 258
 incarnation of, 246-47
 nerves of, 282
 sculpting of, 260-61
Line, 245
Logic, 186-90
Love, 187
Lucifer, 281-95
 in *The Representative of Humanity*,
 229-35, 291-92
Luciferic age, 289
Luciferic element, 203, 217-18,
 288-92, 293
Luciferic forces, 287-88
Luciferic stream, 229

"Manganistic", 215
Materialism, 184-88, 191-92, 219,
 285-87
 mystical, 185
Materialistic age, 182, 237-38
Maya-Maria, 194
Mechanization, 215
Medicine, 293
Melody, 244
Memory, 240-49
Mephistopheles nature, 217
Merck, Johann Heinrich, 128-29
Metamorphosis, 200-1, 268
Michelangelo, 229

Middle Ages, 118
Mineral kingdom, 265
Mineralogy, 190
Moon period
 returning to, 182
 visions in, 178-79
Moon state, 181
Movement, 269
Munich Society of Arts, 221
Music, 147-50, 184, 238-40, 268
 Goethe on, 211
 and life-after-death, 243-45
 of the spheres, 244-45
Mystery plays, 219, 223, 238
Mystic, 284
Mysticism, 285-87

Naturalism, 209, 238
Natural laws, 122, 130
Natural urge, 186
Nature, 266
 art and, 130, 209, 238, 257
 breaking down of, 208
 creative forces in, 268
 death and destruction in, 199
 -200, 202, 205, 208
 gods of, 159
 Goethean transcendence of,
 120
 in Greek art, 117-18
 in Middle Ages, 118-19
 rational urge and, 186-87
 remoteness from, 216
 sense-perceptible/supersensible
 element in, 211-13
 and spirit, 117-19, 126
 transcending, 202
Nerve principle, 283
Nerves, 281-82
Nervous system, 282, 284
New Testament, 293-94

Original sin, 195

Painting, 145-47, 238, 275
 anthroposophical worldview in,
 251-52, 267
 in Goetheanum, 227-28, 251
 landscape, 146
 sensory domains in, 183
 soul element in, 267
 the spiritual in, 245-46
Past, 280
Pedantry, 285-87
Perfection, 131-32
Philosophy, 123
 in Middle Ages, 119
Philosophy of Beauty, The, 132
Physical body. See Body
Pieta, 229
Pillars, 222-25
Plant sculpture, 265
Plato, 119
Play, 125-26
Pleasure, 128
Pleurisy, 283, 290, 291
Pneumonia, 283
Poetic language, 243-44, 248
Poetics, 186
Poetry, 128, 150-53, 238-40, 243,
 268
 and life-after-death, 243-45
 lyric, 152
Portal of Initiation, The, 238
Portrait, 147
Post-Atlantean age, 163
Pre-birth, 272-73
 experiences, 241-49
 forces, 244
 memory of, 240-49
Present, 280
Prose, 239, 248
Prose Aphorisms, 130-31

Psychophysics, 128
Purple, 206
Pyle, William Scott, 228
Pyramid, 145

Raphael, 204
Rationality, 285-87
Rational urge, 186-87
Realism, 123
 limitations of, 117-18
Reality, 129, 189-94, 274
 Goethe on, 122
Rebirth, 237, 241
 See also Pre-birth
Red, 180, 196-97, 206-7
Relief carving, 164-69
Religion, 270-71
Representative of Humanity, The,
 202-3,
 229-36, 291-92
Reuleaux, Franz, 214-19
Roman architecture, 160
Romanesque architecture, 163, 175
Rychter, Tadeusz, 156, 174

Saturn columns, 166
Schelling, Friedrich Wilhelm von,
 126-27
Schiller, Friedrich von, 121
 esthetics of, 124-26
 letters of, 186-88
 truth in, 194
School, 288
 as Christic practice, 293
 of spiritual science, 250-51, 294-
 95
Schopenhauer, Arthur, 127
Science, 127, 152, 217
 art's relation to, 270-71
 limitations of, 122
Sculpting

of head and body, 239, 242, 258-
 63
of human forms, 208-9, 266
plants and animals, 265-66
Sculptors, 259
 Greek, 239
 and human form, 200
Sculptural space, 253-71
Sculpture, 141-43, 238, 240, 269
 aim of, 240-41
 anthroposophical worldview in,
 251-52
 beauty in, 257
 connected to pre-birth, 244-46
 the cosmos in, 259
 head and body in, 239, 242, 258-
 63
 of human form, 207-8, 259, 268-
 70, 275
 pre-birth forces in, 241-49
 The Representative of Humanity as,
 202-3
 in social transformation, 158
 vision in, 199
 See also Sculpting
Self-movement, 184
Sense organs, 181
 and esthetic experience, 176-94
Sense-perceptible/supersensible,
 195-96, 208, 211-13
Senses, 193
Sensory processes, 179-80
Seraphim, 145
Siedlecki, Franciszek, 156
Sight, 146
Signac, 206
Sistine Madonna, 189
Sleep
 rejuvenating force in, 286
 the spirit world in, 245
Solothurn, 221

Soul, 180, 184
-boundaries, 208
element, 266, 267
experience, 240
and goodness, 278
hardening forces in, 285-88
imagination's effect upon, 255-59
life, 198-200
sickness, 283-84
softening forces in, 285-88
Soul processes, 180-88, 193
in art, 197-200, 209
Space, 255-57
dimensions of, 255
Speech organs, 246-47
Spirit, 126, 134, 175, 185
artists and, 133
in Goetheanum windows, 171
hardening force in, 286
as inspiration, 245
and matter, 171, 188
modern, 122
and nature, 117-19, 126
Spirits of Form, 138-39, 144
Spirits of Movement, 138
Spirits of Personality, 141-42
Spirits of Will, 150-51
Spiritualism, 188
Spiritual science, 214, 218, 229,
246-49, 272
as artistic stimulus, 219
in education, 288
imagination in, 211-12
and natural science, 217
in paintings, 227
physical world in, 184
in windows, 226
See also Anthroposophy,
Goetheanum
Sturm und Drang, 129
Supersensible, 195, 209

as origin of the arts, 237-49
See also Sense-perceptible/
supersensible
Supersensible knowledge, 240-41
Sympathetic forces, 180

Teachers, 283-84
Technology, 219
Teleology, 191
Temples, 145, 275
of the Gods, 159-64, 169, 172,
175
Ten Commandments, 295
"The Artist's Apotheosis", 133
Theosophist, 284
Theosophy, 285-87
Tragedy, 185-86
Truth, 182, 272-80
body's relation to, 273-75, 277-79
representations of, 177
as spiritual connection to past, 280
Turgenieff, Assia, 156

Ugliness, 276
Uranus, 150, 193-94

Venus de Milo, 143, 189-91, 257
Vischer, Theodor Friedrich von,
123, 127
Visionaries, 285-87
Visionary urge, 199, 210-11
Visions, 210
art transforming, 199
atavistic, 179
moon, 178-79
in soul life, 198-99

Way to a New Architecture, The, 154
Wege zu einem nuen Baustil, 154
Winckelmann, Johann, 116, 120,
122

Windows
 of Goetheanum, 156, 165, 171-
 72, 174
 spiritual science depicted in, 226-
 27

Yellow, 206-7

Zeus, 150, 194
Zodiac, 179, 182, 256, 259
 of twelve sensory domains, 179

RUDOLF STEINER
(1861-1925)

During the last two decades of the nineteenth century the Austrian-born Rudolf Steiner became a respected and well-published scientific, literary, and philosophical scholar, particularly known for his work on Goethe's scientific writings. After the turn of the century he began to develop his earlier philosophical principles into an approach to methodical research of psychological and spiritual phenomena. His multifaceted genius has led to innovative and holistic approaches in medicine, science, education (Waldorf schools), special education, philosophy, religion, economics, agriculture (Biodynamic method), architecture, drama, and other visual and performing arts including the new arts of eurythmy and speech. In 1924 he founded the General Anthroposophical Society, which today has branches throughout the world.

MICHAEL HOWARD, born in Vancouver, Canada, in 1946, began sculpting at the age of fifteen. He received his B.F.A. from Eastern Michigan University and his M.A. in Fine Arts from Columbia Pacific University. He has studied the work of Rudolf Steiner since 1969. For twenty-seven years Michael has made an independent study of Rudolf Steiner's sculpture, and has taught primarily in Waldorf schools and Anthroposophical centers, both in Europe and North America. Since 1985 he has taught sculpture at Sunbridge College as director of the Life Form Studio in Spring Valley, N.Y., and he is presently leader of the Visual Art Section of the Anthroposophical Society in North America.

ROBERT MCDERMOTT, president of the California Institute of Integral Studies since 1990, has been professor of comparative philosophy and religion since 1964. His published writings include *Radhakrishnan* (1970), *The Essential Aurobindo* (1974) and *The Essential Steiner* (1984), the "Introduction" to William James, *Essays in Psychical Research* (1986), and "Rudolf Steiner and Anthroposophy" in Antoine Faivre and Jacob Needleman, eds., *Modern Esoteric Spirituality* (1992). He was president of the Rudolf Steiner Institute (1983-94), served as chair of the board of Sunbridge College (1986-1992) and Rudolf Steiner College (1990-1996), and currently serves on the Council of the Anthroposophical Society in America.